T0355613

Faces *of the* Civil War Navies

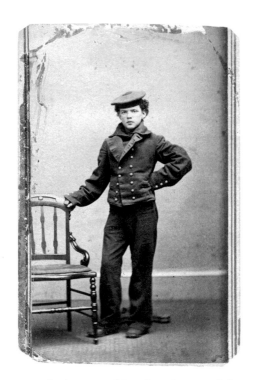

Powder boy, possibly Edward B. Randall

Carte de visite by Freeman of Charlestown, Massachusetts, about 1864–1865. Collection of Steven M. Karnes.

Faces *of the* Civil War Navies

AN ALBUM OF UNION AND CONFEDERATE SAILORS

Ronald S. Coddington

WITH A FOREWORD
BY CRAIG L. SYMONDS

JOHNS HOPKINS UNIVERSITY PRESS
BALTIMORE

Johns Hopkins University Press
2715 North Charles Street
Baltimore, Maryland 21218-4363
www.press.jhu.edu

LIBRARY OF CONGRESS CATALOGING-IN-PUBLICATION DATA

Names: Coddington, Ronald S., 1963–, author.
Title: Faces of the Civil War navies : an album of Union and Confederate sailors / Ronald S. Coddington ; with a foreword by Craig L. Symonds.
Description: Baltimore, Maryland : Johns Hopkins University Press, 2016. | Includes bibliographical references and index.
Identifiers: LCCN 2016010153| ISBN 9781421421360 (hardcover : alk. paper) | ISBN 9781421421377 (electronic) | ISBN 1421421364 (hardcover : alk. paper) | ISBN 1421421372 (electronic)
Subjects: LCSH: United States—History—Civil War, 1861–1865—Naval operations—Pictorial works. | United States—History—Civil War, 1861–1865—Biography. | United States—History—Civil War, 1861–1865—Portraits. | United States. Navy—Biography. | Sailors—United States—Biography. | Confederate States of America. Navy—Biography. | Sailors—Confederate States of America—Biography.
Classification: LCC E591 .C64 2016 | DDC 973.7/570922—dc23
LC record available at http://lccn.loc.gov/2016010153

A catalog record for this book is available from the British Library.

Special discounts are available for bulk purchases of this book. For more information, please contact Special Sales at 410-516-6936 or specialsales@press.jhu.edu.

Johns Hopkins University Press uses environmentally friendly book materials, including recycled text paper that is composed of at least 30 percent post-consumer waste, whenever possible.

For Anne, forever yours

Contents

Foreword

CRAIG L. SYMONDS

MORE THAN THREE MILLION MEN (AND SEVERAL HUN-dred women) fought in the American Civil War. The vast majority of them did so as soldiers on a thousand-mile front from Virginia to Missouri, but more than a hundred thousand fought on ships: at sea or on one of America's great inland rivers. There were no large-scale fleet engagements in the Civil War—no nautical equivalent of Shiloh or Gettysburg—yet the navies, particularly the Union Navy, did much to define the character of the war and certainly affected its length. Moreover, the men who served in those navies, like those who served in the armies, endured transformational life experiences. In his fourth volume about the "faces of the Civil War," Ronald Coddington has collected the images and created profiles for seventy-seven of them.

As in previous volumes, the individuals featured here are not a scientific sample. Rather, their selection and inclusion was driven by the availability of contemporary photographs, in particular what were known as *cartes de visite*. These small (four-inch-by-two-and-a-half-inch) calling cards were enormously popular during the Civil War era. As young men prepared to go off to war, many chose to have their portraits taken in uniform and purchased a few dozen such cards to leave behind with mothers and fathers, wives and sweethearts, friends and siblings, or simply as mementos. Because more naval officers than enlisted sailors availed themselves of this opportunity, there are far more surviving *cartes de visite* of them; consequently, a significant majority of the men profiled here are officers.

They are not, however, the fleet commanders or squadron leaders—those admirals and captains whose names appeared in *Harper's Weekly* and who became famous. Rather, these are men

who served, mostly anonymously, as acting volunteer lieutenants, master's mates, ensigns, and midshipmen, as well as seventeen who served as enlisted men: firemen, boatswains (bo'suns), even landsmen, the rating assigned to new recruits with no seagoing experience at all.

Though more than a few of the officers in the Civil War navies of both sides were veterans who had several years of seagoing experience, the outbreak of war and the dramatic expansion of the navy meant that nearly all of them found themselves tasked with vastly greater responsibilities. Midshipmen became lieutenants, and lieutenants became ship captains. To fill the jobs they vacated, and to officer and man the hundreds of new ships, brand new graduates of the Naval Academy and volunteer officers from the merchant trade stepped into their shoes. Consequently, the officer corps of the Civil War navy, like that of the Civil War army, consisted of a great many neophytes and newcomers leavened with a sprinkling of veterans, and even the veterans occupied new and unfamiliar positions.

As for the enlisted men, some 80 percent of them were entirely new to the service. In 1861, there were 7,600 men in the United States Navy; two years later there were five times as many. Eventually a total of 118,000 would serve (though not simultaneously) in the Union navy, with perhaps five thousand or so in the much smaller Confederate navy. The demographic profile of Civil War sailors differed dramatically from that of Civil War soldiers. While Ohio and the Midwest contributed tens of thousands of men to the Union army, nearly 80 percent of Union navy recruits came from the maritime states. There were significant differences in their backgrounds as well: farmers and farmworkers made up nearly half of all volunteers for the army but only 3 percent of sailors. Navy volunteers were primarily skilled laborers: carpenters, blacksmiths, and machinists, all specialties for which there was a particular need on board nineteenth-century steam warships. All sailors, of whatever nationality, were volunteers, for there was no draft for the navy, though many enlistments were no doubt prompted by a desire to avoid service in the army.

There were other differences as well. Michael J. Bennett, who has conducted the most thorough research into this issue, notes that U.S. Navy sailors were slightly shorter, more prone to getting into fistfights, and more improvident with their money than their army counterparts. They were also less motivated by nationalistic patriotism, perhaps because barely over half of them were native-born Americans. Though students of the Civil War are generally aware of the service of large numbers of Irish immigrants in the Union army (e.g., the Irish Brigade), Irishmen were even more prevalent in the Union navy. While Irish-Americans constituted just over 7 percent of Union soldiers, they made up a full fifth of all Union sailors.

Another difference between army and navy rank and file was the role of African Americans. While the Union army began accepting African American soldiers for military service halfway through the war, organizing them into all-black regiments, the U.S. Navy had included black Americans in its crews since its founding. Historically, some 10–15 percent of the crews on U.S. Navy warships were African American. That dropped to 5 percent in the 1830s and 1840s due to pressure from Southern congressmen, but with the coming of war, it rose again to as high as 20 percent. The most commonly cited figure is that eighteen thousand black Americans—both freeborn and former slave (colloquially called contrabands) served in the U.S. Navy during the Civil War. Though very few of them had an opportunity to create a *carte de visite*, two black sailors are included here.

As the officers and men of this greatly expanded American navy and the quickly assembled Confederate navy posed for their photographs, they often sought to present themselves in a warlike manner. Like the army officers profiled in Coddington's earlier work, *Faces of the Civil War*, most of the officers posed with a sword, either wielded belligerently or sheathed conspicuously at their sides. A sword was a physical symbol of an officer's elevated status, almost a badge of office. While enlisted sailors might be issued temporary custody of a cutlass for an expedition ashore or to board a suspicious vessel, none of them rated an officer's

sword as part of his kit. Several of the officers also adopted the nineteenth-century custom of placing one hand inside their vests or tunics in a pose that modern audiences associate with Napoleon Bonaparte. Not only was this a convention of the time, it also had a practical function of keeping the subject's hands still during the lengthy time it took to expose the photographic plate.

For their part, sailors did not pose with a tool of their trade such as a marlinspike or a ramrod—perhaps because such nautical accouterments were not readily available in the photographer's studio. Soldiers might be portrayed holding their muskets, often with bayonet fixed, but sailors simply presented themselves to the camera, seated or standing, perhaps with a thumb hooked casually in one's trouser top.

For officers and sailors alike, their facial expressions only hint at the feelings that might have been roiling inside them as they prepared to depart for war. Some stare belligerently into the camera; others gaze with a placid benignity into the middle distance with the expression of someone who has no idea of what is to come but is willing to do whatever he must. Some look defiant, some thoughtful; some have no readable expression at all. Not one of them is smiling. Such photographs cry out for explanation. We cannot know all, or really anything, about what they might have been thinking, but Coddington tells us what can be known: where they were from, how they came to be there, and the particular moment in each one's service that tested his mettle in the crucible of war. We find out, too, what happened to them after the war— if, indeed, they survived it. Taken collectively, these "snapshots" remind us that the history of war is not merely a chronicle of campaigns won and lost; it is the collective personal odysseys of thousands of individual life stories—seventy-seven of which we have here.

Bibliographical Note

Among the general histories of Civil War navies are James M. McPherson's *War on the Waters* (Chapel Hill: University of North Carolina Press, 2012) and Craig L. Symonds's *The Civil War at*

Sea (New York: Oxford University Press, 2012). On Civil War officers and enlisted men, see Michael J. Bennett, *Union Jacks: Yankee Sailors in the Civil War* (Chapel Hill: University of North Carolina Press, 2004), and Dennis Ringle, *Life in Mr. Lincoln's Navy* (Annapolis, Md.: Naval Institute Press, 1998). For black sailors, see Joseph P. Reidy, "Black Jack: African American Sailors in the Civil War Navy," in *New Interpretations in Naval History*, ed. William B. Cogar (Annapolis, Md.: Naval Institute Press, 1997), and Barbara Brooks Tomblin, *Bluejackets and Contrabands: African Americans and the Union Navy* (Lexington: University of Kentucky Press, 2009).

Preface

Navigable waters are central to our Civil War narrative. The first hostile shots roared from rebel artillery at Charleston harbor. Along the Mississippi River and its tributaries, federal expeditionary forces engaged in amphibious operations that ended in victory at New Orleans and Vicksburg. Confederate guerrillas and masked batteries along the river responded with lethal surprise attacks. In the Gulf of Mexico and along the Atlantic seacoast, blockaders in blue floated within earshot of the enemy. In the Pacific Ocean, Union crews protected California mail steamers and remained vigilant for spies and secessionists. In Hampton Roads, Virginia, the centuries-long era of wooden warships ended after a drawn battle between ironclad vessels. In the harbor of Portland, Maine, grayjackets captured a revenue cutter. On the opposite side of the Atlantic, in the port of Cherbourg, throngs of French citizens were eyewitness to the fight between a notorious rebel cruiser and a Yankee warship. Half a globe away, in the Bering Sea, another Confederate cruiser fired the last hostile shots of the war across the bow of a New Bedford whaler.

Despite the active engagements and technical advances, the story of the war on the waters is little remembered. The *New York Herald* observed as much in a March 2, 1895, review of the first in the thirty-volume *Official Records of the Union and Confederate Navies*: "That branch of the service has never had its full share of credit for its work in the suppression of the rebellion, owing, perhaps, to the more popular interest in the army, which came so much more closely home to the people."

The relatively small number of sailors involved in the war almost certainly factored into the equation. A recent study by

the Congressional Research Service found that on the Northern side, 84,415 men served in the navy compared to 2.1 million in the army, a ratio of one sailor for every twenty-five soldiers. The Southern side mustered only a fraction of the strength. According to an 1864 estimate by the Navy Department in Richmond, 5,213 sailors were on the rolls of the Confederate navy: 753 officers and 4,460 enlisted men.

Also to be considered is the recruitment and deployment of men. In the army, recruitment was a community event led by prominent townspeople who formed the local populace into military organizations and marched them off to war brimming with esprit de corps. The men shared all the privations of life on campaign and on the battlefield, and hometown newspapers followed their every move from muster in to muster out. In the navy, men enlisted individually or in small groups with little or no fanfare. Ordered to major ports, they were assigned to vessels officered and manned by heterogeneous crews. Media coverage was centered on vessels and stations, which were more connected to the navy at large than to a specific company, regiment, and home place.

The navy death toll was lower in total numbers and overall percentage. Calculations based on the Congressional Research Service findings indicate that 17 percent of Union soldiers died from battle wounds, disease, and other causes, or roughly one of every five men. The ratio in the navy was about one to every twenty men, or about 5 percent of all sailors.

The disparity in numbers does not suggest that the war was any less devastating to navy men. They fought with courage, tenacity, and patriotism equal to their counterparts in the infantry. They laid down their lives amidst grim scenes of carnage on blood-soaked decks and from contagions of yellow fever and other dreaded diseases in cramped quarters far away from land and loved ones. Witness the master's mate who shoots and kills an enemy soldier in close combat during an inland raid in North Carolina. The Marine lieutenant mortally wounded in a failed

assault against Fort Wagner. The paymaster who is lost after his ironclad strikes an underwater torpedo during the Battle of Mobile Bay and sinks in seconds. The veteran sailor who falls victim to disease after his ship is swept by yellow fever on the coast of West Africa.

Long periods of active duty took a mental as well as physical toll on the men and their families. Rear Adm. David D. Porter revealed his state of mind in a letter to the mother of one of his young staff officers killed in action during the desperate ground assault by navy forces at the Battle of Fort Fisher on January 15, 1865. "I have no consolation to give you, unless to console you with the certainty of meeting in a better world than this. I have gone through a great deal in this war. For four years I have been but one month with my family. I have seen my official family cut down one after another, and my heart is so sad that I feel as if I could never smile again.... I would like to drink of the waters of Lethe and forget the last four years."

No mythical waters could erase the memory of the brutality of this war and the unprecedented loss of a significant portion of a generation. Stories of a representative sample of those who served in the Union and Confederate navies are featured in this volume. Each is illustrated with an original period photograph of the individual. This follows the same format as my previous books, *Faces of the Civil War: An Album of Union Soldiers and Their Stories*, *Faces of the Confederacy: An Album of Southern Soldiers and Their Stories*, and *African American Faces of the Civil War: An Album*.

The faces of most of these warriors of the waters have never been included in a book before. They came from all walks of life. Many had prior experience on the seas as merchant mariners, whalers, fishermen, and navy seamen. A few were educated at the U.S. Naval Academy. Some were country farmers and city clerks with no obvious connection to vessels. Almost everyone grew up in proximity to a river or ocean, which is not at all surprising considering the vital importance of waterways and ports

to America's economic livelihood. They came from all regions, especially the New England states, as well as from Canada, Ireland, and England.

They were also the first Americans to grow up with the camera. They were the Photography Generation. Essentially a democratic medium, photography individualized the identity of the common soldier and sailor. The paper prints and hard plates that hold their likenesses are part of an evolution of vernacular photography that continues today in the form of digital images. In recent years, these unique portraits of citizen soldiers and sailors of the Photography Generation have been recognized by major museums and other institutions as part of our country's visual record of the war.

The purpose of this book remains unchanged from its companion volumes: to humanize the Civil War through the stories and images of men in the ranks and officers and through their lives and military experiences in order to increase our understanding of the revolution that resulted in a new America free of slavery and rededicated to equality for all its citizens. In addition, it aims to provide a stepping-stone for further research and scholarship to deepen our appreciation of the origins of the United States of America. The history of the Civil War is the stories of its soldiers and sailors.

About This Volume

This project has its origins in the spring of 2013. This time was a period of reflection on my recently released book, *African American Faces of the Civil War*. One of the realizations was the extent to which my research and writing about men of color fundamentally altered my views of the war. I had glimpsed the Civil War through a different lens and came away with fresh perspectives—and a strong desire to investigate another larger narrative.

My thoughts turned to the naval war. This was uncharted territory for me, and fertile ground to explore. My exposure to the navy up to this point had been, I suspect, similar to most students of the war. A lone chapter in a tome with scant pages dedicated

to the military and technological highlights of the war on the waters. Illustrations of the *Monitor* and *Virginia* at Hampton Roads, Rear Adm. David Farragut tied to his rigging aboard the *Hartford* at Mobile Bay, and the Confederate submarine *H. L. Hunley* as depicted by artist Conrad Wise Chapman.

The naval war seemed to be treated as a sideshow to the main attraction on the ground. During the course of my early investigations into the subject I discovered many excellent books about the navy, often focused on the Union blockade, river operations, commerce raiders, ironclads, and surveys of warships, uniforms, and accouterments. Biographies of the famous and infamous senior officers, too, are relatively plentiful. I found little in the way of stories and images of the common sailor, however.

The challenge of exploring the lives and experience of junior officers and enlisted men excited me. The possibilities of discovering unique entry points into the Civil War navy experience prompted me to push ahead.

I began the project in earnest in August 2013. The first step, the search for original and identified wartime photographic portraits, seemed daunting. Similar searches for my last two books, on Confederates and African Americans, had been arduous. In this case, the work was greatly simplified by two events.

On August 10, 2013, I became editor and publisher of *Military Images* magazine. Founded in 1979, the ongoing mission of *MI* is to showcase, interpret, and preserve early photographs of American soldiers and sailors. The magazine perfectly fits my interests. A subscriber for many years, I had long desired an opportunity to lead and jumped at the chance. I inherited an extensive network of contributors, including historian Ron Field. An authority on the Union navy, he generously shared his knowledge, contacts, and images from his personal collection. A third of the portraits reproduced on these pages were acquired through Ron and his connections.

Also, an unusual number of *cartes de visite* of navy men began to appear on the auction site eBay coincident with the start of my search. All were federals, and many were identified. Bidders

were few, and prices were low relative to soldiers. I purchased as many as I could and added them to my existing collection of Civil War–period *cartes de visite*, which had up to this time included only a small number of navy photographs. Ultimately, another third of the images in the book were added in this manner.

The final third also comes from private collections, with the exception of three photographs from the holdings of the Mariners' Museum in Newport News, Virginia. I had reached out to the Mariners' Museum and other institutions early on, though soon abandoned these searches after discovering the abundance of material within the collecting community.

By the end of 2013 I had secured digital scans and permissions for more than half of the images in the book. Confident that the remaining photographs would surface, I shifted my attention to researching the lives and military service of the men and writing their stories. The work of image gathering continued in the background. The last image, a *carte de visite* of Union Lt. Benjamin H. Porter, was added in May 2015.

The majority of portraits in this volume are in the *carte de visite* format. Altogether, seventy-two profiles are illustrated by these small paper prints attached to cardboard mounts. The other five are tintypes. Each portrait is reproduced in its entirety and original condition, including the dents, tears, and other blemishes common to these relics. The dominance of *cartes de visite* can be explained by my own interest in the format and its unprecedented popularity during the war years.

Photography was twenty-two years old in 1861. The majority of citizen soldiers who fought in the armies of blue and gray were the first to be born into a world with photography. In January 1839, Frenchman Louis Jacques Mandé Daguerre had announced the first successful commercial photographic process. An artist who had used the camera obscura as a drawing aid to project images onto surfaces, he had determined to find a repeatable method to permanently fix these projections to a surface. Daguerre was not alone in this pursuit. Fellow Frenchman Joseph Nicéphore Niépce, an artist who became fascinated with the process of li-

thography, had spent two decades searching for a solution. He had achieved several breakthroughs, including his hazy "View from the Window at Le Gras," produced in 1826 or 1827, which is widely acknowledged as the first photograph.

Niépce and Daguerre joined forces in 1829. After Niépce died in 1833, Daguerre pressed forward, and in 1835 he found the right combination of photosensitive chemicals and other materials. He spent the next few years perfecting his process. When he finally released the news to the world, the effect was electric.

News traveled quickly to America, where the daguerreotype was hailed as a beautiful invention, as Rembrandt perfected. Firsthand accounts from Americans in France were widely published during that heady spring of 1839, including one letter by a Mr. Walsh in the May 29, 1839, edition of the *Massachusetts Spy*. "I was admitted to M. Daguerre's laboratory, and passed an hour in contemplating his drawings. It would be impossible for me to express the admiration which they produced. I can convey to you no idea of the exquisite perfection of the copies of objects and scenes, effected in ten minutes by the action of simple solar light upon his papiers sensibles. There is one view of the river Seine, bridges, quays, great edifices, &c., taken under a rainy sky, the graphic truth of which astonished and delighted me beyond measure. No human hand ever did or could trace a copy."

Mr. Walsh came away with the impression that Daguerre's images were produced on sensitive paper when in fact highly polished silver-plated copper was used. Another observer who happened to be in France at this historic moment would not miss this detail. He was respected artist and inventor Samuel F. B. Morse, who shared his impressions in a letter published in the *Christian Recorder* on April 26, 1839. The images, he described after a visit with Daguerre, "are produced on a metallic surface, the principal pieces about 7 inches by 5, and they resemble aquatint engravings, for they are in simple chiaro oscuro, and not in colors. But the exquisite minuteness of the delineation cannot be conceived. No painting or engraving ever approached it. For example: In a view up the street, a distant sign would be perceived,

and the eye could just discern that there were lines of letters upon it, but so minute as not to be read with the naked eye." Having noted the lack of color and abundance of detail, Morse called out a limitation in the new form caused by long exposure times, "Objects moving are not impressed. The Boulevard so constantly filled with a moving throng of pedestrians and carriages, was perfectly solitary, except an individual who was having his boots brushed. His feet were compelled, of course, to be stationary for some time, one being on the box of the boot-black, and the other on the ground. Consequently, his boots and legs are well defined, but he is without body or head because these were in motion."

The strengths of the daguerreotype outweighed its weaknesses. Before Daguerre, painters and engravers were the chroniclers of our visual history. After Daguerre, photographers emerged as the preferred recorders, though many traditional artists and art critics looked askance at the fledgling medium and its practitioners.

Instructions for how to produce a daguerreotype traveled across the Atlantic as rapidly as news of its discovery had. Entrepreneurs in New York City, Boston, Cincinnati, New Orleans, and elsewhere quickly mastered the medium. These pioneers and those who followed them spread photography to the far corners of antebellum America. Galleries with distinctive skylights cut into the roofs popped up in bustling Northern cities, bucolic Southern towns, and rough-and-tumble frontier settlements. Most of these painters of light toiled anonymously in cramped studios and eked out a modest living. Some, most notably Mathew B. Brady, rose to fame and prosperity as photographers to the elite. A small number lived a nomadic existence, lugging camera and equipment by wagon from town to town.

The photography pioneers needed a long list of supplies to sustain their businesses, including chemicals, plates, mats, cases, and other items. Industrious manufacturers seized the opportunity to support them. In Waterbury, Connecticut, the Scovill family had been in business as buttonmakers and providers of other hardware since the turn of the century. In 1840, about a year after Daguerre's announcement, the company began production

of metal plates to meet the growing demand by daguerreotypists. Within a few years the company became one of the nation's leading providers of photographic supplies.

The daguerreotype remained the popular form of photography in America for nearly fifteen years. Many prominent early citizens of the republic, including sixth president John Quincy Adams, abolitionist Frederick Douglass, and First Lady Dolley Madison were photographed. The first known photographs of conflict are a small, random group of daguerreotypes of the Mexican War (1846–1848).

In the mid-1850s, the introduction of cheaper ambrotypes and tintypes undercut the daguerreotype. Composed of less expensive glass and metal plates, the production cost was significantly reduced. Consumers who once paid $2.50 for a daguerreotype could now shell out as little as 50 cents for a tintype. The daguerreotype would be extinct before the decade was over, although a few diehards continued to practice into 1860 and 1861.

Meanwhile in Europe, a radically different photographic process had been introduced—paper images printed from negatives. Its inventor, British scientist William Henry Fox Talbot, had made his announcement shortly after Daguerre went public in 1839. But Talbot's prints, known as calotypes or talbotypes, were no match for the magnificent qualities of the daguerreotype. Then, in March 1851, another Brit, Frederick Scott Archer, introduced a process that built on Talbot's concept. Archer traced the lack of fine detail to the paper negatives. He deduced that the naturally uneven surface texture caused the quality issues. He replaced the paper with a smooth plate of glass coated in a syrupy chemical cocktail known as collodion. The paper print that resulted rivaled the daguerreotype.

Archer's collodion process sounded the death knell for the daguerreotype, the ambrotype, and the tintype. Looking back on the watershed event a quarter-century later, an article in the February 26, 1875, issue of the *British Journal of Photography* summarized the change: "Previous to the discovery of the collodion process by Archer the production of portraits was confined to the Talbotype

paper process and the daguerreotype. By the former, portraits possessing great vigour and undoubted merit, although devoid of delicacy, were obtained; by the latter, the results secured fulfilled the highest requirements of sharpness and delicacy. There existed, however, a very important distinction between these two processes; for by the former the camera picture was a negative capable of yielding an unlimited number of prints, while by the latter method each picture was complete in itself and lacked the power of reproduction."

Archer published a manual of instruction in 1852. A second edition, *The Collodion Process on Glass*, followed in 1854. British photographer Roger Fenton adopted the collodion process when he made history as the first to systematically cover conflict during the Crimean War (1854–1856).

If Archer sounded the death knell of the hard plates, a former actor and daguerreotypist in Paris landed the killing blow. On November 27, 1854, André-Adolphe-Eugène Disdéri patented the *carte de visite* format. His goal was to make photograph production more cost effective. The concept was simple: instead of making one exposure from a single collodion-treated glass negative, he divided the negative into ten separate exposures. The number was later revised to a more practical eight. The print that resulted was cut into rectangles, and each was pasted to a thin sheet of cardboard that measured about two-and-a-half-by-four inches. This change reduced the cost of a *carte de visite* to a fraction of a daguerreotype, ambrotype, or tintype. A multi-lensed camera was later introduced to make the production more efficient.

The *carte de visite* failed to catch on with photographers or the public at first, even though similar ideas for affixing a photograph to a visiting card had been proposed as early as 1851. Then, in May 1859, Disdéri photographed Napoleon III and Empress Eugénie. Fashion-conscience Parisians finally took note, and the *carte de visite* exploded in a wave of popularity. A year later, in May 1860, a similar event occurred in England when John Jabez Edwin Mayall photographed the royal family. Three months later he was granted permission to distribute the portraits for sale as albums

of *cartes de visite*. British subjects responded with unprecedented enthusiasm.

Though lower cost popularized the *carte de visite*, its intimacy as an object was critical to its widespread adoption. The *Encyclopedia of Nineteenth-Century Photography*, edited by John Hannavy, describes it this way: "Small, ephemeral commodities which were widely available, easy to hold, easy to pass around, easy to look over by the dozen within a drawing room, cartes possessed little distinction in themselves. They were literally 'touchy-feely' artefacts; not to be looked at with deferential awe or revered from a distance but catalogued and collected, gossiped and commented upon" (276–277).

Cartes de visite were social media for the nineteenth century. "Cardomania," or "cartomania," as the phenomenon came to be known, was the subject of a humorous rant that appeared in the April 1861 issue of *MacMillan's Magazine*: "I don't know how it fares with you in London, but I know that we in Paris have a sorry life of it. By which it I do not allude to the frost, nor to the macadamized Boulevards, nor to the tightness of the money-market—no, nor yet to the indefinite rise of house-rents, but to a far worse nuisance—the cardomania. Ever since it has become the fashion to have squinting, ghastly photographs, instead of the true, plain honest visiting-card—ever since it has become the fashion to make collections of these said photographs—above all, ever since the fatal invention of albums ad hoc, farewell peace! Whichever way you turn, requests for your portrait are leveled at you like so many guns. All is acceptable prey; indifferent features, respectable age, obscure position—nothing comes amiss to the greedy monster, Album."

The *carte de visite* arrived in the United States about the spring of 1860. Though Americans were preoccupied with the presidential election and other national issues, they embraced *cartes* with a fervor that rivaled their European cousins. By April 1861, the same month Londoners chuckled about the perils of cardomania over tea and biscuits and South Carolina troops fired the first hostile shots of the Civil War at Fort Sumter in Charleston har-

bor, the *carte de visite* had already spread across the country. On April 10, just two days before the bombardment of Fort Sumter, a Washington, D.C., bookstore advertised a variety of photograph albums in the *Daily National Intelligencer:* "The Parisian Fashion of inserting 'Cartes de Visite' Portraits of one's Friends in an Album is becoming 'the mode' in all the cities and towns of the United States[;] to meet this demand we have procured some twenty Varieties of Albums."

The arrival of the *carte de visite* in America coincident with the start of the Civil War is noteworthy. The inherent strengths of the format—affordability, reproducibility, and shareability—served anxious families on both sides of the conflict who sent their sons off to war perhaps never to be seen alive again. Long periods of separation might be made somewhat more endurable if parents were able to receive a letter containing a *carte de visite* portrait of their soldier from some faraway camp. Conversely, the homesick husband might find consolation by carrying a *carte de visite* of his wife and children on campaign, and the boy away from home for the first time could carry a portrait of the girl he left behind.

Despite the popularity of paper photographs, many preferred ambrotypes and tintypes. Both continued to be produced through the war years. An informal study of surviving soldier images of all formats suggests that enlisted men preferred ambrotypes and tintypes early in the war while officers gravitated to the *carte de visite*. This may reflect a perception that *cartes* were only for the elite, a notion supported by advertising and news reports. Later war images, which include a mix of enlisted men and officers, suggest that any such perceptions had disappeared.

The best-known Civil War story that involved a soldier and a photograph illustrates the transition from plate to paper. Sgt. Amos Humiston of the 154th New York Infantry was killed during the first day of the Battle of Gettysburg, his identity lost in the chaos and carnage of fighting. He died clutching an ambrotype of three children. A description of the youngsters circulated in newspapers throughout the North in an attempt to identify the dead soldier. Eventually, Humiston's wife, Philinda, responded

to the query and received a *carte de visite* copy, which she confirmed as a portrait of her two sons and daughter. The original ambrotype was presented to the widowed Philinda along with the proceeds from the sales of hundreds of *cartes de visite* of the original image.

The *carte de visite* had advantages that were particularly useful in wartime. The front and back of the cardboard mount provided ample space for a soldier to sign his name, rank, company, and regiment, and even to jot a note. Options for soldiers to inscribe an ambrotype or tintype were limited. The most popular methods found on surviving images include writing on the inside of a case, or on the back of the metal or glass plate, or tucking a note behind the back of the image plate.

There was also a minor irritant that the *carte de visite* resolved—an annoyance that even the observant Samuel F. B. Morse failed to mention in his 1839 letter: hard-plate images pictured the subject in reverse, as if looking into a mirror. With pictures of men and women dressed in civilian clothes, this could be overlooked. Patterned dresses, striped trousers, or other bits of clothing appeared generally the same no matter how you looked at them, the most common exception being perhaps the position of a pocket watch chain. But for soldiers, who dressed in uniforms marked with insignia and wore distinctive equipment on the left side and the right, the reversal problem became obvious. Many soldiers compensated by holding their musket in the opposite hand, flipping belts and cartridge boxes, and even reversing the company letters and regimental numbers on their caps. Results were usually not convincing. With the added step of making a paper print from the glass negative, however, the image was unreversed.

Color photography would not be introduced until long after the Civil War. Ambrotypists and tintypists added tints to the plates to give the impression of full color. Some portraits were exquisitely and delicately colored with oil-based washes. But many were treated with less care—a haphazard dash of rose on the cheeks and a thick dollop of gold-gilt that obliterated details on rank insignia, buttons, belt plates, and other uniform brass. The vast

majority of *cartes de visite*, by contrast, were not colored. There may have been less desire to tint the paper photographs because they were thought of in small multiples rather than as uniquely crafted objects. It is also possible that the application of tints to the paper prints, which were typically sold in a dozen at a time, was not cost effective.

Motion was less of a problem in portrait photography compared to landscapes and urban scenes. Most portraits were taken indoors in a controlled environment. Still, *carte de visite* exposure time might take fifteen seconds, necessitating the use of adjustable iron braces to steady the soldier's head. Other more subtle techniques, resting an arm on a prop column or a hand on a chair, for example, helped steady the subject at the expense of making the sitter appear a bit stiff and unnatural. As sitters learned how to pose for the camera, this became less an issue.

Cardomania dominated the American photographic scene throughout the Civil War years. So big had the craze become that one of the great American men of letters, Oliver Wendell Holmes Sr., proclaimed the influence of the little *carte de visite* in an essay published in the July 1863 issue of the *Atlantic Monthly* magazine. "Card-portraits," declared Holmes, "as everybody knows, have become the social currency, the sentimental 'Green-backs' of civilization."

The federal military perceived the value of photography as a tool. It employed photographers in official and semiofficial relationships to record various aspects of the war.

On New Year's Day 1863, the inaugural catalog of the new Army Medical Museum contained a reference to the submission of photographs of specimens. In June 1864, a circular specifically requested medical officers to submit photographs of unusual cases. Some of the images were produced as *cartes de visite*.

The July 2, 1864, *Harper's Weekly* magazine included a pair of woodcut engravings of Hubbard D. Pryor. One showed Pryor dressed in the ragged slave clothes he wore when he turned up in a Union army camp; the other pictured him after his enlistment as a private in Company A of the Forty-fourth U.S. Colored Infan-

try. The engravings were based on *cartes de visite* of Pryor taken by Nashville, Tennessee, photographer A. S. Morse in March or April 1864. Morse, who was affiliated with the Army of the Cumberland, likely took these portraits at the request of the military. Their appearance in *Harper's Weekly* represents an early use of photography as propaganda.

Photography also turned up in the case files of the military. On at least two occasions in 1865, *cartes de visite* were used as evidence in court-martial cases for desertion.

By the end of the war, cardomania had reached its zenith. The introduction of the five-by-seven-inch cabinet card in 1866 marked the beginning of the end for the *carte de visite*. By the early 1870s the cabinet card was all the rage, and the *carte de visite* faded into oblivion.

Today the *carte de visite* appears as a blip on the timeline of photographic history, wedged between the celebrated qualities of the daguerreotype and the brilliant results achieved when the paper formats matured a bit later in the century. The bulk of surviving *cartes de visite* have been ravaged by time. Decades of exposure to the elements have deadened the brilliant shine of their albumen surfaces and drained their purplish hues of their resonance, obliterating the finest details and leaving behind a lifeless sepia tone. Ragged and scuffed mounts prevail, their corners clipped under instructions from album manufacturers to prevent creasing as the thin images were inserted into thick and inflexible album pages.

Meanwhile, their hard-plate cousins remain almost as pristine as when they were first made. The permanence of the materials used to produce them and their careful packaging with brass mats, cover glass, and protective cases have stood the test of time.

Cartes de visite, ambrotypes, and tintypes compose the earliest photographic record of the volunteer American soldier and sailor during a major war. They are a primary source for the study of weapons, uniforms, equipment, and aspects of soldier life. They are also a relatively new source for scholarship. For years, they lay tucked away, largely forgotten, in attics and basements. The cen-

tennial commemoration of the Civil War inspired a new generation of Americans to take an active interest in blue and gray relics. This was when the old photos began to surface. At first, little or no monetary value was placed on them. They were given away as a bonus to the buyer of a musket or sword. Before long, however, sellers of Civil War antiques realized that there was a market for photographs, and by the end of the 1970s a thriving community of photo collectors bought, sold, and traded portrait images.

The legacy of the *carte de visite* is its stunning impact on the democratization of photography. A cheap and reproducible form of social media, *cartes* were accessible to all, no matter where one stood on the economic scale. "Here there is no barrier of rank, no chancel end; the poorest owns his three inches of cardboard, and the richest can claim no more," pronounced the *London Review* on August 9, 1862, adding, "When they serve as pegs on which to hang our knowledge and sentiment, our memories and associations, they may be the highest use."

In a military context, photography provided the common soldier in America with a profound individualism once reserved for a select group of gentlemen officers through canvas and oils. Previously, common soldiers were depicted in grand paintings and engravings of battles and campaigns in faceless masses rather than as individuals. These figures, though perhaps based on authentic information and real-world observation, were invented by artists and not modeled on actual men. Now, for the first time in history, the freckled face of the greenest private could be glimpsed on par with the wrinkled countenance of his seasoned colonel. The escaped slave who enlisted in the U.S. Colored Troops infantry could be viewed next to his impossibly young white captain, perhaps side by side on adjoining pages of a photo album. The upshot was a renewed sense of identity and self-worth for which the American fighting man had taken a special pride since the unexpected triumph of Washington's ragtag band of colonial rebels over the elite troops of the world's reigning superpower. Now this individualism took hold with fresh energy in a new and exciting form of artistic expression.

Confederate portraits and stories compose about 16 percent of the book, or twelve of seventy-seven profiles. This number may appear low at first glance. But compared to the percent of men who served in both navies it is disproportionately high. The combined total of the Confederate and Union navies is 89,628— 84,415 Union and 5,213 Confederate. Confederates made up about 6 percent of the combined navies (10 percent less than their representation in these pages).

The vast majority of men profiled, sixty-two in all, ranked as officers. The fifteen remaining profiles are of enlisted men. Of this number, two are of African descent (about 13 percent). The generally accepted number for African American enlistments is about nineteen thousand, so men of color are underrepresented here.

I followed the same research method used in previous volumes, though advances in technology altered my routine. In the past, my effort began online by submitting queries to genealogical and Civil War message boards and forums. The suspension of activity of my favorite posting place, GenForum, prompted me to move away from message boards and forums. Instead, I turned to three robust databases to start my research: Ancestry.com for genealogical information, Fold3.com for military records, and the American Historical Research Database for service information, regimental histories, and photos.

But the most exciting digital development was access to newspapers. Prior to digitization, newspapers were a cumbersome resource. Bound volumes or reels of microfilm of large-format pages and long columns of text, sometimes unreadable, required field trips or interlibrary loans and always ended in tedious and time-consuming searches. The fully searchable digital archives of titles now available on GenealogyBank and Newspapers.com have made the task of searching for news reports, obituaries, and other references a joy. Details gleaned from these sources have added substantially to the stories of the sailors profiled here.

I also made extensive use of other online resources, including digital books and finding aids of collections, historical societ-

ies, archives, and libraries. Although much has moved online, nondigitized materials required occasional trips to the National Archives and the Library of Congress in Washington, D.C., and a few requests through my local interlibrary loan program. I purchased books when necessary.

Official Union navy records are surprisingly scant. There is no equivalent of the army military service record that tracks a soldier through monthly muster reports and related papers. I relied on navy pension files, which sometimes included service summaries, and newspapers, which included reports of vessels and the status of officers, to fill the void. Confederate navy records are practically nonexistent. Newspapers, pensions awarded to veterans by the former Confederate states, family and local histories, and manuscript collections provided details.

The profiles are informal biographies, not genealogical histories. Dates, names of superior officers, family members, and other particulars may have been omitted to focus on salient points of each story. Details and histories of vessels and explanations of government acts and military orders are included in text and endnotes when relevant. Descriptions of campaigns, battles, and other operations are included when necessary to understand the circumstances an individual and his crewmates encountered. Vessel names have been italicized throughout the volume for consistency and readability, even though they may have not have been italicized in the original text. The use of navy terminology has been minimized as much as possible to avoid lengthy explanations of warship armament, machinery, and other equipment.

The profiles are arranged in a rough chronological order by a key date around which the sailor's central story revolves. (This date is usually indicated in the opening paragraphs of the story.) One profile is set before the war, ten in 1861, twelve in 1862, fifteen in 1863, twenty-four in 1864, eleven in 1865, and four after the war.

The captions below each photograph note the subject's final assignment and rank. The rank does not always correspond with

that worn by the individual in his portrait. The names, home cities, and life dates of the photographers are included when available.

News, narratives, and notes documenting my experience are included on my Facebook author page.

Faces *of the* Civil War Navies

THE PROFILES

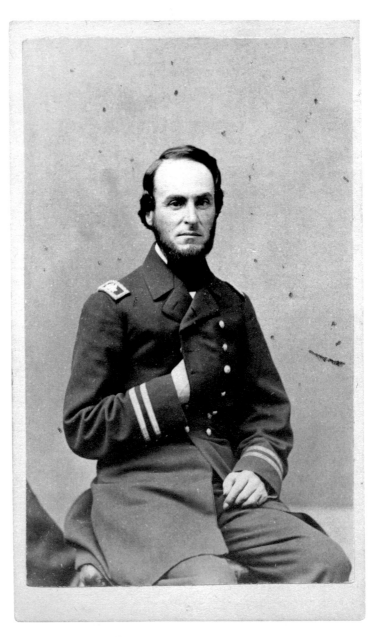

Cmdr. Francis Winslow, U.S. Navy

Carte de visite by James Wallace Black (1825–1896) of Boston, Massachusetts, about 1861–1862. Collection of the author.

Such Men Soon Find Death

Navy Lt. Francis Winslow was between assignments and with his in-laws near Fayetteville, North Carolina, when secession tore the country apart in late 1860. The rift touched him personally. On the Northern side lay his home state of Massachusetts. On the Southern side, his wife, Mary, and their four children, three boys and a girl.[1]

Winslow, forty-two, suffered conflicted emotions as he struggled to come to terms with his loyalties. He had had strong ties to North Carolina since his marriage almost fifteen years earlier. "There were friends and relatives on both sides to whom he was deeply attached and, in addition, he was at the time in the heart of the rebelling country, surrounded by his southern friends and under all the influences of the environment," explained his fourth and youngest child, Arthur, years later. "His wife and all her relatives were intensely southern in their feelings and prejudices, though many deplored the rupture."[2]

Winslow stood by as war fever gripped the townspeople. He watched them become more violent and threatening. When hostilities did come, in April 1861, Arthur noted, he "naturally became an object of suspicion and liable to arrest, as he was well known to be a United States officer. To escape this contingency he decided to leave for the North but, by that time, feelings were very much aroused and his escape was made with great difficulty, by secreting himself on board a schooner in Wilmington, North Carolina, which was about to sail for the North. So near was his capture that a search for him on board this schooner was made, but without success."[3]

The schooner arrived safely in Washington, and Winslow reported to his superiors for duty. Mary and the children, accom-

panied by a nursemaid, soon followed on another vessel bound from Wilmington to Washington. They continued on to Boston, where one of Winslow's cousins put them up in a cottage in nearby Cohasset.[4]

Winslow's actions proved his allegiance to the Union and the navy with which he had been associated for almost three decades. He had entered the U.S. Naval Academy at age fourteen, graduated as a midshipman at twenty, and at twenty-six advanced to lieutenant. He cruised the world on a variety of missions, which always ended with a return to the states to await new orders. On one such occasion in 1845, he met Mary Sophia Nelson. They married the following year. Children soon followed, and over time Winslow found it increasingly difficult to be at sea and away from his family.

Then the war came, and Winslow responded with renewed vigor to protect the Union and his family. Assigned as executive officer to the frigate *Mississippi*, Winslow and his shipmates steamed for the Gulf of Mexico and participated in the newly formed blockade of key Confederate ports.

In September 1861, Winslow received his first independent command when he was assigned to the *Water Witch*. She was a small ship, a light-draft, side-wheel steamer with a bare-bones crew of fifty and five brass cannon. "The armament is sufficient to resist attack by boats or to bring-to an unarmed merchant vessel, but more than this we could not accomplish without heavier metal," he wrote home.[5]

The *Water Witch* joined a vanguard of vessels that reconnoitered the lower Mississippi River in Louisiana during the uncertain early months of the Rebellion, before the massive buildup of federal forces at the mouth of the mighty river and the subsequent occupation of New Orleans by those troops. The little steamer probed the waterways and distinguished itself in minor actions against enemy vessels. Winslow's abilities came to the attention of his superiors, who rewarded him with a larger ship, the gunboat *R. R. Cuyler*, and, in May 1862, a promotion to the rank of commander.

Winslow assumed the mantle of leadership with style and grace. His integrity and fairness made a deep and lasting impression on the crew of the *Cuyler*. One of his subordinate officers declared, "He took care of us all as though we were children. There are not many officers in the service who can command their men as well as he did or in whom his men possess the same kind of confidence," adding, "His kindness to me and the extent he seemed to feel for my success opened my heart to him and I would have done anything for him or to please him. We all loved him[;] we could not help it."[6]

On August 22, 1862, the *Cuyler* was on her way to British Nassau to deliver dispatches when Winslow fell ill with yellow fever. The ship's surgeon and several other crewmembers were also infected with the deadly virus. The *Cuyler* arrived in Nassau the next day and was visited by Surg. Richard Ratliffe of the fifty-one-gun British frigate *Melpomene*. Ratliffe examined Winslow and the other sick men. He advised that the only chance they had for survival was to proceed north as quickly as possible. The captain of the *Melpomene*, Charles J. F. Ewart, also came aboard and sat for a time at the bedside of the gravely ill Winslow.[7]

The leadership of the *Cuyler* weighed their options. "On the 25th a consultation of the officers was held, and came to the conclusion that the shortest and only way to make the ship efficient was to proceed to some Northern port where we could get the sickness out of the ship," reported the acting master of the *Cuyler*.[8]

The gunboat immediately set out for New York in a race against time. Winslow's condition continued to deteriorate, and the beloved commander succumbed to the fever while at sea at 6:35 p.m. on August 26.

The *Cuyler* arrived in New York four days later. By this time, the yellow fever had abated and most of the sick were in recovery. Mary learned of her husband's death through a newspaper report and was devastated with grief and sorrow. She was not alone. Family, friends, and shipmates mourned his passing, including first cousin John A. Winslow, who would go on to captain the

Kearsarge in the historic engagement against the Confederate raider *Alabama* off the coast of Cherbourg, France, in 1864.[9]

Assistant secretary of the navy Gustavus V. Fox summarized Winslow's contributions in a letter to a member of the family. "He was one of our best officers. Loyal to the flag, an accomplished seaman, and possessed of that rare virtue, modest courage. Moreover he was a Christian and went forth to encounter all perils, because it was his duty. Such men soon find their death, and their eternal reward."[10]

Two of Winslow's sons followed their father's footsteps and became navy officers. One of them, Cameron Winslow, advanced to admiral and served during the Spanish-American War and World War I.[11] Mary never remarried. She lived until her mid-seventies and died in 1903 at the Washington home of her son Cameron.[12]

Early Defender of His Homeland

The sturdy paddle wheels of the *Star of the West* beat rhythmically against the waters of the Atlantic as she steamed into Charleston harbor. Packed with supplies and reinforcements for the beleaguered federal garrison holed up inside Fort Sumter, she entered the main shipping channel early on January 9, 1861.

Her every move was watched by a contingent of local militia companies and other volunteers. These men manned coastal batteries and Fort Moultrie in defense of the newly independent state of South Carolina—and in defiance of the Union.

One of the volunteers on the rolls of Fort Moultrie, Jack Grimball, had until recently been a Union navy officer. He acted decisively after South Carolina seceded from the United States on December 20, 1860. On Christmas Eve he resigned his commission and tendered his services to the governor. The *Charleston Courier* praised him: "Nothing less can be expected of true sons of the South."[13]

He was also true to his family in Charleston. One of six boys born to a well-to-do planter and his wife, John Grimball was known as Jack or Johnnie to friends and relatives.[14] He left home in 1854 at age fourteen to attend the U.S. Naval Academy, graduated in 1858, and embarked on a career in the navy. Any dreams he might have had of glory in blue were dashed when South Carolina seceded. He was among the first navy officers from the South to resign. Many of Grimball's peers followed his lead in the months ahead as the Southern states withdrew from the Union. Four of his brothers would also serve in the cause as soldiers in the infantry and artillery.[15]

Grimball's first assignment as a Confederate was in the garrison of Fort Moultrie, which had been occupied by federals. On

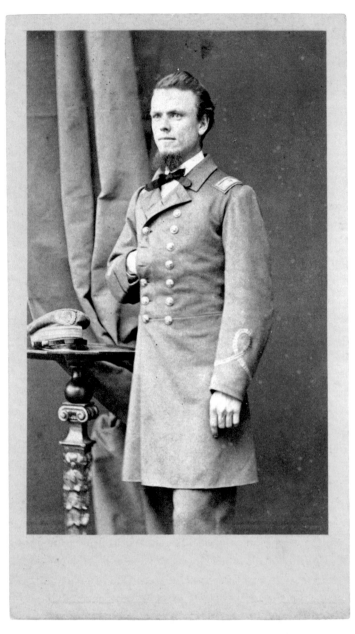

1st Lt. John Grimball, C.S. Navy

Carte de visite by Penabert & Cie (life dates unknown) of Paris, France, about 1864. The Liljenquist Family Collection, Library of Congress.

December 26, 1860, garrison commander Maj. Robert Anderson moved his men to nearby Fort Sumter. The isolated brick and mortar fortress in the center of Charleston harbor offered better opportunities for defense.

Meanwhile in Washington, outgoing president James Buchanan dispatched the *Star of the West* with a cargo of supplies and reinforcements for Anderson and his regulars. The steamer, an unarmed civilian merchant vessel out of New York, was selected instead of a warship so as not to fan the flames of rebellion.

News of the mission spread to Charleston, and it was interpreted as an act of aggression by a foreign power. When the *Star of the West* arrived in the harbor on January 9, Grimball and the rest of the state forces, including cadets from the Citadel, met her about daybreak. A warning shot was fired, and the *Star of the West* increased her speed and hoisted the Stars and Stripes. A flurry of artillery blasts followed. "As soon as five or six shots had been fired upon her from Morris Island, and as many more from Moultrie, it was evident that she would lower her colors to half-mast. She veered about so as to avoid any further messengers of this kind from the fortifications, which with one or two more discharges, finally ceased," the *Charleston Courier* reported.[16]

Seventeen shots were fired, and two struck the hull of the *Star of the West*. Though the damage was minor, the effect was major. The ship turned and steamed back to the North without having accomplished its objective.[17]

South Carolina declared victory. Some claimed that these were the first shots fired in hostility during the Civil War. Others discounted the claim because the *Star of the West* was technically a civilian vessel. The bombardment of Fort Sumter on April 12, 1861, is acknowledged as the official start of the Civil War.

A few days later, Grimball was commissioned a midshipman in the new Confederate navy. Thus began an odyssey during which he served on several notable vessels. His first, a converted merchant steamer commissioned the *Lady Davis* in honor of the wife of the Confederate president, defended Charleston harbor during the early months of the war.

Grimball advanced to first lieutenant and in 1862 joined the crew of the ironclad *Arkansas*. On July 15, he commanded one of her bow guns during a successful run by the Union fleet afloat assembled above Vicksburg, Mississippi. Following the loss of the *Arkansas* in August 1862, Grimball served a stint on the ironclad ram *Baltic* in Mobile Bay before being called to special duty in Europe. He posed for his *carte de visite* portrait in a Paris photograph salon about 1864.

Later that year he reported for duty to the *Shenandoah*. Grimball and his shipmates hunted Yankee merchant ships on the high seas during a yearlong cruise. Their exploits inspired Southerners during the waning months of the Confederate nation and prompted Northerners to brand them pirates. The *Shenandoah* continued to operate for months after the surrender of the gray armies and dissolution of the government. The crew had heard rumors of the downfall of the Confederacy but had no confirmation of it.

"We were now the only Confederate cruiser afloat, and as we continued our course around the world, passing from ocean to ocean, meeting in turn ships of various nationalities, I always felt that whenever our nationality was known to neutral ships the greetings we received rarely warmed up beyond that of a more or less interested curiosity, and while we had many friends ashore who were most lavish and generous in welcoming us to port, underlying it all there appeared to exist a wish of the authorities to have us 'move on.'"[18]

The cruise of the *Shenandoah* finally ended on November 6, 1865, when the vessel was surrendered to British authorities. Grimball and other officers were promptly released from captivity. Hearing rumors that they would be arrested as pirates and likely face the hangman's noose if they stepped foot on American soil, Grimball and his fellow officers fled to other countries.

The rumors were false. Grimball spent a year on a ranch in Mexico and then returned to his family in South Carolina. By this time he decided to abandon the sea. With the aid of his father, he studied law and became an attorney. Grimball practiced in

Charleston for a short time and then established a firm with a partner in New York City. In the early 1880s, "His heart turned toward Charleston and he came back," reported a state historian. In 1885, at forty-four, he wed Mary Georgianna Barnwell, a belle half his age. They started a family that grew to include four sons. The marriage was Grimball's second: the first, in 1875, had ended tragically after less than a year when his bride died of disease.

Grimball was best known during his later years for his service on the *Shenandoah*, which by the late nineteenth and early twentieth centuries had become celebrated as part of the Lost Cause narrative embraced by Confederate veterans. Grimball presented at least one speech on the cruise. After his death in 1922, at age eighty-two, however, his service was placed in a larger perspective that took into account his time at Fort Moultrie and the *Star of the West* encounter. "Without a doubt this constitutes the longest service of any man on either the Union side or the Confederate side of the long struggle and makes a unique distinction," declared the *State* newspaper in Columbia.[19]

Perhaps the finest tribute to his memory was personal. "Those who knew Mr. John Grimball in his later years will remember him with warm affection for many reasons, and, perhaps chief among these, for the youthfulness of his spirit. He was one of those men who seemed destined never to grow old. Years came upon him, but, until his last illness descended, his heart remained young," noted one writer. "John Grimball will not be forgotten by those who shared his friendship and came within the influence of his buoyant, cheering, heartening personality."[20]

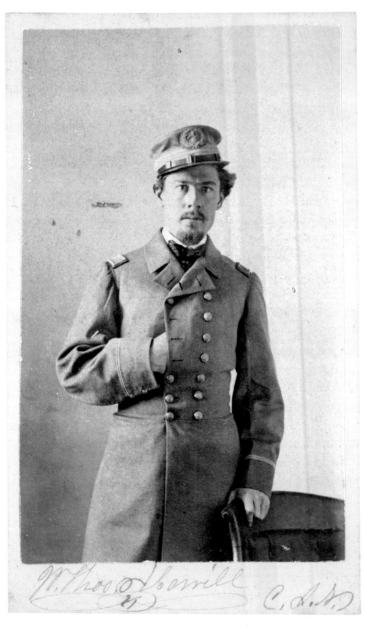

1st Asst. Eng. William Thomas Morrill, C.S. Navy

Carte de visite by James Wallace Black (1825–1896) of Boston, Massachusetts, about 1863–1864. The Liljenquist Family Collection, Library of Congress.

Crisis in Pensacola

By early January 1861, mechanic W. Thomas Morrill and other employees of the Pensacola Navy Yard in Florida were caught in a humanitarian crisis. They had not been paid for two months—the result of civil unrest that disrupted the flow of money and materials to U.S. military outposts in the Southern states as the country drifted towards civil war. Hunger became a real and present danger.[21]

Morrill had a wife and two infants to feed. Many of his fellow workers also had families to support, and no relief was in sight. On January 8, the workers rallied at a mass meeting at a Masonic hall in Warrington, a village outside the walls of the yard.

They appointed a committee who promptly met with the commander of the yard and requested that provisions be issued in lieu of pay. The sympathetic officer in charge, Cmdr. James Armstrong,[22] acted promptly to relieve their sufferings. Flour, sugar, rice, coffee, and butter were distributed on January 10—the same day Florida legislators voted by a wide margin to secede from the Union.

Two days later, armed rebel forces converged on the navy yard and demanded the surrender of the military garrison. Armstrong capitulated, and the yard passed into Confederate hands without the firing of a shot.

Morrill, who also belonged to a local militia company, the Warrington Artillery, joined the victorious rebels. The militiamen elected officers, a common practice among volunteers, and they voted Morrill orderly sergeant.[23]

The Warrington Artillery served on various guard and other duties in the Pensacola area during the early months of 1861. After the bombardment of Fort Sumter, Morrill left the company to

become an officer in the Confederate navy, which sorely needed mechanically minded men. Over the next year he advanced in rank to third assistant engineer and was assigned to two ships at the yard: the *Fulton*, a wooden vessel being converted to an ironclad, and the steamer *Bradford*.

Morrill might have remained at the yard for the remainder of the war, but federal forces moved to retake Pensacola, forcing the Confederates to evacuate. In the hasty exodus from Pensacola in May 1862, the unfinished *Fulton* and the *Bradford* were burned to prevent them from falling into Yankee hands.

Forced to leave his family behind, Morrill spent the rest of 1862 and early 1863 in Georgia building ships at the Columbus Iron Works and in Savannah aboard the ironclad ram *Atlanta*. He also served a stint in Charleston, South Carolina, working with torpedoes, or underwater mines.[24]

On June 17, 1863, Morrill was present for duty aboard the *Atlanta* when she grounded during the beginning of a battle with a pair of Union monitors. The commander of the *Atlanta* surrendered his ship and crew. Morrill and other officers were sent to the North and imprisoned at Fort Warren in Boston harbor. He posed for his *carte de visite* portrait during this time.

Morrill remained a prisoner for more than a year. While he awaited his release, the navy promoted him to first engineer. Finally, he received a parole in September 1864 and was exchanged the following month in Virginia. His arrival in the commonwealth was a homecoming of sorts. Born and raised in the port city of Norfolk, he had left for Florida in 1854.

His stay in Virginia was brief. Before the end of the year, he received orders to report to Albany, Georgia, where he was attached to a newly established gristmill and bakery that supplied food to sailors in the region. Evidence suggests he reunited with his wife and children at some point along the way. Morrill remained in Albany until April 1865, when he surrendered and received a parole.[25]

Morrill returned to Pensacola and restarted his life as an engineer. He eventually fathered eight children, only three of which would live to maturity. Morrill died in 1911 at age seventy-four.

Fall in Love, Join the Army, or Blow Your Brains Out

In February 1861, William B. Mann anxiously awaited the results of his final exams. The twenty-two-year-old medical student at the University of Buffalo had worked the last five years to get to this moment. He shared his tensions in a letter to one of his instructors, Dr. Horace Clark, a physician who understood the rigors of study firsthand. Clark replied in a humorous vein, "I suppose if you are rejected you will either fall in love join the army or blow your brains out."[26]

Clark's army reference evoked the storm clouds of war that loomed over New York and the rest of the country. South Carolina and six other Southern states had seceded from the Union, captured federal arsenals, and threatened other military installations. President-elect Abraham Lincoln, of whom Mann was a staunch supporter, was on his way to Washington to take the helm of the disunited states of America.[27]

Mann ultimately passed his exams and graduated with a medical degree. He had plans to go into private practice. But after the bombardment of Fort Sumter, he decided to join the army—making his instructor's words somewhat prophetic.

Mann promptly applied for a surgeon's commission from the state Adjutant General's Office. He received it on May 1, 1861. But finding a regiment in which to serve proved a challenge. The surgeon general of New York wrote to Mann on June 6: "The volunteer force is I believe all supplied with surgeons—unless a new call is made by the President, we shall not need more surgeons—You are not the only one disappointed, and it is very creditable to see with what alacrity and enthusiasm our young men present themselves."[28]

Mann then applied to the Board of Naval Surgeons, which was

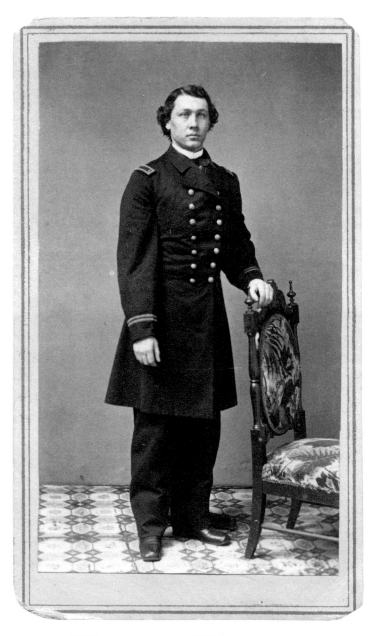

Asst. Surg. William Barrow Mann, U.S. Navy

Carte de visite by Hope (life dates unknown) of New York City, about 1863–
1864. Collection of the author.

sorely in need of medical men. The board approved him as an assistant surgeon, and he received a commission in September 1861.

He was soon assigned to a new gunboat, the *Miami*, a sidewheel steamer equipped with rudders on the bow and stern. Known as a "double-ender," she and others of her class were designed to navigate narrow waterways without having to turn around.

The *Miami*, with Mann as the senior medical officer, participated in operations along the Mississippi River, including the Siege of Vicksburg. In late 1863, the *Miami* transferred to the Atlantic coast and was stationed along the North Carolina Outer Banks to enforce the Union blockade and prevent Confederate military activity.

The rebels responded by constructing ironclad warships. The *Miami* engaged one of these vessels, the ram *Albemarle*, during the Battle of Plymouth. Before dawn on April 19, 1864, the *Miami* and another wooden warship, the *Southfield*, were chained together to increase their firepower. The commander of the *Miami*, Charles W. Flusser,[29] drove the two ships straight at the *Albemarle*. The prow of the rebel ram ripped into the *Southfield*, and she began to sink rapidly. The crew of the *Miami* poured shot and shell from its heavy guns into the *Albemarle* as she extricated her prow from the doomed *Southfield*. Flusser personally fired the first three shots from one of the *Miami's* nine-inch Dahlgren guns. A fragment or fragments from the third shot, a 73.5-pound shell, ricocheted off the sloped side of the *Albemarle* and killed Flusser.[30]

Mann could do nothing to save his commander, who was the only man killed on the *Miami*. He did however attend to eleven other officers and crew who were injured.[31] The *Miami* withdrew from the scene with some of the survivors of the *Southfield*. The *Albemarle* fired two shots at the *Miami* but did not pursue.

Mann left the navy in May 1865 and returned to New York. He settled outside Buffalo in the village of Brockport, the home of his instructor, Dr. Clark. Mann married Clark's daughter, Evelyn, and they started a family that grew to include six children.

Dr. Mann entered into private practice as he had planned before the war. Friendly and lovable, he was widely trusted and respected by his fellow villagers. He became known as the "Grand Old Man" of Brockport after his retirement, in 1902. Active in the Grand Army of the Republic, he served as surgeon of his local post. He had lasting memories of his Civil War experience. According to one report, "His commission, signed by Abraham Lincoln and Gideon Welles, secretary of the navy, was delivered to him while at sea and since has held a high place among his war-time treasures."[32]

Mann lived until 1920, dying at age eighty-two. His passing was mourned by a large group of family, friends, and former patients.

The First Naval Shot of the War

A LONE STEAMER SPED ON A COURSE TOWARDS CHARLES-
ton harbor during the evening of April 11, 1861. Alert lookouts
positioned in the harbor defenses spotted the vessel on the distant
horizon and sent two red rockets and a blue flare into the night
sky—the signal that an enemy ship approached.[33]

She was the sleek side-wheel cutter *Harriet Lane*, rigged with
brigantine sails and armed to the teeth. She moved through the
coastal waters with all the grace of her namesake, the comely
young lady who had until very recently served as White House
hostess to her bachelor uncle, President James Buchanan.[34]

The *Harriet Lane* was one of the best-known American ships
on active duty, and her able commander one of its most popular
officers. Capt. John Faunce had been associated with the *Lane*
from her construction in 1857 and took charge as her original
captain the following year. High-profile adventures came quickly.
They participated in an expeditionary force sent to Paraguay to
seek redress for the firing on a U.S. warship that resulted in the
death of a sailor. There were hunts along the Atlantic coast for
illegal slave traders, and several were nabbed before they at-
tempted the cross to Africa. They carried the teen-aged Prince
of Wales from Washington to New York on a memorable trip
in 1860. The future king of England presented Faunce with a
gold chronometer watch and chain as a token of thanks.[35] "He
loves [her] as his life," is how one newspaper reporter described
Faunce's feelings for the *Harriet Lane*.[36]

Meanwhile, the bitterly divided United States descended to the
brink of war after South Carolina seceded from the Union on De-
cember 20, 1860. While the Buchanan administration pondered

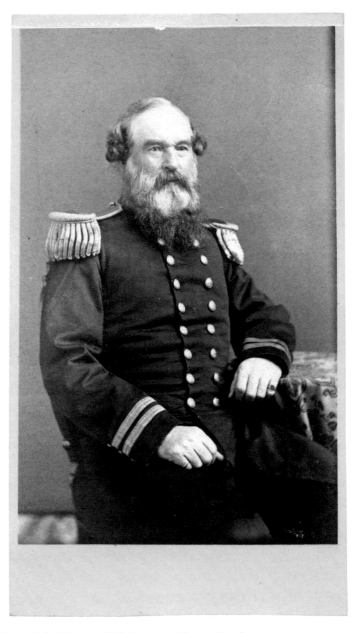

Capt. John Faunce, U.S. Revenue Marine Service

Carte de visite by Jeremiah Gurney (1812–1895) & Son of New York City, about 1864. Collection of Martin Schoenfeld.

its options, speculation ran rampant throughout the capital. Faunce and the *Lane* were at the center of one rumor: the captain and his ship had received orders to sail for Charleston with Gen. Winfield Scott, the old hero of the War of 1812, and two hundred regulars to teach the rebels a lesson they would not soon forget. The *New York Commercial Advertiser* laid the rumor to rest in its January 2, 1861, edition. "Capt. John Faunce, of the *Harriet Lane*, states that all the rumors regarding him and the craft he commands are mere fabrications."[37]

In early April 1861, navy officials tapped Faunce for a special mission. On the morning of April 8 in New York City, the *Lane* hauled down its Revenue Marine Service flag (the vessel belonged to the Treasury Department, which employed Faunce) and replaced it with the Stars and Stripes to indicate her temporary transfer to the navy. Once the vessel was at sea, Faunce broke the seal on secret orders and learned that he was to rendezvous with a convoy of ships outside Charleston. There they were to deliver supplies and troops to the beleaguered garrison of Fort Sumter.

On the evening of April 11, the *Lane* arrived outside Charleston harbor. She had outsailed the convoy, so the crew bade their time until the other vessels arrived. In the harbor, the steamers *Clinch* and *Seabrook* of the South Carolina navy had been trolling, under orders to prevent an expected federal troop landing. They were alerted to the arrival of the *Lane* by the rockets and flare about 7:30 p.m. The crews instantly prepared for action. But Faunce made no aggressive moves. The South Carolinians held their position but did not advance.[38]

About eight hours later, at 3:00 a.m. on April 12, the steamer *Baltic* arrived on the scene and linked up with the *Lane*. The *Baltic* carried Gustavus V. Fox, a navy man appointed by President Abraham Lincoln to command the relief expedition.[39]

Another federal vessel, the sloop-of-war *Pawnee*, was spotted about 6:00 a.m. Fox and Faunce boarded her and met with Cmdr. Stephen C. Rowan.[40] Fox informed Rowan of the orders to provision the Fort Sumter garrison. Rowan countered that his own orders required him to wait for the warship *Powhatan*, which

had yet to arrive, and added "that he was not going in there to inaugurate civil war."[41]

Fox and Faunce left and determined to go on without Rowan and the *Pawnee*. Fox boarded the *Baltic* and steamed ahead. He reported, "Followed by the *Harriet Lane*, Captain Faunce, who cheerfully accompanied me. As we neared land heavy guns were heard and the smoke and shells from the batteries which had just opened fire upon Sumter were distinctly visible."[42] The Civil War had begun.

Faunce and Fox looked on as the Charleston batteries pounded Fort Sumter's brick walls to dust. Faunce and the *Lane* stayed in position while Fox and the *Baltic* went to inform Capt. Rowan of the situation. Fox was surprised to meet the *Pawnee* coming in. Rowan apparently had had a change of heart. "He hailed me," Fox explained, "declaring his intention of standing in to the harbor and sharing the fate of his brethren of the Army. I went on board and informed him that I would answer for it that the Government did not expect any such gallant sacrifice."[43]

The *Lane*, *Baltic*, and *Pawnee* remained outside the harbor. None of the other ships in the convoy showed up that day. They were however joined by civilian merchant vessels on routine business, and they waited with the Union navy.

While the bombardment raged and gun smoke mixed with low-lying banks of mist, a steamer appeared with no ensign flying. At 11:20 a.m., Faunce and the crew of *Lane* went to battle stations. They signaled the vessel to show her colors and come to. The ship did not respond. Faunce ordered a warning shot fired. Daniel D. Tompkins, the second lieutenant in charge of the bow gun, obeyed his captain's command. According to a revenue service historian, "A thirty-two pound shot ricocheted across the bows of the strange steamer, a grim and significant warning to heave to and render an account of herself. The American ensign was at once displayed from her main peak." She was the merchant steamer *Nashville*, and Faunce allowed her to pass.[44] Some historians credit this event as the first naval shot fired during the Civil War.

The rest of the convoy finally arrived, but it was too late to relieve the garrison. Its commander, Maj. Robert Anderson, surrendered Fort Sumter on April 13. After the surrender was completed, the *Nashville* steamed into the harbor and docked. Confederate authorities seized her and turned the vessel into a cruiser.[45] Faunce and the *Lane* would go on to participate in amphibious operations—among the earliest of the war—along the North Carolina coast against the shore batteries of Hatteras Inlet on August 28, 1861.

Soon afterwards, the Revenue Marine Service formally transferred the *Lane* to the navy. Faunce, technically an employee of the service, and his beloved vessel parted ways. Faunce captained several more revenue cutters during the war, and participated in numerous patrol and transport duties. The navy ordered *Lane* and her new commander, Jonathan M. Wainwright II,[46] to the West Gulf Squadron. Wainwright was killed in action during a surprise Confederate assault against Union-occupied Galveston, Texas, on January 1, 1863. The *Lane* fell into enemy hands after being raked by volleys of musket fire and rammed by a rebel warship.

The *Lane* was eventually repaired and became the blockade-runner *Lavinia.* On April 30, 1864, she made a successful run with a load of cotton to Havana. Spanish officials sympathetic to the Union detained her until the end of the war.[47]

In 1867, Spain turned over the *Lane* to the United States. The government sent Faunce to bring her home. He found her in poor condition, ravaged by the elements and scuttled by an 1865 fire rumored to have been started by a disgruntled Confederate crewmember who had traveled aboard her from Galveston and never received his pay. "She had been for some time considered worthless and it will cost more than she is worth to make her at all useful," the *New York Times* opined.[48]

Faunce arranged for repairs and made her serviceable. On March 29, the *Lane* with Faunce and a skeleton crew arrived in New York City. The government ultimately decided that she would never be fit for active duty and sold her to a Boston mer-

chant. He named her the *Elliot Ritchie*. She carried cargos of all types until hurricane-force winds in the Caribbean brought her down in May 1884. The crew abandoned the ship at sea. Her death was news across the country, including this headline in the Washington *Evening Star*: "Good Bye Harriet! The Last of a Once Famous Vessel."[49] By this time, Faunce had closed out his postwar career in the revenue service as the first individual to survey the Atlantic and Pacific coasts and Great Lakes to locate life-saving stations.

On June 5, 1891, the fiftieth anniversary of his appointment to the revenue service, Faunce was on the lawn of his Jersey City, New Jersey, home laying out a croquet set with his son when a pain in his side suddenly struck him. He son, daughter, and other members of his family rushed to him, but he was unconscious and died about five minutes later. The cause of death was attributed to his heart. In his pocket was the watch given to him by the Prince of Wales. Faunce was eighty-five years old. He had outlived two wives and the *Harriet Lane*.[50]

Go It, Old Jamestown

An alert crewman aboard the Union sloop-of-war *Jamestown* made a startling discovery in the early light of August 5, 1861. He spotted the sail of a suspicious ship on the horizon along Florida's Atlantic coast near Amelia Island. He immediately notified his superiors, and the cry of "Sail ahoy!" jolted his shipmates from their slumber. Soon, the ship buzzed with activity as the men scrambled to their posts under the watchful eye of veteran officers.[51]

Among those who whipped the crew into shape was the *Jamestown*'s chief sailor, William Long. Born in Britain and raised in America, Long knew the sailor's art as well as anyone. He had forged his way from the ranks to boatswain during a career that spanned almost two decades.[52]

Long had been between enlistments when the Civil War started, but he returned to the navy soon after the bombardment of Fort Sumter. In May 1861, navy officials appointed him boatswain on the *Jamestown*. Launched in 1844, the aging sloop was perhaps best known for its 1847 mission to deliver food to starving Irish families in the wake of potato crop failures that became known as the Great Famine.

Long and the rest of the *Jamestown* crew were assigned to the Atlantic Blockading Squadron and patrolled the Georgia coast outside Savannah. On August 3, 1861, the *Jamestown* left the Savannah blockade with orders to sail to Florida. The alert crewman noticed the unfamiliar sail two days later. One of his commanding officers climbed the mainmast to get a better look. The officer identified the ship as a bark and observed that she was headed for the shore. Her movements appeared evasive, and the officer concluded that she was attempting to break the blockade.[53]

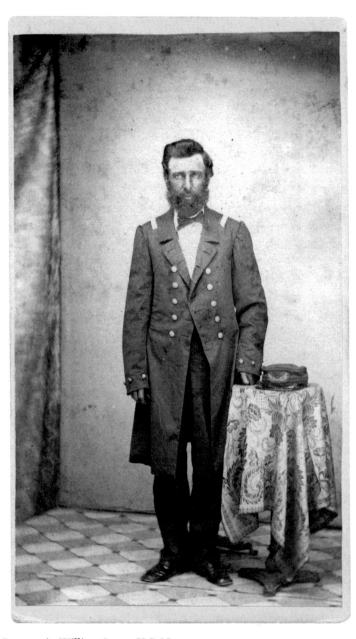

Boatswain William Long, U.S. Navy

Carte de visite by an unidentified photographer, about 1864. Collection of Ron Field.

The officer was correct. The vessel was the *Alvarado*, and she was an unlikely blockade-runner. The ship and crew had set out from their home port of Boston back in February 1861 on a merchant mission to the Cape of Good Hope to pick up a load of scrap iron, copper, and other raw materials. The war began while the *Alvarado* was at sea, and she arrived at the cape on or about April 30. News of the war had not yet made its way in this part of the world.[54]

The *Alvarado* departed with its cargo on June 3, 1861, her crew still clueless about the war. They found out on July 21. That morning, about 1,100 miles west of the southern tip of Florida, the *Alvarado* crossed paths with a ship flying no banner. The vessel came alongside and hoisted the English flag, and her crew fired a shot across the bow of the *Alvarado*. The English colors were then replaced with an ensign that the *Alvarado*'s sailors did not recognize.[55]

The ship was the *Jeff Davis*, and a dozen of her crew boarded the *Alvarado*. The leader of the group informed Capt. Gardner C. Whiting that his vessel was now a prize. "I asked by what authority," replied Whiting. "By the authority of that big gun and of Jefferson Davis," he recalled being told.[56] A prize crew of about eight men took charge of the *Alvarado*. They removed the regular crew but kept Whiting, his wife, and an African American cook aboard as prisoners. The now Confederate *Alvarado* made haste for the Florida coast.

Boatswain Long and his shipmates had no knowledge of the fate of the *Alvarado*. But they sensed an enemy and gave chase. One of the Long's fellow officers, in an unsigned letter published in the *Boston Herald*, stated, "Our noble vessel pushed towards her, and I was forced to exclaim, 'Go it, old *Jamestown*.'"[57]

Hours passed, and the *Jamestown* closed in. The privateers decided they could not beat the blockader and ran the *Alvarado* aground. Her bottom came to rest on a shoal about 1,100 yards from land. The privateers boarded a rowboat and requested Capt. Whiting to join them. He declined. "Immediately after they left I hoisted the American flag, union down, and then tried to get the

sails aback," recalled Whiting, "but the wind blowing so directly on to the shore we could not succeed."[58] The rowboat full of privateers soon returned. They forced Whiting to remove the flag and then forced him, his wife, and cook to come with them.

Back on the *Jamestown*, Cmdr. Charles Green[59] was mindful that his bigger ship might easily become stranded on a shoal. He brought the *Jamestown* within three miles of shore and stopped. He observed, "People began to collect near by on the beach, to the number of perhaps 200, and soon after we saw them dragging down several pieces of artillery." These individuals were Confederates from the nearby defenses of Fernandina, Florida, and curious citizens.[60]

Green ordered Boatswain Long and forty-four other men in three boats to board the *Alvarado*. Green entrusted command of the mission to his able second lieutenant, Charles W. Flusser. Green stated in his after-action report, "Mr. Flusser's orders were to go in an reconnoiter the vessel, and if abandoned, or if but a small force was on board, to board her and if possible to get her off, but otherwise to burn her, and not to run the risk of being overpowered by enemies from shore."[61]

The boats set out about 3:00 p.m. Long occupied the lead boat with Flusser and a detail of officers and marines armed with Sharps rifles, muskets, revolvers, and cutlasses. When the convoy was about a half mile from the bark, the Confederates on shore opened fire. Cannon and musket shot passed harmlessly over and around the boats during the next half hour as they approached and pulled up alongside the *Alvarado*.

The men boarded her without opposition, raised the Stars and Stripes, and set about the task of freeing the ship. They had barely begun their work when the smoke of another ship came into view. Green surmised that this was an enemy vessel intent on capturing the boarding party and ordered a single shot to be fired from one of the *Jamestown*'s guns. This was the recall signal.

Flusser heard the signal and ordered the *Alvarado* burned. She was fired in three places with a container of oil that had been brought along for the purpose. The boarding party made

their escape under enemy fire, which had resumed the moment flames and smoke became visible. According to the unnamed officer whose letter was printed in the *Boston Herald*, "The bark burnt all that night and part of the next day. The glorious flag of the Union waved over her, and was the last to go down with the mizen-mast."[62] The *Jamestown* left the scene, and continued to patrol the Atlantic. She captured six blockade-runners, including the *Alvarado*.

In the fall of 1862, the *Jamestown* was dispatched to the Pacific coast and assigned the same duty. Long did not accompany the crew. He transferred to another ship and served the remainder of the war in the Atlantic and the Gulf of Mexico. He remained in the navy after hostilities ended and retired in 1882.

Long spent the rest of his years in the Boston area. He lived until age seventy-seven, dying of heart failure in 1902. His wife, Sarah, whom he had married in 1860, survived him.[63]

Acting Boatswain John F. Sullivan, U.S. Navy (*center*) with comrades

Carte de visite by Villroy L. Richardson (about 1827–unknown) of Lima, Peru, about November 1864. Collection of the author.

The Smell of Warship Smoke

Navy secretary Gideon Welles fretted about the safety of California after the outbreak of war in 1861. The threat of rebel privateers preying on mail steamers loaded with treasure and secessionists seeking to take the southern part of the state was real. Welles had but six vessels in the Pacific Squadron to patrol an immense area.

The flag officer in command of the Pacific Squadron, John B. Montgomery,[64] summarized the situation to Welles on August 23, 1861: "My very limited force of four steamers and two sailing ships will prove wholly inadequate for the protection of our commerce with the numerous ports along this coast, extending from Talcahuano to San Francisco, a distance of 7,000 miles."[65]

Montgomery asked Welles for four additional steamers. In the meantime, Montgomery assigned the ships at his disposal to cover critical areas. He dispatched one of his most reliable vessels, the *Narragansett*, to a four-hundred-mile stretch of Mexican coast from Acapulco Bay to Manzanillo.[66] The *Narragansett*, a screw-propeller sloop that had joined the Pacific fleet a year earlier after a stint in the Atlantic Ocean, was armed with five guns. Her crew of fifty men and officers included John Sullivan, a career navy man known for honesty and integrity.[67]

The son of Irish immigrants, Sullivan was born at sea in 1832, likely on the vessel that carried his parents from Ireland to America. Raised in the Boston area, he joined the navy at age nineteen in 1850. He served aboard the *Bainbridge* and *Falmouth* and joined the *Narragansett* about the time she was commissioned, on November 6, 1859.

In early 1860, Sullivan and his shipmates on the *Narragansett* embarked on a four-month journey to the Pacific. They were

perfectly positioned to protect the coast when the war came. The *Narragansett* spent a significant amount of time in the vicinity of the Mexican port of Manzanillo, a potential target for Confederates. "The mail steamers, both from San Francisco and Panama, touch at Manzanillo on or about the 27th of each month," noted Charles H. Bell,[68] who followed Montgomery as flag officer of the squadron in 1862. Bell added, "As these ships have generally a large amount of treasure on board, it is important that you be at the latter place at this particular date. Manzanillo has no harbor defenses and it is here that an attempt might be made to seize these ships by a party, consisting of rebels and traitors to our country, many of whom, calling themselves American citizens, are prowling about this coast."[69]

The *Narragansett* spent the duration of the war cruising Manzanillo and other harbors in the Americas, taking care, as Bell ordered, to "remain in port only long enough, from time to time, to refresh your crew and to replenish your stores. You must endeavor to economize your fuel by using your sails as much as possible."[70]

In November 1864, during a brief stay in Lima, Sullivan and two of his mates stretched their legs in the Peruvian capital. They visited the studio of American photographer Villroy Richardson[71] and posed for a group portrait. By this time, Sullivan had advanced in rank to acting boatswain, the officer responsible for equipment and crew. The image of the trio of officers was likely the last time that they were photographed during the war. In mid-December the *Narragansett* received orders to report to New York and arrived there on March 19, 1865, as the war in the east was winding down.

The *Narragansett* participated in no hostile actions during her wartime service. However, her presence in the Pacific reassured Americans in the West. "It can do no harm, but a great deal of good to have an armed vessel where the treasonous pirates smell her smoke once in while," observed one newspaper after a visit by the *Narragansett*.[72]

Sullivan mustered out of the navy less than a week later and settled in Boston. In 1867 he married widow Emma Kimball. Her

first husband, a sailor on a civilian schooner, had died at sea, of disease, shortly after the end of the war.[73] Sullivan and Emma began a family that grew to include three children. He supported them early on as a mariner and later as a watchman at the Boston Navy Yard. He was an active member of the Kearsarge Association of Naval Veterans.[74]

In 1891, when Sullivan was fifty-nine, his health began to decline. Dementia overcame him, and he was eventually moved to the Worcester Lunatic Asylum, where he died six years later of a cerebral hemorrhage. His wife and a daughter survived him.[75]

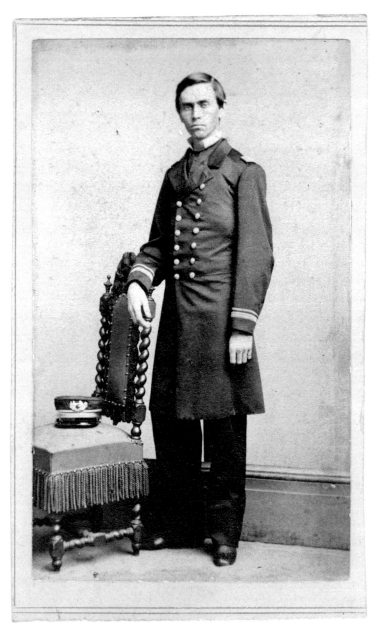

Lt. Tecumseh Steece, U.S. Navy

Carte de visite by Charles DeForest Fredricks (1823–1894) & Co. of New York City, about 1862–1863. Collection of Earl Sheck.

The Most Gallant Cutting-Out Affair
That Occurred during the War

In early September 1861, the schooner *William H. Judah* slipped past the federal blockade along Florida's Gulf Coast and arrived safely in Pensacola harbor. Her cargo of mercury, lead, and tin was of immense value to the Confederate cause.

Union observers kept a close eye on the schooner during the days that followed and remarked on a flurry of activity around her at the Pensacola Navy Yard. They watched with concern as the rebels installed cannon on the *Judah*, and they concluded that she would soon be headed out to sea to terrorize the Northern merchant fleet.[76] The navy determined to stop her. A strike force was organized aboard the frigate *Colorado* to undertake a daring mission to assault the heavily guarded shipyard and take out the *Judah*. One of the officers selected to lead the attack, Tecumseh Steece, was a promising young man on his first assignment.

The son of a War of 1812 veteran who had settled in Ohio during frontier times, Steece was appointed to the U.S. Naval Academy in 1857.[77] Upon his graduation in mid- 1861, the Civil War was well under way. He was ordered to the Gulf Blockading Squadron for duty on the *Colorado*, setting the stage for his participation in the expedition against the *Judah*.

On the night of September 13, 1861, Steece and his comrades, about one hundred strong, crossed Pensacola harbor in four rowboats with muffled oars. The crews of two of the boats were charged with the destruction of the *Judah*. Those on the other two craft were ordered to neutralize a nearby artillery fieldpiece. Steece commanded one of the latter boats. All wore white caps to distinguish themselves from the enemy.[78]

At about 3:30 a.m. the boats had closed to within a hundred yards from the wharf when an alert sentry aboard the *Judah*

fired a warning shot. The seventy-five Confederates aboard the schooner followed with a musket volley that shattered the stillness of the night. The bluejackets rowed as rapidly as possible, landed on the wharf, and scrambled aboard the schooner amidst a hail of gunfire.

Meanwhile, Steece and his shipmates charged the cannon. A lone Confederate on duty managed to level the ten-inch Columbiad and fire off a single round. It missed the attackers. Simultaneously, a bullet from the musket of a Union sailor brought down the rebel. The bluejackets swarmed the Columbiad and spiked it. They carried away its tampion, a plug used to keep moisture out of the muzzle, as a trophy of war. Steece diverted his command to aid the attacking party on the *Judah* and according to official and unofficial reports performed valuable service.[79]

Back on the *Judah*, the fighting intensified as hand-to-hand combat broke out. The rebels were driven from the vessel, and the *Judah* was set afire. The blaze spread rapidly, and she was soon engulfed in flames. The Confederates rallied on the wharf with other guards and kept up a lively fire, but it was too late to save the *Judah*.

By this time the attacking party had climbed back into their boats and set off under fire for the return to the *Colorado*. Behind them the flaming *Judah* lit up the night sky. She burned down to her waterline, broke free from her moorings, floated out into the harbor, and sunk. The triumphant sailors returned to the frigate about daylight. The mission lasted about fifteen minutes, and it was a complete success. The cost amounted to three dead and thirteen wounded. Steece escaped unharmed. Newspapers across the North carried reports of the victory, including *Harper's Weekly*, which displayed an engraving of the Judah burning on its cover.[80]

The embarrassed Confederate brigadier in command of this part of the Gulf, Braxton Bragg, reported the loss to Richmond. He linked the attack to the recent desertion of nine rebel Marines and wrongly assumed they had led the Union operation. Bragg did not state his losses, though according to a slave that escaped

and was picked up by the Union navy, the rebels suffered about thirty casualties.[81]

In Washington, D.C., secretary of the navy Gideon Welles heaped high praise on all involved in an official letter of commendation issued on October 4, 1861. "The whole country is indebted for one of the brightest pages that has adorned our naval record during this rebellion," he wrote. "The expedition will give renown, not only to those who were immediately concerned in it, but to the Navy itself. It will inspire others in the service to emulation; its recital hereafter will thrill the heart with admiration."[82] Twenty-five years later, Adm. David Dixon Porter wrote in his *Naval History*, "This was without a doubt the most gallant cutting-out affair that occurred during the war."[83]

Steece went on to serve in a variety of roles, including a stint as an assistant to the commandant of midshipmen at the U.S. Naval Academy. On December 7, 1862, he was aboard the steamer *Ariel* in the Caribbean Sea en route to an assignment when the Confederate raider *Alabama* captured the ship. He and the other sailors were released and eventually returned to the United States.

Steece spent most of 1863 with the South Atlantic Blockade Squadron as an officer on the gunboat *Sebago*. The year would be marked not by combat, though Steece was on regular duty, but by more scholarly doings. A twenty-four-page paper he had written at the Naval Academy, "A Republican Military System," a defense of the American way of small standing armies, was published to some fanfare. He received a patent for an improvement to rifled cannon. He also married his sweetheart, Mary Davis, while on a brief leave.

By this time Steece had advanced in rank to lieutenant. In mid-1864 he received orders to report to the frigate *San Jacinto*, then at the Brooklyn Navy Yard undergoing routine repairs. He departed with his new command on June 24, 1864, for blockade duty in the Gulf of Mexico. The ship and crew arrived at Key West, Florida, in the midst of an outbreak of yellow fever. The vessel left as quickly as possible to avoid the contagion and spare the crew. But it proved impossible to escape. On July 6 the first of many

sailors fell ill with the dreaded fever, and many more cases soon followed.

A ton of ice was brought on board to ease their suffering, and Steece made it his business to make sure the ice was reserved only for them. Then Steece fell ill. The assistant surgeon of the *San Jacinto* reported, "On the 9th Lieutenant Steece called me into his room and said, 'Doc, I have the fever, and I feel that I am going to be seriously ill. I am perfectly contented and not at all afraid. I have had the bilious-remittent fever before, and feel somewhat now as I did then.'"[84]

The ice Steece had so jealously guarded for his comrades now eased his own pain. "It was a pleasure to me to see how thoroughly he enjoyed the luxury himself, being permitted to hold pieces of it in his mouth" observed the surgeon. "When it gave out, and the intense heat of his skin became almost insupportable, his strong imagination grew eloquent in depicting to me rivers, lakes, and fountains of cool water in which he would like to repose."[85]

Steece succumbed to the fever on July 16, 1864, and was buried at sea. He was about twenty-five years old.

Unmasking a Rebel Battery
at Freestone Point

THE LIGHT OF DAWN ON A CRISP AUTUMN DAY IN 1861 revealed suspicious activity along the Potomac River about twenty-five miles below Washington. A group of workers armed with axes and shovels busied themselves on the Virginia side of the river at Freestone Point. Their actions caught the attention of the federal Potomac flotilla anchored on the Maryland side at nearby Indian Head.[86]

One of the flotilla's six vessels was the tugboat *James Murray*. Her commander, nineteen-year-old midshipman John F. McGlensey of Pennsylvania, was ready for action. The eldest son of a Philadelphia grocer-father and his Irish-born mother, he had only recently completed his studies at the U.S. Naval Academy.[87]

McGlensey had graduated on June 1, 1861, when the Civil War was just six weeks old. Washingtonians at the time were fearing for the safety of the capital. They had just cause for their concerns, as neighboring Virginia was aggressively mobilizing citizen sailors and soldiers. The commander of the commonwealth's military forces, Maj. Gen. Robert E. Lee, updated Gov. John Letcher in a progress report on June 15: "Arrangements were first made for the establishment of batteries to prevent the ascent of our enemy by hostile vessels. As soon as an examination was made for the selection of sites their construction was begun and their armament and defense committed to the Virginia navy."[88]

One of the sites targeted for a battery was Freestone Point. Its strengths included a commanding view of the Potomac and the mouth of the Occoquan River, an access point to Manassas Junction and other interior locations. Workers soon began construction of gun emplacements under cover of pine trees.

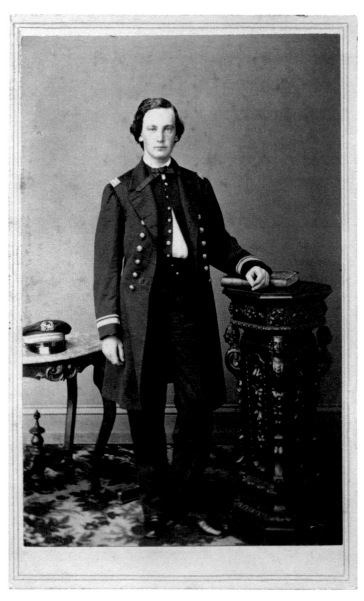

Capt. John Franklin McGlensey, U.S. Navy

Carte de visite by Frederick August Wenderoth (1819–1884) & William Curtis Taylor (life dates unknown) of Philadelphia, Pennsylvania, about 1862. Collection of the author.

At daybreak on September 25, 1861, the federal fleet observed the detail engaged in what appeared to be digging earthworks. A wisp of smoke rising through the trees, perhaps from a campfire, may have also attracted the attention of the navy.[89]

Two vessels, the *Jacob Bell* and the *Seminole*, investigated the activity. The commander of the *Jacob Bell*, Lt. Edward P. Mc-Crea,[90] described what happened next in his after-action report: "At about 9:30 a.m., I got close under the point and opened my guns with shell, throwing several among the workmen, dispersing them. After having fired sufficiently long without any return of fire I stood out from underneath the point. At that moment a shot was fired at me from the point. The *Seminole* also about that time opened her guns upon the discovered battery."[91]

The rebels raised their flag and replied with a barrage from their big guns.[92] They kept up a rapid fire into the afternoon. At some point during the action, the federals observed a small launch anchored in front of the battery. Midshipman McGlensey ordered the *Murray* in and captured the craft. The bold move drew fire from the Freestone battery, but the crew of the *Murray* managed to secure the launch and tow it away. "She accomplished it without any injury to herself or those on board," noted Lt. McCrea.[93]

The warships were unable to dislodge the rebel guns that day. In fact the battery continued to harass traffic along this section of the Potomac for months. Finally, in late February or early March 1862, the massive buildup of Union forces in the region compelled the Confederates to abandon Freestone Point.

By this time, McGlensey had been transferred to the South Atlantic, where he had participated in one of the earliest amphibious operations of the war against Port Royal Sound off the South Carolina coast on November 7, 1861. McGlensey went on to earn his lieutenant's bars and serve aboard the steamer *Pocahontas* and the ironclad monitor *Nantucket*. He remained in the navy after the war concluded and served on various vessels in American and international waters.

McGlensey retired from the navy in 1893, as a captain, and died three years later at age fifty-four. His wife, Mary Jane, and a son and daughter survived him. He was buried in the Naval Academy Cemetery. In reporting his death, the *Army and Navy Journal* remembered McGlensey as having served "with great efficiency and credit."[94]

Out of Retirement

THE NEED FOR UNION WARSHIPS TO SUPPORT THE MAS-
sive Southern blockade prompted the recommissioning of moth-
balled vessels. One of the ancients to be recalled to service, the
forty-four-gun frigate *Brandywine*, had been launched in 1825
and on her maiden voyage had carried Revolutionary War hero
Lafayette home to France. Her sails were furled in 1850.

A decade later she was called out of retirement. In late Sep-
tember 1861 the *New-York Tribune* reported: "The old frigate
Brandywine is being rapidly converted in a storeship—about the
only thing she is fit for. When completed she will present a rather
patched appearance, but she will no doubt answer the purpose
for which she is intended."[95] Other newspapers referred to her as
the "Hulk *Brandywine*."

Her new crew included a veteran officer who had also come
out of retirement. Samuel Shipley, a forty-seven-year-old lieu-
tenant, had resigned his commission in 1852.[96] The ocean was
Delaware-born Shipley's first love. "Our subject," noted the writer
of a biographical sketch, "when a school boy near the Delaware
Bay watching the ships go down to the ocean, early evidenced a
desire to go to sea."[97] The death of his father, when Shipley was
about four, prompted his widowed mother, Mary, to relocate to
eastern Indiana to be closer to her family. The move took Shipley
away from his beloved sea but did not dampen his ambition.[98]

His dreams were realized in 1834 when, thanks to friends
and his congressional representative, Shipley was appointed a
midshipman in the navy.[99] At this time in American naval his-
tory, young officers received their education on warships. Shipley
started his training on the brig *Enterprise*. Meanwhile, calls for
a formal school to train naval officers led to the establishment of

an academy in Philadelphia, and Shipley was a member of the first class to pass examinations there in 1839.[100]

The U.S. Naval Academy opened its doors in Annapolis, Maryland, six years later. By that time, Shipley had established himself

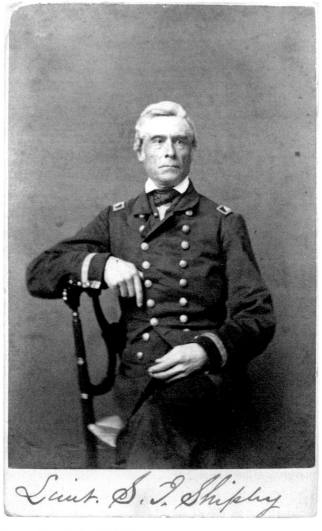

Lt. Samuel J. Shipley, U.S. Navy

Carte de visite by an unidentified photographer, about 1861–1862. Collection of the author.

as an up-and-coming officer. Between assignments he had purchased a farm in Indiana, married, and fathered a daughter.

Tragedy struck during the birth of their second child, a son. His wife, Martha, succumbed to complications, and the infant also died. Shipley placed his daughter in the care of family and returned to the sea. He was stationed along the African coast when war with Mexico erupted in 1846. He remained in Africa until his tour of duty ended in early 1848. Shipley was assigned to serve as a lieutenant aboard the storeship *Germantown* and sailed for Mexican waters. But by the time the vessel arrived, in May 1848, hostilities had ceased and a peace treaty had been signed.

In 1852, Shipley resigned his commission due to the effects of fever contracted in Africa. He returned to Indiana, rejoined his family, and settled into life as a farmer.

Shipley offered his services to the navy after the start of the Civil War. On September 25, 1861, he was reappointed to his old rank and ordered to join the crew of the *Brandywine* in New York City. About a month later, on October 27, 1861, the old frigate left her moorings at the New York Navy Yard for the first time in more than a decade. She was towed by the side-wheel steamer *Bienville* to Hampton Roads, Virginia, and deployed as a storeship and hospital.

Neither Shipley nor the *Brandywine* would remain in the navy until the end of the war. Shipley resigned in early 1863 on account of poor health. On September 3, 1864, the *Brandywine* sank at her moorings in Norfolk, Virginia, gutted by an accidental fire. Shipley returned to Indiana and lived on his farm until his death in 1897 at age seventy-three.

Penetrating the Buckler of Secession

AT TWENTY MINUTES PAST TWO ON THE AFTERNOON OF November 7, 1861, a detachment of bluejackets hoisted the Stars and Stripes above Fort Walker. The coastal South Carolina stronghold, key to the Confederate defenses of Port Royal Sound, was in Union hands after a brief but intense naval bombardment.[101]

The army soon joined them. For the first time since the fall of Fort Sumter a half-year earlier, federals were on Palmetto State ground in force. "I learn that when they saw our flag flying on shore, the troops were powerless to cheer, but wept," noted Samuel F. Du Pont, the Union's flag officer in charge of navy operations.[102]

Du Pont praised the officers and enlisted men under his command. "Each one did his part in his place," he declared.[103] One of the sailors was Aaron Joseph, and he had joined the navy to fight for the freedom of his race and preserve the Union.[104]

Born free in Boston, Massachusetts, Joseph was the second of four sons raised by his father, an immigrant from Bermuda, and his mother, who hailed from New York City.[105] He entered the tanning industry as a young man and became a currier, or specialist in finishing hides. At the start of the Civil War, he practiced his trade in the Boston suburb of Charlestown. On October 12, 1861, Joseph set aside his tanner's apron and enlisted in the navy as a landsman. He was assigned as to the *Mohican*. The sloop-of-war had recently arrived in Boston after a tour of duty hunting for illegal slave traders along the coast of Africa.

Meanwhile in Washington, D.C., Du Pont had presided over a commission to consider naval operations against the fledgling Confederacy. In October, as Landsman Joseph adjusted to mili-

tary life, the navy acted on commission reports and organized an expedition to Port Royal. Du Pont was named commander of the seventy-five-vessel fleet, which included fifteen warships, troop transports, and supply vessels. The transports carried twelve thousand troops led by Brig. Gen. Thomas W. Sherman.[106]

The expedition included the *Mohican*. She and her crew rendezvoused with other vessels at Hampton Roads, Virginia. Joseph by this time had been assigned as a wardroom steward.

The full fleet departed on October 29, 1861, and arrived off Port Royal Sound on November 4. Three days later, the warships went into action. Du Pont's flagship, the *Wabash*, led two attack columns. The *Mohican* was third in line in the main column.

Du Pont's vessels easily defeated a small Southern flotilla and silenced shore batteries. Casualties in the fleet numbered thirty-one. The losses on the *Mohican* were one killed and seven wounded, the highest toll on any single Union warship in the engagement. Joseph survived without injury.[107]

The North, still reeling from the devastating defeat at Bull Run, Virginia, a few months earlier, celebrated the victory with wild abandon. The *New York Times* declared: "The spear has penetrated through the bosses of the buckler of secession. The glorious oriflamme of the Union, first struck down by parricidal hands in that State, reappears after six months with flaming vengeance on the soil of South Carolina. Already the whirligig of Time begins to bring round his revenges."[108] Port Royal and the surrounding islands, including Hilton Head, remained occupied by the Union military as a major base of operations for the duration of the conflict.

Joseph left the *Mohican* after his one-year term of enlistment ended, then immediately rejoined the navy and was assigned to the *Wabash*. He was aboard the vessel when she and her crew participated in the January 15, 1865, attack on Fort Fisher, North Carolina. The engagement ended with the fall of the fort and the capture of nearby Wilmington, thus closing the last major Atlantic port to the Confederacy. It may be fairly stated that Joseph was present and accounted for during two of the Union's

most important naval successes along the Atlantic coast during the Civil War.

Joseph mustered out of the navy in May 1865 and returned to Massachusetts. He married Jane Maddox, the sister of a soldier who had served in the Fifty-fifth Massachusetts Infantry.[109] Joseph and his newlywed wife started a family that grew to include seven children, only three of whom lived to maturity. They settled

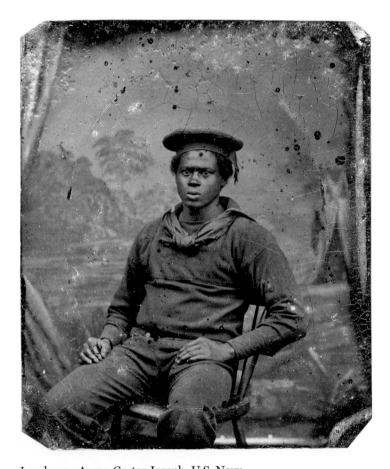

Landsman Aaron Carter Joseph, U.S. Navy

Sixth-plate tintype by an unidentified photographer, about 1861–1865. Collection of Greg French.

in Plymouth, where Joseph worked as a steward on merchant ships.

In 1881, Joseph moved his family to New Bedford. He became active in the Grand Army of the Republic. By this time men of color were not permitted to join the local chapter of the veterans organization, so they formed their own post. Following the custom of naming the post for a prominent soldier, they selected Robert Gould Shaw, the colonel of the Fifty-fourth Massachusetts Infantry killed in action during the assault against Fort Wagner on Morris Island, South Carolina, on July 18, 1863. Joseph commanded the post when it closed its doors in 1901 due to the increasing age and illness of its membership.

Joseph lived until 1916, dying of tuberculosis at age seventy-three.[110]

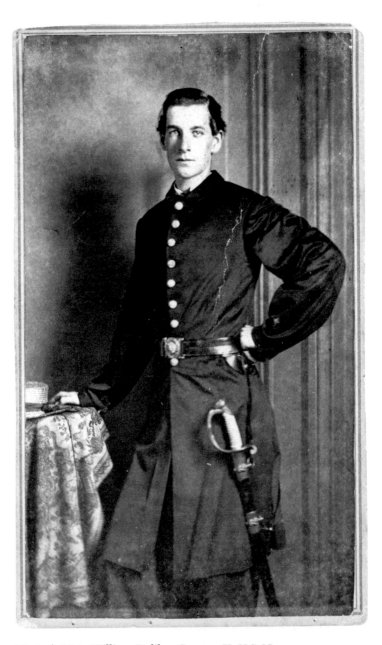

Master's Mate William Doliber Gregory II, U.S. Navy

Carte de visite by unidentified photographer, about 1864–1866. Collection of Earl Sheck.

True Marblehead Spirit

THE BRIG *Bohio* DEPARTED NEW YORK HARBOR ON JANU-ary 13, 1862, with little fanfare. Lightly armed with only two guns and powered by no more than the sails that billowed from her twin masts, she garnered less attention in an era of steam and iron.

Still, her crew was as patriotic and full of fight as their counterparts on the largest vessels in the federal fleet. The commander of the *Bohio*, William D. Gregory, was a master mariner from the Massachusetts fishing village of Marblehead. His adventures at sea were the stuff of legend in his hometown. Among his crew could be found several spirited Marblehead men, including his nephew and namesake William Doliber Gregory II.

Young Gregory, a fifteen-year-old high school student, had recently suffered the death of his mother. His widowed father, Joseph, made a living in Marblehead's lucrative shoe industry. Records suggest his father was one of the few members of the Gregory clan who worked inland. When the war came and his Uncle William joined the navy, Gregory set aside his studies and enlisted. He was assigned to the *Bohio* as an apprentice sailor, or "boy," under his uncle. The rank was subdivided into three tiers, and Gregory was rated upon examination of his skills and abilities as a second-class boy.[111]

Gregory served on the *Bohio* through 1862 and performed myriad tasks in support of his shipmates on the hunt for blockade-runners along the western coast of the Gulf of Mexico. They took four prizes and might have taken a fifth, but her crew scuttled the vessel to prevent its capture. Towards the end of the year, the *Bohio* participated in the destruction of valuable salt works along St. Andrew Bay on Florida's panhandle.

By this time Gregory's uncle had resigned his command "in consequence of some feeling which appeared to exist between himself and the other officers," according to military records.[112] Though his uncle was gone, Gregory remained aboard the *Bohio* and advanced to the rank of seaman. On January 8, 1864, a week shy of his eighteenth birthday, he received a commission as acting master's mate. He served in this capacity on several vessels in the Gulf of Mexico until the spring of 1866 when he was honorably discharged.[113]

Gregory went home to Marblehead and married. According to his wife, Sarah, "He wished to give up the Sea but it was not easy to adapt himself otherwise." Gregory was lured back to the water by one of Marblehead's brightest marine stars, Josiah Perkins Cressy, the veteran captain who had commanded the clipper *Flying Cloud* on her record-setting, eighty-nine-day eight-hour voyage between New York and San Francisco in 1854.[114] Cressy, now captain of the *Archer*, offered the position of mate to Gregory and he accepted.

Gregory eventually left the *Archer* to become chief mate of the merchant ship *Radiant*. In February 1876, she and her crew encountered a typhoon in the Indian Ocean and never were heard from again. Gregory was thirty years old and childless.

Wife Sarah received a pension for her late husband's service. Years later, she wrote pension bureau officials and thanked them for the compensation. In her letter, she paid tribute to the fighting Gregory family and noted, "You must pardon my natural pride in having been the wife of one who did such long & worthy service and also many of his family who had the 'true Marblehead spirit' of which you had probably heard about."[115]

Sarah never remarried and lived until 1931.

Baptism under Fire on the Monitor

THE ORIGINAL SLATE OF OFFICERS ASSIGNED TO THE IRON-
clad warship *Monitor* represented a wide range of naval education
and experience. On one end of the scale stood John L. Worden,[116]
his long graying beard and lined forehead a testament to his years
of service on the high seas and a recent, seven-month stint as a
prisoner of war. On the other end stood fresh-faced eighteen-
year-old Mark Sunstrom, a Maryland boy on his first assignment.

Sunstrom traced his lineage to Sweden, the birthplace of John
Ericsson, the inventor and engineer who designed the *Moni-
tor*. Sunstrom's father, Robert, was the first generation born in
America. A brickmaker in Baltimore, he had succumbed to a
prolonged illness in 1853. The death left his wife, Rachael, an
English immigrant, a widow with two boys and five girls to raise
on her own. Sunstrom, the eldest of her two sons, grew up and
went to work as a bookkeeper.[117]

Sunstrom's first glimpse of war may have been in April 1861,
when pro-secession mobs attacked the Sixth Massachusetts In-
fantry as the regiment passed through Baltimore on its way to
Washington, D.C. At some point he decided to cast his lot with
the Union and on February 1, 1862, received a commission as an
engineer.

That same day, newspapers reported the launch in New York of
an experimental ironclad vessel. Curious reporters, not knowing
what to make of the round revolving metal turret attached to a
flat-topped deck just above water level, referred to it as a "float-
ing iron battery" and the "Ericsson bomb proof battery." Ericsson
himself gave the strange craft its identity. "I propose to name the
new battery *Monitor*," he wrote to assistant secretary of the navy
Gustavus V. Fox. "The impregnable and aggressive character of

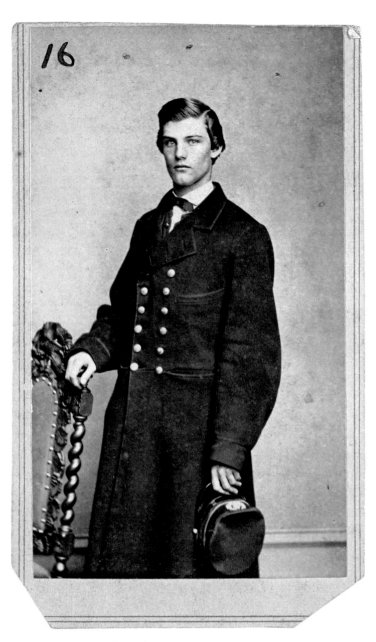

2nd Asst. Eng. Mark Trueman Sunstrom, U.S. Navy

Carte de visite by F. H. Pierce (life dates unknown) of New York City, about 1862–1863. Collections of The Mariners' Museum, Newport News, Virginia.

this structure will admonish the leaders of the Southern Rebellion that the batteries on the banks of their rivers will no longer present barriers to the entrance of Union forces." He added, "The iron-clad intruder will thus prove a severe monitor to those leaders."[118]

On February 7, Sunstrom was assigned to the *Monitor* as fourth assistant engineer. He was one of at least three officers who happened to have connections to Maryland—almost a third of the ten-man command core.[119] Sunstrom and his crewmates had barely settled into their duties when the *Monitor* left New York to face the newly constructed iron-sheathed Confederate warship *Virginia.*

The development of ironclads was an open secret. Citizens, sailors, and soldiers north and south of the Mason-Dixon line waited for the two vessels to face off with the same zeal and anticipation generated by a horse race or prize fight. Each sung the praises of their champion. "The first warning which the rebels will receive of the exact destination of this terrible 'Monitor' will be in the shape of an iron globe weighing about 180 lbs.," bragged one Northern newspaper.[120]

The contest took place on March 9, 1862, along the Virginia coast off Hampton Roads. The metal monsters pounded away at each other for about four hours, but no vessel gained a clear advantage. The first fight between iron ships in history was technically a draw, though both sides claimed victory. The *Monitor* and her bluejackets suffered minor damage. Sunstrom emerged from the fight without a scratch.

Sunstrom continued to serve on the *Monitor* and was pictured in at least two photographs on her deck with fellow officers and crew. He was aboard on December 31, 1862, when she encountered a powerful storm off Cape Hatteras along the coast of North Carolina. While strong gales and heavy seas whipped the *Monitor* about like a child's toy boat, Sunstrom tossed and turned in his berth with a severe case of pneumonia. When the word came to abandon ship, the *Monitor's* doctor rescued Sunstrom from certain death.

Asst. Surg. Grenville M. Weeks[121] later remembered the moment. "I had to struggle desperately to pull him from his berth where his breathing was so difficult, and prostrating, that I could hardly rouse him to the supreme effort required, to enable him to drag himself with my aid through the ship's hatchway down which the ocean waves poured almost frowningly upon us, ere we could get up on the 'Monitor's' turret above the foam of the sea whirling so frowningly about us."[122]

Sunstrom made it into a boat from the consort *Rhode Island* and to safety on the side-wheel steamer. Weeks, who claimed to be the last man to leap from the turret, also survived. The two men numbered among the lucky ones. A total of forty-seven sailors made it out alive and sixteen were lost, including four officers and twelve crewmen. The *Monitor* eventually succumbed to the storm and sunk beneath the waves while the survivors watched from the deck of the *Rhode Island*.

Sunstrom recovered and returned to duty. He spent the rest of the war in relative calm along the Atlantic coast on the gunboats *Unadilla*, *Pontoosuc*, and *Ashuelot*. He advanced in rank to second assistant engineer and resigned his commission in November 1865. In his letter of resignation, he complained of chronic seasickness and dyspepsia.[123]

His health did not improve after he returned to his home in Baltimore and went to work as a clerk. A friend recalled Sunstrom's frequent complaints of trouble with his lungs. He was diagnosed with tuberculosis in early 1875 and fought a long and painful eight-month battle that ended in his death before the end of the year. Sunstrom was thirty-two years old. His wife, Rhoda, and comrades in the Masons, Knights of Pythias, and other fraternal organizations mourned his passing.[124]

Disappointment at Hampton Roads

T HE SUCCESS OF THE CONFEDERATE IRONCLAD *Virginia*
against the Union fleet was unprecedented. In the March 8, 1862,
action at Hampton Roads, Virginia, she destroyed the wood frig-
ates *Cumberland* and *Congress* and ushered in a new era of naval
warfare.

The crew of the *Virginia* was elated. They cheered repeatedly
as shot after shot wreaked havoc on the wooden dinosaurs. The
men kept cool and worked closely together even though they were
mostly strangers under fire for the first time.[125]

But for one man on the *Virginia* the experience was a disap-
pointment. Douglas Forrest, an aide to *Virginia* commander
Franklin Buchanan,[126] felt useless as he shuttled to and fro with
orders while the business of fighting fell to others.[127] Truth be told,
he preferred the army. Less than a year earlier, he had begun his
service as a second lieutenant in an Alexandria, Virginia, militia
company, the Old Dominion Rifles. It became Company H of
the Seventeenth Virginia Infantry. According to the regiment's
historian, Forrest established a reputation as "a good officer, a
courteous gentleman and a social companion." He and his com-
rades participated in several early engagements, including the
First Battle of Manassas on July 21, 1861.[128]

During the fight, Forrest was recognized for bravery when
he cheered on the men during an attack under a galling fire
by an enemy artillery battery of five guns.[129] Forrest survived
Manassas, which proved to be the last battle that he fought with
his regiment. A few months later he was appointed to the staff
of Brig. Gen. Isaac R. Trimble.[130] Forrest fell ill soon after he
joined Trimble's staff. Though the nature of his ailment was not
reported, it was serious enough to result in a convalescent leave

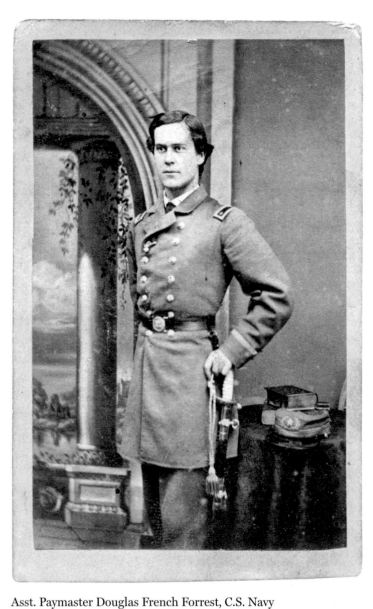

Asst. Paymaster Douglas French Forrest, C.S. Navy

Carte de visite by Louis Chevreuil de La Chaperonnière (life dates unknown) of Calais, France, about 1863–1864. Collection of Gerald Roxbury.

in Norfolk. There he reunited with his father, Flag Officer French Forrest. A Marylander who started his navy service in the War of 1812, the elder Forrest assumed command of the Norfolk Navy Yard in the days following the bombardment of Fort Sumter.

Forrest had not followed his father's career path. Instead he had graduated from Yale in 1857, studied law at the University of Virginia, and became an attorney in Alexandria.[131]

During his recuperation in Norfolk, Forrest observed the final stages of the conversion of the frigate *Merrimack* to the *Virginia*—she had been burned to the waterline and abandoned by the U.S. navy rather than fall into Confederate hands when Norfolk was evacuated in 1861. Forrest completed his convalescence and asked Buchanan to take him on as a volunteer aide. Forrest may have been motivated by boredom and inactivity, or excitement and wonderment about the *Virginia*.[132]

Whatever the reason, Buchanan agreed. Forrest was present aboard the ironclad during the historic engagement on March 8. Afterwards he and another officer were dispatched to Richmond to deliver news of the victory and present the captured flag of the destroyed *Congress*. This caused him to miss the drawn battle with the Union ironclad *Monitor* the next day.

Forrest returned to the Seventeenth and received an appointment as commander of his company. On May 6, 1862, while on the Virginia peninsula near Yorktown preparing to fight federals from the Army of the Potomac, he was ordered to report to Richmond. Upon his arrival he received a commission as an assistant paymaster in the Confederate navy. Forrest did not ask for the commission. According to an historian, it was probably the doing of his father, who likely believed that his only son stood a better chance for survival on a gunboat rather than in the infantry.[133]

Forrest protested to no avail. Forced into acceptance, he reported to the relatively quiet naval station at Wilmington, North Carolina. A year later he was ordered abroad to England and France. He was assigned to the *Rappahannock*, a British-built cruiser plagued by mechanical problems and political issues that effectively ended her career before it started. In August 1864 her

officers and crew were discharged with the exception of Forrest, who remained behind to look after public property.

In the spring of 1865 Forrest left England for the Confederacy. In Havana he learned of the surrender of the Army of Northern Virginia by Gen. Robert E. Lee. Determined to return, he boarded a blockade-runner bound for the Gulf of Mexico and arrived in the Texas port city of Galveston on May 3, 1865.[134] He served briefly and unofficially as an aide to Gen. John G. Walker.[135] After the end of hostilities, Forrest attempted an escape to Mexico, but it failed and he returned to Virginia.

In 1866, Forrest opened a law office with a partner in his birthplace, Baltimore. Always a spiritual man, he became involved in religious work. A trip to the Holy Land in 1871 inspired him to enter the ministry. He dissolved his law practice, entered the Theological Seminary of Virginia in Alexandria, and was ordained an Episcopal priest in 1873. This same year he married Richmond belle Sallie Rutherford.

Forrest spent the rest of his days tending to flocks in Maryland, Washington, D.C., Ohio, West Virginia, and California. He also earned a doctor of divinity degree from the College of William and Mary.

His health failed about the turn of the century, and he died of a heart attack in 1902. His wife survived him. They had no children.[136]

Annoying the Enemy at Yorktown

Along the Virginia coast on April 10, 1862, Union Maj. Gen. George B. McClellan stood on the banks of the York River and gazed on the scene before him. Rebel-occupied Yorktown, plainly visible in the distance, bristled with defenses. He watched with growing anxiety as enemy schooners delivered men and supplies to the stronghold.[137]

A few days later, "Little Mac," as the commander of the Union Army of the Potomac was popularly known, asked the navy for help. "If you possibly can, please spare me something with a 100-pounder rifle. We need it to annoy their working parties on the other side of the river," he wired Louis M. Goldsborough, the flag officer in charge of naval forces at nearby Hampton Roads, on April 13.[138]

Goldsborough promptly responded by sending one of his best fighting ships, the *Sebago*. A gunboat named for a lake in southwestern Maine, her able crew included Frank Morey, a fireman tasked to extinguish flames and clear debris in the heat of battle.

Morey, a twenty-two-year-old miller from the hamlet of Keeseville in northern New York, had worked along Lake Champlain just a month earlier. He joined the navy on March 2, 1862, and was assigned to the *Sebago* as a fireman. A newly built side-wheel steamer with rudders at the bow and stern for easy navigation in narrow waterways, or "double-ender," she was armed with six guns. The most formidable of the group, a Parrott rifle, was an iron giant that fired the heavy shells McClellan requested.

Morey reported for duty to the Portsmouth Navy Yard, home port of the *Sebago*. On April 6, 1862, he and the rest of his comrades steamed for the South, arriving at Hampton Roads five days later. Meanwhile, McClellan's 120,000-strong army was three

weeks into a massive invasion up the Virginia peninsula to take Richmond and destroy the Confederate government. "Little Mac" moved with characteristic caution, which allowed the enemy in Yorktown and Gloucester additional time to reinforce.

About 10:00 a.m. on April 15, the *Sebago* opened up its big gun

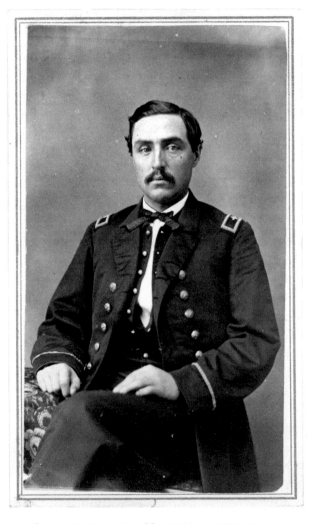

Acting 2nd Asst. Engineer Franklin C. Morey, U.S. Navy

Carte de visite by Horace S. Tousley (1825–1895) of Keeseville, New York, about October 1865. Collection of Ron Field.

on enemy batteries located across the river from Yorktown heights at Gloucester Point. Her crew lobbed hundred-pound shells at the rebels every half hour through the morning and afternoon and continued at intervals over the next two days. At one point the *Sebago* steamed to within two and a half miles of Gloucester Point—the closest she would get to the enemy.[139]

Confederate gunners replied. According to a naval attaché with McClellan's entourage, a pair of heavy guns returned fire that did not hit the *Sebago* but "exhibited excellent long-range practice, throwing the water over her and all passing in close proximity."[140] Other federal gunboats joined the fray and traded shots with the Yorktown artillerists for the next two weeks. No serious damage was reported on the *Sebago* and Fireman Morey's services were not required.[141]

Morey and his crewmates woke up on the morning of May 4, 1862, to see the Stars and Stripes floating over Yorktown. Confederate forces had evacuated the city, falling back to a stronger line of defenses.

McClellan's army continued its march up the peninsula and the *Sebago* supported its movements. The army abandoned its goal to take Richmond after a series of engagements that came to be known as the Seven Days Battles. The failures on the peninsula cost McClellan his command before the year was out.

By this time Morey had ended his yearlong enlistment. He returned to the navy in July 1863 with an appointment as an assistant engineer. Assigned to the gunboat *Gertrude*, he spent the rest of the war chasing blockade-runners in the Gulf of Mexico.

Morey received an honorable discharge in November 1865. He returned to New York and married Lavina Owen. She died in 1877, leaving Morey a widower with two young sons. In 1879 he wed Lucinda Proctor, the daughter of a Civil War veteran and eleven years Morey's junior.[142] The couple had two daughters. Morey supported his family as a customs service inspector and later as an insurance agent.[143] Morey lived until age sixty-seven, dying in 1906 of heart disease. Lucinda and three of his four children survived him.[144]

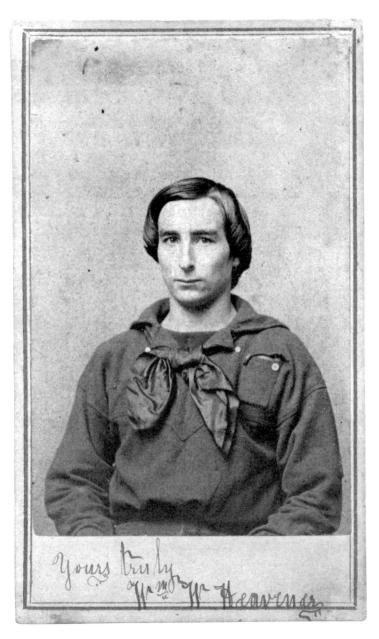

Landsman William W. Heavener, U.S. Navy

Carte de visite by Edward Guay (about 1832–about 1878) & Co. of New Orleans, Louisiana, about 1864–1865. Collection of Ron Field.

Whirlwind before New Orleans

William Heavener's first two months in the navy were a whirlwind of activity. The Maine-born mariner enlisted at a Boston recruiting station on February 21, 1862, and reported to the *Ohio* to await assignment. A decades-old ship of the line anchored in Boston harbor, she was used as a receiving vessel for sailors.[145]

Less than forty-eight hours later, the navy assigned Heavener as a cook to the newly commissioned *Katahdin*. A light draft ship designed for river and ocean travel, she and others in the *Unadilla* class were nicknamed "ninety-day gunboats" due to their rapid construction.

"The *Katahdin* is a good sea boat and well built," declared her commander, Lt. George H. Preble,[146] in a letter quoted in a New England newspaper. Privately, he was much less optimistic. "As cruising men-of-war I consider them failures," he stated bluntly in an official report. He criticized the *Katahdin* for lack of speed and tendency to roll. "For special service as a gunboat in smooth, shoal water she is an efficient vessel, but for the general service of the Navy she is not of much use. If caught at sea in anything like rough weather she would prove almost defenseless and an easy prey to anything that came along."[147]

Heavener climbed aboard the *Katahdin* on February 25—his fourth day in the navy—and steamed for the Gulf of Mexico on March 1. Seven weeks later, he would participate in one of the most important naval actions of the war—the capture of New Orleans. Emblematic of the power and wealth of the rising South, the city's location at the mouth of the Mississippi River made it the keystone of Union efforts to split the fledgling Confederacy along its main artery.

To get into New Orleans by water from the Gulf, warships would have to run the formidable batteries of Forts Jackson and St. Philip. The fortresses bristled with more than a hundred heavy guns. Rear Adm. David Farragut assembled a fleet of seventeen warships organized into three divisions to pass the forts. Heavener, Lt. Preble, and the rest of the crew of the *Katahdin* took its place in the lead division.

On April 16, 1862, the fleet steamed up the Mississippi to a place below the forts while a Union mortar boat flotilla launched a bombardment to soften the defenses and weaken the rebels' resolve. The flotilla pounded away day after day while Farragut prepared to strike. The bombardment climaxed during the predawn hours of April 24, and Farragut's divisions steamed upriver with guns blazing.

One by one the ships ran the gauntlet of rebel guns. The *Katahdin*, sixth in line, fired on the forts as she passed. Two enemy shells struck her; one hit the smokestack and another the foremast. No one aboard was hurt. Heavener's exact location during the fight was not reported, although he likely set aside his cook's apron to take an active role.[148] The *Katahdin* and other vessels continued upriver and passed safely beyond the range of the forts and moved on New Orleans.

Meanwhile, news of Farragut's success reached New Orleans and prompted Confederate forces to evacuate. On the way out, they tossed bales of cotton into the river and set warehouses and ships on fire to keep goods and supplies out of the hands of the federals. By the time the *Katahdin* arrived, the riverfront was a mass of burning ships and sunken docks. Through the smoke and flames, Lt. Preble spied a schooner loaded with cotton. "Fearing she might be fired, I boarded her and hoisted the American flag at her masthead," he noted in his after-action report. This was one of the first Stars and Stripes to be raised over the conquered city.[149]

The crew of the *Katahdin* participated in cleanup operations and acted in a support role after the occupation of the city. They would go on to relatively less eventful duties on patrol along the

Mississippi River and Texas coast. Heavener remained on the gunboat until March 1865, when navy authorities transferred him to the side-wheel steamer *Bienville*. He served with her crew as a landsman until May 1865, when he received an honorable discharge.[150]

Heavener returned to his home in Waldoboro, Maine, a fishing village about sixty miles north of Portland. In 1866 he married and settled in the nearby hamlet of Damariscotta, where he and his wife raised two boys and a girl. Heavener worked as a ship's carpenter to support his family. He lived until 1924, dying at age eighty-four.[151]

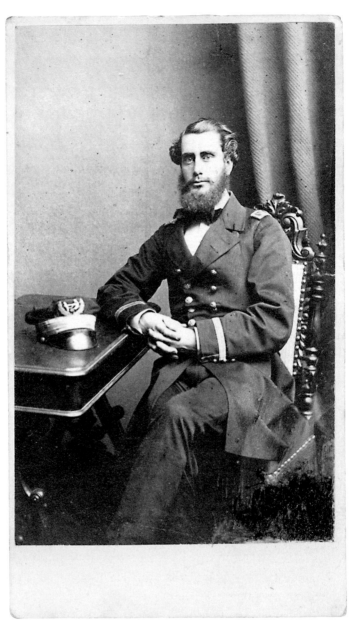

Lt. Charles Henry Swasey, U.S. Navy

Carte de visite by John Adams Whipple (1822–1891) of Boston, Massachusetts, about 1861–1862. Collection of Earl Sheck.

Victorious in Defeat, and Covered with Glory

During the wee hours of April 24, 1862, Lt. Charles Swasey picked his way along the crowded deck of the warship *Varuna* and checked in with the 150-man crew. They had been called to quarters, and as executive officer it fell to him to be sure all was in order. He visited the bluejackets at each station and observed that they were calm and quiet.[152]

As Swasey tended to his duties, the *Varuna* steamed steadily along the Mississippi River below New Orleans, smoke pouring from her single tall stack. Originally designed for commercial purposes, she had been converted into a fighting ship armed with ten powerful guns. Her commander, Charles S. Boggs, was a career navy man with more than three decades in the service.[153]

On this night, the *Varuna* was in the vanguard of a Union armada. Four warships forged ahead of her and twelve behind. The fleet was under the command of Rear Adm. David Farragut, a man determined to hoist the Stars and Stripes above the Pelican City.

But to get there, Farragut had to pass the guns of Forts Jackson and St. Philip. The moon was just rising above the fortresses when the fleet came into range. About 3:30 a.m., Cmdr. Boggs recalled, the first rebel shots roared through the night sky. The firing intensified as a hundred cannon pounded the *Varuna* and the rest of the fleet.[154]

Boggs ordered Swasey to return fire. He immediately set the gun crews into motion. "When abreast of the forts we fired the starboard battery in broadside, then loaded with 5-second shell," Swasey stated in his after-action report. "After the first discharge we loaded and fired grape and canister as rapidly as possible." Amidst the drifting gun smoke and whistling shells, the fleet

became disordered. The *Varuna* was the first to make it free and clear of the forts—and straight into a hornet's nest of enemy gunboats.[155]

There was no way out but forward. Boggs ordered his pilot to steer the *Varuna* to the swarm of enemy vessels at point-blank range and Swasey to open up with everything they had. "The order was given 'to work both sides' and to load with grape," Swasey reported. "Our guns were trained for extreme lateral train forward, and as we brought them to bear successively on the enemy's vessels, ranged in succession on each side of the river, we fired, the guns having been first pointed with the greatest care. As far as my own observation showed me, in no case did we miss the object aimed at, and the effect of our firing seemed to keep the enemy aloof."[156]

Swasey continued, "Finding that we were getting too far from the enemy for the use of grape, we loaded with 5-second shell and fired. One of these shells struck a steamer and, bursting, carried away his port wheelhouse and exploded his boiler. Three other steamers were set on fire and driven ashore by our shell."[157]

By this time it was about 6:00 a.m. and the crew of the *Varuna* had been in action for two and a half hours. Twice set afire by shells, the crew had acted quickly to extinguish the flames. Leaking badly and losing steam, she had almost passed through the entire enemy squadron. But at this moment two rebel warships reinforced with railroad iron and cotton bales attacked. The *Governor Moore* hit first. The side-wheel cotton-clad raked the port gangway with shot that took out thirteen crewmen and rammed the *Varuna* twice. Swasey, at Boggs's command, poured a few shells into the *Moore* and drove her back. Then a second cotton-clad, the *Stonewall Jackson*, rammed the *Varuna* with her iron-sheathed bow. The *Varuna* rocked from the blow. *Stonewall* backed off and rammed her again in the same place. The iron bow crushed the wooden side of the *Varuna*—a mortal wound. Boggs and Swasey, still on their feet, kept the gunners on target. They pumped five shells into the *Stonewall* and sent her reeling.

The cotton-clads dropped out of range, and after close encoun-

ters with other vessels in Farragut's armada they were destroyed. The *Varuna* meanwhile was in her death throes as she took on river water. "I ran her into the bank, let go the anchors, and tied up to the trees," Boggs reported. Swasey kept the crew at the guns and continued to fire until the water was over the gun tracks on deck. At this point the ship was evacuated.

Boggs recalled, "We were taken off by boats from the squadron who had now come up; the crews cheering as the *Varuna* went down with her flag flying; victorious in defeat, and covered with glory."[158] The *Varuna* came to rest on the bottom of the Mississippi, only her topgallant forecastle visible above the waterline.

The *Varuna* was dead. Boggs, Swasey and their crewmates had inflicted serious damage on the rebel fleet. They had destroyed four warships outright and contributed to the destruction of two others. Five days later New Orleans fell to federal forces.

The story of the *Varuna* made newspaper headlines across the Union. The deeds of the crew became the stuff of legend and inspired a poem. In "The *Varuna*," George H. Boker celebrated the ship and extolled the crew: "Cherish the heroes who fought the *Varuna*; / Treat them as kings if they honor your way."[159]

Swasey found temporary quarters on the *Brooklyn*, where he wrote a detailed after-action report. He singled out several of the crew for their actions, of which eight were awarded the Medal of Honor.[160] Swasey also paid tribute to Boggs. "Permit me to thank you for the many kindnesses received at your hands while under your command, and I desire to express the regrets of the crew in losing a commander under whom they enjoyed many pleasant hours."[161]

Swasey's compliment carried the weight of his own experience in the navy. Back in 1854, at age fifteen, he had left his family in Taunton, Massachusetts, and entered the Naval Academy. He graduated in 1859 and began his career on the *Hartford*, then a part of the East India Squadron. A few months after the start of the Civil War, he was promoted to lieutenant and before the end of the year was detached from the *Hartford*. In January 1862 he was assigned to the *Varuna* and the West Gulf Squadron.

His tenure as executive officer of the *Varuna* lasted about three months.

Two weeks after the *Varuna* sunk, Swasey was named temporary commander of the *Tennessee*. The warship had been seized by rebels in 1861 and added to the Confederate navy. She was recaptured and returned to federal service after the fall of New Orleans.

Swasey soon left the *Tennessee* to become the executive officer of the gunboat *Sciota*. In the months that followed, the *Sciota* and other vessels came under increasing risk of ambush by partisan groups hidden along the Mississippi River. These irregular forces had moved into the area north of New Orleans following the occupation of the city.

During the early fall of 1862 Swasey and the *Sciota* joined a convoy charged with the disruption of enemy supply routes from Texas to the eastern Confederacy. On October 1, near Donaldsonville, Louisiana, they spotted a herd of 1,500 longhorn cattle. Swasey was placed in command of a landing party and sent to investigate. He returned with five drovers. After an interrogation, he learned that the cattle were headed from Texas to Camp Moore, a Confederate base about 80 miles north. The navy confiscated the herd and loaded most of the cattle on five transports.

On the afternoon of October 4, the convoy set out for New Orleans with the *Sciota* in the lead. About 2:10 p.m. a few miles south of Donaldsonville, a masked battery opened fire on the *Sciota*. Anticipating an attack, the decks had been cleared and the crew immediately went into action. Swasey aimed a gun at the battery and just as it fired a twelve-pound rebel shot tore through the bulwark of the *Sciota*. It struck Swasey in the hip and hand, almost cutting his body in two. He lingered until about three o'clock. His last words were, "Tell my mother I tried to be a good man." He was twenty-eight years old.[162]

The following morning, a Sunday, the *Sciota* and the rest of the convoy arrived in New Orleans and Swasey's remains were sent ashore. Later that day funeral services were held and the

body transferred to the steamer *Potomac* for the final journey to his family in Massachusetts.[163]

The commander of the *Sciota*, Reigart B. Lowry,[164] paid tribute to his executive officer in an official report. "This officer was characterized by all the elements which make up the hero—brave, imbued with patriotic ardor and professional ambition, chivalric as a gentleman, gentle, and with a heart full of Christian principles." He added, "I respectfully request that his death, so heroic and noble, may be especially known to the nation through the Navy Department."[165]

Two fighting ships were named in his honor, a destroyer commissioned in 1919 and a destroyer escort launched in 1943.[166]

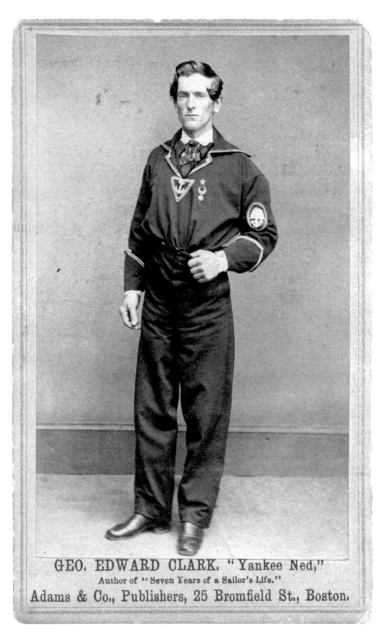

GEO. EDWARD CLARK. "Yankee Ned,"
Author of "Seven Years of a Sailor's Life."
Adams & Co., Publishers, 25 Bromfield St., Boston.

Ordinary Seaman George Edward Clark, U.S. Navy

Carte de visite attributed to Adams (life dates unknown) & Co. of Boston, Massachusetts, about 1867. Collection of Jerry and Teresa Rinker.

The Precarious Position of "Yankee Ned"

In April 1862 along the North Carolina coast near Beaufort, federal siege batteries pounded Fort Macon. The stubborn gray garrison inside the five-sided fortress fired back.

Ned Clark, a Yankee sailor, observed the action from the deck of his warship, the *Gemsbok*. "The rebels answered with their heaviest guns, and their shot threw the white, dry sand, in wide spirts, high in the air, but seldom harmed the Union troops, who steadily shelled the low fort, night and day," he recalled in his postwar memoirs.[167] Clark and his crewmates were eager to jump into the fray. "Every day the land forces were at it, banging at each other; and at night the rush and roar of mortar shell, with their red fire streaming amid the darkness, made us impatient to enter the final combat."[168]

The nineteen-year-old bluejacket had seen little in the way of actual fighting since he had enlisted the previous summer. He did however have a passion for the sea that extended back to his childhood in Salem and Lynn, Massachusetts. "Having escaped the thousand ills that young tuggers encounter, was kept to the school-room, and other similar institutions until my soul was sick of books, music, and dancing. I saw pleasure only in the water, and sketching little pictures of vessels in various positions. Anything in the shape of a boat was my fond delight."[169]

Clark went on his first ocean voyage at age fifteen under the watchful eye of a family friend, who captained a merchant ship. Upon Clark's return, his parents encouraged him to become a printer and sent him to school to learn the trade. But he was not interested and soon was back at sea. He spent his late teens cruising the African coast and experiencing life that most boys would only read about in books.

Clark returned to his family on the eve of war. He "was at home, living in comparative ease, waiting for something to turn up, when our country was startled from a long repose in peaceful pursuits, by the book of Sumter's guns, the echo of which made the loyal millions wake to the call of 'to arms.' Without any hesitation, I sought out a number of active young seaman, and we all shipped in the navy."[170]

Assigned to the *Gemsbok*, a graceful bark named for a species of African antelope, Clark and his mates were soon hunting blockade-runners along the North Carolina coast.

Meanwhile in early 1862, Union Maj. Gen. Ambrose Burnside led a division-sized invasion force on amphibious operations against the Tar Heel State. Burnside's armada of sixty-five vessels entered Pamlico Sound on February 7, landed on Roanoke Island, and defeated Confederate forces the following day. The bewhiskered general then turned his attention to other coastal targets, including New Bern and Beaufort.

Fort Macon, which was occupied by the rebels shortly after the beginning of the war, protected the main channel to Beaufort. Federal ground forces infiltrated the area and laid siege to the fortress. Events came to a head on April 25, 1862. Clark reported, "The army, on the long neck of land, slowly but surely advanced nearer the fort, and having attained a commanding position, opened a terrible cannonade upon the rebels. At the same time the signal for action flew from the senior commander's ship, and all was activity. The wind was blowing a perfect gale, and under double-reefed topsail we ran straight for the fort and came to anchor just outside the bar."[171] Other vessels from the Union fleet also moved in for the kill.

"We were so near that we could plainly see the rebels as they jumped up and loaded their guns," Clark recalled. "The wind was at the westward, cold and strong; we opened fire on the fort, and the loaders and spongers stripped to the waist, and worked like men. We soon found that our guns threw their balls beyond the fort into the marsh, and town of Beaufort; we, therefore, took the precaution to obtain an exact range with five-second shell,

and soon had a terrible fire pouring into the fort." The *Gemsbok's* gunners focused their shots on the flagstaff above the fort but were unable to knock it down.[172]

Detailed as a sail trimmer, Clark found himself in a perilous position among the ship's rigging. "I expected every minute to have a shell cut me in two," as one well-aimed shot laid waste to ropes and other infrastructure that supported the masts. "The shot and shell struck not lower than eight feet above the rail of our vessel," he observed. "No harm came to myself, nor to any of the crew."[173]

But the damage to the *Gemsbok* was severe enough to attract the attention of the flag officer. He ordered her to pull back for repairs. Clark remembered that as they left the scene, crews from other Union vessels "cheered long and loud, to see us there with tattered rigging, and the men alive and working."[174]

Later that day, the garrison of Fort Macon surrendered. "The glorious flag of freedom was flying in the place of the rebel rag," Clark declared.[175] The commander of the *Gemsbok* noted in his after action report that the crew fired twenty-eight rounds at the fort.[176] The capture of Fort Macon proved to be one of the highlights of Clark's military service. In August 1862 his one-year term of enlistment expired, and he returned to civilian life in Massachusetts.

In 1867, Clark's memoirs, *Seven Years of a Sailor's Life*, were published under the nom de plume "Yankee Ned." It received positive reviews, including one that appeared in an Ohio news-paper: "It has been said, 'No one but a sailor can write a sailor's book,' and here we have evidence of what a sailor can do. So graphically is every page written, that, as we read, we can almost hear the wind whistling among the shrouds, snuff up the salt air, and see the white spray on the vessel's path."[177]

Clark's volume is more than a collection of tales of derring-do. It is also a tribute to the American fighting man during the war: "Too much credit cannot be given to the soldier and sailor at any time; and those haughty, conceited people, who were wont to exclaim 'Only a private,' 'Only a common sailor,' may yet be obliged

to own the superiority of those humble, brave, and glorious bands of men."[178]

The book marked the end of his career at sea. "As Yankee Ned, the sailor, I here close my log-book, and bid farewell to the past. I have a new mission to fulfill. New life, new hopes inspire me; new joys are before me. Home, friends, peace and duty, all hail!"[179]

He spent the rest of his days in Lynn, where he married and worked as a traveling salesman. He lived until age seventy-one, dying of a cerebral hemorrhage in 1914.

Action at Plum Point Bend

A DENSE CLOUD OF SULFUROUS SMOKE SHROUDED THE Mississippi River above Fort Pillow, Tennessee, as Confederate and Union gunboats blasted away at each other on the hazy morning of May 10, 1862. During the heat of the action, a rebel ram bore down on the federal ironclad *Cincinnati* and struck her armor plates amidships. The Union crew responded with a powerful broadside. Yankee lead tore through rebel timbers with a terrible crashing sound, and the Confederate vessel drifted helplessly downstream.[180]

One of the men on the *Cincinnati*, Charles Gardner, was a relative newcomer to the crew. A few months earlier, he was on duty in the defenses of Washington, D.C. How he came to serve on board the ironclad is noteworthy.

The eldest of four children born to a Morocco leather dresser and his wife in Massachusetts, Gardner worked as a mariner along the New England coast before the start of the war. After the bombardment of Fort Sumter, he enlisted not as a seaman, as might be expected considering his profession, but as a private in the Second Maine Infantry.[181] Gardner's father also enlisted. He became a sharpshooter and served with distinction until a caisson accident caused him to leave the army with a disability discharge.[182]

The Second made its way to Washington in May 1861. Gardner and his comrades served most of their first year in the capital defenses with the exception of a three-week campaign that ended in the Battle of Bull Run. Gardner visited the studio of Mathew Brady during his stay in Washington and posed for his photograph with a pet dog.

Meanwhile in St. Louis, Missouri, the U.S. War Department

contracted with James B. Eads to build the stern-wheel casemate gunboat *Cincinnati* and other ships sheathed in armor plates. Commissioned in January 1862, the *Cincinnati* participated in the victory at Fort Donelson, Tennessee, the following month.

A shortage of Union sailors resulted in a call for able-bodied seamen from the ranks of the army. Gardner volunteered and

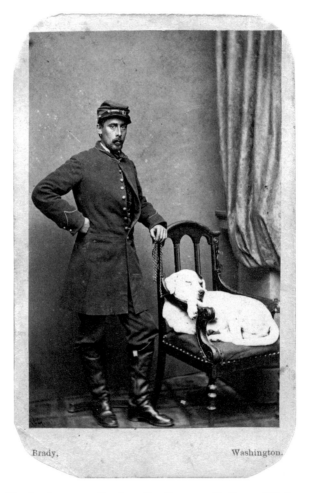

Brady, Washington.

Pvt. Charles Augustus Gardner Jr., Company B, Second Maine Infantry

Carte de visite by Mathew B. Brady (1822–1896) of New York City and Washington, D.C., about 1861–1862. Collection of the author.

reported for duty on the *Cincinnati* two weeks after the victory at Fort Donelson. According to his military service record, Gardner was detached from his regular duty to serve as a crewman. Technically he still belonged to the Second Maine.

On May 10, 1862, he participated in the fight above Fort Pillow, which came to be known as the action at Plum Point Bend. According to official reports, a flotilla of eight Confederate vessels, including as many as four gunboats equipped with rams, targeted a federal mortar boat that had just been towed into position on the Mississippi. Six Union vessels, led by the *Cincinnati* and *Mound City*, steamed to the defense of the mortar boat. For the better part of an hour "a most terrific battle was raging, the like of which the usually peaceful waters of the Mississippi has never before witnessed," declared a *Chicago Times* reporter.[183]

The Confederate vessels repeatedly rammed the *Cincinnati* and *Mound City*, disabling both ironclads and forcing them into the shoals, where they grounded in about a dozen feet of water. The Confederates then left the scene and were not pursued. Casualties were described as slight, although the captain of the *Cincinnati* suffered a serious gunshot wound. Gardner survived without injury.[184]

The *Cincinnati* and *Mound City* were raised, repaired, and returned to active duty. Gardner remained on the *Cincinnati* until November 1862, when authorities discharged him from duty. His whereabouts are unaccounted for until late May 1863, when he rejoined the Second in Bangor. The regiment had just returned home to muster out of the army at the end of its two-year term of enlistment.[185] During his absence the regiment had distinguished itself in engagements in the Peninsular Campaign, as well as the battles of Fredericksburg and Chancellorsville.

Gardner mustered out with his comrades on June 9, 1863—two weeks after the *Cincinnati* went up against the river batteries at Vicksburg and was sunk (and later raised) for the second time in her history.[186] Gardner did not rejoin the army or navy. He died in 1874 at age thirty-five. According to his family, he succumbed to disease contracted in the military.[187]

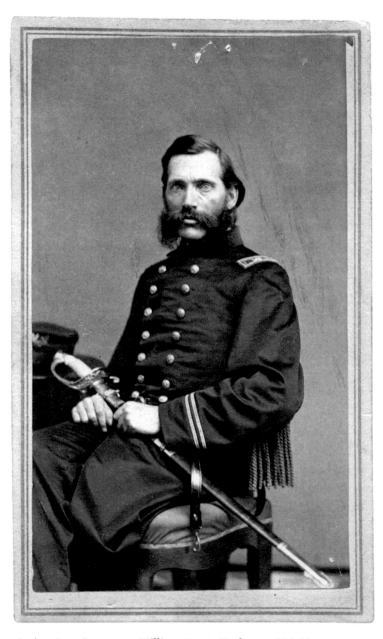

Acting Asst. Paymaster William Henry Hathorne, U.S. Navy

Carte de visite by Russell Ambrose Miller (1824–1909) of Boston, Massachusetts, about 1863. Collection of the author.

First Assignment on a Noted Gunboat

WEDNESDAY, APRIL 29, 1863, PASSED IN RELATIVE QUIET for the crew of the gunboat *Cincinnati*. Among the comings and goings that occurred on the vessel was the honorable discharge of the acting assistant paymaster.[188]

The man sent to replace him was William Hathorne. Just two months earlier, the thirty-six-year-old bachelor had sold dry goods in Worcester, Massachusetts. If Hathorne had kept up with the news, he would have known all about the *Cincinnati*. The stern-wheel steamer with its distinctive sloping iron sides had participated in operations along the Tennessee, Yazoo, and Mississippi rivers. Her list of engagements included Fort Henry, Island No. 10, and Fort Pillow. The latter action, which occurred along the Mississippi River above Plum Point Bend on May 10, 1862, did not end well for the *Cincinnati*. She was repeatedly rammed by enemy vessels, forced into the shoals, and grounded in low water. But she was soon raised, repaired, and returned to duty.

Hathorne could not have known that he and his crewmates were destined to meet the enemy again along the Mississippi River. In late May 1863 during the Siege of Vicksburg, Confederate artillery and sharpshooters posted on the hills above the fortress city menaced the Union army as it attempted to secure its right flank along the Yazoo River. Federal generals Ulysses S. Grant and William T. Sherman called in the navy to clear the area.[189]

Acting Rear Adm. David D. Porter promptly dispatched the *Cincinnati* and three other vessels. The *Cincinnati* steamed downriver to execute the order on the morning of May 27, her heavy metal sides reinforced with logs and hay. Porter reported that he "sent her down to enfilade some rifle pits which barred

the progress of our army." He added, "Thinking it was only an attack on rifle pits, I went down after her in a tug, to direct the operation if necessary. As I approached her, I saw that she was coming up stream at a great rate, under a heavy fire from all the enemy's guns in that vicinity."[190]

Maj. Gen. Sherman watched the action, "ready to take advantage of any success to be gained by the gunboat attack." He recounted, "The enemy's shot at first went wild, but soon got her range and struck her several direct shots, and two right under her stern."[191]

One of the shots tore into the *Cincinnati*'s magazine, and water poured into the room, which prevented sailors from returning any more fire. Rebel lead continued to pound the ship. "A heavy rifle shot penetrated through the pilot house," reported George M. Bache, the lieutenant in command. "The starboard tiller was shot away; all of her staffs were shot away, rendering it necessary to nail the flag to the stump of the fore-staff."[192]

Bache watched helplessly as enemy fire worked away at his vessel. "We were especially annoyed by plunging shots from the hills, and 8-inch rifle and a 10-inch smoothbore doing us much damage. The shots went entirely through our protection—hay, wood, and iron."[193]

Bache realized that his ship was finished. The crippled *Cincinnati* limped upstream and grounded along the shore. "The boat sank in about 3 fathoms of water, lies level, and can easily be raised. She lies within range of the enemy's batteries," Bache reported.[194] The crew abandoned ship. When it was all over, Bache counted twenty-nine casualties, which included five killed, thirteen wounded, ten drowned, and one captured. Bache included additional casualties from the Fifty-eighth Ohio Infantry. Soldiers from the regiment scrambled to rescue the sailors. One was wounded, and two drowned.

Hathorne's whereabouts on the *Cincinnati* during the battle went unrecorded, although it was common for paymasters to remain aboard during hostile actions. Acting Rear Adm. Porter noted in a report to secretary of the navy Gideon Welles, "Officers

and men lost all their effects; only the public money was saved." This suggests that Hathorne was present for duty.[195]

Sherman reportedly said, "The style in which the *Cincinnati* engaged the battery elicited universal praise."[196] Secretary Welles, too, praised the crew: "Amidst an incessant fire of shot and shell, even when the fate of the vessel had been sealed and destruction both from the elements and the enemy was threatened, the officers and men appear to have stood bravely at their posts, and it is a proud record of the *Cincinnati* that when her last moments came 'she went down with the colors nailed to the mast.'"[197] Six crewmembers received the Medal of Honor.[198]

Three days after the *Cincinnati* sank, a small Confederate force raided the grounded ship and captured the Stars and Stripes. They set her afire and left with the banner.[199] Despite the burning, the navy was able to raise and salvage the *Cincinnati*. She eventually returned to duty and served through the rest of the war.

Hathorne went on to serve as a paymaster on the *Silver Cloud*, a light-draft steamboat used primarily for transport duties along the Mississippi River. Hathorne left the navy in October 1865 and returned to Massachusetts. He married a widow in 1867 and worked as a commercial traveler, or traveling salesman.[200] On November 18, 1904, he died while on a business trip in Cincinnati, the city for which the gunboat on which he served during the war was named.[201]

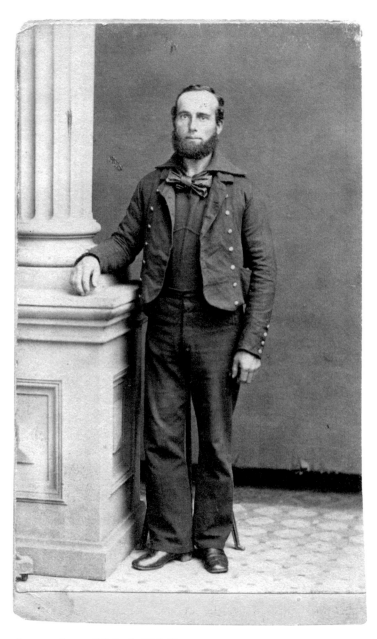

Seaman Justus W. Buck, U.S. Navy

Carte de visite by Charles Cohill (about 1820–unknown) of Philadelphia, Pennsylvania, about 1861–1863. Collection of Jerry and Teresa Rinker.

Seaman in Command

For a brief time during the summer of 1862, a lowly ordinary seaman commanded his own ship in South Carolina. Justus Buck, thirty-one, wrote about the assignment with pride to his father at home in Fort Edward, New York, "You must know, that I have been a sort of a captain on my own hook. Our Captain put me in charge of a schooner with one gun."[202]

Buck's captain, William T. Truxton,[203] commanded the *Dale*, a decades-old sloop-of-war sent to blockade key Southern ports. The crews of the *Dale* and other Union vessels soon encountered a phenomenon that they were ill prepared to handle: large numbers of escaped or abandoned slaves who flocked to the Stars and Stripes. Deemed contraband of war by the federal government, the slaves, or "contrabands," required assistance that strained the resources of Union expeditionary forces from Virginia to Florida.

The influx of fleeing slaves continued unabated into 1862. The federals established contraband camps to support them. One such camp was located in South Carolina's Lowcountry at Beaufort, near St. Helena Sound, where the *Dale* was stationed.

Truxton needed to transport these contrabands from the Sea Islands to the Beaufort camp, but he lacked the means. So he improvised. He found a schooner and assigned it to Buck, who traveled as far as twenty to twenty-five miles to islands in and about the sound and carried men, women, and children to safety.

Buck was an excellent choice for command. An experienced peacetime sailor who grew up along the Hudson River, his widowed father was a canal lock tender. Buck was also skilled as a clerk. He was quick to enlist in the navy after the war began. His two younger brothers followed him into the military, but they chose the army instead.[204]

Buck's assignment came to an abrupt end in August 1862 after the *Dale* was ordered to another port and replaced by the gunboat *Shepherd Knapp*. "The ship that relieved us in St Helena Sound took the Schooner, also, so I was relieved of my command," he recounted to his father.[205]

Back aboard the *Dale,* Buck became the ship's yeoman, a job just above his official rank of ordinary seaman. He described his new title, duties, and benefits to his father. "I have the best billet in the ship at any rate my shipmates tell me," he wrote, adding, "I have charge of the ships stores have a nice little room to myself and have to do all the writing for the 1st Lieutenant and keep the ships books, beside the ship Log &c."[206]

The *Dale* was recalled to the North for repairs at the end of September 1862, and navy authorities transferred Buck to the bark *James L. Davis.* He continued to serve as yeoman until the expiration of his term of service in the fall of 1863.[207]

Buck reenlisted and spent the rest of the war working behind the scenes, including a stint in the ordnance department of the navy yard in Philadelphia. He remained in the navy after the end of hostilities and settled in Philadelphia. He wed a local girl, but the marriage ended in 1874 when he divorced her for unstated reasons. He remarried five years later, quit the navy, and became a musician. He had little time to enjoy his new life. Chronic depression and Bright's disease took a severe toll on his health and landed him in the Pennsylvania State Hospital for the Insane, where he died in 1881. He was about forty-eight years old. His wife survived him.[208]

A Navy and Army Man

By all accounts the 1862 recruiting campaign of the frigate *Sabine* was an overwhelming success. During a three-month stint, her officers fanned out from the harbor of New London, Connecticut, and enrolled 390 seamen, landsmen, and boys for the service—an average of about four recruits per day.[209]

One of the New Englanders who signed up was George Ormsbee, a grocer's son born and raised in Providence, Rhode Island. He may have responded to one of the advertisements placed in newspapers around the region.

On September 16, 1862, Ormsbee signed on as a landsman for a one-year term of enlistment. He soon shipped out with a group of other recruits for the navy yard in Washington, D.C. After basic training, he joined the crew of the *Colorado*, a fifty-two-gun steam frigate assigned to the Gulf Blockading Squadron.

On January 30, 1863, Ormsbee was abruptly discharged after authorities served him with a writ of habeas corpus for being a minor. Evidence suggests he ran away from home and joined the navy without the consent of his parents, who filed the writ that voided his enlistment.[210] Ormsbee's navy career was over after less than two months of active duty.

Two years later, Ormsbee returned to the military during the closing weeks of the war. On March 9, 1865, he enlisted as a private in Battery E of the First Rhode Island Light Artillery. Organized in 1861, it had participated in engagements with the Army of the Potomac, including the battles of Fredericksburg, Chancellorsville, and Gettysburg and operations against Petersburg and Richmond.

Ormsbee mustered out when the battery disbanded in June 1865, and he returned to his family in Providence. He labored as

a blacksmith and a railroad expressman for the rest of his life, with the exception of a brief period about 1910 when he ventured west and worked in the Wyoming copper mine boom. He eventually returned to Rhode Island and died in 1918. He was about seventy-five years old.[211]

Landsman George F. Ormsbee, U.S. Navy

Carte de visite by Washington Gallery of Providence, Rhode Island, about 1862–1863. Collection of Ron Field.

Death of the Monitor

Officers gripped the turret rail of the *Monitor* and braced for impact. Moments later a massive wave fueled by a winter storm crashed against them. The wall of water was taller than the round iron turret and struck with a force that heightened concerns for the survival of the ship and crew.[212]

The heavy waves kept on coming as the *Monitor* steamed along the North Carolina coast off Cape Hatteras during the evening of December 30, 1862. Below deck, sailors struggled to stay on their feet as the sea rolled over and lifted the ironclad and then dropped it like a rock against the ocean surface. The impacts caused the hull to tremble and seawater to seep into cabins, coalbunkers and other spaces.

In the engine room, the situation was bad and growing worse by the minute. About 9:00 p.m., acting chief engineer Joseph Watters reported that steam pressure had dropped from 80 to 20 pounds because the coal had become too wet. Moreover, the bilge pumps were not enough to handle the rapidly gaining water.[213]

Watters would play a critical role in the *Monitor*'s struggle for survival, and it was only his second day on the job. A New Jersey machinist, Watters hailed from Bordentown, a community along the Delaware River south of Trenton. He joined the navy in the autumn of 1860 as a third assistant engineer and during the early part of the war patrolled the Atlantic coast on the warships *Crusader*, *Winona*, and *Ossipee*.[214]

Watters advanced in rank to second assistant engineer of the *Ossipee* in early December 1862. He spent Christmas at Hampton Roads, where nine months earlier the *Monitor* famously fought the Confederate ironclad *Virginia* to a draw. The *Monitor* happened to be back in Hampton Roads on Christmas Day. Her crew

Jos. Watters

1st Asst. Engineer Joseph Watters, U.S. Navy

Carte de visite by Frederick August Wenderoth (1819–1884) & William Curtis Taylor (life dates unknown) of Philadelphia, Pennsylvania, about 1862–1863. Collections of The Mariners' Museum, Newport News, Virginia.

had just received orders to steam south for joint army-navy opera-
tions. On December 28, chief engineer Albert B. Campbell[215] was
injured while making final preparations for departure.[216] Watters
replaced him as acting chief.

Campbell, an original member of the crew, was distraught
about being removed. "It is hard, after waiting so long, to be taken
from my ship, just as there is a prospect of doing something; but
I have to bear that with the rest of my pains."[217]

The *Monitor*, with Watters aboard, departed Hampton Roads
escorted by the side-wheeler *Rhode Island* on December 29 under
clear skies. The weather changed the following morning. Swelling
seas and occasional squalls of rain continued throughout the day.
Bilge pumps kept the modest amount of water that leaked into
the vessel in check. A relative period of calm towards evening
suggested a change for the better. This was good news for the
crew, for the *Monitor* was not designed for the open seas.

About 7:30 the weather took a menacing turn and the situation
deteriorated.[218] Soon the full fury of a winter storm pounded the
Monitor. Watters checked in with the ship's commander, John
P. Bankhead,[219] and updated him regularly from his station in
the engine room. Watters observed with growing alarm as the
pumps, now all engaged, were losing a battle with the ocean. As
the night wore on the advancing seawater slowly suffocated the
coal fires that generated steam.

Watters stated in his after-action report, "The ash pits at the
time were more than half full of water, allowing but very little air
to reach the fires; at the same time the blowers used for producing
a current of air to the fires were throwing a great amount of water."
He added, "The pressure of steam decreased and the amount of
water in the ship increased, until it reached the fires."[220]

The smoldering remains of the fire died down and the gradual
loss of power caused the engine to cease. The pumps continued
to function though at a greatly reduced capacity until they too
finally shut down. "I reported the circumstances to Captain Bank-
head," Watters noted. "A few minutes later I received an order
to leave the engine room and proceed to get in the boats. It was

then between the hours of 12 p.m. and 1 a.m., and the fires nearly extinguished."[221]

Watters climbed to the turret, where a flickering red warning lantern cast a dim light upon the ocean surface and rescue boats from the *Rhode Island*. He was transported with others to safety and was likely an eyewitness to the *Monitor*'s end. As ship's surgeon Grenville M. Weeks described it, "For an hour or more we watched from the deck of the *Rhode Island* the lonely light upon the *Monitor*'s turret; a hundred times it reappeared, till at last, about two o'clock, Wednesday morning, it sank, and we saw it no more."[222]

Though her existence was brief, the *Monitor* became one of the best-known warships in American history. During the months and years that followed, various crewmembers shared their experiences. Watters would not be among them. In the summer of 1866, while on duty as first assistant engineer assigned to ironclads at New Orleans, he fell victim to yellow fever. He was not quite thirty years old. His wife, Caroline, whom he had married in 1860, and two young sons survived him.[223]

Prisoner of War on the Alabama

THE CONFEDERATE RAIDER *Alabama* PRESENTED AN UN-
usual sight as she steamed the Caribbean Sea towards the island
of Jamaica in late January 1863. Part of her upper deck had been
transformed into an outdoor hospital ward. Sick and wounded
men breathed fresh air from comfortable cots, and a guard kept a
close eye on their movements. Everyone aboard was under orders
to avoid making noise and not to disturb the patients.[224]

The arrangements were the work of a Union doctor, Edward
Matthews. The patients were his crewmates, and all of them were
prisoners of war. Until recently they had served on the *Hatteras*,
one of the navy's most successful vessels. An iron-hulled, side-
wheel steamer, she and her crew had wracked up captures of
blockade-runners along the Florida and Gulf coasts. Her longtime
commander, the much-respected George "Pop" Emmons,[225] had
recently been transferred. His replacement, Lt. Cmdr. Homer C.
Blake,[226] was a gallant career officer. He was, at age forty, old
enough to be the father of most of the 125 junior officers and
men on board.

Pennsylvania-born Matthews, an 1860 graduate of the Co-
lumbian College in Washington, D.C,[227] offered his services to
the navy after the war began. He received an appointment as an
assistant surgeon in July 1861 and was assigned to the crew of
the *Hatteras* for duty in the West Gulf Blockade Squadron.[228]

On January 6, 1863, the *Hatteras* joined an armada assembled
off the Texas coast by Rear Adm. David Farragut to capture the
port of Galveston. Five days earlier, on New Year's Day, rebel
forces had surprised and defeated federals that garrisoned the
city. The *Hatteras* lay at anchor with the fleet outside Galveston
on the afternoon of January 11 when a signal was received from

Surg. Edward Sylvester Matthews, U.S. Navy

Carte de visite by William A. Paret (life dates unknown) of New York City, about 1864. Collection of Ron Field.

the flagship *Brooklyn*. An unknown sail had been spotted on the horizon, and the *Hatteras* was ordered to give chase.

Lt. Cmdr. Blake reacted. "I got underway immediately and steamed with all speed in the direction indicated," he stated in his after-action report. "I continued the chase and rapidly gained upon the suspicious vessel. Knowing the slow rate of speed of the *Hatteras*, I at once suspected that deception was being practiced, and hence ordered the ship to be cleared for action with everything in readiness for a determined attack and vigorous defense."[229] Officers and sailors scrambled into position. Matthews may have taken his place below decks in the sick bay.

"When within about 4 miles of the vessel, I observed that she had ceased to steam and was lying broadside on, awaiting us," Blake reported. It was nearly 7 o'clock and quite dark, but notwithstanding the obscurity of the night I felt assured from the general character of the vessel and her maneuvering, that I should soon encounter the rebel steamer *Alabama*."[230]

Outgunned and outmanned, Blake brought the *Hatteras* in close and searched for an opportunity to board the *Alabama* and capture her crew. "I came within easy speaking range, about 75 yards, and upon asking 'What steamer is that?' received the answer, 'Her Britannic Majesty's ship *Vixen*.' I replied that I would send a boat aboard, and immediately gave the order. In the meantime both vessels were changing their positions, the stranger endeavoring to gain a desirable position for a raking fire. Almost simultaneously with the piping away of the boat the strange craft again replied, 'We are the Confederate steamer *Alabama*,' which was accompanied by a broadside."[231]

The Hatteras returned fire and closed to within thirty yards. Musket and pistol shots mixed with cannon fire on both vessels. Then the gunners of the *Alabama* struck with deadly accuracy: one shell tore into the *Hatteras* amidships and set fire to the hold. Almost simultaneously a second shell ripped through the sick bay, exploded in an adjacent room, and set it afire. A third shell mortally wounded the *Hatteras* when it struck and disabled

her engine cylinder. Deprived of power to maneuver or operate pumps, the *Hatteras* was effectively dead in the water.

Still, Blake fought on. "With the vessel on fire in two places, and beyond human power a hopeless wreck upon the water, I still maintained an active fire, with a double hope of disabling the *Alabama* and of attracting the attention of the fleet off Galveston, which was only 25 miles distant."

At this point Blake was informed that more shells had struck the *Hatteras* below the waterline and that she was rapidly taking on water. On board the *Alabama*, Capt. Raphael Semmes[232] paused. The Maryland-born former U.S. navy officer signaled to assist the doomed crew. Blake accepted the offer: "I felt that I had no right to sacrifice uselessly, and without any desirable result, the lives of all under my command."[233] The entire crew of the *Hatteras* was saved, including Matthews, who had suffered a concussion that might have resulted from the explosion of the shell near the sick bay.

Southerners were jubilant when news of the *Alabama*'s victory arrived. The *Hatteras* "was sent where Semmes loves to send Yankee ships, and where there is ample anchorage for more of them," the *Charleston Daily Courier* boasted.[234]

Northerners put a brave face the loss. According to the *New York Herald*, "The gallant little *Hatteras* died game, and showed her pluck to the last. For twenty minutes she sustained and returned the raking fire of her huge antagonist, and at last went down, under the gallant Blake, with her guns still speaking and the old flag flying from the peak."[235]

Meanwhile, Semmes and the *Alabama* steamed towards the Jamaican port of Kingston. According to interviews conducted by the *Herald*, "Semmes minutely superintended everything in connection with the movements of the prisoners himself, and our gallant officers and soldiers found themselves for the first time in their lives, treading the decks of a real pirate ship as prisoners, and that ship manned by their own countrymen in arms against the flag which had proudly waved from mastheads in every part of the civilized globe. They looked aloft and saw the rebel emblem

flying, when the sailor's heart, which is always open to the tenderest emotions of patriotic ardor, beat high with indignation at the thoughts that he was compelled to live, for the time being, under the bastard rag of a bastard confederacy."[236]

"With regard to the treatment which they received during their entire stay on board the *Alabama*," the *Herald* conceded, "the officers and men of the *Hatteras*, without an exception, speak in terms of eulogy. Every comfort was provided for them, and the strictest attention paid to their every little want."[237]

Matthews must have been particularly pleased. His suggestions for the comfort of the wounded, which numbered five, and sick were adopted. He also had plenty of medicine from the *Alabama*'s well-stocked supplies with which to treat his patients.

Semmes paroled the *Hatteras* crew at Kingston and continued to raid Union vessels on the high seas for more than a year. The *Alabama*'s reign was brought to an end on June 19, 1864, when the sloop-of-war *Kearsarge* defeated and sunk her off the coast of Cherbourg, France.

Blake, Matthews, and their shipmates checked in with the U.S. consul and then journeyed back to the United States via Key West, Florida. They arrived in New York City on February 25, 1863, and obeyed their paroles until formally exchanged. Blake went on to distinguish himself in military operations along the James River in Virginia and remained in the navy after the end of the war. He died in 1880 on active duty with the rank of commodore.

Matthews suffered chronic neuralgia from the concussion he received in the fight with the *Alabama*. Still, he continued in the service. In December 1864 he was assigned to the sloop-of-war *San Jacinto*. During the predawn hours of New Year's Day 1865, near the Bahaman island of Great Abaco, the vessel wrecked on a reef off Green Turtle Cay. The experience exacerbated his neuralgia.

Navy authorities granted Matthews a leave, and he went to Providence, Rhode Island. There he married Mary Elliott, whom he had met shortly before he joined the *San Jacinto*. Soon after the wedding he received orders to report to Key West, where

bouts with yellow fever and malaria further weakened his already precarious health.

Matthews returned to Providence in May 1865. "He came home in charge of a nurse, and was so feeble when he arrived," remembered Mary, "that he had to be assisted and upstairs, and I do not think he had good health after that; there was scarcely a day that he did not have to take some medicine to relieve himself from the neuralgic pains."[238]

The medicine was morphine. Mary administered it, at his request, in increasingly larger doses. She was at first unaware that the drug was an opiate, and by the time she discovered the truth Matthews was a raging addict. "I, having read up a book upon the opium habit, commenced to try to cure him myself, and in my desire to substitute a less evil for a greater advised him to take chloroform [inhale it] in order to get relief from pain." She added, "The effect was terrible, for the chloroform finally made him a raving maniac, and so disturbed him, and he had such a craving for it that it was dangerous to be about the house with him."[239]

Matthews attempted to kick the morphine habit several times but failed. The addiction eventually cost him his career. Mary ran out of options and at her father's suggestion decided to commit Matthews to an asylum. Her father and Matthews set out for an overnight trip to the facility on August 15, 1881. They stopped at a hotel, and Mary's father stepped away for a few minutes. Matthews left the hotel and took a high dose of morphine from a bottle that he procured or had carried with him. A policeman found him leaning against a fence, apparently ill. The officer came to his aid, and Matthews collapsed in a stupor. Transported to a hospital, he died that night at 12:35 a.m. He was about forty-one.[240]

Matthews was remembered for his war service. "He was an officer of remarkable ability and skill. His bravery in action, and his heroism in the presence of danger, and his conspicuous patriotism were worthy of the high commendation which they received from his commanding officers."[241]

Captured on Patrol

MIDSHIPMAN FRANK BEVILLE WAS TAKEN PRISONER DUR-
ing the evening of March 14, 1863. Hostile forces overpowered
the eighteen-year-old Confederate naval officer as he commanded
a guard boat on a patrol off the Georgia coast near Savannah.
Beville was completely surprised, for the captors were his own
five-man crew.[242]

He had done nothing to provoke the sailors, and they had no
grievance against him. The men had simply grown tired of bad
pay, food, and clothing, and they wanted out of the navy. The de-
serters navigated the boat under a flag of truce and surrendered
to Union forces that occupied nearby Fort Pulaski.

Unlike the deserters, Beville's devotion to the Southern cause
had remained solid since the war began. In May 1861, he had
joined the Oglethorpe Light Infantry in Savannah. Organized
and commanded by prominent local attorney and state politi-
cian Francis S. Bartow, the company was jokingly referred to as
"Bartow's Beardless Boys" for the unmarried young men and boys
in the ranks.[243]

Then fifteen-year-old Beville fit the profile. He was uniquely
connected to Bartow, a family friend who was his namesake and
legal guardian. Bartow had raised young Beville after his father
and grandfather died in the early 1850s.[244]

Beville and the rest of the Beardless Boys wound up in Virginia
as part of the Eighth Georgia Infantry.[245] The rank and file of the
new regiment voted for officers and elected the popular Bartow
colonel. He advanced to command a brigade in Gen. Joseph E.
Johnston's Army of the Shenandoah.

On July 21, 1861, during the First Battle of Manassas, Bartow
was shot and killed as he led a desperate charge against a Union

Acting Master's Mate Francis Bartow Beville, C.S. Navy

Carte de visite by James Wallace Black (1825–1896) of Boston, Massachusetts, about 1863–1864. Liljenquist Family Collection, Library of Congress.

battery. Casualties in the Eighth were heavy, and they included Beville. A minie bullet struck him on the right side of the chest below the collarbone. His comrades carried him from the battlefield, and a surgeon operated to cut the Yankee lead out of his back. Beville recuperated from his wound in a private home in Richmond. Nerve and muscular damage limited motion to his right arm and hand, and he received a discharge from the army before the end of the year.[246]

No longer able to perform in combat but still eager to serve, Beville found a way back into the military and a return to his Savannah home: in early 1862 he received an appointment to the navy as a midshipman and was assigned to the formidable casemate ironclad *Atlanta*. Here he received basic training on active duty. (The Confederacy would later establish a naval school ship in Richmond for this purpose.)

Meanwhile, the Union blockade choked the life out of the Southern economy and slowed the flow of supplies to the Confederate military. Savannah was no exception. Desertions by soldiers and sailors increased, including a trio that escaped into the marshes below Savannah on or about March 14.

Beville and a five-man search party were dispatched to find the three deserters. At this point, Beville's men mutinied. The *New York Times* reported that the men caught Beville off guard and "astonished him by taking away his arms and informing him that he was a prisoner, bound for Fort Pulaski. He protested, but in vain."[247]

Beville was held at Fort Pulaski for a short time, then transported to the North and held at Fort Warren in Boston harbor, a prison for Confederate officers. A few months later, Beville's fellow officers from the *Atlanta* joined him at Fort Warren. They had been captured on June 17, 1863, when the *Atlanta* ventured out of Savannah to attack Union warships and grounded. Two monitors counterattacked and forced the Southerners to hoist the white flag.

In October 1864, Beville gained his release from Fort Warren and was formally exchanged. He eventually wound up in

Richmond and evacuated when the capital fell to Union forces. Beville marched out of the city on April 3, 1865, with the naval brigade, a group of about three hundred sailors from the defenses of Richmond.[248] Commanded by Flag Officer John R. Tucker,[249] the brigade joined the rear guard of Gen. Robert E. Lee's Army of Northern Virginia. It was attached to Lt. Gen. Richard S. Ewell's corps and assigned to the division commanded by Lee's eldest son, Custis.[250]

Just a few days later, on April 6, federal cavalry led by Maj. Gen. Phil Sheridan effectively surrounded a quarter of Gen. Lee's army. Three Confederate corps, including Ewell's, were cut off and attacked by the aggressive Sheridan. "The naval brigade held the right of the line," according to Tucker's biographer, "and easily repulsed all assaults on it. A flag of truce was sent by the Federal General commanding at that point to inform Tucker that the Confederate troops on his right and left had surrendered, and that further resistance was useless." The biographer added, "Tucker, believing that the battle had only commenced, refused to surrender, and held his position until reliable information, which he could not doubt, reached him of the surrender of General Ewell and his corps."[251]

The naval brigade was among the last to leave the battlefield. Casualties included Beville, who suffered his second wound of the war, the nature of which went unreported. The engagement came to be known for the stream that meandered across the battleground, Sailor's Creek—aptly named considering the participation of the navy.

Beville signed the oath of allegiance to the federal government on June 18, 1865, and returned to Savannah. He went to work in the hotel business and managed several fine inns around the region. "Frank Beville, the popular and well known hotel man of middle Georgia, happy as the day is long, smiles a continued welcome upon his guests," declared an Atlanta newspaper in 1879. He also worked as a drummer, or traveling salesman, in his home state and neighboring South Carolina.[252]

In 1888, Beville married seventeen-year-old Anna McIntosh

Falligrant, a young woman about twenty-five years his junior. She had not been born until after the end of the war. The following year, Anna gave birth to their only child, a daughter whom they named Ruth.

Beville lived until 1905, dying of albuminuria, which affects the kidneys. He was about sixty. His wife and sixteen-year-old daughter survived him.

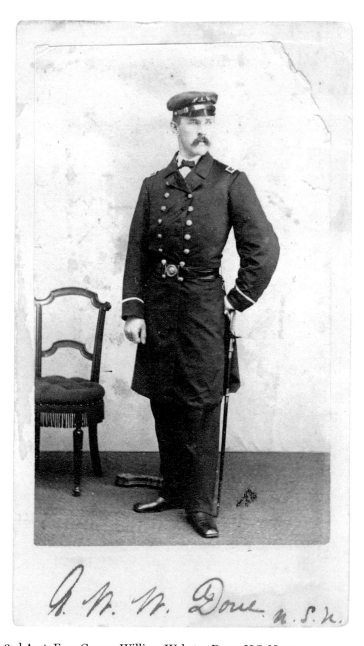

3rd Asst. Eng. George William Webster Dove, U.S. Navy

Carte de visite by Albin Yeaw (1827–1889) & Co. of Lawrence, Massachusetts, about 1861–1863. Collection of Earl Sheck.

Running the Gauntlet at Port Hudson

The Union warship *Richmond* was moments away from a successful run against a gauntlet of artillery batteries at Port Hudson, Louisiana. As she steamed passed the Confederate cannon in a hot crossfire during the night of March 14, 1863, one shell landed with deadly accuracy.[253]

The projectile, forty-two pounds of rebel lead, ripped through the battle smoke that lay heavy across the Mississippi River and struck her starboard side. It tore through wood and laid waste the engine room. The most serious damage, a ruptured steam drum, released a rush of live steam that flooded the compartment, the adjoining fire room, and the berth deck.[254]

The *Richmond* was dead in the Mississippi. The engineering crew, however, was very much alive, and they included George Dove of Andover, Massachusetts. A graduate of prestigious Phillips Academy and Harvard, he was the only son of a flax-spinner from the Scottish burgh of Brechin who had come to America and established a prosperous manufacturing company.[255]

Dove had studied science and engineering at Harvard. The degree he earned in 1857 would serve him well when on some future day he would run the family business. Then the war came. Communities on both sides rallied to raise volunteer militias, and Andover followed suit. Dove's father, John,[256] presided over the first meeting of townsmen to raise funds for a militia company. Within days the necessary donations had been secured with more than a third of the money contributed by John Dove. The Andover Light Infantry was promptly organized and its recruits voted for officers. They elected young Dove as their first lieutenant.[257]

In the summer of 1861 the Andover Light Infantry mustered into the Union army as Company H of the Fourteenth Massa-

chusetts Infantry.[258] Dove however was no longer a part of the regiment. On July 11 he had accepted a commission in the navy. The factors that prompted him to join the navy are not known.

Appointed third assistant engineer, he reported to the Brooklyn Navy Yard and joined the crew of the *Richmond*. Launched a year earlier, her compliment of 259 officers and men had just returned from their first tour of duty in the Mediterranean Sea.

Now they shipped out with new orders that would take them from the coast of Cuba to the mouth of the Mississippi River. In early 1862, the *Richmond* played an important role in the momentous operations against New Orleans that ended with the surrender of city to federal naval forces on April 29.

The rear admiral who led the federals to victory, David Farragut, soon turned his attention to Port Hudson and Vicksburg. The formidable fortress cities were key to the Confederate defense of the Mississippi River. Farragut decided to move part of his fleet above Port Hudson to stop the flow of supplies along the river to Vicksburg. Meanwhile, Maj. Gen. Ulysses S. Grant and his army made inroads against the city by land.

About 9:00 p.m. on March 14, 1863, Farragut set out with seven vessels to run the batteries.[259] Three warships steamed into action as a single column, each with a smaller gunboat lashed to its port side to assist the bigger ships should they become grounded. A fourth warship had no consort. The *Richmond*, second in line behind Farragut's flagship *Hartford*, was attached to the *Genessee*. Dove was aboard the *Richmond* and may have been in the engineering room.

What happened next was some of the fiercest fighting of the naval war. The Confederate batteries pounded Farragut's fleet with intense artillery fire as they rounded the sharp bend at a point in the river where Port Hudson was located. A thickening pall of dense mist and battle smoke settled across the Mississippi and enveloped the ships. Flashes of fire from the upper and lower batteries were the only visible targets.

Despite a serious pounding, the *Hartford* and her consort *Albatross* successfully ran the gauntlet. Then came the *Richmond*

and *Genessee*. "We opened on the batteries with grape, canister, shrapnel, shell, and everything that we had. The rebel sharpshooters opened on us, but they were soon silenced. The engagement now became terrible," noted the *Richmond*'s log. "The rebel's guns raked us as we came up to the point. The lower batteries were silenced as we passed, but misfortune now befell us; as we were turning the point almost past the upper batteries we received a shot in our boilers, and at almost the same time the *Genessee* got a shot in her machinery and a fire broke out in her, and another shot went through our steam drum. Our steam was all gone."[260]

The *Genessee* drifted, nearly defenseless. "Torpedoes were exploding around us, throwing water as high as the tops. We were, for a few minutes, at the rebel's mercy; their shells were causing great havoc on our decks; the groans of the wounded and the shrieks of the dying were awful. The decks were covered with blood."[261]

The crippled ships floated helplessly downriver, exposed to more fire. The vessels behind them suffered a similar fate. None made it past Port Hudson. The *Richmond* suffered fifteen casualties. Dove escaped without injury.

The damage to the *Richmond* was repaired and the lost men replaced. After the fall of Vicksburg on July 4, 1863, rendered Port Hudson untenable, the Confederate garrison was surrendered. The *Richmond* and other vessels now steamed uncontested through waters that they had been unable to pass a few months earlier.

On July 30, 1863, the *Richmond* steamed for New York and a much-needed overhaul. Dove took the opportunity to resign his commission. A local historian in Andover suggested that he quit the navy because hostilities had ceased. If true, Dove may have believed that federal control of the Mississippi was the effective end of the war, though hostilities would continue for two more years.[262]

Dove returned to Andover and helped run the family flax firm. He later became involved as a director in other business ventures out of Boston, including railroads and mining operations. One

of the enterprises, the Pacific Guano Company, failed in 1889 to the tune of millions of dollars.[263] Though cleared of any wrongdoing, Dove retired from business and spent the rest of his days in personal and philanthropic pursuits common to men of wealth and position.

Dove died in Andover in 1908 at age seventy-three. He had suffered from dementia. His wife and three of their four children survived him.[264]

Battling Bronchitis in the Gulf of Mexico

Harry Keegan was not a well man. The rigors of blockade duty off the coast of Alabama at Mobile Bay had exposed him to elements for days on end. In April 1863 he fell ill with a serious case of bronchitis.[265]

An experienced sailor in peacetime, Keegan hailed from Holland. At some point before the war he came to America and settled in Portsmouth, New Hampshire. "I am a very poor writer and speller at my best never having an opportunity to attend school to get any education," he once told a government worker. His lack of schooling may suggest he went to work at an early age to support himself and his family.[266]

In the summer of 1862, perhaps lured by bounties for able-bodied men, he enlisted in the navy and was assigned to the *Colorado*. The forty-gun frigate was in Portsmouth for routine repairs after a long stint in the Gulf of Mexico.

The *Colorado* returned to the Gulf in late 1862 with Keegan aboard. Winter weather and constant activity likely contributed to the case of bronchitis that he contracted. He eventually recovered from the illness and returned to duty.[267]

Keegan's term expired in February 1864. He immediately reenlisted, this time as a substitute to fill state quotas that had lagged behind in the war-weary North. The quality of substitutes was generally poor, with numerous reports of desertions and bounty jumping. Keegan was not of this less-desirable class. He returned to the crew of the *Colorado* and fulfilled his obligation with honor. He participated with his shipmates in the bombardment and capture of Fort Fisher, North Carolina, January 13–15, 1865.

Keegan continued in the navy after the end of the war and served in the European Squadron until his discharge in 1867. He

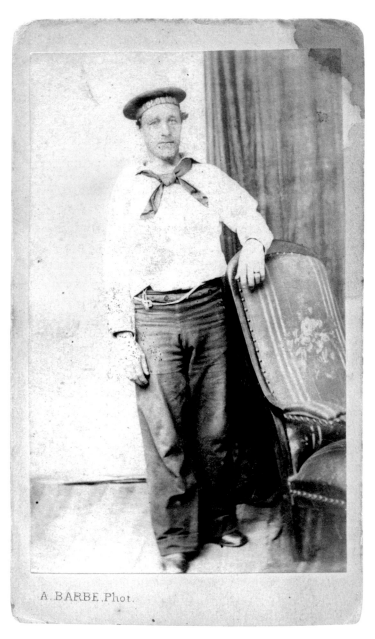

A.BARBE.Phot.

Seaman Harry Keegan, U.S. Navy

Carte de visite by A. Barbe (life dates unknown) of Cherbourg, France, about 1865–1867. Collection of Ron Field.

returned to Portsmouth and married a local girl, eighteen-year-old Eldora Foye, who was about eleven years his junior. They started a family that grew to include two children, a boy and a girl. Keegan worked as a stevedore until he succumbed to a long battle with stomach cancer in 1894. He was fifty-four.[268]

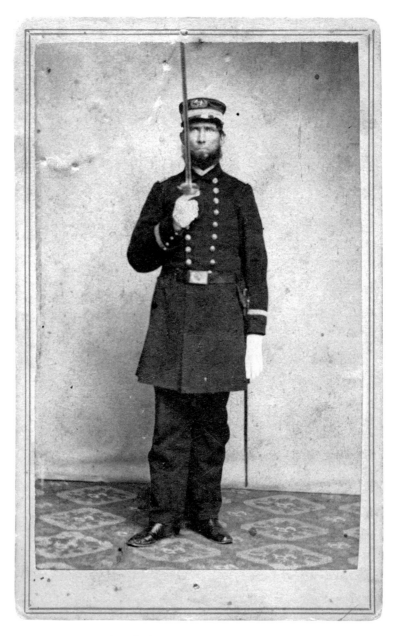

Acting Master John Clark Dutch, U.S. Navy

Carte de visite by an unidentified photographer, about 1861–1864. Collection of the author.

The Terror of the Rebels along the Coast

ONE EVENING IN THE SPRING OF 1863, A DETACHMENT OF Union sailors moved stealthily across the grounds of a South Carolina plantation. Thirty-five strong and heavily armed, they were attracted to the estate by a report of rebel activity. Before long they surprised a picket of nine Confederate cavalry and captured them after a brief fight.

The bluejackets served on the *Kingfisher*, a sleek bark that operated in and about the Sea Islands below Charleston. Her commander, forty-two-year-old John Clark Dutch, enjoyed a sterling reputation in these parts—and this exploit added to his luster.

"He is a bold and enterprising man and has thoroughly explored these shores and creeks. He knows every picket and fortified position of the rebels near here. They say he goes in a dugout right under the guns and shoots the pickets of the enemy," declared Laura Towne, a Northern volunteer with the Freedman's Aid Society. "Captain Dutch was energetic, hated the enemy, was a good protector to the islands, and made himself the terror of the rebels along the coast."[269]

Most officers could only hope for such a characterization. Dutch, who had no formal military training, earned his through experience and strict attention to duty. Born in New Hampshire, he went to sea as a young man and rose to become the prosperous captain of the merchant bark *S. J. Roberts* out of Providence, Rhode Island. A marriage in 1844 resulted in the birth of a daughter, Annie, five years later.[270]

Dutch bid his family farewell and joined the navy in 1861. Commissioned acting master, he spent a year as a subordinate officer aboard the steamer *Sumpter* in the South Atlantic Blockade

Squadron. In November 1862, he took command of the *King-fisher*. According to Towne, Dutch maintained an exquisitely orderly and clean ship.[271]

Stationed in Saint Helena Sound, Dutch and his crew patrolled islands and inland waterways in search of the enemy. The events that led to the capture of the Confederate cavalry picket began on April 9, 1863. That morning, a group of escaped slaves under Dutch's protection showed up at the *Kingfisher*. Dutch interrogated them and learned from one, James "Jim" Hutchinson, that rebels were stationed on nearby Edisto Island. They monitored federal troop and gunboat movements along the Edisto River.

Dutch decided to go after them. He and thirty-five of his crew set out in three rowboats from the *Kingfisher* about six o'clock. Ten escaped slaves, including Hutchinson, accompanied them. They rowed some distance up St. Pierre Creek and landed at a plantation near the center of the island. The men marched about a mile to a house where they found the picket composed of a sergeant, corporal, and seven privates who served in Company I of the Third South Carolina Cavalry. Gunfire erupted—no one knew exactly who fired first—and the Confederates surrendered.[272]

Only one injury occurred on the federal side: one of Dutch's officers suffered a bullet wound in the ankle. The captured Confederates were taken back to the *Kingfisher* and sent to the North as prisoners of war.[273]

Jim Hutchinson later joined the navy and served on the *King-fisher*. Dutch continued in command of the *Kingfisher* for another year. On March 28, 1864, the bark ran hard aground in shallow water near Otter Island in Saint Helena Sound. She quickly flooded with water and sank. Dutch was not blamed for any wrongdoing—he had alerted his superiors that the *Kingfisher* had been in need of an overhaul for some time.[274] The loss coincided with a personal tragedy when his wife of twenty years unexpectedly died.

Dutch received a new assignment as commander of the light-draft ironclad monitor *Chimo* and served in this capacity along

the North Carolina coast for the rest of the war. He received an honorable discharge in the spring of 1866.[275]

Dutch never returned to the sea, but he did return to the South. He moved to Savannah, Georgia, and served a four-year stint as inspector of customs and special agent of the U.S. Treasury Department.

In 1867, Dutch's daughter Annie married Union Col. Edmund Rice, a hero of the Battle of Gettysburg who would go on to active duty in the Spanish-American War. Annie succumbed to tuberculosis less than two years into the marriage, however.

In 1868, Dutch married Harriet "Hattie" Goodman in Washington, D.C. The chaplain of the U.S. House of Representatives performed the service. Hattie, two decades Dutch's junior, provided him a second child, daughter Helen, in 1871. By this time the family had left Savannah and settled in New Hampshire.

The union was short lived, for Hattie died three years later. Dutch raised Helen as a single father and established a lucrative business as a wood dealer in the town of Exeter to support her. He also became active in county and state politics with the Prohibitionist Party, which had been established after the war to curb the sale and consumption of alcohol.[276] In 1895, Dutch died of pneumonia and complications from a heart ailment at age seventy-four.

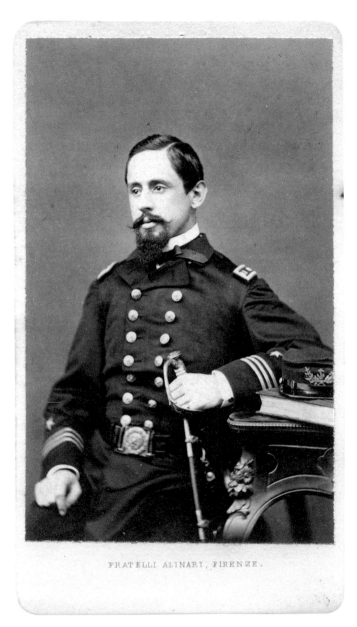

FRATELLI ALINARI, FIRENZE.

Lt. Roswell Hawks Lamson, U.S. Navy

Carte de visite by Leopoldo Alinari (1832–1865), Giuseppe Alinari (1836–1890), & Romualdo Alinari (1830–1890) of Florence, Italy, about 1865. Collection of the author.

A Brilliant Engagement at Hill's Point

IN SOUTHEASTERN VIRGINIA DURING THE SPRING OF 1863, rebel artillerists entrenched on the high ground known as Hill's Point occupied an enviable position. In front of them lay the Nansemond River, a wide and easily navigable tributary that flowed into the much larger James River. To the left ran the withered western branch of the Nansemond. To the right, the main branch of the Nansemond continued, though considerably narrowed and twisted, all the way to Union-occupied Suffolk.

On April 14, the Union side-wheel gunboat *Mount Washington* fell prey to these Confederates. Crippled by a direct hit to the boiler during an earlier run-in with the enemy, the warship was in tow by the ferryboat *Stepping Stones* when she bottomed out on a shoal in plain view and easy range of the cannon on Hill's Point.[277]

The *Mount Washington* was a sitting duck. The rebels unmasked their five-gun Battery Huger and opened up a storm of shot and shell that riddled the steamer. Sharpshooters picked off the exposed and helpless sailors.

Lt. Roswell H. Lamson, the twenty-five-year-old Naval Academy graduate in command of the vessel and three others along this section of the Nansemond, assessed the situation and realized there was one chance for escape: he and the crew had to fight back until the high tide came in and released the gunboat from the shallows.[278]

Lamson leaped into action. He called to the nearby *Stepping Stones* and had her pull alongside. He transferred all the officers and men to the vessel. The long towlines were cast off and the *Stepping Stones* moved out of harm's way. Lamson remained on the disabled ship with a bare-bones crew. They pushed a small

howitzer behind a side-wheel paddle box on the upper deck and returned fire. Some of the men grabbed carbines and used them to hold the sharpshooters at bay.[279]

The Confederates continued a devastating fire. One shot struck the *Mount Washington*'s flagstaff about two feet above the upper deck and sent the shattered top half of the pole and the Stars and Stripes tumbling into the river below. The rebels cheered the fallen banner. Lamson and two other crewmen crossed the deck in the hail of enemy fire and hauled the wet flag up by the still-attached halyards and lashed the broken staff to the stump of the pole.[280]

What happened next, recounted a shipmate and friend, Francis P. B. Sands, was the stuff of legend. "As soon as the wind filled out the Stars and Stripes in their glory, firing ceased at once from the shore; the rebels mounted their works and gave three rousing cheers to Lamson and his gallant men; and he was told that he could, without interruption, call up the *Stepping Stones* to tow his crippled steamer down the river. This was promptly done. What a tribute was not that to valor! What a chivalric spirit, was it not, that prompted it from the enemy!"[281]

The *Mount Washington*, or what remained of her, was saved. Lamson emerged with only a bruised arm after being struck by a spent bullet. "It was only through the kind providence of God that we were not all killed or wounded," he declared in a letter to his fiancée, Kate. "After the action was over, the sailors gathered around me on the deck, took hold of my hands and arms, threw their arms around me, and I saw tears starting from eyes that had looked the rebel battery in the face unflinchingly."[282] The thanks of the crew were not enough, however. "I shall not be satisfied unless I can take that battery that knocked the *Mount Washington* to pieces," Lamson wrote in a brief note to his commanding officer.[283]

Lamson was not one to make an idle boast. The son of old Massachusetts stock, he was born in Iowa and, at about age nine, in 1847, set out with his family across the Rocky Mountains and settled in Oregon. The hardships he endured, according to his

friend Sands, "tended to develop the mind of young Lamson, to make him thoughtful and serious beyond his years, taught him self-reliance, and gave him a degree of confidence in himself that manifested itself in the emergencies of his eventful career later on."[284]

The Civil War thrust Lamson into the spotlight. Assigned as acting master on the frigate *Wabash*, the flagship of Adm. Samuel F. Du Pont, his actions during successful operations against Port Royal, South Carolina, in 1861 established him as one of the best young officers in the service. A stint in the Navy Department from the fall of 1862 to the spring of 1863 brought him to the attention of military and civilian leaders.

Meanwhile, in early 1863, Confederate forces commanded by Gen. James Longstreet moved east from Richmond to the Virginia coast and threatened to capture the Union garrison of Suffolk, which lay along the Nansemond. Lamson was dispatched to the area to command a flotilla that included the *Mount Washington*, *Stepping Stones*, and two tugs. His task was to hold a narrow and twisted seven-mile section of the Nansemond along which the rebels had established rifle pits and batteries.

After the near destruction of the *Mount Washington* on April 14, Lamson conducted a reconnaissance of the area around Hill's Point and proposed an audacious attack plan. Navy and army leaders promptly approved it.

On April 20, Lamson set out in the *Stepping Stones* with her decks cloaked in hammock cloths to shield four field howitzers and their crews from view. Also hidden on board were 270 soldiers from the Eighty-ninth New York and Eighth Connecticut infantries under the command of Brig. Gen. George W. Getty.[285]

The *Stepping Stones* moved slowly along the river towards Hill's Point and Battery Huger. Sands recalled, "Lamson, pretending that he was afraid to venture into that zone of fire, stopped the vessel and slowly retired up stream, where he rested for awhile. Then, as though intending to make a supreme dash past the battery, he ordered full speed ahead, and downstream went the *Stepping Stones* until just short of the bend before the battery, when

the helm was put to starboard and she went hard against the river-bank."[286]

Shielded from the river bend, the hammock cloths were pulled up. Getty's men jumped out of the ferryboat and made their way ashore through the muck and mud and hurried up a ravine behind the enemy gunners. The howitzers and their crews followed on long gangplanks and took up a position behind Getty and his infantry.

Getty stated in his after-action report that the cheers of his men alerted the Confederates, who responded with musket fire. Sands reported, "The amazed rebels in the battery stood inactive for a moment and then attempted to swing a gun around to their rear." They managed one or two shots that flew harmlessly overhead.[287]

One of Lamson's howitzer crews responded with a blast of canister. The rebel commander surrendered immediately. According to Sands, "By sunset the five guns of this battery and all the ammunition, together with the entire force of the enemy there, 161 men (not a man escaping), were transferred to our side of the river under guard, the captain commanding having surrendered his sword in person to Lieutenant Lamson, who had thus nobly recouped for the drubbing they had given him six days before."[288]

Union casualties were minimal. Lamson received praise from senior navy and army commanders for his leadership. Getty declared the action "one of the most brilliant achievements of the war."[289]

Lamson went on to serve with distinction during the attacks against Fort Fisher, North Carolina. On December 24, 1864, he escorted the *Louisiana*, loaded with 215 tons of gunpowder, in an attempt to breach the defenses of the fort. This "Powder Vessel" failed to accomplish its objective. Three weeks later, on January 15, 1865, Lamson landed with other troops and participated in the successful assault against the fort. Lamson led a division of sailors and suffered gunshot wounds in the left arm and shoulder as he approached the palisades along the sea face of the fort.

He eventually returned to his duties and remained in the navy after the war. As flag lieutenant on the *Colorado,* Lamson traveled extensively through European waters. But the monotony of life at sea, the slow pace of promotions, and a desire to wed his fiancée prompted him to resign his commission in 1866.[290]

Kate and Lamson married in 1867, and it was one of the few bright spots during his postwar years. A business partnership with an uncle failed. Five of his seven children died young, and Kate succumbed to cancer in 1892.[291]

Lamson's own health, which had been compromised since he left the service, worsened as he aged. A spinal disease normally caused by syphilis, perhaps the result of a wartime indiscretion, wasted away his body and prompted him to walk with the aid of a cane or crutches.[292]

About this time, according to the Portland *Oregonian*, Lamson met Gen. Longstreet at a reception for the visiting former Confederate. A conversation ensued, during which Longstreet learned of Lamson's involvement in the capture of Battery Huger at Hill's Point. Longstreet reportedly said to Lamson, "Well, it was done handsomely."[293]

Lamson died in 1903 at age sixty-five. His casket was draped with the same Stars and Stripes that he had restored to the shattered flagstaff of the *Mount Washington* forty years earlier.

The navy honored Lamson by naming three warships in his honor. The last, a destroyer launched in 1936, was stationed at Pearl Harbor, Hawaii, during the Japanese attack of December 7, 1941. The *Lamson* and her crew happened to be on patrol duty and missed the bombing that devastated the base and fleet.

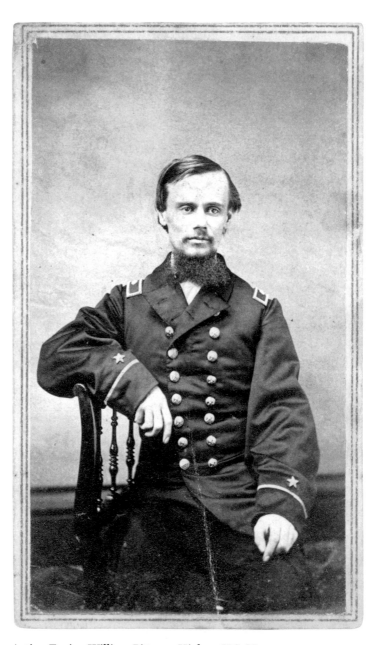

Acting Ensign William Pittman Higbee, U.S. Navy

Carte de visite by the gallery of Julius E. Dewey (about 1828–1905) of Cincinnati, Ohio, about 1865. Collection of Ron Field.

Running the Gauntlet at Vicksburg

Lurid flames from a burning building along the Mississippi River across from Vicksburg rose high into the night sky on April 16, 1863. Other fires erupted simultaneously on both banks of the river—all started by alert Confederate defenders after they detected activity on the water. The bright lights revealed a Union flotilla approaching the formidable enemy batteries defending Vicksburg.[294]

The profile of one warship was conspicuous in the glowing firelight. According to an eyewitness, "The *Lafayette* seemed to attract particular attention from the rebel batteries from the start. Her tall chimneys and wheelhouses almost immediately identified her as the bellwether of the fleet."[295] The observer was perhaps a bit biased—he was an officer aboard the vessel and a special correspondent for the *New York Times*. But there was truth to his statement. A 280-foot iron behemoth, the *Lafayette* was a double stern-wheel steam ram sheathed in an inch of armor. Added to her bulk was the wooden steamer *General Price*, lashed to her starboard side, and a coal barge in tow. Thick logs and wet hay were attached for extra protection from the enemy's guns.

The *Lafayette* was under the command of Henry Walke, a Southern-born career navy man who remained loyal to the United States.[296] His crew of about two hundred included William Higbee. An Ohio native born and raised in Cincinnati, he was the second of two sons of a prosperous merchant and his wife, who had died when Higbee was a toddler. Higbee's father remarried, and the family eventually expanded to include five more children.

By the start of the Civil War, Higbee had graduated high school and taken a job as a clerk. An older brother, Josiah, enlisted in

the Twelfth Ohio Infantry in the summer of 1861 and remained in the army until the end of the war.[297]

Higbee joined the navy in January 1863 and reported to Cairo, Illinois, for duty. He was assigned to the recently launched *Lafayette* as an acting master's mate, one of eight men on board at this rank.

While Higbee and his crewmates trained and became familiar with each other and their new ship, the Vicksburg Campaign was in its early phase. During one reconnaissance, on March 8, 1863, the *Lafayette* carried two distinguished officers: Walke's superior, Rear Adm. David D. Porter, who commanded the Mississippi Squadron, and Maj. Gen. William T. Sherman, who at the time was leading the army's Fifteenth Corps. The *Lafayette* steamed within range of Vicksburg and lobbed nine hundred-pounder shells at the enemy batteries and into the city.[298]

Five weeks later, the *Lafayette* was one of a dozen ships in the Mississippi Squadron that ran the Vicksburg defenses.[299] Confederate gunners guided by the light from the fires opened up with shot and shell from about forty heavy guns. The officer and *Times* correspondent noted that the cannon "flashed like a thunder-storm along the river as far as the eye could see." He added, "At each round the rebel artillery-men gave a shout, which seemed surprisingly near. At one time we could not have been one hundred yards from the Vicksburg wharves."[300]

But the vessel pressed on undaunted. "Captain Walke, cool, energetic and strong-voiced, went from one part of the ship to another, trumpet in hand, now issuing his orders, then cautioning some over-rash officer not to expose himself. He was here at one moment, there at the next, everywhere by turns, having an eye to every movement of the ship, whether on deck or down below."[301]

Higbee's exact movements were not recorded. As a master's mate, however, he might have been almost anywhere on the ship. Higbee, Walke and the rest of the crew escaped without injury. Nine shots struck the *Lafayette*, and none caused serious damage. The other vessels in the fleet, with the exception of the transport *Henry Clay*, survived the fight.[302]

Walke wrote two days after the event, "How we escaped the firing ordeal as well as we did, is a mystery to us all. We were under fire for over an hour: and such a fire! Earthquakes, thunder and volcanoes, hailstones and coals of fire; New York conflagrations and Fourth of July pyrotechnics—they were nothing to it."[303] His mention of Independence Day was prescient. On July 4, 1863, Lt. Gen. John C. Pemberton surrendered the Vicksburg garrison to Maj. Gen. Ulysses S. Grant.

The crew of the *Lafayette* earned a share of the credit for the capture of the city. Higbee went on to receive a promotion to acting ensign and a new assignment on the single-turret monitor *Neosho*. He and the crew participated in the failed Red River Campaign and in operations along the Cumberland River.

Higbee received an honorable discharge from the navy in September 1865. By this time he had contracted tuberculosis, and he succumbed to the infection four months later. He was twenty-four and unmarried.[304]

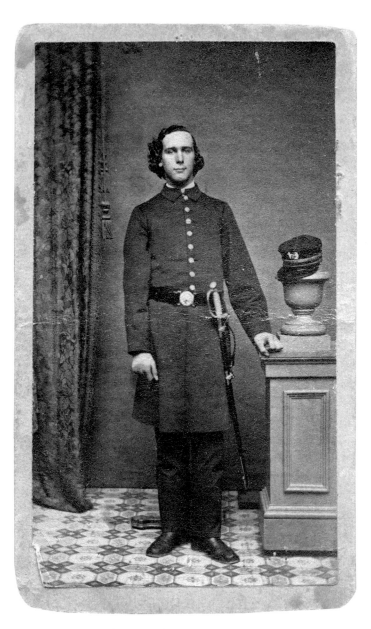

Acting Ensign David King Perkins, U.S. Navy

Carte de visite by Philip Guelpa (about 1822–1883) & Giacinto Demoleni (life dates unknown) of Boston, Massachusetts, about March 1863. Collection of the author.

On Board the Seminole

DAVID PERKINS SET OFF THROUGH THE BUSTLING STREETS of New York City on the evening of Monday, May 11, 1863, in a celebratory mood. It was his twentieth birthday, and he was going to attend the New York debut of soprano sensation Lizzie Parker[305] in Verdi's *Il Trovatore*. At the last minute, two of his pals persuaded him to go and roll ten-pins instead.[306]

Perkins was full of energy despite a tedious day of drill on board the *Savannah* in the Brooklyn Navy Yard. The old frigate was detailed as an instruction and practice ship for Perkins, an acting master's mate, and other rookie officers in training.

That afternoon, the navy had presented Perkins with a birthday gift of sorts—a chance to visit the *Seminole*, a sleek sloop-of-war to which he had been assigned. She had been on active blockade duty along the Atlantic coast during the early part of the war and was now laid up at the navy yard for repairs. Perkins climbed aboard and was pleased. He scribbled a pencil note in his pocket diary packed with brief entries, "getting along with her fine."[307]

Perkins was well acquainted with ships. The son of an impoverished merchant sailor, he grew up with his two brothers and two sisters in the Maine seaport of Kennebunkport. The family eked out a living on several small tracts of poor-quality land and generally struggled to make ends meet.

Life at this time was rigid and cheerless, according to his oldest brother George,[308] who had run away from home when he was twelve years old. Perkins did the same when he was fourteen, "When, like the majority of boys whose homes were within sight of the Atlantic ocean, he entered upon the life of a sailor, with a view of making that his lifetime occupation," an old friend recalled

years later. "After making eleven voyages to Europe and several to South America, he saw that his education was far too limited to admit of rapid advancement to his chosen field."[309]

Perkins, then eighteen, left the sea temporarily and enrolled in a state-sponsored nautical school in Boston. "He had just completed his course when the Civil war broke out, and the call was made for men to come to the rescue, by land and by sea," his friend noted. "He had sailed too long beneath the stars and stripes, and had seen the old flag honored by every nation on the earth, too often to unheed the call."[310]

Perkins promptly took and passed the navy officer examination. Appointed an acting master's mate in January 1863, he spent the next months at the Boston Navy Yard on the training ship *Macedonian* and in Brooklyn on the *Savannah*.[311]

Meanwhile, the *Seminole* was refitted. On June 8, 1863, the vessel was formally recommissioned. "Everything passed away quite pleasantly," Perkins remarked in his diary, adding, "We have a smart looking set of men."[312]

The *Seminole* soon departed for the Gulf of Mexico. The high point of her service was the victorious Battle of Mobile Bay on August 5, 1864. Perkins, now an acting ensign, described the climactic moment of the fight when the *Seminole* faced the rebel ironclad ram *Tennessee*: "At about 11 the engagement commenced with the Ram and the fleet, the Ram firing the first shot which was directed at this ship, we immediately replied by discharging a broadside, one shot which struck her—but glanced harmlessly from her iron sides."[313]

Perkins remained on duty in the Gulf until navy authorities honorably discharged him in November 1865. He made a beeline for California and reunited with his brother George, who had risen from runaway to wealthy merchant.

In 1867, George and two partners founded a shipping firm later known as the Pacific Coast Steamship Company and offered David a position. He accepted, and worked there for about a year before he moved to Oroville, California, located about seventy miles north of Sacramento. Brother George had gotten his start

here when it was known as the mining camp of Ophir, and he had established a prosperous general store. George would go on to become a Republican politician, governor of California, and one of the Golden State's longest serving U.S. senators.

David eventually became a partner in the general store, and rose to prominence in Oroville's civic affairs. "He was a natural leader among men. In the many enterprises started in this vicinity, he was invariably called on to take the lead, and when he did so, the others willingly fell into line and obeyed the commands without question, for they felt they had a leader on whose banner victory would surely perch," his old friend declared.[314]

Perkins dabbled in various business enterprises, including the construction of a mine to extract quartz. Soon after its completion, in the autumn of 1896, he was critically injured when a wagon loaded with supplies overturned on a steep grade. The contents of the wagon spilled out, and Perkins, who had followed behind on foot, became trapped. He managed to free himself but discovered that he could not move his legs. By this time a cold rain and sleet had set in. He lay in the harsh climate for twelve hours until he was found and brought home.[315]

David Perkins succumbed to his injuries soon after. He was fifty years old. His wife, Mary, whom he had married in 1872, and six children survived him. Fellow members of his local Grand Army of the Republic post, brother Masons, and the citizens of Oroville mourned his untimely death.

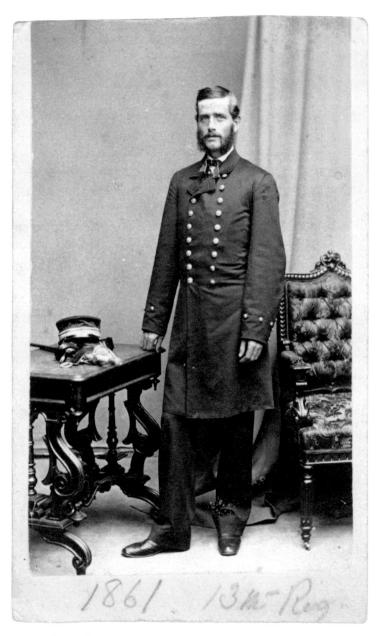

1861. 13th Reg

Rear Adm. Nehemiah Mayo Dyer, U.S. Navy

Carte de visite by James Wallace Black (1825–1896) of Boston, Massachusetts, about 1861. Collection of Earl Sheck.

Citizen Sailor, Native Genius

GENERALS NATHAN BEDFORD FORREST AND JOHN A. Logan are well-known examples of citizen soldiers who despite formal military training became highly effective leaders. Recognized as equals on the battlefield by their West Point peers, each possessed a native genius that served him well during the Civil War. The Union navy had such a citizen sailor, the high-minded son of a sea captain who would become one of America's most celebrated commanders.

Nehemiah Mayo Dyer of Barnstable, Massachusetts, was all of eight years old when he first followed his father to sea. His schooling was aboard a whaling ship, where he learned the ropes alongside hardened merchantmen. When he was about twenty, Dyer left the seafaring life and settled in Boston, where he found a job as a clerk in the counting room of a carpet warehouse.[316]

During the winter of 1860–1861, he enlisted as a private in a militia company, the Boston City Guards.[317] When the war began in the spring of 1861, it became Company A of the Thirteenth Massachusetts Infantry. Dyer traveled with his comrades for the South, but his tenure in the regiment was short lived. In April 1862 he received a commission as an acting master's mate and reported for duty to the navy yard in Boston.[318] Assigned to the gunboat *R. R. Cuyler*, Dyer joined his shipmates and cruised the Gulf of Mexico coast, where a singular act of derring-do launched his navy career.

On the night of May 17, 1863, near the mouth of Mobile Bay, Dyer was commanding a cutter and a crew of nine bluejackets on a routine patrol to watch for enemy vessels. About 11:00 p.m. Dyer noticed a suspicious schooner a couple hundred yards away from Confederate-held Fort Morgan. She was the *Isabel*, loaded

with two hundred bales of cotton. Upon further observation Dyer determined the vessel was not in motion. Curious, he cautiously maneuvered between the *Isabel* and Fort Morgan and discovered a hawser that ran from ship to shore.[319]

Dyer realized that the *Isabel* was grounded and acted quickly to capture her. He and his sailors rowed alongside and boarded the vessel, taking her captain and six crewmen by surprise. Then they went to work to free the *Isabel*. At this point, someone noticed a ship approaching. She was the side-wheel rebel gunboat *Gaines*, en route to assist the stranded *Isabel*. Dyer fired the *Isabel* and boarded the cutter with the prisoners and ship's papers. But the fire was slow to spread. Dyer returned to the schooner and found two barrels of turpentine. He broke them open, spilled the contents and reset the fire. By the time he rejoined his comrades on the cutter, the *Isabel* was in flames.[320]

"As a cool, energetic, and smart young officer, I can not speak too highly of Mr. Dyer," noted Lt. Cmdr. James Jouett of the *Cuyler* in his official report. Jouett, who had performed a similar feat in Galveston harbor in 1861, added, "I beg he may be given an ensign's appointment, as I know how well he would fill that position, and as a regular officer, I would not recommend any unfit person for the service."[321]

Rear Adm. David Farragut, commander of the West Gulf Blockading Squadron, acted immediately on Jouett's recommendation. "I was highly gratified at the conduct of Master's Mate Dyer and have sent him an acting ensigncy," he wrote. "It is a bright spot when I can promote for gallantry; my constant distress is to punish officers for leaving their vessels and misbehaving in the presence of the enemy. I know as well as anyone that we are all liable to be overpowered and conquered, but pusillanimity does not belong to the American Navy."[322]

Dyer was the antithesis of pusillanimity. If there was any chance of a fight, he wanted part of it. Such was the case in the summer 1864. Dyer, now an acting master and independent commander of the side-wheeler *Glasgow*,[323] had been granted a much-deserved leave of absence. Aware of pending plans to attack Mobile Bay, he

refused the offer and requested new orders. On July 19, he was assigned to the *Metacomet*, which was under the command of his old captain, James Jouett.[324]

On August 5, 1864, Dyer, Jouett and their shipmates on the *Metacomet* steamed into Mobile Bay in the vanguard of the Union armada. Lashed to the side of Farragut's flagship *Hartford*, the *Metacomet* cast off early in the action to attack a trio of rebel gunboats that raked the fleet with cannon fire. One of the enemy vessels was the *Gaines*, which Dyer managed to avoid during the *Isabel* affair. She soon retreated after suffering heavy damage. Another ship, the *Morgan*, was also driven back. The last of the three, the *Selma*, surrendered. Jouett dispatched Dyer to take charge of the prize. He hoisted the Stars and Stripes above the *Selma* and transferred her crew to the *Metacomet*.[325]

After the victory at Mobile Bay, Dyer took a brief leave and then returned to duty. He spent the rest of war in command of several vessels in the waters around Mobile. One of them, the lightly armored "tinclad" *Rodolph*, was charged with clearing underwater mines left by the rebels. On April 1, 1865, she sunk after striking one of the mines. Dyer happened to be away from the *Rodolph* at the time. Fifteen of his crew were killed and wounded.

Dyer remained in the navy after the end of hostilities. By the Spanish-American War he had risen to the rank of captain. He became legendary in the service for his toughness and temper. "Though the crews of our warships were tough in those days, no sailor man was ever as tough as Dyer, nor had as hard a fist," declared one of his subordinates, Ensign Edward L. Beach. "Dyer expected every man to do his duty. On Dyer's ship every man knew he would 'catch Hell' if he did not," noted Beach. "To him a thing done 10 percent poorly was 100 percent unsatisfactory."[326]

Though Dyer ruled by fear and intimidation, he could also inspire. Ensign Beach described Dyer as he prepared his four-hundred-man crew of the *Baltimore* for battle against the Spanish armada at Manila Bay in 1898. "There stood our captain, his very person radiating force, power, and confidence. From a little hook on his white blouse, he lifted with his left hand a pair of

eyeglasses. As he was putting them on, he raised his head, and with it his left arm akimbo, he then slowly moved his head from left to right, and back again, his left elbow following his head in its movements, in which there was an unconscious grace. An intense stillness pervaded, except for the splashing of the seas against the bows of our ship, and the subdued thunking of her engines. He had caught the attention of every man on deck."[327]

Beach continued, "'Men of the *Baltimore*,' he said, 'you are about to listen to the most shameful set of lies, the most abominable falsehoods, the most horrible statements, ever made against Americans. You are denounced as thieves, scoundrels, murderers, violators of women, destroyers of religion. Listen! This is what the Spanish governor general of the Philippine Islands has published. And this means me, and you, and you! and you! and *you*!'"[328]

Dyer then read a provocative missive issued by Spanish authorities to the Filipino people. "As Captain Dyer read, he became possessed of a mad fury that constantly augmented. His wonderful voice rolled over the deck and reached and roused every heart," Beach recalled. "With the last words he had become a mass of passion. He lost control of himself, threw the paper on the deck, jumped on it, threw his hat at it, cursed it, then broke into a most beautiful, though violent, statement about the soul of America, past and present. A wild cry went up from the hearts and souls of the Americans before him. He had stirred us as a body in a way I had never before seen men stirred. The cry became a mighty roar. Then up went Dyer's arm; there was perfect silence. 'March divisions to their quarters! Pipe down!' he ordered."[329]

On May 1, 1898, Dyer led the *Baltimore* into the Battle of Manila Bay, second in line behind Comm. George Dewey's flagship *Olympia*, and played a key role in the American victory and utter destruction of the Spanish armada. Dyer was hailed as a hero, and his name was splashed across the front pages of newspapers across the country, along with Dewey's other captains. The stress of command took a toll on Dyer, however. During the weeks that followed, the crew noticed a marked increase in his anger level. "We were not so much disturbed by what he said, so much by his

manner, his high voice, his overwhelming rage, the convulsive workings of his facial features," recalled Ensign Beach. "And, one day, a new development occurred. After a violent admonition or order, he burst into uncontrollable sobbing. From then on, nearly every outbreak was followed by an outburst of wild weeping."[330]

On March 27, 1899, Dyer was ordered home. The public, having no knowledge of his mental state, embraced him as a hero. The city of Baltimore, namesake of the cruiser he led into Manila Bay, invited him to be the guest of honor in an elaborate celebration on September 12, 1899. "Residences and business houses were gay with bunting, the streets were jammed with people wearing 'Dyer' buttons and 'Dyer' badges, and all the ships in the harbor, regardless of nationality, were bedecked in his honor," reported one newspaper. Later that day in a formal ceremony and banquet, the mayor presented a set of resolutions and sword as a token of appreciation from the people of Baltimore.[331]

The festivities in Baltimore were but one of many gatherings to honor Dyer. He remained on active duty until his retirement in 1901 as a rear admiral. Unmarried, he lived in his sister's home in Melrose, Massachusetts. Dyer died of rectal cancer in 1910 at age seventy. The country mourned his passing and acknowledged him as a man who had risen to the top of his profession solely by his own merits—the embodiment of American ideals.

Perhaps the finest tribute ever given to Dyer was made by Rear Adm. Winfield Scott Schley, another navy officer who served in the Civil War and the war with Spain. "His name will live and last forever in the annals of the navy as that of a great captain and his name will endure in the verse and song of the country forever."[332] Eight years after his death, the destroyer *Dyer* was commissioned and served as an escort between Gibraltar and Marseilles, France, during World War I.

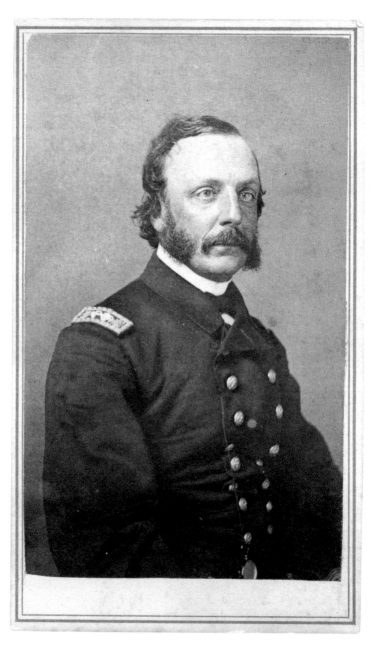

Lt. Cmdr. John Elliot Hart, U.S. Navy

Carte de visite by an unidentified photographer. Collection of the author.

The Day the War Stopped

IN A SOLEMN ACT OFTEN REPEATED ACROSS THE WAR-ravaged South, men gathered in graveyards with heads bowed to pay respects to a fallen comrade. One such event occurred in the Louisiana hamlet of St. Francisville during the third spring of hostilities—and although the scene was all too common, the circumstances were quite extraordinary.

The deceased was the respected commander of the Union gunboat *Albatross*. John E. Hart, New York–born and Naval Academy–educated, was a grandson and namesake of a navy lieutenant killed during the War of 1812.[333] A half century later, Hart followed in the footsteps of his grandfather and went off to war. Assigned to the Gulf Squadron as a subordinate officer aboard the sloop *Vincennes*, Hart left behind his wife of six years, Hattie, and a young son. "I do so hope that my little wife and my little one's prayers will be heard by our Heavenly Father and I hope that I may be spared to come home again, if I am not, we will all try to meet, won't we?" he wrote Hattie in the summer of 1861. His idea of a heavenly meeting probably included a reunion with his second son, who had died in infancy only a few years earlier.[334]

Hart took charge of the *Albatross* as lieutenant commander in late 1862. A small gunboat with little firepower, she made a big name for herself in the Gulf. Hart scored several successes, including the destruction of valuable salt works along a stretch of Florida coast. His most notable accomplishment was running the batteries of Port Hudson, Louisiana. On March 14, 1863, Rear Adm. David Farragut led a fleet of seven ships passed the formidable defenses of the fortress city. Farragut's flagship *Hartford*, with Hart's little *Albatross* lashed to her side, ran the gauntlet with minimal casualties and damage. The rest of the

fleet however was forced back and one vessel destroyed. Farragut complimented Hart in his after-action report. "Whenever he could bring a gun to bear, ahead or astern, on the port side, it was instantly fired."[335]

The *Hartford* and *Albatross* steamed into a section of the river between the last two Confederate strongholds—Port Hudson and Vicksburg—and began operations with other Union vessels against critical enemy supply bases.

The *Albatross* was upriver from Port Hudson near Bayou Sara on June 7, 1863, when Hart penned an upbeat letter to Hattie, "My little boat is quite a wonder, and is as well known on this river as the name of the River itself." He looked to the future and longed for the fall of Port Hudson, "I want to see the old flag on those cliffs, and I shall be quite delighted."[336]

Four days later at 4:15 in the afternoon of June 11, Hart sat in his stateroom, pressed the muzzle of a pistol behind his right ear and pulled the trigger.[337] A steward rushed into the stateroom after the shot was heard and found Hart stretched out on the floor with blood oozing from his head and the pistol lying nearby. The ship's surgeon was summoned, but it was too late. Hart was dead at age thirty-nine.

His suicide was attributed to remittent fever that affected his brain and drove him insane. Hart did in fact suffer at the time from remittent fever and "frequent paroxysms of excessive despondency," according to the ship's surgeon. But the doctor also explained, "For several months past, he has been subject at times, to great depression of spirits." A note in Hart's handwriting, tucked underneath a vase on a bureau in the stateroom, revealed a darker secret: "I am a Dyspeptic. Will God forgive this rash act? It has been a mania with me for years. God knows my sufferings."[338]

Hart's second-in-command, 1st Lt. Theodore B. DuBois,[339] turned the *Albatross* around and charted a course for the *Hartford*. While en route, she was intercepted by the steamer *Bee* with orders from the *Hartford* to return to Bayou Sara. DuBois followed orders. He anchored the *Albatross* at Bayou Sara and about ten o'clock that night sent officer William Harcourt ashore

to find a coffin in which Hart's body could be sent home to Harriet in New York for burial. Harcourt failed to find one.[340]

The decision was then made to bury Hart along the river. DuBois explained, "Feeling most anxious to preserve his body, and knowing that all traces of a grave on the bank of the river would soon be lost, I determined to apply at the church in St. Francisville (a beautiful little town about one mile back from Bayou Sara), for permission to bury him there." He added, "Taking with me a strong guard, I proceeded to the church and made my application."[341]

DuBois learned that a plot was available for nonresident Masons. As he and the late Hart were Masons, the plot was perfectly suited for the remains. DuBois went to the local lodge to seek permission to bury Hart there.

First contact did not go well, DuBois recalled. "I had great difficulty in obtaining admission to this Lodge. On requesting it, I was told they considered me an enemy to their country, one who had come to deprive them of their homes and liberty, and they wished to have nothing to do with me."[342]

DuBois argued that as a Mason he had the right to have his request honored. "In the body of a just Lodge there can be neither politics nor civil war," he reminded his Southern brothers.[343] DuBois's words were persuasive. The senior lodge brother present, William W. Leake,[344] granted the request.

Leake could well appreciate the higher bonds of Masonry. He was a former captain in the First Louisiana Cavalry and an officer on the staff of Port Hudson's commanding general, Frank Gardner.[345] Union cavalry captured him a month earlier and released him on parole. Leake awaited a formal exchange from his home in St. Francisville, where he and his family had endured shelling from the *Albatross* and other Union warships.[346]

On June 13, 1863, DuBois and fifty of his crewmen accompanied Hart on his final journey. DuBois recounted, "I took our Brother's remains on shore, and as we marched mournfully up the hill to the beautiful little church of St. Francisville, we were met by a procession of Brother Masons, who took charge of the

coffin. Exchanging my side-arms for the snow-white apron, I joined them, my men following on. We buried our Brother with Masonic honors."[347]

DuBois added, "I feel sure that every Mason on the spot felt better for having done his duty towards the remains of a deceased brother—though an enemy in war, *still a brother.*"[348] The event came to be known by locals as "The Day the War Stopped."

A simple cypress board marked the burial spot until about 1900, when the rotted wood was replaced with a headstone by the U.S. Navy at the request of the Daughters of the Confederacy. Leake decorated the grave with flowers until his death, in 1912. He was buried near Hart. The Masons added a marble slab over both graves in a 1956 ceremony. In 1999, the town of St. Francisville held its first annual festival to remember the day in 1863 when the war was suspended to bury a brother Mason.

Unflappable Commander
of the Raider Georgia

On a breezy Sunday morning in June 1864, a dense column of smoke billowed high into the bright sky off the coast of Brazil. It emanated from a roaring fire that rapidly consumed the Yankee merchant *Good Hope.*

Nearby lay the source of the vessel's destruction—the Confederate raider *Georgia.* On her deck the crew of the *Good Hope*, now prisoners, intermingled with the rebel sailors around a makeshift wood coffin. Inside were the remains of the captain of the burning vessel. He had died earlier during the voyage, and the crew had preserved his body for the return to their home port in Boston.

The commander of the *Georgia* decided the body had to go. William L. Maury, a fifty-year-old navy veteran, stood at the head of the crude casket and recited the ritual for the burial of the dead at sea from his prayer book. During the impromptu service the officer of the deck stole up behind Maury as he read and whispered in his ear, "American man-of war bearing down on us rapidly!"[349]

The officer, midshipman James M. Morgan, recalled Maury's reaction. "Never a muscle did he move, nor was there the slightest change in his solemn voice until he had finished." Only after the ceremony was completed and the body committed to the ocean did Maury order Morgan to prepare the men and guns for action.[350]

The vessel that bore down on them turned out to be another merchant that flew the Stars and Stripes. Her captain was attracted to the smoke from the *Good Hope* and he made haste to rescue the crew. According to Morgan, the ship hove to, a boat was lowered, and the unwitting captain hustled over to the *Georgia.*

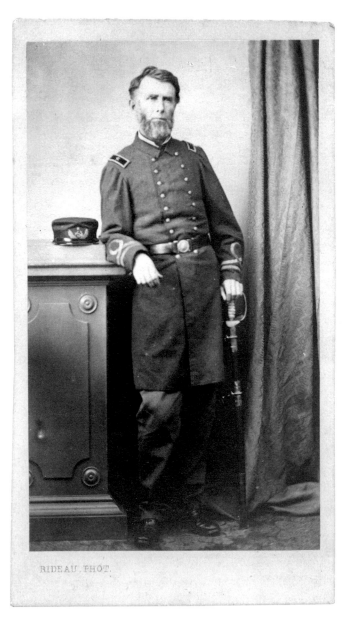

RIDEAU, PHOT.

Cmdr. William Lewis Maury, C.S. Navy

Carte de visite by Rideau (life dates unknown) of Cherbourg, France, about October 1863 to January 1864. Collection of Gerald Roxbury.

"As he leaped on to our deck he exclaimed, 'This is dreadful! Can I be of any assistance?—How did it happen?'"[351]

"Maury stepped forward and told him the *Good Hope* had been burned by his orders," Morgan observed. "The man for a moment looked aghast, and then an expression of indignation passed over his features as he asked, 'Are you a pirate?'" Maury responded, "That is what your people call me."[352]

Maury escorted the stunned captain to his cabin and listened to his incredible story. The captain explained that he and his vessel, the bark *J. W. Seaver*, had been at sea for some years. Maury broke the news to him that a state of war existed between the North and South. A search of the *Seaver* turned up many newspapers but none more current than October 1860. Morgan recounted what happened next, "Maury let him go, saying that he would stand a court martial before he would burn the ship of a man who had come on an errand of mercy to help fellow seamen in distress."[353]

Maury's ethical act was characteristic of the man. An unflappable Virginian with a serious demeanor occasionally broken by a soft chuckle, he got his start in the U.S. Navy in 1829. Had the Civil War never happened, he might have been remembered as an explorer. He was one of a party of sailors, scientists, and artists named to the United States Exploring Expedition, a modest fleet of ships that conducted a highly successful survey of the Pacific Ocean region from 1838 to 1842. Maury Island in Puget Sound was named in his honor during the voyage. A century later, an ice-filled harbor in Antarctica was christened Maury Bay as a tribute to his pioneer efforts.

He was not the only Maury to distinguish himself as a navy oceanographer. Matthew Fontaine Maury,[354] a brilliant officer respected worldwide for his many scholarly contributions to oceanography, became known as the "Pathfinder of the Seas." The men were cousins linked by an eighteenth-century ancestor.[355]

Soon after the bombardment of Fort Sumter, the cousins cast their lot with the Confederacy. Maury resigned his commission

on April 20, 1861, a week after Sumter fell to rebel forces in South Carolina. His prominent cousin resigned the same day.

Maury began his Southern service as a commander in the short-lived Virginia navy. In June 1861 he was commissioned as a lieutenant in the Confederate navy. He spent the rest of the year and most of the next at stations in Wilmington, North Carolina, and Charleston, South Carolina. In the latter place he participated in the laying of underwater mines, or torpedoes, the block Union warships from entering Charleston harbor.

Though his coastal defense work was highly regarded, there was an even greater need for his expertise overseas. In late 1862 he was sent to London with authority from the Confederate government to negotiate contracts to construct warships with funds raised from cotton sales. A few months later, in February 1863, he traveled to Scotland and took charge of the merchant *Japan*, later renamed the *Clyde*. The vessel had been purchased by the Confederate government in secret to avoid detection by U.S. officials who closely monitored rebel activity across Europe.

Maury sailed the *Clyde* to France. Working clandestinely, his hired crew of English and Scottish sailors transformed her into a warship. On April 9, 1863, the *Clyde* left the coast of France and beyond the three-mile limit into international waters. Morgan recalled what happened next. "Maury called all hands to the mast and reads his orders, hoisted the Confederate flag and his pennant, and declared the Confederate States cruiser *Georgia* to be in commission. His remarks were received with three lusty cheers."[356]

Though the *Georgia* was classified as a cruiser, the label was a misnomer. Her long and low profile, engines that required copious amounts of coal and frequently broke down, and insufficient sail power combined to make her a most unworthy craft. Still, Maury and his crew managed to capture nine merchants from the spring through the early autumn of 1863. Her third prize, taken June 13, was the bark *Good Hope*.[357]

In late October the *Georgia* arrived at the French port of Cherbourg for much-needed repairs. It turned out Maury's mental

health was in a serious state as well. Some weeks earlier he had learned that his wife, Anne, and their children had become refugees.[358] Maury rarely left his cabin afterwards.

Though no one knew it, the *Georgia* was finished as a raider. In January 1864, the Confederate authorities decided to sell the *Georgia* and reinvest the proceeds in other ventures. On January 19, Maury was relieved of duty because of his ill health and turned over command to a subordinate.

Maury returned to the Confederacy in April 1864 and received good news that his family was unharmed and safe. He also delivered bad news to his superiors at the Navy Department in Richmond. He handed over dispatches entrusted to him before he left Europe that detailed failures to secure contracts for ironclad ships and articulated a shift in attitude towards the Confederate nation as a result of the Union's military and political successes.[359]

Maury was sent to Wilmington, North Carolina, and placed in command of a newly constructed ironclad named for the Tar Heel State. The *North Carolina* proved to be unseaworthy and served in a limited role as a guard ship in the Cape Fear River, where she foundered and sunk on September 27, 1864.

Maury's active service in the navy ended here. At some point he and his family moved to New York, where Maury became a customs collector. He died in New York City in 1878 after a brief illness at age sixty-six. His remains were buried in Virginia.

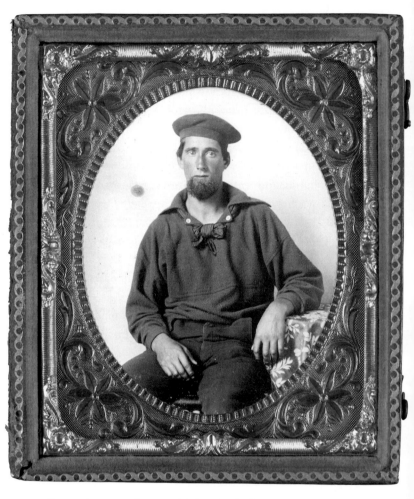

Ordinary Seaman Ebenezer McKay, U.S. Navy

Sixth-plate tintype by an unidentified photographer, about 1862–1863. The Liljenquist Family Collection, Library of Congress.

The Second Clash of the Ironclads

PROSPERITY SMILED ON EB MCKAY. THE FISHERY HE established along Michigan's Saginaw Bay yielded massive catches and handsome profits. The future looked bright for the Canadian-born fisherman who had migrated from Nova Scotia with his family to seek better opportunities in the United States.[360] Then came the Civil War, which killed his lucrative Southern market.[361]

A year later, in the summer of 1862, he traded his work clothes for the blue jacket of an ordinary seaman in the Union navy. McKay was assigned to a new ironclad that would become one of the most celebrated warships of the North. She was the *Weehawken*, an improved class of single-turreted monitor that was bigger, more heavily armed, and more seaworthy than the original. Launched in November 1862 and commissioned in January 1863, the iron giant was commanded by John Rodgers. The grandson of a Maryland militia colonel during the Revolution and son of a distinguished commodore, he followed his father into the navy.[362]

McKay and his shipmates steamed for the South Atlantic Blockade Squadron for duty off Charleston, South Carolina. Their first engagement was on April 7, 1863, in the first major naval attack against the formidable defenses of Charleston since the bombardment of Fort Sumter. The *Weehawken* led the way and suffered fifty-three hits and a torpedo explosion beneath her keel in the failed operation.

The *Weehawken* was repaired and dispatched to Georgia, where rumors circulated that the rebel warship *Atlanta* prepared to take the offensive against the blockade at Savannah. Originally the Scottish-built blockade-runner *Fingal*, the *Atlanta* was con-

verted into an ironclad by the Confederate navy about the time McKay enlisted.

The *Atlanta*, according to a newspaper report, "is quite a formidable looking craft. She has a cut-water in the shape of an immense steel saw, with monster teeth; outside of that an iron frame with a torpedo attached, for damaging vessels; and above a boom-like piece, for penetrating anything on which she might run."[363]

But the *Atlanta* had problems. Her armor, four inches of recycled English railroad ties bolted to a foot-and-half layer of oak and pine, increased her draft to about sixteen feet. This made navigating inland waterways difficult. She was also coarsely finished and offered little in the way of comfort for her crew.

Still, her presence "has been a perfect thorn in the flesh, for she has required constant watching, and might at any time have taken advantage of the absence of iron-clads on other service to come here and destroy all our wooden vessels," noted one Union officer on the Savannah blockade.[364] Federal fears were realized on June 17, 1863, when the sawtoothed ironclad cut through the Wilmington River and entered Wassaw Sound. "I got underway with the hope of surprising the enemy," stated the commander of the *Atlanta*, William A. Webb.[365] McKay and his shipmates had been alerted to the danger thanks to a Union staff officer. Col. Charles G. Halpine had interrogated Confederate deserters and learned from them that the *Atlanta* was on the move.[366]

Webb and his crew were confident of victory—until the *Atlanta* grounded and stuck fast against the bank. The *Weehawken* and another monitor, the *Nahant*, found the stranded ironclad and steamed in for the kill. The *Weehawken* got there first and fired at a range of about three hundred yards. This was at 5:15 a.m., according to Capt. Rodgers. Five shots later, the *Atlanta* hauled down its rebel ensign and surrendered. What would later be billed as the second clash of the ironclads (following the *Monitor* and *Virginia* the previous year) lasted no more than fifteen minutes.[367]

Four of the five shots from the *Weehawken* struck the *Atlanta*.

The first broke the armor plates and wood backing and strewed the deck with iron fragments and oak and pine splinters. The third shot knocked off the top of the pilothouse, wounding two pilots and stunning the sailor at the wheel. Cmdr. Webb and 164 other Confederates, including sixteen wounded, were captured. One of the wounded men later died. There were no casualties reported on the *Weehawken*.

Spectators from Savannah crowded on two rebel warships watched the events with dismay. After it was all over they returned to the city with the bad news.

Three hours after the *Weehawken* fired its last shot, the tide has risen high enough to allow the *Atlanta* to be refloated. She was soon repaired and joined the Union fleet. Rodgers wrote his after-action report later that day, and he paid tribute to his men. "The behavior of the officers and crew was admirable," he wrote. "In a word, every man in the vessel did his duty."[368]

Six months later, on December 23, 1863, Rodgers received the Thanks of Congress from a grateful nation for his victory over the *Atlanta*. By this time, the *Weehawken* was no more. Two weeks earlier, on December 6, she sank off the coast of South Carolina. Four officers and twenty-seven men drowned.

McKay was not aboard when the *Weehawken* was lost. He had been discharged in August 1863 after his one-year term of enlistment expired and returned to his home in the Michigan village of Sebewaing.

McKay prospered as a fisherman and sailor in the Saginaw Bay area for years. He took great pride in the *W. T. Chappel*, a schooner he designed and built. She was reputed to be one of the fastest vessels in the region. He married in 1866 and started a family that included two daughters and a son, E. Murray McKay, a prominent Detroit fine artist.[369]

McKay lived until 1920, dying of complications from the effects of a stroke. He was eighty-six years old.[370]

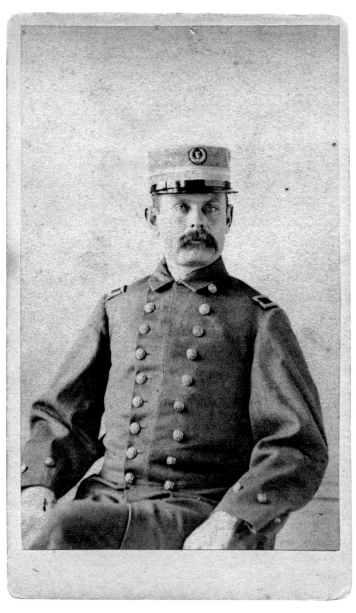

3rd Engineer Eugene H. Brown, C.S. Navy

Carte de visite by James Wallace Black (1825–1896) of Boston, Massachusetts, about 1864. Collection of Gerald Roxbury.

Confederates in Maine

THE SCHOONER *Archer* EASED INTO PORTLAND HARBOR AT sunset on June 26, 1863, and anchored amidst the Maine merchant fleet. She attracted no special attention from surrounding ships or forts, and there was no reason why she should. Her masts blended in with the forest of others in the harbor.

Beneath her sails, the situation was anything but ordinary. The crewmen were Confederates, and as the sun waned in the summer sky, their commander gathered his officers and laid out a daring plan. After dark, explained twenty-three-year-old Lt. Charles W. Read,[371] they would capture the one vessel that would provide them with enough speed and firepower to get away from Portland and terrorize Yankee shipping along the New England coast. She was the *Caleb Cushing*, a sleek revenue cutter owned by the U.S. Treasury Department.[372]

One subordinate expressed a serious concern about the mission—Eugene Brown, the lone engineer and second-in-command. "Strange to say, at the decisive moment Mr. Brown declared himself incompetent to work the engines of the steamer unless he had another engineer to coöperate with him," Read wrote to a fellow officer soon afterwards.[373]

Up to this point Brown's actions were consistent with a game fighter who had risked everything for the Confederate cause. A native of Portsmouth, Virginia, Brown responded to the first call to arms after state legislators voted to secede from the Union. On April 20, 1861, he enlisted in the Virginia Defenders, a militia company that became part of the Sixteenth Virginia Infantry. The men served a one-year enlistment in Norfolk, "leading there rather a quiet life, varied only by occasional alarm," observed an

historian.[374] Brown spent part of his time on detached duty with the navy.

Many in the Sixteenth reenlisted in 1862. Brown elected to join the navy as third engineer, a position well suited to his peacetime occupation as a machinist. Dispatched to Mississippi in May 1862, he joined Lt. Read and others aboard the ironclad ram *Arkansas*. It is likely that this is the first time the two men had met.

The ten-gun *Arkansas* was generally considered inferior to others of her class. The poorly secured armor plating that sheathed her was composed of worn railroad iron. But her new engines performed well on trial runs and generated enough steam for a fair speed. The *Arkansas* performed well in actual combat, and her crew did too. During July 1862, she fought a running battle with the enemy at close quarters in the vicinity of Confederate-occupied Vicksburg. Battered and bruised, her captain ordered the *Arkansas* in for repairs and for her not to be moved until they were completed.

The ranking Confederate military commander in the region, Maj. Gen. Earl Van Dorn,[375] had other plans. After the captain and several ranking officers left the vessel for a brief furlough, and with the chief engineer absent sick, Van Dorn ordered the *Arkansas* to Louisiana to support ground forces fighting at Baton Rouge.

The unrepaired *Arkansas* departed on August 4 with Brown and Read aboard. The next morning, about fifteen miles below Port Hudson, the engines suddenly stopped. Read, who happened to be officer of the deck at the time, recalled the situation. "All of the engineers were called and started to work to get the machinery in order. Each engineer had a different idea of what should be done." He noted that with the chief engineer away, "All of the other engineers were incompetent to run such engines as those of the *Arkansas*, but they were the only ones to be had there at that time. They were mostly engineers who had served their time with the simple high-pressure engines of the Mississippi river boats; a few were navy engineers who had been in the service but a year

or two, and had no practical experience. But they were all true, good men, and no doubt did their best."[376]

Their best was not good enough. The engines quit again and again, and Brown and the other engineers struggled to patch them up. On August 6, in the face of the federal fleet, the critical crankpins on both engines failed simultaneously. The commanding officer ordered the *Arkansas* set afire and abandoned. She blew up about noon. The *Arkansas* was no more. The survivors were reassigned to other ships, and Brown and Read joined the crew of the raider *Florida*.

On May 6, 1863, off the Brazilian coast, the *Florida* captured the *Clarence*, a brig laden with coffee bound from Rio de Janeiro to Baltimore. Read proposed to take the captured vessel and a crew of twenty to raid Virginia's Chesapeake Bay—specifically Union-occupied Hampton Roads and the stronghold of Fortress Monroe. He submitted a plan to the commander of the *Florida*, John N. Maffit.[377] "There can be no doubt of my passing Fortress Monroe successfully," Read declared. "Once in the Roads I would be prepared to avail myself of any circumstance which might present for gaining the deck of an enemy vessel. If it was found impossible to board a gunboat or merchant steamer, it would be possible to fire the shipping at Baltimore."[378]

"If you think proper to accede to my proposal, I beg that you will allow me to take Mr. Brown," Read requested.[379] Why Read asked for Brown in particular is not exactly known. He might have recalled Brown's efforts to save the *Arkansas*, or he was simply making the best of limited choices.

Maffit approved the mission and gave Read everything he asked for plus a single howitzer. Read designated Brown as his executive officer and second-in-command, and the crew embarked on the *Clarence* for American waters.[380]

The *Clarence* steamed towards Fortress Monroe, encountering several vessels along the way—some were neutral and others were Yankee merchants that Read captured. Military intelligence gathered from newspapers and prisoner interrogations revealed the overpowering strength of Union naval forces. The closer Read

got to his destination, the greater his concerns became. He finally became convinced that he could not win and turned away from Fortress Monroe. Instead of heading south, however, Read charted a course for New England.[381]

On June 12, 1863, Read's raiders captured the merchant bark *Tacony*. "As she was a much better vessel than the *Clarence*, I transferred everything to the former and burned the latter vessel," Read reported.[382] Over the next two weeks the *Tacony* powered up the Atlantic coast like a hurricane as Read, Brown, and crew captured fifteen ships. The last of these prizes was the fishing schooner *Archer*. On the morning of June 25, Read transferred his men and materials to the *Archer* and burned the *Tacony*.

The following evening in Portland harbor, Read listened as Brown explained that he could not work the engines of the cutter *Caleb Cushing*. Read was dismayed. "All my plans were crushed," he acknowledged soon afterwards.[383] If Read had considered the fate of the *Arkansas*, he might not have been as overwhelmed by Brown's pronouncement.

Read determined to stay the course. "I felt confident that Mr. Brown would do his utmost to perform the duty required of him, but as the nights were very short it was evident that if we failed to get the steamer underway, after waiting to get up steam, we could not get clear of the forts before we were discovered."[384] Read and his men boarded the *Caleb Cushing* during the wee hours of June 27 and easily subdued the surprised crew. But trouble slipping the mooring cable, light winds, incoming tides, and Brown's failure to get the steam up slowed progress. Come dawn, they had yet to get out from under the guns of the harbor defenses.

By ten o'clock in the morning, about eight-and-a-half hours after the capture, Read had put only about twenty miles between the cutter and Portland. His worst fears were realized about this time when a convoy was spotted headed out of the harbor—two large steamers and three tugboats packed with sailors, soldiers, and civilians coming to take the *Caleb Cushing* back.

"The cutter was cleared for action, and as soon as the leading steamer was in range we opened fire upon her," recounted Read.

"From the movements of the enemy's steamers it was evident that they intended to attack us simultaneously on each side and endeavor to clear our deck with their sharpshooters." He added, "It was plain that we could offer but an ineffectual resistance, and therefore I directed the cutter to be set on fire and the crew to take to the boats."[385]

About noon the roaring flames that ripped across the decks of the *Caleb Cushing* penetrated the magazine and exploded with a massive force that sent her to a watery grave. She became the last casualty of Read's reign of terror along the Atlantic Coast. Read, Brown, and their shipmates were aboard the steamer *Forest City*, which had plucked them out of the ocean from their escape boat, when the explosion occurred.

News of the Confederate incursion into Maine was overshadowed the much larger invasion of Pennsylvania by Gen. Robert E. Lee and his Army of Northern Virginia, which culminated a few days later at the Battle of Gettysburg. Read and Brown were eventually sent to Boston harbor and imprisoned in Fort Warren. They were paroled in September 1864 and transported to Virginia, where they were formally exchanged and returned to active duty.

Read went on to participate in operations along the James River in Virginia, and in 1865 he was placed in command of the raider *Webb*. Captured and imprisoned in Fort Warren for a second time, he was released in July 1865 and lived until 1890. He became the subject of articles and books and was given the noms de guerre "Savvy" and "Seawolf of the Confederacy" in recognition of his exploits.

Brown was largely forgotten by history although he fought on to the very end of the Confederacy. Ordered to Wilmington, North Carolina, and assigned to the steamer *Chickamauga*, he defended the port city against the Union bombardment of Fort Fisher in December 1864 and January 1865. He suffered a wound in one of the engagements, though the nature of his injury was not reported. Brown escaped from Wilmington after Fort Fisher fell to federal forces on January 15, 1865. He made his way to

Richmond and served in the James River Squadron until the fall of the Confederate capital on April 3. About three weeks later, on April 26, he surrendered to Union authorities at Greensboro, North Carolina, and received a parole.

Brown settled in Baltimore, married, and started a family that grew to include two children. He worked as a traveling salesman and became active in the Maryland Confederate Society. He died in 1916 at age seventy-nine.[386]

Blasting Fort Wagner into Sand Heaps

Hours before the Fifty-fourth Massachusetts Infantry and other federal infantry assaulted Fort Wagner, South Carolina, on July 18, 1863, the Union navy launched a furious bombardment. Six ironclads steamed to within 1,200 yards of the fort and unleashed hell on the garrison. Shell after shell belched from the fiery mouths of the big guns in the turrets of the metal monsters to soften the position, which was critical to the rebel defenses of Charleston.[387]

The ironclads did not operate alone. They were joined by shore batteries and six wooden gunboats, which blazed away from long range. For the crew of one of the gunboats, the *Chippewa*, the day would be remembered as a defining moment in her service. "The *Chippewa* has gained great credit for going nearer than any other of the gunboats, and firing faster and making the best shots, and for answering signals, &c.," one officer declared. "In fact, the ship had got something of a name at last."[388]

One of the crewmembers present that day was Albert J. Kenyon, serving as third assistant engineer. The eldest of four children born and raised in Owego, New York, Kenyon grew up along the Susquehanna River. He and his father worked in a local machine shop, where Kenyon received a practical education about engines and other equipment.[389]

On September 21, 1861, the eve of Kenyon's twentieth birthday, he joined the navy and became an original member of the crew of the *Chippewa*. She had been launched just a week earlier at New York harbor. Constructed of white oak, yellow pine, and larch in less than seventy-five days, the *Chippewa* was one of six screw-propelled gunboats built under a government contract that summer.[390] The *Chippewa* was assigned to the South Atlantic

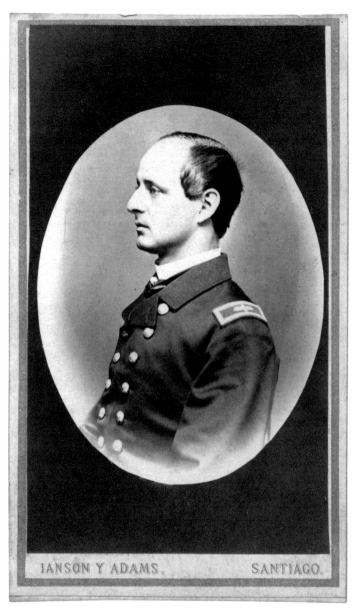

Chief Eng. Albert J. Kenyon, U.S. Navy

Carte de visite by Bernard Janson (life dates unknown) & Peter Hubert Adams (about 1830–1900) of Santiago, Chile, about 1867. Collection of the author.

Blockade Squadron and patrolled the coast with the exception of a stint in late 1862 and early 1863 when she joined other Union vessels in a fruitless search for the Confederate raider *Florida*.

The events that led to the *Chippewa*'s distinguished performance at Fort Wagner occurred during the week leading up to the July 18 assault. She and the other five gunboats shelled the Confederates regularly each day. One sailor aboard the monitor *Montauk* observed the *Chippewa* and the other vessels sending "some magnificent shots into and beyond Wagner" on the afternoon of July 14.[391] Kenyon and his fellow engineers did their part in keeping the machinery in working order so that they could respond quickly and efficiently to orders.

About eight o'clock the morning of July 18, a steam tug pulled up alongside the *Chippewa* with orders to resume firing at Fort Wagner. She responded an hour later and had dropped thirty shells by noon. Then the ironclads moved in, and the *Chippewa* and other gunboats followed at a distance. Over the next seven hours, the fleet blasted Fort Wagner with heavy metal. The *Chippewa* and her crew followed the monitors and, at 1:00 p.m., went in to close range—about a thousand yards—and fired forty-seven shells in forty-eight minutes. It was during this brief period that the *Chippewa* received her greatest recognition.

The *Chippewa* fired another nineteen shots that afternoon for a grand total of ninety-six. The navy guns fell silent about 6:30 p.m., and soon after the crew of the *Chippewa* watched the Fifty-fourth Massachusetts Infantry and other troops advance along the narrow strip of beach and storm the fort.[392]

"We then found to our sorrow," noted a reporter from the *New-York Tribune*, that the bombardment had little effect on the garrison of Fort Wagner. "Only the parapets of the fort had been knocked into sand heaps."[393] Still, the crew of the *Chippewa* could be proud of its achievement. Kenyon received a promotion to second assistant engineer two weeks after the assault.[394] Meanwhile the federals renewed their efforts against the fort and other Confederate positions on Morris Island, and this time they were

successful. Union troops occupied Fort Wagner on September 7, 1863, after the rebel garrison was forced to evacuate it.

About this time Kenyon received orders to report to the twenty-one-gun steam sloop *Richmond*. The 259-man crew of the wooden warship had seen plenty of action in Louisiana and Mississippi, including at New Orleans, Vicksburg, and Port Hudson. Kenyon and his new shipmates would go on the fight in the Battle of Mobile Bay on August 5, 1864, and other operations through the end of the war.

Kenyon continued on in the navy and spent the majority of his service on assignments and vessels that took him across the globe. He advanced in rank to first assistant engineer in 1866, and chief engineer in 1884. Four years later he died of kidney disease while awaiting orders at home in Owego. He was forty-seven and single. His parents and two younger sisters survived him.[395]

The Storming of Fort Sumter

A MASSIVE AND RELENTLESS UNION ARTILLERY BOMBARD-ment blasted Fort Sumter into a pile of brick dust and heaping ruins during the summer months of 1863. The onslaught wreaked havoc on the fort's guns and left its rebel garrison incapable of mounting any serious offense against enemy vessels entering Charleston harbor.

This symbol of Southern resistance lost its strategic value. "Sumter was now, in fact, nothing but an outpost to be held by the enemy as a matter of pride," stated one Union navy officer.[396] To add to the woes of the rebels, two links in the harbor's defensive chain were broken after Fort Wagner and Battery Gregg fell to the federals on September 7.

Union Rear Adm. John A. Dahlgren[397] capitalized on the situation. A brilliant ordnance officer who had invented a reliable gun that bore his name, he recently had been placed in charge of the South Atlantic Blockading Squadron. Dahlgren demanded the immediate surrender of Fort Sumter. The commander of the fort's defenses, Maj. Stephen Elliott,[398] replied to the sailors who delivered the missive under a flag of truce, "Inform Admiral Dahlgren that he may have Fort Sumter when he can take and hold it."[399]

Dahlgren called for volunteers to form a storming party. Among those who stepped forward was twenty-three-year-old Marine lieutenant Charles Bradford, of Portland, Maine. An introvert by nature, he was one of the earliest to sign up after the original rebel bombardment of Fort Sumter in April 1861. He had joined First Maine Infantry as a sergeant and served with his comrades in the defenses of Washington for a three-month term of enlistment. Immediately after the regiment mustered out

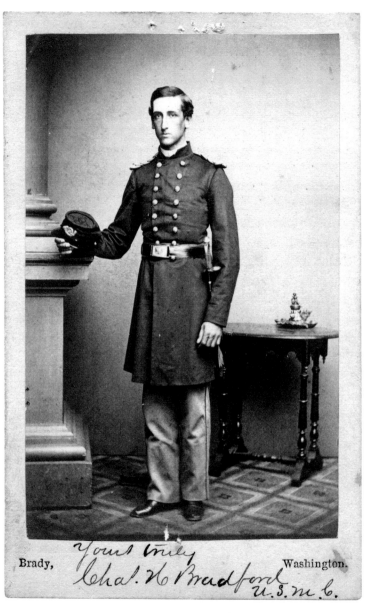

Brady, Washington.

Your truly
Chas. H. Bradford
U.S.M.C.

1st Lt. Charles Henry Bradford, U.S. Marine Corps

Carte de visite by Mathew B. Brady (1822–1896) of Washington, D.C., about
1862–1863. Collection of Ronn Palm.

in August 1861, Bradford took and passed an officer's examination and received an appointment as a second lieutenant in the Marine Corps.[400]

Bradford spent the next two years in a variety of assignments, including amphibious operations along the South Carolina coast that culminated in the victorious Battle of Port Royal on November 7, 1861, and duty off the front lines at the navy yards in Portsmouth, New Hampshire, and Brooklyn, New York.

Bradford was in Brooklyn when, on August 1, 1863, he received orders to join the Marine Battalion in South Carolina. By this time he had advanced in rank to first lieutenant and was detailed as battalion quartermaster.[401] Bradford and the Marines landed on Morris Island, the location of Fort Wagner and Battery Gregg. They played a minor role in the capture of these fortifications.

During the afternoon of September 7, Bradford and the other Marines who volunteered to storm Fort Sumter—133 men altogether—were organized into a division. Four other divisions of volunteer sailors rounded out the force at about four hundred. Confident that the iconic fort had been weakened sufficiently, they set out about 10:00 p.m. in twenty-five small boats towed by the steamer *Daffodil*. About midnight the steamer arrived within eight hundred yards of Fort Sumter. The towlines were cut and the Marines and sailors cast off and rowed towards the target. Visibility was limited to a few yards and tides were stronger than anticipated, causing the boats to become separated.[402]

Inside the shell-pocked and crumbling walls of Fort Sumter, the stalwart garrison of about two hundred defenders had received word that an attack was imminent. Maj. Elliott stated in his journal, "I had one-third of the garrison under arms on the parapet, and the remainder so posted as to reinforce it with promptness." He continued, "At 1 A.M. this morning, I saw a fleet of barges approaching me from the eastward. I ordered the firing to be reserved until they should arrive within a few yards of the fort." When the moment came, Elliott's men let loose with their muskets, then tossed hand grenades, turpentine balls, and

anything else that they could lay their hands on—bricks, chunks of masonry, and other rubble. The garrison fired off a red signal rocket, which alerted nearby Confederate batteries that Sumter was under attack. Big guns from these positions lit up the night sky as a storm of shot and shell rained down in front of and into the fort.[403]

Only about half of the storming party, including Bradford, landed on the narrow strip of debris-strewn ground at the base of Fort Sumter. Greeted by a withering fire, they scattered and took cover. Pinned down and unable to advance or escape, about 125 were captured or surrendered in groups and were ordered to march into the fort. One group, led by navy Lt. George C. Remey, picked their way across the debris and stumbled upon a seriously wounded officer. It was Bradford. He had been shot in the groin. Remey later recalled that he spoke to Bradford. "I told him I would ask the commanding officer of the fort to have him brought in an attended, which I did, and it was done.[404]

A party of Confederates carried Bradford inside the fort. About this time Bradford recalled a suggestion made by his father, Freeman Bradford, some weeks earlier. The elder Bradford, upon learning that his son was headed for Charleston, "wrote to him charging him if he ever entered Charleston as a victor or as a captive, to at once, if possible, let Dr. A. G. Mackey know that he was the son of a Mason, and that he would receive all the attention it was possible to afford."[405]

Albert Gallatin Mackey, a fifty-six-year-old Charleston resident, had written and published extensively about Freemasonry and was well known to fraternal brothers on both sides of the divided nation. Mackey was also a physician and an avowed Unionist.

Bradford passed along his father's suggestion to one of his fellow officers, who conveyed the request to Mackey. Bradford was then transported to a hospital in Charleston for treatment, and his baggage was forwarded to him under a flag of truce.

Mackey met him at the hospital. According to news reports,

"Dr. Mackey, with his usual kindness, did all that he possible could do to alleviate the sufferings of the gallant soldier." Despite the doctor's efforts, Bradford succumbed to the wound on September 23. Mackey preserved Bradford's personal items, which included a memorandum book "in which Lieut. B. had commenced a letter to his mother. He had only been able to write one line, assuring her that his wounds were improving satisfactorily."[406]

Mackey arranged a funeral and the burial of Bradford's remains in the Masonic section of Charleston's Magnolia Cemetery. The interment of the Union officer in this sacred place did not sit well with some locals. "Violent secessionists, or rather fiends, happening to learn of the circumstances of the burial, became wild with rage and took measures to intimidate Dr. Mackey into having the body disinterred and conveyed to Potter's Field," one New England newspaper reported.[407]

After Charleston fell to Union forces on February 18, 1865, Rear Adm. Dahlgren became aware of the fate of Bradford's body. "With an inhumanity disgraceful to any cause, his remains were compulsorily exhumed and carried to the Potter's Field," an enraged Dahlgren announced in an order dated March 15. "Determining to put the mark of reprobation on this barbarous act, I desire to restore the body to the resting place, where, through the kindness of a friend it was originally placed."[408]

The next morning, the body was disinterred from Potter's Field and accompanied to St. Paul's Church by a detachment of the 144th New York Infantry. A large congregation of officers and men from the navy and army listened to a sermon delivered by a naval chaplain. The remains were then carried outside to a waiting hearse. Dahlgren and other top brass lined up behind it, and the entire procession marched solemnly to the gravesite at Magnolia Cemetery followed by a throng of Marines, sailors, soldiers, and citizens. Bradford was laid to rest again, and a file of Marines fired three volleys over the remains at the end of the solemn ceremony.[409]

The body would be moved once again in 1873, when military

officials in Washington ordered the remains of Bradford and other Union soldiers and sailors disinterred and moved to a new national military cemetery in Florence, South Carolina. Magnolia Cemetery records indicate that this was accomplished between April and May.[410] The Florence National Cemetery has no record of the body being buried.

Wild Dayrell

THE *Wild Dayrell* WAS IN TROUBLE. THE SLEEK, SIDE-wheeled blockade-runner had bottomed out in low waters along the North Carolina coast just above Wilmington. During the early morning hours of February 1, 1864, her frantic crew tossed cargo overboard to lighten the load and free the stranded vessel. The boilers were fired up, and thick black smoke streamed from her stack into the sky.[411]

The smoke caught the attention of the crew of the federal gunboat *Sassacus*, then cruising in the Atlantic a half dozen miles distant. Francis A. Roe, the lieutenant commander of the ship, ordered his men into action.[412] The crew included several dependable citizen sailors, including engineer Ben Wood.

An unpretentious and enterprising New Yorker in his early twenties, Wood was described by an admiring comrade as a gifted engineer filled with gumption. "He could see into a millstone as far as the wisest man, and, with his rule in his hand, could tell very closely what the diameter of a shaft should be or the amount of draft a key should have, and you might figure on it an hour without being able to prove the error, if it existed."[413]

Wood had worked as a machinist for a company that built ship engines in New York City before the war. In 1861 he enlisted in the navy and was appointed third assistant engineer. He began his service on the sloop-of-war *Lancaster*.

Wood joined the crew of the side-wheeler *Sassacus* in late 1863 and shipped out for duty with the Union blockade fleet off Wilmington. The newly commissioned vessel was named for a seventeenth-century Native American chief from the Pequot tribe. The *Sassacus* was the first in a class of gunboats with rudders at each end. Known as "double-enders," the novel design

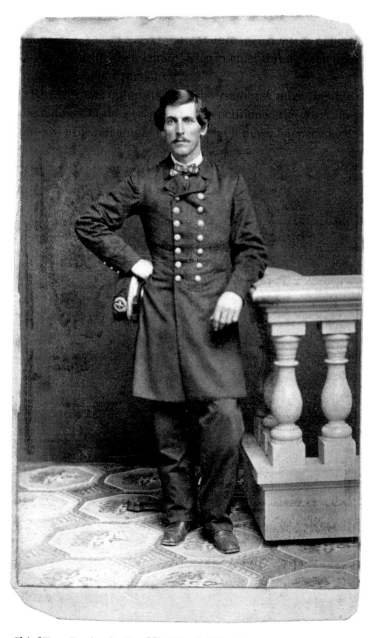

Chief Eng. Benjamin Franklin Wood, U.S. Navy

Carte de visite by unidentified photographer, about April 1862. Collection of the author.

enabled them to navigate back and forth in narrow inlets without having to turn around. Wood impressed his new shipmates with his resourcefulness after the *Sassacus* lost her steering gear during a storm at sea. Several unsuccessful attempts were made to restore the steering before Wood improvised a temporary solution.[414]

Meanwhile, in a Liverpool, England, shipyard, the *Wild Dayrell* was commissioned. Named for an acclaimed British thoroughbred racehorse, the vessel was built for speed. Edgar Holden, a writer for *Harper's New Monthly Magazine* who accompanied the *Sassacus* and later wrote about his experience, described the British blockade-runner as having a "long, low hull, with raking masts and smoke-stack."[415]

The *Wild Dayrell* crossed the Atlantic bound for Wilmington via the Bahaman port of Nassau. The *Sassacus* found her at the mouth of Stump Inlet.[416] *Harper's* writer Holden described the meeting. "Swiftly, like a hawk on its prey, the *Sassacus* sped toward her. Scarcely six miles away, clearly visible as she was to us, almost, indeed, within range of our guns, yet she tried to escape."[417]

Wood and his fellow sailors steamed close enough to see the bales of goods floating in the water around the ship, and more that had drifted on to a nearby beach. As the desperate crew worked feverishly to free the *Wild Dayrell*, a shot fired from the *Sassacus* whistled over their heads. Holden recalled the reaction of the enemy crew. "Helter-skelter ran every one for the boats, and leaving everything as it stood, with the engines still moving, they fled precipitously. A narrow creek led inland, and with all dispatch they pulled up into it and disappeared."[418]

The *Wild Dayrell* was abandoned. "The surf dashed against her sides and at times completely washed her decks. Clouds of smoke and steam poured from her, mingling with the spray. It seemed certain that the rebels must have set her on fire, great as was their haste," Holden recounted. Roe and a detachment boarded the *Wild Dayrell*. "Heavy cases of goods from firms in New York, and of shoes marked as from Lynn, Massachusetts,

were lying about the deck," Holden observed. "In the hold bales of dry goods were still swinging from the whips; while in the cabin all sorts of articles of toilet or apparel, hastily emptied trunks and valises, bottles and glasses, were strewn about the floor."[419]

Roe noted in his after-action report, "I found her furnaces filled with fuel and burning, with the intention of destroying her boilers." He and his men spent the next two days in several failed attempts to free the vessel and claim her as a prize. The Union gunboat *Florida* arrived on the scene and pitched in without success. On February 3, a new threat emerged when Confederates hidden along the beach fired on the Union crews. Roe responded with his cannon and drove them off. He then ordered his men to burn the blockade-runner.[420]

Holden observed the scene. "The curling tongues of flame that now shot out from the decks of the *Wild Dayrell* showed that the torch had been faithfully applied; clouds of lurid smoke poured from the holds, and enveloped the whole of her light masts, sails and rigging." Roe was leaving nothing to chance. "To insure complete ruin of her engines, and to preclude the remote possibility of her ever serving again either her owners or the rebels, both the *Sassacus* and *Florida* took position, and shot after shot was fired through the iron hull. Bursting shells soon tore immense holes in bows and stern, or threw masses of shattered deck and cargo high into the air."[421] The *Wild Dayrell* was no more.

The *Sassacus* would continue to ply the North Carolina coast on blockade duty. A few months later, on May 5, 1864, she suffered serious damage after boldly ramming the Confederate ironclad *Albemarle* in an engagement that went down in the record books as a drawn battle. The *Sassacus* was decommissioned in May 1865.

Wood survived the war and continued on in the navy for the next three decades. He served primarily in the North Atlantic, with the exception of a tour of duty in Asia in the late 1870s. He retired in 1892 as a chief engineer. A few years later during the Spanish-American War, he came out of retirement for a brief stint in the New York Navy Yard.[422]

Wood died in 1910 at age seventy-nine. His wife, Blanche, and two children, Mariette and Benjamin, survived him.[423] A comrade remembered Wood as "a prepossessing man, with very handsome eyes, fine features and very dark hair, which never turned gray. He was a reticent man, though rather pugnacious. He was a 'stickler' for what was right, but, when beaten, always accepted the result, and was never vindictive." He added, "Among our shipmates we look for men of capability, integrity and amiability. Ben. Wood possessed the essential of these, and it is a pity that he could not have lived longer."[424]

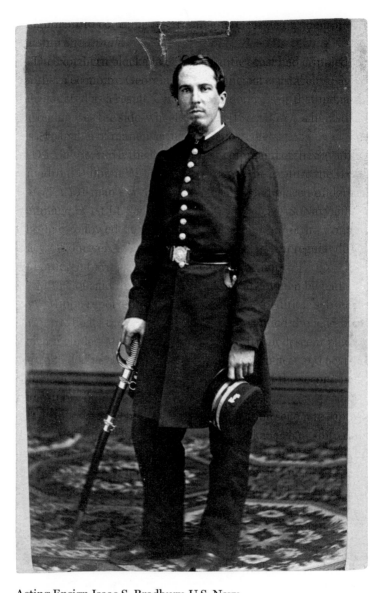

Acting Ensign Isaac S. Bradbury, U.S. Navy

Carte de visite by Charles Henry Williamson (1826–1874) of Brooklyn, New York, about 1863. Collection of the author.

Face to Face with a Rebel

ONE DAY IN EARLY 1864, THE UNION WARSHIP *Cambridge* left her place along the outer line of the blockade along the North Carolina coast near Wilmington on a routine patrol. She steamed towards land and took up a position from which her crew could observe Confederate batteries.

The ship and crew operated at a relatively safe distance, but close enough to hear the surf pounding the beach and the bugle calls of the enemy. At one point, a *Cambridge* sailor spotted a group of five rebels. They had wound their way behind sand hills and disappeared behind the dunes. The commanding officer was made aware of the situation, and he ordered a rowboat of armed sailors to investigate.

The officer placed in charge of the expedition was the ship's well-regarded master's mate. Isaac Bradbury, twenty-four, was the eldest of seven children born to a mariner and his wife in the fishing village of Machias, Maine. Bradbury came of age as clouds of war gathered over the country, and he entered into a union with a Machias girl, Caroline, soon after the bombardment of Fort Sumter severed the constitutional bonds of the republic.[425]

While the newlyweds settled and started a family in Machias, the Union war machine shifted into high gear. The navy acquired civilian vessels for the service, including the sleek, screw-propelled steamer *Cambridge*. Built in Massachusetts in 1860, she was purchased by the navy in the summer of 1861. Her decks were fitted with guns and she was sent south to join the blockade of Confederate ports along the Atlantic coast.

In March 1863, Bradbury accepted an appointment as an acting master's mate. His motivation for joining the navy is unknown, but it is evident he became enamored of the lifestyle. "I

like my 'Commander' as well as I love my life, and in return have his confidence and respect. We have a gentlemanly set of officers all through, and a good crew of over a hundred & fifty men," he wrote during the autumn of 1863 to a friend in Machias. "They have been baptized in fire & blood, and stood the test well."[426]

"You can imagine my feelings the first time I was under fire," he continued. "We got nigh in too the Batterys and they opened on us, and we in return engaged them. Death & destruction was all around, the shells as a majority all over shot us, so at the flash of every gun of the 'Rebs' all the officers & men on the spar deck would throw themselves flat on their faces, and as the shells went over us a screaming they made anything but delightful music, in fact I thought I would rather be at home hearing the 'Machias Cornet Band' playing 'Home Sweet Home,' I think it would be far preferable. But I was doomed to be put to a severe test for a shell suddenly burst among the men cutting one in two and severely wounding several others. The one that was killed fell towards me and the blood spouted over my uniform."[427]

Bradbury tried to keep calm as the battle raged. "With great difficulty I kept possession of my feelings, all though it cost me a big effort, but after the action was over, as cool as I thought I was, my under clothes was dripping wet with sweat, and my face after the action was over, and the excitement died away, was as white as a sheet and I noticed that I was not alone."[428]

A few months later, he received orders to go ashore in command of a detachment to find out what the five rebels were doing. Armed with muskets and cutlasses, Bradbury guided his command along the beach and to the dunes without attracting the attention of the enemy. "We crept down until we was about one hundred yards, when our party rushed out and summoned them to surrender," Bradbury explained in another letter to his friend. "One of the d——d scoundrels answered me with a 'ball & buck' it missed me, and I instantly drawed a bead on him with my 'Sharps rifle' and I made a hole in his face as big as an egg. I went up to the corpse and it was a horrible sight, oh god I hope & pray that this awful was will soon come to an end. But I had to

do this action for self defense, there was nothing on him excepting a rebel newspaper 'Wilmington Journal' and two or three envelopes."[429] Bradbury did not mention the fate of the other four rebels, and it is assumed that they escaped. Bradbury and the rest of the detachment returned to the *Cambridge* and resumed their regular duties.

This and other experiences prompted Bradbury to declare to his friend, "You can rest assured the blockade is as effective as it can be possibly and that we are constantly having exciting times, and dangerous too. But I hope the god of battles will protect me and carry me over again safe to 'Old Machias' but you can rest assured that whenever I am called to go I shall try to do my duty faithfully."[430]

Bradbury went on to participate in other events on the *Cambridge* and received a promotion to acting ensign. In May 1865, the navy transferred him to the Gulf of Mexico, where he served on several vessels, including the *Estrella*, *J. C. Kuhn*, and *Narcissus*. Bradbury commanded the *Narcissus*, an armed tugboat with a crew of thirty-two sailors stationed in Florida at the Pensacola Navy Yard.[431]

In late December 1865, Bradbury was ordered to take the *Narcissus* to New York City, where the vessel would be decommissioned and sold and he and the crew mustered out. Bradbury looked forward to returning to "Old Machias."[432] The *Narcissus* and a sister ship, the *Althea*, departed Pensacola on New Year's Day 1866. Three days later off Tampa Bay, the vessels encountered a storm. Bradbury and his counterpart on the *Althea* decided to pull into port and wait for the weather to clear. As the *Narcissus* steamed ahead at full speed, she struck a sandbar and grounded about two miles north of Egmont Key. Just after 7:00 p.m., her boiler exploded, and she sank with all hands aboard. There were no survivors.[433]

The next morning, the crew of the *Althea* found wreckage and the body of a sailor washed up on a beach. They also found Ensign Bradbury's papers.[434] Bradbury was twenty-six. His wife and a young daughter survived him.[435]

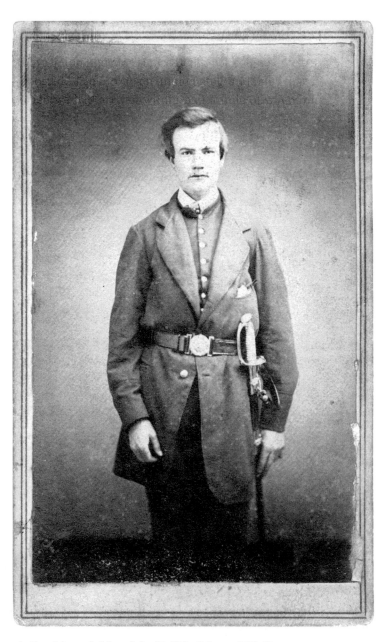

Acting Master's Mate John DeWitt Moore, U.S. Navy

Carte de visite by unidentified photographer, about 1863. Collection of Ron Field.

The Most Excellent Crew of the No. 9

An estimated three hundred Confederate cavalry attacked Union troops on a reconnaissance along the Mississippi River below Vicksburg on February 13, 1864. Surprised and outnumbered, the federals rallied and engaged in hand-to-hand combat until reinforcements arrived and drove the attackers away. Eleven Union men were killed. The rebels launched fresh attacks on each of the next two mornings, but they were repulsed.

This is the gist of an after-action report filed by the captain in command of the Union troops. His official account of events of the three-day period barely mentioned a crucial detail—the navy gunboat crew that came to their assistance.[436] She was the *Forest Rose*, a lightly armored stern-wheeler, or "tinclad." Equipped with six cannon, the sturdy steamer patrolled this section of the Mississippi. The ship was also known as the *No. 9* for the large identification number painted on the sides of her conspicuous pilothouse.

Her crack crew included seventeen-year-old John D. Moore from Floyd County in southern Indiana. "I was a school boy when I entered the service," stated Moore when asked about his military experience years later. He referred not to the navy but to a day back in 1862 when he joined the Seventh Indiana Legion, a state militia unit active along the boundary with the border state of Kentucky. He recalled that he was fourteen when he enlisted in the Seventh, although there is no record to support his claim.[437] Moore also noted that he left the legion to join the navy. According to a government file, he enlisted at Cairo, Illinois, on August 7, 1863.

The *Forest Rose* happened to be in Cairo at this time for routine repairs. She had recently participated in operations with Rear

Adm. David D. Porter's Mississippi River Squadron, including the campaign against Vicksburg, Mississippi, that ended with the surrender of the fortress city on July 4, 1863.[438]

Crew changes aboard the *Forest Rose* were also made in Cairo. Moore was assigned as a steward to the newly appointed paymaster. The commander was replaced by John V. Johnston, a highly respected officer who had received his lieutenant's stripes for gallantry during amphibious operations along the Mississippi River earlier in the war.[439]

Meanwhile, bands of Confederates supported by sympathetic locals operated in pockets along the river. Union army commanders dispatched expeditionary forces to drive them off. On January 29, 1864, one such expedition arrived at the Louisiana village of Waterproof, about sixty miles below Vicksburg. Commanded by Capt. Joseph M. Anderson[440] of the Eightieth Ohio Infantry, the 280-man force included troops from the Eleventh Louisiana Infantry, African Descent.[441]

The presence of black men in Union blue roused the indignation of the rebels. Their anger was heightened after Capt. Anderson sent scouting parties into the countryside around Waterproof every day during the first week of February. They seized horses, mules, weapons, cattle, and cotton.

The Confederate cavalry strikes against Anderson's men on February 13–15 might have ended differently had the *Forest Rose* not been present at Waterproof. Although Anderson did not mention her presence in his account, he did send a letter of appreciation to Lt. Johnston shortly after the events. It was preserved in navy records.

"Permit me to return to you many thanks for the gallant manner in which you defended my little force against the rebel forces," Anderson stated. "I hope you will not consider it flattering when I say I never before saw more accurate artillery firing than you did in these engagements, invariably putting your shells in the right place ordered. My officers and men now feel perfectly secure against a large force, so long as have the assistance of Captain Johnston and his most excellently drilled crew on board the *No. 9*."[442]

The *Forest Rose* fired 270 shells during the fighting. Moore's exact role is not known. But less than two weeks later he received a promotion to acting master's mate, and the timing suggests that he performed well under fire.[443] Moore's advancement to the officer's ranks included reassignment to another ship in the squadron, the *Avenger*. He served aboard her and another vessel, the *Moose*, until he received an honorable discharge in November 1865.[444]

Moore headed west to the Nebraska Territory and found work on the transcontinental railroad. According to one account, Moore "helped build the Union Pacific railroad from Omaha westward, became in turn a brakeman, conductor and finally and official of the road." He retired as a superintendent and lived in Helena, Arkansas, until his death from congestive heart failure in 1930. He was eighty-three years old. His wife, Mary, and a daughter, Mabel, predeceased him.[445]

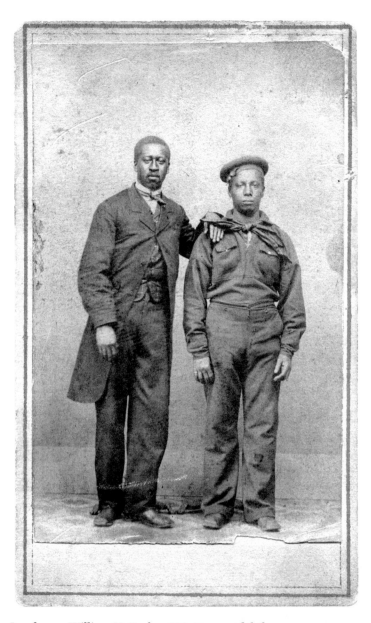

Landsman William H. Tucker, U.S. Navy, and father

Carte de visite by unidentified photographer, about 1864. Collection of Jerry and Teresa Rinker.

Lifting the Mystique of the Albemarle

Baltimore's vibrant community of free African Americans was an important source for navy recruits throughout the war. In one week alone, February 13–20, 1864, twenty-six Marylanders of color enlisted. They came from all walks of life, including porters and waiters, a barber, and a brickmaker. One of the men who enrolled was William H. Tucker, a twenty-three-year-old waiter with no evidence of prior sailing experience in his record.[446]

Tucker started his service as a landsman, the lowest rank in the navy. Landsmen typically performed unskilled labors aboard warships and navy stations. Tucker was assigned to the *Commodore Perry*, a side-wheel ferryboat attached to the North Atlantic Blockade Squadron in Baltimore for repairs.[447]

In April 1864, navy authorities assigned Tucker to the *Wyalusing*, a side-wheeler named for an old Indian settlement. She was a "double-ender," equipped with rudders on the bow and stern to navigate narrow waterways without having to turn around. She and her crew were ordered to the North Atlantic Blockading Squadron and joined a flotilla of warships stationed along the North Carolina coast at Albemarle Sound on April 29.

Meanwhile, the highly effective Union blockade had placed an economic stranglehold on the Tar Heel State. Determined Confederates built compact ironclad rams, designed especially for inlets and other shallow waters, to break the Yankee grip. Rumors about the ram program spread through the federal fleet and fueled fears among the crews.

In Albemarle Sound, a ram named for its home estuary made good on the rumors. On April 19, 1864, the *Albemarle* made a

dramatic debut. Confronted by Union blockaders, she sunk one and drove the others away.[448] The next day, Confederate forces captured the federal garrison at nearby Plymouth. Momentum shifted to the rebels as fears were heightened among the Yankees.

Landsman Tucker and his shipmates on the *Wyalusing* would soon have an opportunity to test the *Albemarle* in combat. On the afternoon of May 5, the *Albemarle* and two consorts steamed out of the Roanoke River, and the Union fleet drew her into battle. Five federal vessels, including the *Wyalusing, Mattabesett*, and *Sassacus*, pounded the *Albemarle* with heavy metal. The commander of the *Wyalusing* reported, "We opened fire simultaneously with the *Mattabesett* and *Sassacus*, passing the ram at the distance of 150 yards, firing rapidly." The *Wyalusing* circled back, according to her commander. "I made again for the ram and followed her up closely, passing around her and firing as often as possible at her, the distance varying from 100 yards upwards."[449]

The rebel ram roared back and blasted the blockaders with its big guns. Six shots struck the *Wyalusing*, including one that killed a sailor who manned one of the cannon. Another shot, a hundred-pounder, tore into the wooden planking on the starboard side about three feet above the waterline but caused no serious damage. Tucker and the rest of the crew were uninjured.[450]

The engagement ended that evening. A Northern newspaper recounted its conclusion. "Darkness coming on, the *Albemarle* slowly retreated, pursued by the gunboats. It succeeded in entering the Roanoke river, where further pursuit was deemed perilous. Our vessels sustained very slight damage. It is not know how much injury was done the enemy. The ram has lost its terrors. People have no further dread of it, and active preparations are making for its capture or destruction."[451]

The mystique of the *Albemarle* was lifted. The ram continued to ply inland waterways until she was struck and sunk by a spar torpedo during the night of October 27–28, 1864.[452] The

Albemarle was eventually refloated and taken to the navy yard in Norfolk, Virginia, where she lay until the end of the war.

Tucker's service ended when his one-year term of enlistment expired on February 15, 1865. It was the last time his name appeared on a government record. He was about twenty-four.[453]

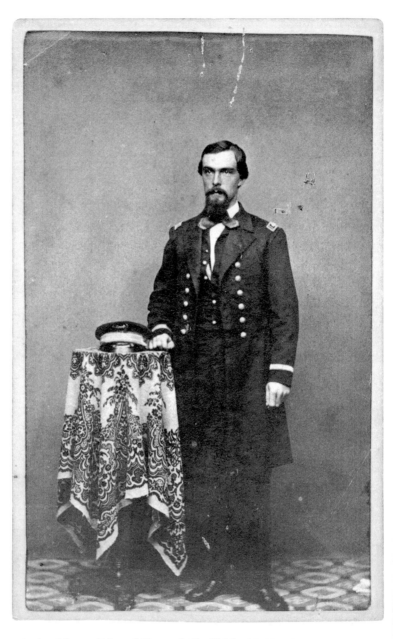

Acting Master Edward Hancock Sheffield, U.S. Navy

Carte de visite by an unidentified photographer, about 1862–1864. Collection of Ron Field.

Expedition to Capture the Little Ada

A GROUP OF REFUGEES IN A SMALL CRAFT HAILED THE Union gunboat *Winona* as she patrolled the South Carolina coastline near Charleston on March 21, 1864. Eight in number, they came aboard with news: a blockade-runner of Scottish origins, the *Little Ada*, had slipped past federal warships north of the city and steamed to the village of McClellanville to pick up a load of cotton.[454] An exchange of communications between the commander of the *Winona* and navy headquarters resulted in orders to find the *Little Ada* and prevent her from going to sea.

The *Winona* left Charleston harbor less than forty-eight hours later. A side-wheel steamer, she had recently joined the South Atlantic Blockade Squadron after extensive duty in the Gulf of Mexico and the Mississippi River. Her veteran crew included Acting Master Edward H. Sheffield, the *Winona*'s executive officer. The eldest son of a prosperous Connecticut ship's carpenter, he would play a key role in coming events.[455]

Sheffield and his shipmates arrived at the mouth of the Santee River, about forty-five miles north of Charleston, at 5:30 p.m. on March 23 and set anchor. At sunset, three small boats left the *Winona* in search of the blockade-runner. Sheffield led the expeditionary force, which included four officers and twenty-one crewmen. The commander of the *Winona*, Aaron W. Weaver,[456] stated in his after-action report, "I gave Mr. Sheffield orders to proceed up the Santee, and if he discovered the steamer *Ada* either to destroy her or bring her out."

Sheffield and his force returned at 4:00 a.m. the next morning after a fruitless search. Weaver, undeterred, weighed anchor and took up a new position about eight miles south and closer to McClellanville. He dispatched Sheffield's expedition about 5:00 p.m.

The three boats made their way through inland waterways as day turned into evening. Sheffield and his command explored several bayous without success. Finally, at 6:00 a.m. on March 25, Sheffield found the *Little Ada* anchored at McClellanville.

Weaver recounted Sheffield's next move. "It being by that time broad daylight, and fearful that he had been discovered, he determined to attempt the capture of the steamer. The boats got within a few hundred yards before they were perceived by the enemy." It began to rain, which may have made the approaching federals less visible.[457]

Sheffield and his men descended rapidly on the *Little Ada*. Her crew rushed about the deck in a frantic effort to escape. Two of the Union boats, with Sheffield in the lead, pulled along the *Little Ada*'s port side and scrambled aboard. The crew of the third craft ran across the blockade-runner's bow and intercepted a boat in which they found the fleeing captain. They forced him to return to the *Little Ada*. "The surprise was complete, and in five minutes the captain and crew were disarmed and below decks with a sentry at each hatch."[458]

Sheffield ordered fires started to bring the steam up in the engines and prepared the *Little Ada* for departure. But they ran into trouble at the stern of the ship, where intricate moorings and a short anchor chain slowed progress. The men grabbed cold chisels and began to cut through the thick chain.

Suddenly, a masked three-gun Confederate battery opened fire at short range, sending shot and shell into the *Little Ada*. The range was perfect and the surprise complete. Sheffield grew concerned for the safety of his men and the possibility that his boats might be sunk by enemy fire. He reluctantly withdrew.

Sheffield's force rowed away under heavy fire from the battery. Meanwhile, the enemy captain and his crew resumed control of the *Little Ada*. They opened fire from a small Whitworth gun mounted on the deck. "This fire was kept up some time after the batteries had ceased theirs, shrapnel bursting near the boats when they were a long distance off," according to Weaver. Sheffield and his men made it back to the *Winona* with the loss of one man, an

ordinary seaman who deserted to the enemy. Weaver dismissed him as "an Englishman, and a man of no character."[459]

Weaver was impressed with the conduct of the officers and men during the entire expedition, even though it failed to achieve its aims. He recommended Sheffield and the other officers for promotion in his after-action report.

Navy high command was not impressed. Secretary Gideon Welles fired off a letter to Weaver's commanding officer. "It is a pity that an expedition so well conceived and conducted with such perseverance should not have been provided with fire balls to set the steamer on fire below, in case she could not be brought out. A few pounds of powder would have disabled the machinery of the steamer entirely. The captain should have been brought off. For want of due preparation, the steamer is doubtless very little injured."[460]

Welles was correct. The *Little Ada* suffered only minor damage and was soon back at sea. But her career as a blockade-runner was short lived. On July 9, 1864, the warship *Gettysburg* captured her at Cape Romain, South Carolina. The *Little Ada* was converted into a Union warship and went on to participate in the attacks that culminated in the fall of Fort Fisher in January 1865.[461]

Sheffield continued to rank as acting master and later commanded the *Winona*. He received an honorable discharge in October 1865. He returned to his home in Stonington, Connecticut, and rejoined his wife, Hannah, whom he had married during a furlough just a few months before the *Little Ada* encounter.

Sheffield worked as a ship's captain for many years. He lived until age eighty-five, dying in 1923. His wife predeceased him, and a son, George, survived.

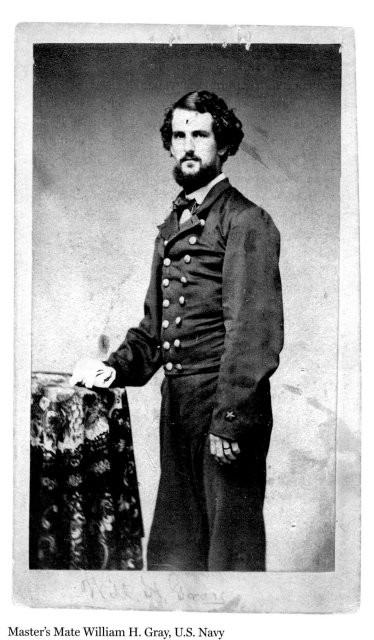

Master's Mate William H. Gray, U.S. Navy

Carte de visite by an unknown photographer, about 1863–1864. Collection of Ron Field.

Dispatched to the Relief of Fort Pillow

On April 13, 1864, a report that the Union garrison of Fort Pillow, Tennessee, was under attack prompted swift action from the navy. The captain responsible for the federal fleet along this section of the Mississippi River dispatched two gunboats to assist the beleaguered fort.[462]

One of the vessels ordered into action was the *Hastings*, a small light-draft steamer well suited for operations in the shallow tributaries of the Mississippi. She was also known as *Gunboat No. 15* for the large numbers painted on her pilothouse.

The crew of the *Hastings* included Master's Mate Will Gray. The son of Irish immigrants, he had been born in Illinois and called Peoria home. Gray had jumped into the Civil War a week after the bombardment of Fort Sumter. He enrolled as a private in the Eighth Illinois Infantry for a three-month term on April 20, 1861, but his enlistment was cut short after two months when he was discharged for disability.[463]

Two years passed before Gray returned to uniform. In mid-1863 he joined the navy and was assigned to the *Hastings* as master's mate. He and his shipmates engaged in various activities in western waters, including duty as a transport to ferry troops from Maj. Gen. William T. Sherman's army across the Tennessee River during operations that culminated in the victorious Battle of Chattanooga in November 1863.

Rebel activity in Tennessee continued into 1864. Maj. Gen. Nathan Bedford Forrest and seven thousand cavalry raided the western part of the state and eastern Kentucky. On April 12, a 1,500-saber-strong detachment of Forrest's troopers launched a furious assault against Fort Pillow. The 557-man garrison, which

included 262 African American soldiers, waged a desperate fight. The garrison received supported from the gunboat *New Era*.

By the time the *Hastings* arrived, on the afternoon of April 14, the outcome of the attack had been determined. Forrest's cavalry captured Fort Pillow and massacred African Americans after they had surrendered. The rebels removed the cannon, set fire to valuables that could not be carried away and to tents that housed wounded federal casualties, and abandoned the ruined fort.

Gray and his comrades, and crews from other gunboats on the scene, secured the area. Their first order of business was to drive away Confederates who lingered in the vicinity of the fort. The overall commander of the naval forces, Lt. Cmdr. Le Roy Fitch, reported, "After learning the true state of affairs, I ordered the *Hastings* to round to and shell the woods along up to Plum Point, as the rebels were there in strong force in these woods and were showing their honesty and bravery by firing the wood piles along the bank." He added, "The *Hastings* also got several good shots at them behind the woodpiles."[464] The heavy fire hastened the withdrawal of Forrest's command.[465]

Detachments of sailors landed at the fort to evacuate wounded and provide other assistance as needed. Gray, in his capacity as master's mate, would likely have been included in a landing party. He left behind no formal record of his activity or observations, but one civilian eyewitness recorded the horrors he observed in a letter to the editors of the Memphis *Argus*: "Now that the excitement is over, the thought of those charred bodies, together with the nausea occasioned by the burning human flesh, and the 200 or more dead bodies mangled, dying as they did, pleading for quarter, many with faces distorted with pain, eyes bayoneted, skulls broken, and some with bowels torn from the human casements, some so besmeared with blood and the flesh of comrades as to render them incog. to even their own fathers and mothers, it has sickened me that I can write no more."[466]

Gray continued to serve on the *Hastings* until June 1865, at which time the gunboat was only a few weeks away from being

decommissioned. He served briefly on another vessel, the *Juliet*, before his discharge in August 1865.

Gray returned home, went to work as a clerk, and married in 1870. He and his wife relocated to Chicago and started a family that grew to include a son and a daughter. They eventually moved to New Mexico Territory. In 1882, Gray fell sick with smallpox and succumbed to the infection after a short illness at about age thirty-nine.[467]

Seaman Frederic Bearse, U.S. Navy

Ninth-plate tintype by an unidentified photographer, about 1862–1864. Collection of Dan Binder.

From Corporal to Seaman

In camp along the Virginia Peninsula near York-
town on April 24, 1864, the rank and file of the Thirteenth New
Hampshire Infantry stripped down to light marching order.
They reduced their belongings to the uniform on their backs,
one change of underclothes and whatever they could fit in the
knapsacks. The spring campaign was about to begin and hard
times lay ahead.[468]

One corporal in the ranks would not be going with them. Fred-
eric Bearse bid his comrades farewell and left camp that day to
join the navy. His move coincided with the publication of General
Order 91. Issued by the War Department in Washington, it al-
lowed any soldier who could prove his vocation was a mariner a
transfer to the navy.

The navy's operations had expanded faster than its manpower,
and it desperately needed experienced seamen. Bearse, forty-two,
fit the bill. Born and raised in the Cape Cod village of Barnstable,
Massachusetts, he had made his living as a sailor for many years.
But by the time the war came, Bearse had settled into the life of
a miller in Exeter, New Hampshire, with his wife, Ann.

In the summer of 1862 he enlisted in the Thirteenth, one of
the many regiments across the Union organized in response to
President Abraham Lincoln's call for 300,000 men to put down
the rebellion. Bearse, old enough to be the father of most in the
ranks, may have been motivated to join the army by his eldest
brother, Austin. A sea captain who had observed the horrors of
slavery firsthand in his travels in the deep South and elsewhere, he
had become a fervent abolitionist and an active participant in the
Underground Railroad.[469] Bearse might also have been inspired

by his late father, Eleazer, an infantry private in the Massachusetts militia during the War of 1812.[470]

Bearse took his place in Company G as a corporal and traveled with the regiment to Washington, D.C. In December 1862, the Thirteenth moved into Virginia and was present for the Battle of Fredericksburg, though little engaged in the fight. Afterwards, the regiment reported to eastern Virginia and participated in operations against Suffolk and other coastal flash points through the spring of 1864.

On May 4, 1864, ten days after Bearse left to join the navy, the Thirteenth broke camp and marched off into the spring campaign. The regiment participated in the Battle of Cold Harbor and the Siege of Petersburg, and numbered among the first to enter Richmond after Confederate forces evacuated the city on April 2, 1865.

Bearse spent the rest of the war as a bluejacket on warships in the Atlantic. He started on the frigate *Minnesota*, the flagship of the North Atlantic Blockade Squadron. As a member of the crew of the side-wheel steamer *Miami,* Bearse participated in operations in the James River against Richmond and Petersburg. He also served on the flagship *Malvern*, which famously transported President Lincoln to Richmond after the Confederate government and military evacuated the city.

Bearse mustered out of the navy in October 1865 and returned to his wife in Exeter. He found a job at the freight station of the Boston & Maine Railroad and eventually became its superintendent. In 1871, he died of heart disease at age fifty. The couple had no children.[471]

$2,545.43

The newly commissioned Union gunboat *Mattabesett* arrived worse for wear at Pamlico Sound on April 26, 1864. Battered by a southeastern gale en route from Hampton Roads, Virginia, to the North Carolina coast, she suffered damage to her protective ironwork and steering.[472]

Her rough and tumble journey to North Carolina was a harbinger of active times ahead. The vessel and crew would be heavily engaged in operations along inland waterways of the Tar Heel State over the next year.

The man who carried the heaviest responsibility on the *Mattabesett* was no doubt her captain. But the busiest and perhaps most overworked individual was likely her acting assistant paymaster, Henry Meigs Meade. The twenty-four-year-old New Yorker was designated as the lone disbursing officer for all of the many federal vessels in the regional fleet. It fell to Meade to balance the ledger books in a challenging theater of operations with meager resources. Meanwhile, his superiors in Washington held him to strict accountability. To add to his burdens, Meade was also placed in charge of the delivery and distribution of gunpowder on his own ship.[473]

Meade might have known what he was getting into when he joined the navy, for he hailed from a patriotic family with deep military roots. His uncle was Maj. Gen. George G. Meade, the commander of the Army of the Potomac. Quartermaster General Montgomery C. Meigs was his third cousin. Older brother Richard Worsam Meade Jr., who graduated from the U.S. Naval Academy in 1856, commanded a gunboat during the war and retired years later as a rear admiral. Younger brother Robert Leamy

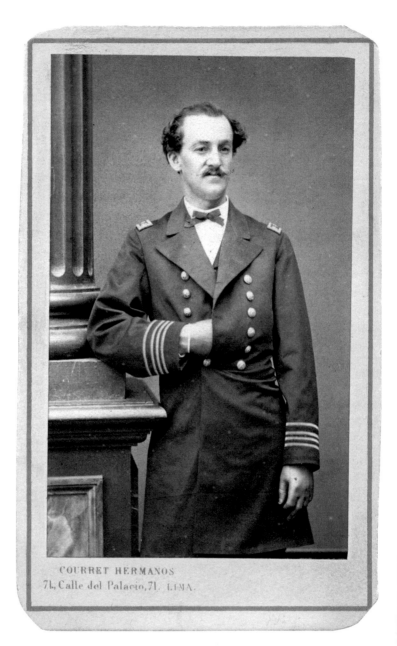

Paymaster Henry Meigs Meade, U.S. Navy

Carte de visite by Eugenio Courret (1841–about 1900) & Aquiles Courret (life dates unknown) of Lima, Peru, about 1869. Collection of the author.

Meade, a Marine officer, attained the rank of brigadier general in a long career marked by gallant and meritorious service.[474]

By all accounts, Meade did the best he could in North Carolina. Still, when his yearlong stint on the *Mattabesett* ended in May 1865, clothing and other small items valued at $1,052.53 were missing. "It was impossible under the circumstances, amidst the excitement and confusion of the frequent engagements by the fleet with the enemy, to avoid such losses," noted the Committee on Naval Affairs of the U.S. House of Representatives in a postwar report.[475]

Meade remained in the navy after the end of hostilities. He was assigned to the Navy Department in Washington and served in the Bureau of Provisions and Clothing for a while. In 1868, he advanced to full paymaster, with the salary and benefits of a lieutenant. In this capacity he sailed the South Pacific on the *Kearsarge* and the Eastern seaboard on the *Iroquois*.[476]

Then, calamity struck. During a four-month period in 1871 according to the Committee on Naval Affairs, "it was the misfortune of Mr. Meade to fall suddenly into habits of dissipation, caused by domestic concern." The committee did not detail the nature of his troubles, but as he never married they may have involved his extended family or have been business related.

Meade was dismissed from the navy on February 23, 1872. He left with a tarnished reputation—and a bill from the Treasury Department. He was held accountable for the material losses during his time on the *Mattabesett* and the rest of his ten years in the service. The total due was $2,545.43.

Friends and former shipmates came to his aid. Six months later his dismissal was revoked and his resignation accepted. This restored his honor to a degree. But there was still the matter of monies owed. A move to dismiss the charges against him made its way through government channels. In 1878, the Committee of Naval Affairs issued a report that exonerated Meade of any wrongdoing and recommended passage of bill for his relief. A revised report issued the following year stated, "During his service more than twenty millions of dollars worth of money and

property passed through his hands, and his duties during the war were extremely arduous." Additionally, "In the peculiar situation in which said Meade was place during the war, it was impossible for him to avoid losses, and relief has been frequently granted by Congress in cases not so deserving as the one presented by him."[477]

On March 1, 1879, Congress passed the bill that authorized the Treasury Department to credit Meade's overdue account "for unavoidable losses and checkages sustained by him in the legitimate performance of his duties as paymaster in the United States Navy."[478]

Meade lived in Washington for the rest of his days. Active in the Grand Army of the Republic, he maintained membership in Meade Post No. 1 in Philadelphia, which was named in honor of his uncle.

The life-span of Meade men tended to be less than the average, and so it was with Henry Meigs Meade. He died at age fifty-seven in 1897. His remains were interred in Arlington National Cemetery with full honors.

Trouble on the Neptune

The *Neptune* was falling apart. The wooden warship was taking on eighteen to twenty-two inches of water per hour, and her crew worked pumps almost around the clock to keep her afloat. The leakage was attributed to several sources, which included the weight of a heavy gun that fired hundred-pound shells. It caused the main deck to sag.[479]

The primary cause was an extended period of rigorous ocean duties. For several months in early 1864 the *Neptune* traversed the same section of the Caribbean Sea. On each occasion, she protected civilian vessels laden with riches bound from California to the northeast Atlantic coast from rebel privateers.

The crew of the *Neptune* included Charles C. Chamberlain. A mariner from Bangor, Maine, he hailed from an old New England family with notable military connections.[480] His grandfather, Joshua L. Chamberlain, had served as a militia colonel during the War of 1812 and suffered defeat at the Battle of Hampden on September 3, 1814. Victorious British troops had then sacked Bangor and neighboring villages. The loss marred Col. Chamberlain's military reputation.

Chamberlain's cousin, Col. Joshua Lawrence Chamberlain of the Twentieth Maine Infantry, fared better than his grandfather. On July 2, 1863, during the second day of the Battle of Gettysburg, Chamberlain and his regiment stubbornly resisted determined Confederates in the desperate fight for Little Round Top. He became a war hero.

Perhaps inspired by his cousin's military success, Charles Chamberlain joined the navy as an acting master's mate on August 7, 1863—about one month after Gettysburg.[481] His first assignment was the *Neptune*. A large screw-propelled steamship

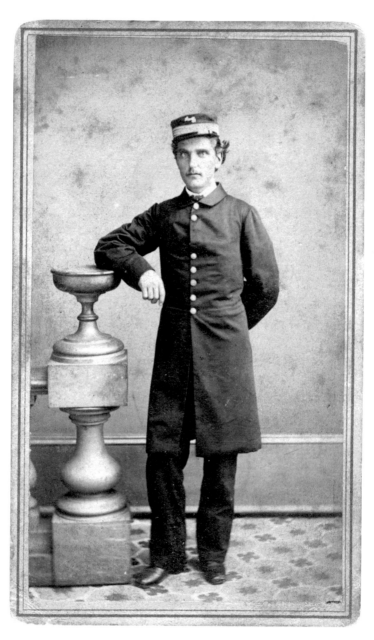

Acting Master's Mate Charles Carroll Chamberlain, U.S. Navy

Carte de visite by Richard A. Lewis (1820–1891) of New York City, about 1863–1864. Collection of Ron Field.

armed with eleven guns, she measured 209 feet long—30 feet longer than the ironclad *Monitor*. In January 1864, the *Neptune* with Chamberlain aboard departed New York for the West Indies with orders to protect California steamers.

The *Neptune* arrived in the harbor of Cap Haitien in northern Haiti on February 9, 1864. Over the next four months, this work-horse of the West India Squadron accompanied seven convoys without incident. During the eighth convoy, the cumulative effect of ceaseless activity and climate resulted in leaks that crippled the ship. Mechanical failures also surfaced. The crew was forced to abandon its convoy and return to Cap Haitien, where the vessel's chief engineer evaluated the damage and recommended a complete overhaul.[482]

The *Neptune* limped back to New York for repairs in June but soon returned to the West Indies, where she resumed her duties. Chamberlain remained a member of the crew until the fall of 1864, when navy authorities transferred him to the newly constructed iron-hulled side-wheel steamer *Suwanee*. Assigned to the Pacific fleet, she spent the rest of the war on patrol for Confederate raiders.

Chamberlain served as master's mate on the vessel until he received an honorable discharge in July 1865. He remained on the west coast and died in San Francisco of an unknown cause in 1869. He was about twenty-nine years old.

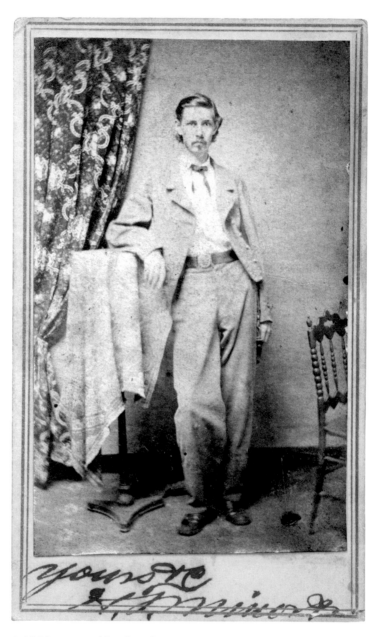

Midshipman Hubbard Taylor Minor Jr., C.S. Navy

Carte de visite by Richard H. Howell (about 1821–) & Brown (life dates unknown) of Savannah, Georgia, about 1863. Collection of David W. Vaughan.

Brilliant Affair on Ossabaw Sound

SOUTHERNERS IN A CLUSTER OF BOATS ROWED ACROSS Ossabaw Sound off the Georgia coast under cover of darkness and storm clouds during the night of June 2–3, 1864. Drizzling rain and rumbling thunder obscured the sound of oars slapping water. The occasional flash of lightning lit up the channel, remembered one of the men, like a "sea of fire."[483]

The man, not much more than a boy, was Hubbard Minor. A midshipman at the Confederate Naval Academy, he had recently been assigned to the Savannah Squadron for training. Though unpracticed in naval warfare, the nineteen-year-old brought a depth of military experience that belied his age. He had joined the Confederate army at seventeen and earned a reputation as an excellent artillerist in the defenses of Port Hudson, Louisiana, and Jackson, Mississippi.[484]

Minor requested a transfer to the navy as soon as he turned eighteen. "His hope was to win a share of the glory which Semmes and his confreres were reaping on the ocean," noted one writer with a reference to Capt. Raphael Semmes, the feisty Marylander who had wreaked havoc on Yankee ships.[485]

The application was accepted in July 1863. Minor joined other midshipman at the newly established academy on the school ship *Patrick Henry*, anchored in the James River near Richmond. "We have it a great deal worse that I expected & sometimes I wish I were still in the army," he confided in his diary that summer, "but then I think that here I am getting a good education & at the same time serving my country I am content."[486]

Minor proved a good student, though deficient in conduct—he was fond of a good cigar and pretty young ladies. Still he managed to pass his exams and before the end of the year received an

assignment to continue his training in Georgia on the ironclad warship *Savannah*.

The Northern blockade of the Atlantic coast had crippled the Southern economy. Georgia and its principal coastal city, Savannah, suffered as a result. One of the Union vessels that menaced the region was the side-wheel steamer *Water Witch*, a light-draft vessel capable of maneuvering in shallow inlets.

On May 31, 1864, the flag officer in command of the Savannah Squadron, William W. Hunter,[487] ordered the capture the *Water Witch*. A 131-man expedition was formed and placed under the command of 1st Lt. Thomas P. Pelot, a former U.S. Navy officer who had followed his native South Carolina into the Confederacy.[488] Fourteen officers were detached from their regular duties and ordered to report to Pelot, including Minor.

"Mr. Pelot said that it was the finest body of men he had ever saw," Minor reported in his diary.[489] The expedition set out in seven rowboats the same day. Pelot commanded the lead boat, which included Moses Dallas, a pilot of African descent paid by the Confederate government. Pelot's executive officer and next-in-command, Lt. Joseph Price,[490] was in charge of the second boat, and Minor commanded the third.[491]

The following evening, June 1, the expedition set out to capture the *Water Witch*. However, either the blockader had shifted its position or Pelot and his crew lost their way in the dark, and the mission ended without success. The Confederates made a second attempt the next night. The expedition launched about 8:00 p.m. and by 12:30 a.m. they were in position. The boats then moved out in two columns across Ossabaw Sound in search of the *Water Witch*. "About 2 a.m., we discovered a light which we supposed to be that of a vessel, as nearer we came by the lightning's flash we discovered the vessel we were in search of," Minor stated. It was the *Water Witch*, and she was about a thousand yards away. The men continued to row steadily and silently towards her. "When with in three hundred yards all seemed to be asking God, as I know I was, to prosper our undertaking, to shield us from harm, & to make us do our duty."[492]

The boats advanced to within eighty yards of the target when a voice broke the silence. It was a hail from the *Water Witch*. Pilot Moses Dallas answered, "Runaway Negroes," followed instantly by Pelot, who shouted, "We are Rebels, give way boys!"[493]

The sixty-eight officers and crew of the *Water Witch* hustled to battle stations. Her steam was up, and her great paddle wheel began to turn rapidly backward and forward in an effort to prevent the enemy from boarding. Moments later, Pelot's boat struck the port side of the *Water Witch* and the boat commanded by executive officer Price simultaneously hit the starboard side. The boat containing Minor and his men came up behind Pelot, and two more of the small craft soon bumped up against the ship. The men scrambled out of their vessels and began to slash protective netting on the sides of the *Water Witch*.[494]

A hail of small arms fire rained down upon them as they cut through the nets and gained the deck. Pelot was mortally wounded after a bullet ripped into his chest and pierced his heart. He lived but a short time. Lt. Price continued the attack. Minor suffered a bullet wound in the left leg. "I was shot soon after touching the deck by one of the lookouts, who after shooting me ran down to the hatch which I was guarding. I shot the man going down the hatch, but only wounded him."[495]

Hand-to-hand combat raged as the hiss of bullets and clank of cutlass blades mixed with the screams and shouts of blue and gray. Ten minutes later the fight ended with Price, Minor, and their comrades in control of the *Water Witch*.

Casualties to the Union crew totaled twelve. The Confederates lost twenty-two, including eight dead and fourteen wounded. Among the killed was pilot Moses Dallas. He died before his boat reached the *Water Witch*. The loss of Dallas deprived the Confederates of the only man capable of navigating the warship to friendly waters. The lieutenant found the Union pilot and discovered that he had been badly wounded and was unable to assist. Price finally compelled one of the Yankee quartermasters to pilot the ship.

The vessel ran aground no less than three times as she steamed

along narrow waterways to safety inside the Confederate defenses of Savannah. The *Water Witch* anchored off Burnside Island at Battery Beaulieu that evening. "When we came up we had a boat pennant flying above the stars & stripes & we met with hearty cheers from all the assembled spectators," Minor recounted.[496]

He added, "I must say that all those who boarded the vessel merit honor for so doing & none but gallant men dare do such things." Flag Officer Hunter agreed with Minor's assessment. He described the capture of the *Water Witch* as a "very brilliant affair" and heaped praise on all who participated.[497]

Minor was sent with other wounded to a Savannah hospital and made a full recovery. He parted ways with the *Water Witch* at this time. Her service as a Confederate warship was short lived. Six months later, on December 19, 1864, she was burned to prevent capture by Maj. Gen. William T. Sherman's Union army on its march through Georgia. The following day, Minor evacuated Savannah with other Confederates as Sherman's advance forces bore down on the city. Minor spent Christmas and New Year's Day 1865 in Charleston while the Union army celebrated in Savannah.

Three months later, on April 3, 1865, Minor was part of another major evacuation when Richmond fell to Union troops. He marched out of the capital with other navy men and headed south. He had plans to return to Georgia, where he would reunite with Anne Cazenove Lamar, a belle who captured his heart during his deployment in Savannah.[498]

He traveled as far as Charlotte, North Carolina, where he encountered Union soldiers who confiscated his sword but did not take him prisoner. There is no record that Minor ever surrendered or took the oath of allegiance to the federal government.

Minor eventually made it to Savannah and reunited with Anne. They married in 1867. She gave birth to a boy and a girl before she succumbed to typhoid fever in 1870. Four years later Minor died of an unknown cause at age twenty-nine.

Nine Shots at Tunica Bend

REAR ADM. DAVID D. PORTER WAS VEXED BY REBEL ACTI-
vity along the Mississippi River during the summer of 1864. Iso-
lated batteries in northern Louisiana had become a general nui-
sance. Every so often one would pop up and take a few potshots at
ships before being driven away. "This firing is extremely annoying
to passenger boats with women and children on board," Porter
observed in a report to secretary of the navy Gideon Welles. "As
long as they fire on the gunboats we do not mind them, though
they occasionally do damage and kill men."[499]

The officers and men of the *Naiad* could speak firsthand to
Porter's statement. A stern-wheel steamer that had only recently
joined Porter's Mississippi Squadron, her crew included a twenty-
year-old army veteran fresh off the front lines. Lewis Laybourn
had just completed a six-month enlistment with the 129th Ohio
Infantry in Kentucky. He and his comrades had skirmished
against Southern forces and participated in the capture of the
two-thousand-man garrison at Cumberland Gap. Laybourn mus-
tered out of the regiment in early March 1864 and before the end
of the month joined the navy.[500]

The federal navy needed ships to bolster its defense of the Mis-
sissippi River and its tributaries against enemy raids. In Cincin-
nati, purchasing agents acquired the merchant steamer *Princess*
and converted her into the *Naiad*. The navy commissioned the
Naiad on April 3, 1864. Laybourn was assigned to one of eight
gun crews and designated its fireman. His weapons of war in-
cluded a fire bucket and ax, and both would be used during battle
to extinguish flames and clear debris.

Laybourn served in this capacity when the *Naiad* encountered
one of the batteries that irked Rear Adm. Porter. The *Naiad* was

on patrol before dawn on June 15, 1864, when she happened upon a sister ship, the *General Bragg*, engaged with enemy artillerists above Baton Rouge at Tunica Bend. The commander of the *Naiad* reported, "I got up steam immediately and ran to her assistance. When we had arrived within half a mile of where the *General*

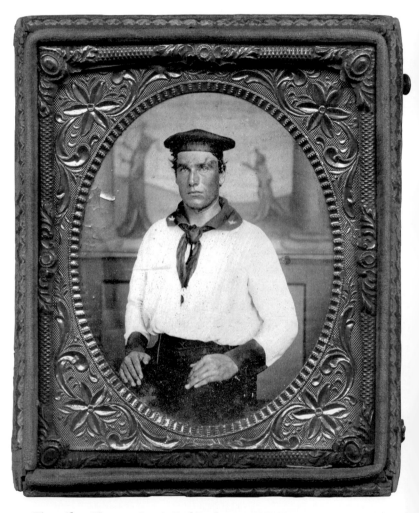

First-Class Fireman Lewis Joel Laybourn, U.S. Navy

Sixth-plate tintype by unidentified photographer, about 1862–1865. Collection of Jerry and Teresa Rinker.

Bragg lay, a rebel battery opened on us, directing the shots at first toward the pilot house, and in a few shots completely disabling our steering apparatus."[501]

Some of the crew turned to ropes and pulleys to steer the ship while others, including Laybourn, scrambled into action and opened a brisk fire from the *Naiad*'s guns. The Confederates continued to strike with deadly accuracy. Nine shots tore into the *Naiad* and shattered the pilothouse, mangled the steering, and damaged one smokestack. Casualties included one killed and six wounded. Laybourn survived without injury. The *Naiad* fired thirty-seven shots before the battery was silenced then limped back to its base for repairs.

The action prompted Rear Adm. Porter's letter to Gideon Welles. Porter used the opportunity to fire a potshot at the Union army. "These batteries will continue to come in on the river until more effective measures are taken by the military authorities to land troops and chase them up until they are all taken." He added, "I am in hopes we will soon have proper landing parties of troops prepared to act in concert with gunboats, when there may be a hope of keeping the river free of these marauders."[502]

The *Naiad* continued to patrol the Mississippi and associated waterways for the remainder of the war. Laybourn received a promotion to first-class fireman and expanded duties that involved work in the engine, coal and ammunition rooms. He served brief stints on several other gunboats, including the *Black Hawk*, during which time he posed for his tintype portrait.

Laybourn left the navy in April 1865 with an honorable discharge. He returned to his birthplace in Clark County, Ohio, and became a farmer. "He pays considerable attention to the growing of corn and wheat, rotating those cereals with clover and grass. Mr. Laybourn has a thorough understanding of the principles of agriculture and has an equipment that enables him to carry it on according to the most approved and successful methods," observed one county historian.[503]

In 1873, Laybourn married Jennie Bird, who gave birth to a daughter, Mary, in 1885. One year later Jennie died, and Lay-

bourn raised infant Mary on his own. Laybourn lived until age ninety, dying in 1934. Mary survived him.[504]

He was well remembered by neighbors and friends. Another county historian noted, "Mr. Laybourn has held rank as one of the most extensive and successful farmers of his native county, is a man of fine personality, a loyal and progressive citizen, and commands the high regard of all who know him."[505]

Victory at Cherbourg

Accounts of soldiers and sailors who made accurate premonitions of their own deaths in battle occurred with grim regularity during the Civil War. Less common was the man who believed he would survive and committed it to writing.

Such was the case with Union navy engineer William Cushman of the sloop-of-war *Kearsarge*. "A gleam of light appears to tell me that in the Allwise being who directs all things has not decreed that I should be taken away," he wrote to his mother in Philadelphia on June 15, 1864. "I feel as if tho terribly wounded I would be allowed to survive for your sake."[506]

Cushman penned the letter just after he received disturbing news. Capt. Raphael Semmes and his pirates aboard the rebel privateer *Alabama* were coming out to fight that night or the next day. The *Alabama* had terrorized the Northern merchant fleet unchallenged for two years, during which time Semmes and his boys had taken sixty-five prizes and destroyed a Union gunboat.

Cushman pondered his fate and that of his mates. He debated their chances in the letter to his mother. All things considered, he explained, the two vessels were almost equally matched. Though the *Alabama* was more powerfully armed, the *Kearsarge* could better concentrate her firepower. "We throw the heaviest weight of metal at a broadside," he noted. "If our shot is decently managed we will whip her in half an hour."[507]

There was another advantage, Cushman acknowledged to his mother, that favored the *Kearsarge*—his side fought for a righteous cause. Though Cushman did not elaborate on the point, his statement carried the weight of his military experience.

Cushman had joined the navy in 1855 as a third assistant engineer. By 1859, he had advanced to first assistant. That summer,

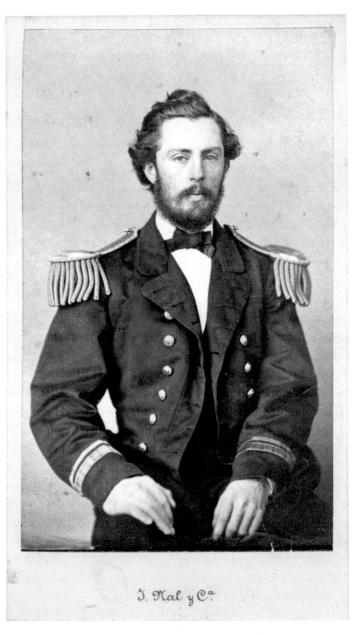

Chief Engineer William Henry Furness Cushman, U.S. Navy

Carte de visite by José Nal (life dates unknown) & Co. of Cádiz, Spain, about 1865. Collection of Earl Sheck.

he was assigned to the steamer *Wyandotte* on a Caribbean cruise to track slave ships that carried illegal cargoes of Africans. On May 9, 1860, the *Wyandotte* captured the slaver *William* off the Cuban coast. Based in Baltimore and flying the Stars and Stripes, the *William* left the Congo River for Key West with 744 souls. By the time the *Wyandotte* intercepted her, only 570 individuals remained.[508]

Later that year, the *Wyandotte* arrived at the navy yard in Pensacola, Florida, for minor repairs. On January 9, 1861, the work was completed and the vessel returned to duty. Three days afterwards armed rebels demanded and received the surrender of the navy yard. The commander of the *Wyandotte*, Lt. Otway H. Berryman,[509] refused to hand over his ship and remained in the harbor. Boats from the *Wyandotte* and the only other federal ship present, the *Supply*, transported Union troops spread out in detachments around the harbor and consolidated them in Fort Pickens at the mouth of the bay. Here, it was determined, federal forces could best protect Union interests.

During the tense weeks that followed, rebels in Florida and elsewhere across the South expanded their gains as the Union dissolved. The bombardment of Fort Sumter heralded the birth of the Confederate nation.

Back in Pensacola Bay, the *Wyandotte* floated defiantly. Cushman and the rest of the crew stood watch over Fort Pickens until reinforcements arrived. One of the vessels dispatched to the scene was the frigate *Sabine*. Her captain, Henry A. Adams,[510] praised Cushman, "During a long period of daily and nightly excitement, and frequent alarms, he was constantly at his post, and through his close attention and exertions the engines were kept in such order as to be available at a moments notice. The services of the *Wyandotte* were of the highest value during this time, and I believe it was through his care and ability they were not lost to us."[511] The endorsement from Adams was made to a navy board of examination. It recommended Cushman for a promotion to chief engineer, and he received the honor in October 1861.

A few months later, in February 1862, the newly commissioned

Kearsarge steamed from the docks of navy yard at Portsmouth, New Hampshire, with Cushman in charge of the engineering division. He and his mates were under orders to hunt Confederate raiders along the coast of Europe.

In November 1862 the *Kearsarge* arrived at the Spanish port of Cádiz, where Cushman sat for his *carte de visite* portrait. While he and his shipmates wintered in the coastal city, a new threat to Union commerce ships emerged—the *Alabama*. The sleek new steamer was under the command of Semmes. He had most recently captained the cruiser *Sumter* on a six-month journey that yielded eighteen prizes.

Semmes's reign of terror continued on the *Alabama*. The *Kearsarge* left Cádiz in March 1863 and searched up and down the northern European coast to no avail. Finally, on June 14, 1864, the Union vessel blocked the *Alabama* in the French port of Cherbourg, where she had sought refuge and repairs. Cushman wrote his mother the next day. "We have made up our minds that we will have a hard fight & I think being in the right must come off victorious," he declared.[512]

On June 19, under blue skies and light clouds, Cushman's prediction came true. The fight lasted sixty-five minutes, during which time the *Kearsarge* fired 173 rounds and sunk the *Alabama*. The *Kearsarge* was hit by twenty-eight shots, twelve of which struck the hull. Two shells ripped into the engine room where Cushman was stationed but caused no injuries.[513]

A jubilant Cushman wrote his mother the same day, dating the letter from the "U.S.S. Victorious Steamer *Kearsarge*": "We had the pleasure of seeing her haul down her flag—it had been twice shot down—& surrender."[514] The executive officer of the *Kearsarge*, Lt. Cmdr. James S. Thornton,[515] praised the officers and crew in his after-action report, "The engineer's division was admirably and efficiently conducted under the command of Chief Engineer W. H. Cushman." Ship's captain John A. Winslow[516] endorsed the sentiment.[517]

News of the destruction of the *Alabama* swept through the North, and its citizenry heaped additional praise—and in some

cases cash—on the victors. Grateful merchants in New York took up a collection under the auspices of the state Chamber of Commerce and awarded Cushman a share of $800. In New England, the Board of Trade in Boston followed suit with $500.[518]

He would put the money to good use on behalf of his mother, Frances. Years of abuse by a philandering husband who had failed in business had taken a toll. Cushman, the eldest son of six children, had long filled the emotional and financial void created by his ne'er-do-well father.

About the time the awards were announced, Cushman was diagnosed with tuberculosis. Sent home to Philadelphia, he barely survived the war, succumbing to the infection on November 2, 1865. He was twenty-eight years old and unmarried. His devastated mother divorced her husband shortly before Cushman died. She received all of his prize money and a navy pension until her death in 1877.[519]

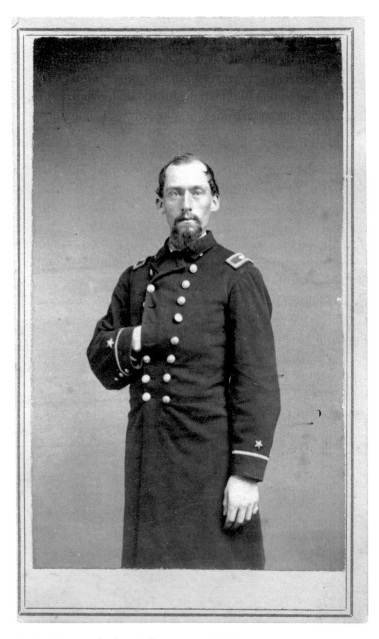

Acting Ensign Charles Mellen Rowe, U.S. Navy

Carte de visite by Howard (life dates unknown) & Marsh (life dates unknown) of Brooklyn, New York, about 1864–1865. Collection of the author.

Stint on a Monitor to Nowhere

In the summer of 1864, President Abraham Lincoln and his administration were taking a serious beating from the press across the war-weary North. The Union armies were in a stalemate in front of Richmond and Atlanta. Lincoln became convinced that he would not be reelected in November.

To add to his burdens, the Navy Department was lambasted for the shoddy construction of new class of twenty monitors. One of them, the *Naubuc*, was the subject of a scandalous and scathing report in the *New-York Tribune* on June 24, 1864. Statements by an anonymous source revealed inferior materials, poor workmanship, and dishonest dealings that plagued the project. "If all or any considerable part of the allegations are true, they disclose a systematized and deliberate fraud in the building of a vessel of war, to the stanchness of which perhaps the honor of the nation, and certainly hundreds of lives, are to be intrusted."[520]

Meanwhile, in Maine, a twenty-three-year-old sailor, Charles Rowe, joined the navy. One of seven children born to a North Yarmouth farmer and his wife, he had an older brother in the army.[521] He was appointed an acting ensign on October 5, 1864. The timing of his appointment occurred a month after the fall of Atlanta to Maj. Gen. William T. Sherman's army. The victory gave renewed hope to a critical mass of Northerners that the end of the war was in sight and ensured Lincoln's reelection.

Rowe may have seized what appeared to be the last chance to see the war firsthand. He could not have known how little he would actually see. A few weeks after his appointment, Rowe was assigned to the *Naubuc* and reported to the Brooklyn Navy Yard for duty.

By this time, the *Naubuc* had been launched and deemed un-

seaworthy. Her poor construction, a faulty design that affected the performance of many monitors, and bureaucratic meddling were to blame. Navy authorities acted promptly to clean up the bureaucracy.[522] They also converted the *Naubuc* and other problematic monitors to light draft torpedo boats. The bow of the *Naubuc* was fitted with spar torpedo equipment that consisted of a long pole with a bomb attached to the end. It could be used to ram the hulls of enemy warships.

Despite all of its issues, the *Naubuc*'s sleek style impressed onlookers. "She is very long, narrow, and 'cigar-shaped,' and the deck which appears to be barely 24 inches above water, feels as solid as the great globe itself beneath one's feet. One turret—of layers of iron 11 inches thick—forms the pilot house, and is almost the only object to obstruct the flatness of the long, perfectly level deck," a *New-York Tribune* reporter observed.[523]

The *Naubuc* was commissioned on March 27, 1865, just two weeks before the surrender of Gen. Robert E. Lee's Confederate Army of Northern Virginia. Rowe and his shipmates remained on board in the waters off Brooklyn with little to occupy their time other than to celebrate the end of the war.

Rowe was detached from duty on the *Naubuc* soon afterwards and received an honorable discharge in August 1865. His stint in the navy lasted ten months and took him no farther than New York.[524] Rowe returned to Maine, and in 1867 he moved to New Jersey and settled in Cumberland County, located along the Delaware Bay. He married Adelia Hemingway the following year. The couple had one child, who died soon after birth.[525]

In the 1880s, Rowe gave up the seafaring life and became a farmer. He raised chickens and vegetables on a small plot of land. Adelia died in the early 1910s, and the last time his name appeared on a government document was 1915. He was about seventy-four years old.[526]

Fateful Shore Leave

S ailor N athan H opkins and two of his comrades from the Union frigate *Minnesota* strolled through the Virginia countryside one day in late June 1864. They had been given a brief shore leave to stretch their legs, which was occasionally granted to the bluejackets to break the monotony of routine patrols along the James River.

While they walked, Hopkins's companions related a story they had heard about a monument with a strange inscription located on a nearby hill. They trekked on about a half mile and saw no signs of the monument. Hopkins paused, but his mates encouraged him not to give up. "It is a little further on," one of his comrades assured him.[527]

The trio continued. Soon, two Confederate pickets stepped out of the brush and confronted the sailors. Hopkins recalled, "My two companions promptly shook hands with our captors but I did not."[528] Thus began an odyssey that landed Hopkins in notorious Andersonville Prison.

Hopkins, twenty-three, had had a relatively long connection to the sea. Born in Maine and raised along the Quinebaug River at Jewett City, Connecticut, he made his first ocean voyage at age fourteen and was a veteran sailor by the outbreak of the war. Along the way he had developed clerical skills that served him well after he joined the navy as a paymaster's steward in the autumn of 1861. Assigned to the storeship *Brandywine*, he spent the majority of the next two years aboard the old frigate anchored outside Fortress Monroe, Virginia.

In the summer of 1863 he left the navy, and before the end of the year was recruited by the hard-fighting Twelfth New Hampshire Infantry. The regiment had suffered severely in the recent

Ordinary Seaman Nathan Edwin Hopkins, U.S. Navy

Carte de visite by an unidentified photographer, about 1865. Collection of Jerry and Teresa Rinker.

battles of Chancellorsville and Gettysburg and desperately needed substitutes to replace their losses. These "Subs," bemoaned the historian of the Twelfth, were the dregs of society. "Such another depraved vice-hardened and desperate set of human beings never before disgraced an army. To send such vile rubbish to take the place of the fallen brave, and fill up the ranks of the veteran heroes who still remained, was an insult to them, and a desecration to the memory of their late comrades." The historian lumped sailors into this motley crew, though acknowledged that many of them made good soldiers.[529]

Hopkins did not spend enough time with the regiment to be fairly judged. On April 30, 1864, as Lt. Gen. Ulysses S. Grant was on the verge of launching his spring campaign into the heart of Virginia, Hopkins transferred back to the navy. He reported to Fortress Monroe for duty and joined the crew of the *Minnesota*. The wood frigate and her crew had distinguished themselves two years earlier during the Battle of Hampton Roads and the clash of the ironclad vessels *Monitor* and *Virginia*.

"Sometime in May, about a hundred of us from the *Minnesota* were sent up the James River to do picket duty at night in advance of our fleet," explained Hopkins. "On or about June 28th 1864 three of us went on shore leave for exercise." Unbeknownst to him, the two sailors were bounty jumpers who intended to desert at the earliest opportunity.[530]

Once in Confederate hands, they were marched to the headquarters of the picket guard. Two officers, one older and another younger, interrogated them. Hopkins's shipmates were quizzed about the strength and position of the Union navy. Hopkins was questioned about two Confederate sailors who had deserted. The younger officer asked Hopkins if he knew what became of them. Hopkins told the officer that they were captured and "we put them in durance [prison] and put a man over them with a drawn sword, the same as we would over any rogues." Hopkins recalled, "My questioner made a quick motion to his sword hilt and would have drawn the blade and run me thru had not the older officer seized his arm and held him until he ceased to struggle."[531]

Hopkins and the other two prisoners were transferred to Richmond the next day and taken to the provost marshal's office. The two sailors declared themselves deserters and were led away. Hopkins declared himself a prisoner of war and was sent to Libby Prison.

Two weeks later, in mid-July, he and a large number of other prisoners were packed on a train destined for Georgia. Hopkins discovered, perhaps much to his surprise, the two sailors with whom he had been captured were also on board. They had been held at Castle Thunder with political prisoners and suspect citizens. Whatever case they had made for their freedom had been rejected. One of the sailors, whom Hopkins described as an Englishman who deserted the British navy to take advantage of the sizable Union bounties, jumped the train somewhere in North Carolina and disappeared. The other remained on board and kept a low profile.[532]

Hopkins arrived at Andersonville about July 22, 1864. Fourteen long weeks later, on September 27, 1864, he boarded a train with about 150 Union sailors. They were headed for Richmond to be paroled and exchanged for a like number of rebel seamen. Hopkins observed that his other shipmate remained at Andersonville rather than return to the Union and face the consequences of his attempted desertion.

In mid-October, Hopkins's prisoner of war status ended outside Richmond along the James River—not far from where his odyssey had begun four months earlier. He and the rest of the prisoners were transferred from a Confederate flag-of-truce boat to the Union steamer *Mary Washington*. A newspaper correspondent was eyewitness to the event. "On coming near the little rebel flag-of-truce boat, formerly a tow tug, I found its deck full of men, whose appearances at once impressed me that they were rebels. Upon inquiry I ascertained they were our half-starved and half-clothed sailors, whose external semblance gave evidence of bad treatment and worse fare. It was a sad sight to look upon these heroes, shivering under the cool breeze of the morning, many of them with nothing to wrap themselves up."[533]

In an account of his wartime experiences written years later, Hopkins did not detail the particulars of his treatment inside Andersonville. But he did describe his homecoming at Annapolis, Maryland. "Our condition was such that it was not considered safe to let us use any building, so we were sent direct to Washington D.C. by rail. As soon as the gates were opened in the morning we were marched in a body into the Navy Yard and taken around the rear were stripped and the rags burned. Then we were washed and shaved, and our hair cut and given new uniforms and were once more made fit to be seen by human eyes."[534]

The navy granted Hopkins a furlough, and he returned to his family in Connecticut. In January 1865 he returned to duty and was assigned to the side-wheel steamer *Florida*. He spent the rest of the war making round trips from New York to New Orleans to deliver supplies to sailors stationed along the Gulf of Mexico.[535]

According to Hopkins, dissatisfaction among the sailors of the *Florida* ran high after shore leaves were unexpectedly canceled. "Many left the ship by boatload," he remembered. Hopkins joined them and skipped out on the remainder of his enlistment.

Years later he applied for a military pension and was rejected because of his status as a deserter. He appealed. In February 1923 he received notice that his long-delayed pension had been approved by the U.S. House of Representatives and would likely pass the Senate. By this time he suffered from tuberculosis, and he succumbed to the illness two months later at age eighty-two. Three daughters survived him. His wife, whom he married shortly after he left the service, had predeceased him.[536]

R.S.Dana W.S.Dana.

Cmdr. William Starr Dana, U.S. Navy (*right*) and his brother,
Richard Starr Dana

Carte de visite by an unidentified photographer, about October 1863. Collection of the author.

Redemption before Mobile Bay

A HAILSTORM OF REBEL ARTILLERY POUNDED UNION REAR Adm. David Farragut's flagship, the *Hartford*, as she steamed into Mobile Bay at the head of the attacking fleet on August 5, 1864. Shells tore through her planking as heavy metal fragments and wood splinters careened through the air at lightning speed, taking a deadly toll on officers and men.

One well-aimed projectile ripped through the *Hartford*'s battle-scarred wooden hull and blasted the forward berth deck. The commander of this section of the ship, Ensign William S. Dana, recalled, "Fragments of the shell flew over my head and I was covered by the brains and blood of the man next to me." This single shot killed three and wounded two, which removed more than a third of his thirteen-man crew.[537]

Dana, twenty-one, had recently joined the *Hartford*. The youngest of three children born to a prosperous merchant and his wife,[538] Dana had graduated from the U.S. Naval Academy less than a year earlier. His first assignment, an as ensign on the steam frigate *Niagara*, almost ended his career after he and five other officers were reported for leaving their watch before being properly relieved—an offense punishable by death.[539]

The officers pleaded ignorance. The Navy Department refused to accept the excuse. "It must, indeed, be obvious to the most ordinary intelligence that if an officer cannot be trusted in his watch, he has yet to learn the simplest practical duties of his profession, and is unfitted for a station where the lives of others, as well the honor of his country, may depend on his vigilance and fidelity," admonished secretary of the navy Gideon Welles in a ruling dated March 22, 1864.[540]

Two of the officers, who had both been recently confirmed as

lieutenants, were downgraded to ensigns. Dana and the others were stripped of their appointments as acting ensigns and returned to the Naval Academy as midshipmen.[541]

Three months later, Dana was given a second chance when he received orders to report to Farragut outside Mobile Bay. Dana checked in with the rear admiral on July 1 amidst a buzz of excitement: the previous night, a blockade-runner, the *Ivanhoe*, had steamed through the Union line with a cargo of valuables and run aground below formidable Fort Morgan at the entrance to Mobile Bay. Farragut was determined to destroy the *Ivanhoe* before the rebels could tow her in. After federal gunboats shelled the stranded ship without success, Farragut's flag lieutenant, J. Crittenden Watson,[542] volunteered to lead a raid to board and burn her.

An expedition of four small boats in charge of Watson and assisted by six other officers, including Dana, carried out the mission under cover of darkness during the night of July 5. Hundreds of Union sailors watched as the expedition made their way to the *Ivanhoe* and burned her. Rebel sentries did not discover the act until it was too late.[543]

The destruction of the *Ivanhoe* was a timely gift for the jubilant Farragut, who celebrated his sixty-third birthday that day. The next day, he released General Order No. 9 to the fleet. "The entire conduct of the expedition was marked by a promptness and energy which shows what may be expected of such officers and men on similar occasions. They have the thanks of the admiral commanding for the manner in which they performed their respective duties."

Dana had redeemed himself. He was assigned to the *Hartford* and given command of the thirteen-man Powder Division that distributed ammunition for the warship's twenty-four guns.

A month later, at Mobile Bay, the *Hartford* sustained heavy losses—51 killed and wounded of the 310-man compliment. Dana's Powder Division suffered ten casualties. "One poor fellow," recalled Dana, "after being struck down by a splinter, which car-

ried away his left arm, was dreadfully mangled by a shell which came in before he could be attended to by the surgeons."[544]

The carnage was worse above his forward berth station. "All over the decks you would see, here a leg, there an arm or head, and on some parts of the deck blood was nearly an inch deep," Dana observed. "I went to bed, thanked God for my escape and felt very faint and weak from the sights and work I had gone through during the day."[545]

Dana's tenure on the *Hartford* was short lived. He fell ill just a few weeks after the fall of Mobile Bay and was sent north to recuperate. He eventually returned to duty with the steam sloop *Lancaster* in the Pacific Squadron.[546] Dana remained in the navy after the war ended. He was assigned to various duties that took him around the globe and advanced in rank to commander by 1881.

On or about Christmas Day in 1889, Dana contracted the flu while on leave in Paris, France. Pneumonia set in, and he succumbed to the illness on January 1, 1890. He was forty-six years old. His body was returned to New York and buried in Brooklyn's Green-Wood Cemetery.

Dana left behind a wife, Frances, who was his junior by eighteen years. She was an amateur botanist and intimate childhood friend of Theodore Roosevelt.[547] The couple had married in 1884 and did not have children.

In 1893, her *How to Know the Wildflowers*, written under the name Mrs. William Starr Dana, was published in New York. Considered the first field guide to North American wildflowers, the volume became an instant bestseller and is still in print.

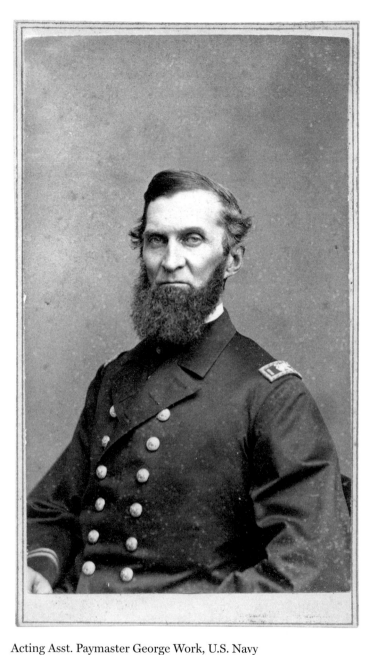

Acting Asst. Paymaster George Work, U.S. Navy

Carte de visite by Charles DeForest Fredricks (1823–1894) & Co. of New York City, about February 1864. Collection of the author.

Thirty Seconds at Mobile Bay

REBEL SHOT AND SHELL RAKED THE DECKS OF THE *Hart-ford*. The fire intensified as the Union squadron's flagship encountered the formidable defenses of Mobile Bay on the morning of August 5, 1864. As the ship approached Fort Morgan at the mouth of the bay, a sailor aboard the *Hartford* surveyed the federal fleet through drifts of battle smoke. Suddenly, he cried out that a sister vessel, the monitor *Tecumseh*, was sinking.[548]

The *Tecumseh* had gone into action just a short time earlier. Her commander, Tunis Augustus McDonough Craven, was an affable man who was popular with his brother officers.[549]

Craven's crew was composed of volunteers from all walks of life, including George Work of Connecticut. The forty-two-year-old bachelor had left a career as a schoolteacher in the 1850s to become a trader. By 1860, he had amassed a small fortune.[550] Work had sat out the early part of the war, perhaps due to his age. After a few years, however, he cast his lot with the navy, although there is no record that he had any experience as a sailor.

In February 1864, Work received a commission as an acting assistant paymaster and reported to New York, where he sat for his *carte de visite* portrait. He received orders to report for duty to the *Tecumseh* before the end of the month.[551]

The *Tecumseh* was one of the newest monitor-style warships in the federal fleet. She featured improvements to the original design by engineer and inventor John Ericsson, including tweaks to the machinery and thicker iron sheathing to the hull, decks, and revolving turret. Despite Ericsson's enhancements, the *Tecumseh* had detractors. "She is a costly mass of iron, armed with two heavy guns, capable of being fired at the rate of once in about seven minutes each. She has cost over half a million of dollars,

and we doubt if she will ever do for the coasting service enough to repay one-fourth of that sum," opined the *New York Herald* on March 29, 1864. Craven was another critic. "He was opposed to the *Monitor* system in all its details, yet he would not request any other command," noted one biographer.[552]

There is no evidence that Paymaster Work shared Craven's opinion. The two men, and the rest of the crew, shipped out toward Southern waters aboard the *Tecumseh* in April 1864. Meanwhile, Rear Adm. David Farragut[553] was gearing up for a joint army-navy operation to take out the defenses of Mobile Bay. He organized an armada of eighteen vessels. A quartet of metal monitors, including the *Tecumseh*, would lead the attack.

Confederates mobilized land batteries, three gunboats, and the ironclad ram *Tennessee*. They also planted sixty-seven mines, or torpedoes, in the bay. Packed with gunpowder and submerged below water, the use of these "infernal machines" was considered diabolical and uncivilized by many.[554]

Farragut's force got under way on August 5. An officer identified only as "Frank" described the scene in a letter printed in a Boston newspaper: "At sunrise we formed in line of battle, and a grand and glorious sight it was—the flower of the American navy with the national flag streaming from every ship moving to the attack of one of the strongest forts on the continent. Two monitors took the lead and opened the ball."[555]

The pair of ironclads were the *Tecumseh* and her sister ship *Manhattan*. The *Tecumseh* was out in front, and she fired the Union's first shot. She continued on as a gentle westerly wind blew battle smoke into the face of the enemy.[556]

"When nearly abreast of Fort Morgan," reported two acting masters of the *Tecumseh*, "a row of buoys was discovered stretching from the shore a distance from one to two hundred yards. It being reported to Captain Craven, he immediately gave the vessel full speed and attempted to pass between two of them."[557]

The *Tecumseh* advanced on the rebel ram *Tennessee* and turned to engage her. At this moment, 7:40 a.m., the hull of the *Tecumseh* struck a torpedo. The two masters recalled that the explosion oc-

curred, "directly below the turret, blowing a large hole through the bottom of the vessel, through which the water rushed with great rapidity."[558]

"Finding that the vessel was sinking, the order was given to leave our quarters, and from that moment every one used the utmost exertions to clear himself of the wreck," they reported.[559] A few men escaped through a hatch in the turret. Craven, who wore a life preserver, and his pilot scrambled for a narrow ladder and safety. The pilot stepped aside to let Craven escape first, but the commander yielded. "After you, pilot!"[560]

Craven made it to the turret before the *Tecumseh* reeled heavily to her port side, then careened violently and plunged bow first towards the bottom of the bay. Adm. Farragut observed the scene from his perch in the main rigging near the top of the *Hartford*. "I saw the *Tecumseh* disappear almost instantaneously beneath the waves, carrying with her gallant commander and nearly all her crew."[561] The stricken ironclad slipped below the surface in about thirty seconds.

One of Farragut's subordinates, Capt. James Alden[562] of the *Brooklyn* also watched the final seconds of the *Tecumseh*. "Sunk by a torpedo! Assassination in its worst form! A glorious though terrible end for our noble friends, the intrepid pioneers of that death-strewed path! Immortal fame is theirs; peace to their names."[563]

Total casualties on the 115-strong *Tecumseh* were 94, including Craven, who likely perished in the vortex created by the sinking vessel. Also lost was Paymaster Work, likely trapped somewhere inside the ship.

Farragut and the rest of the fleet went on to achieve victory. In a brief congratulatory order issued the next day, he paid tribute to Craven, Work, and their crewmates. "It has never been his good fortune," Farragut stated in the third person, "to see men do their duty with more courage and cheerfulness, for although they knew that the enemy was prepared with all devilish means for our destruction, and though they witnessed the almost instantaneous annihilation of our gallant companions in the *Tecumseh*

by a torpedo, and the slaughter of their friends, messmates, and gunmates on our decks, still there were no evidences of hesitation in following their commander in chief through the line of torpedoes and obstructions."[564]

Farragut was optimistic that the *Tecumseh* might be raised. The families of the deceased sailors petitioned the government to recover the remains of the crew, but it never happened.

Wood Meets Iron at Mobile Bay

Philip Langer braced for impact. The wooden sloop-of-war on which he served, the *Monongahela*, was only yards away from ramming the rebel ironclad ram *Tennessee* in the waters of Mobile Bay on August 5, 1864.

The *Tennessee* fired its guns into the approaching *Monongahela* at this critical moment. Two shells crashed into the *Monongahela*'s bow. One tore into the wood siding near the prow and lodged in the berth deck. The other ripped through the berth deck where Langer and others stood firm. It exploded and sent iron fragments, splinters of wood, and other debris through the air. The crew was thrown violently to the floor.[565]

Then the *Monongahela* struck her prey full force amidships. The blow, according to a news report, caused "the huge rebel monster to reel like a drunken man."[566] Langer, unharmed by the explosion, scrambled to his feet as the *Monongahela* turned to strike again.[567]

How Langer came to be in Mobile Bay is rooted in a boyhood fascination with engineering. Born in Philadelphia, Pennsylvania, he was the eldest of six children raised by German-born parents. Father Joseph worked as a baker, and he hailed from the state of Baden. Mother Catherine was born in the Kingdom of Württemberg.[568] In 1860, eighteen-year-old Langer entered into the study of engineering, drafting, and the machine trade in his home city. He dreamed that someday he would become a marine or land engineer.[569]

The war came a year later, and Langer at first stuck to his studies. But in 1862 he cast his lot with the Union navy and was assigned as a third assistant engineer.[570] He reported to the West Gulf Blockading Squadron and joined the crew of the *Mononga-*

hela. He spent the bulk of his time in the vessel's fire room, where boilers were stoked to power the engines. Langer remembered that he was "very ambitious to do my duty" and rarely left his post despite the intense heat and the effects of coal dust and ash.[571]

He saw his first action on the night of March 14–15, 1863, in an attempt to run the formidable enemy batteries along the Mississippi River at Port Hudson, Louisiana. The *Monongahela* did not make it past the Confederate defenses—only two vessels got through—and suffered heavy casualties. Langer emerged unharmed.

In June 1864, Langer was promoted to second assistant engineer and served in this capacity in the Battle of Mobile Bay. The *Monongahela* went into action with a custom-made, heavy iron casing fitted to the forward edge of her prow. This enhancement was designed for ramming enemy vessels. The federal squadron commander, Rear Adm. David Farragut, hoped the enhancement would give her an edge against the *Tennessee*.

It did not. The iron casing either fell or was knocked off during

2nd Asst. Eng. Philip Joseph Langer, U.S. Navy (*left*) and comrades

Carte de visite by William Watson Washburn (about 1828–1903) of New Orleans, Louisiana, about 1863–1864. Collection of the author.

the attack. Adm. Franklin Buchanan,[572] the overall commander of the Confederate navy, recorded in his after-action report, "She struck us with great force, injuring us but little. Her prow and stem were knocked off and the vessel was so much injured as to make it necessary to dock her."[573]

In fact, the *Monongahela* grounded after the first strike. She managed to break free, but by the time she got back into action other vessels in the Union armada had forced the *Tennessee* to surrender. The battle ended in a complete Union victory.

The *Monongahela* limped back for repairs and counted casualties. Six sailors were wounded, including three by the explosion of the shell on the berth deck. Langer was not injured during the fight.

Langer served on the *Monongahela* for the duration of the war. He remained in the navy after the cessation of hostilities, serving in the South Pacific and West Indies.

In 1869, while cruising aboard the *Narragansett* off the coast of Cuba, Yellow Fever broke out on the ship. "Most of the officers were on the sick list, which necessitated extra duty upon those who had withstood the attack of the disease," recalled Langer. "Extra duty and loss of rest, caused by attending to the wants of my sick comrades, overcame me and I was attacked with the fever, on Sunday, July 4th 1869."[574]

Langer recovered, but his health was broken. He resigned from the navy in 1870 and returned to Philadelphia to reunite with his wife, Maggie, whom he had wed on leave two years earlier. They started a family that grew to include a daughter and son, but both died in childhood.

Langer decided to become a physician, perhaps motivated by the loss of his children and his experience serving his stricken crewmates on the *Narragansett*. He graduated from Hahnemann Medical College in 1883.[575]

His career as a caregiver was short lived, however. He contracted tuberculosis about 1886 and succumbed to the disease the following year. Langer attributed his illness to exposure while in the fire room of the *Monongahela*.[576]

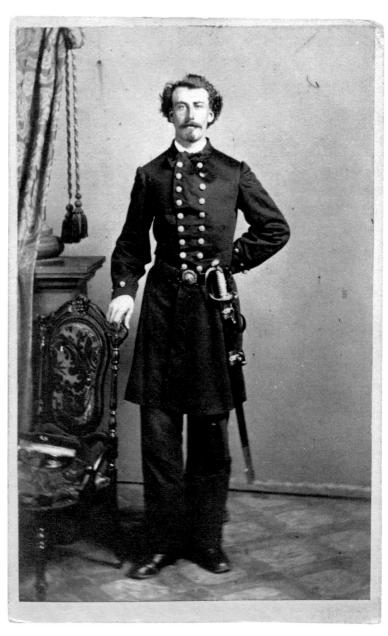

Ensign William Wingood Jr., U.S. Navy

Carte de visite by Blanchard P. Paige (about 1818–1894) of Washington, D.C., about 1862–1864. Collection of the author.

The Surrender of the Tennessee

A JUGGERNAUT OF EIGHTEEN UNION WARSHIPS POWERED through the main shipping channel of Mobile Bay with guns blazing on the morning of August 5, 1864. The fleet left a wake of devastation. That is, with one exception—the iron-sheathed rebel ram *Tennessee*. She somehow managed to get behind the federal ships.

Fleet commander David Farragut acted to take out the *Tennessee*. "Signal was a once made to all the fleet to turn again and attack the ram, not only with the guns, but with orders to run her down at full speed," the rear admiral stated in his after-action report.[577]

One of the vessels that responded to the call was among the last to enter the bay—the *Ossipee*. The crew that manned the wooden-screw-propelled sloop-of-war included an up-and-coming master's mate, William Wingood Jr. A handsome six-footer with gray eyes and dark complexion, he grew up in the bustling town of Rockport, Massachusetts, located at the tip of the Cape Ann peninsula. Its populace thrived as laborers in local granite quarries and as fishermen. Wingood made the latter occupation his career.[578]

Wingood enlisted in the navy as an acting master's mate in 1862. After a stint in officer's school on board the thirty-six-gun frigate *Macedonian*, he reported for duty to the *Ossipee* in the North Atlantic Blockading Squadron. In the middle of 1863, the vessel and crew received a new assignment in the Gulf of Mexico.[579]

Wingood's responsibilities included assistant to the master of the *Ossipee* and the supervision of supply storage. In the event of hostile action, he would be called on to assist in the engine room

or with the steerage. He likely performed these functions during the Battle of Mobile Bay.

The weather was calm and pleasant when Wingood and his crewmates steamed into the enemy harbor and encountered Mobile's formidable defenses on August 5. The *Ossipee* crossed paths with the *Tennessee* about 8:30 a.m. when the ram passed the starboard bow of the *Ossipee*. So close were the vessels that the bore of one of the *Tennessee*'s guns almost touched the side of the *Ossipee*. The *Tennessee* fired its guns at point-blank range but did not cause serious damage.[580]

Union warships descended and attacked the *Tennessee* in rapid succession. First came the *Monongahela*, who slammed into the *Tennessee* and let loose a broadside before being grounded. Next came the *Lackawanna*. She butted the *Tennessee* where the casemate meets the deck. The rebel ram swung around and fired a single round that did no damage. Farragut's flagship, the *Hartford*, moved in and struck a heavy blow.[581] The *Tennessee* continued on, but the cumulative effects of ramming and fire from the Union ships destroyed her smokestack and damaged the steering and port gun shutters.

Now Wingood and his shipmates on the *Ossipee* bore down on the injured ram. The men prepared for impact. But at the last moment—less than a hundred yards away—an officer on the *Tennessee* was observed on the casemate with a white flag. According to the commander of the *Ossipee*, William E. LeRoy,[582] "This ship was so close to the Tennessee when the white flag was displayed that though we reversed the engine we struck her such a blow as to injure our stem. Hailed her commander to know if he surrendered, and receiving a reply in the affirmative, sent a boat on board." LeRoy added that two officers in the craft, "received the surrender, hoisted the American flag, and took possession of the prize."[583] The prisoners included Farragut's counterpart, Adm. Franklin Buchanan, who had been seriously wounded. The fighting in the bay ended soon afterwards, closing the last major port in the deep South to the Confederacy.

One month later, Wingood received a promotion to ensign

and transferred to the steamer *Penobscot*. He served in this capacity for the rest of the war, cruising the Texas coast with his shipmates.[584]

Wingood's active service ended in July 1865. He returned to Rockport and reunited with his wife, Beulah, whom he had married in 1862.[585] Wingood never returned to the sea. He worked as a foreman in a glass manufacturing company and later as postmaster of Rockport. Active in the Grand Army of the Republic, he helped organize the local post of the powerful veteran's organization and served as an officer for many years.[586]

Beulah died in 1902. The childless Wingood moved to Tennessee to live with extended family and in 1905 entered the Mountain Branch National Military Home in Johnson City. The old sailor died there in 1912 at age seventy-four.[587]

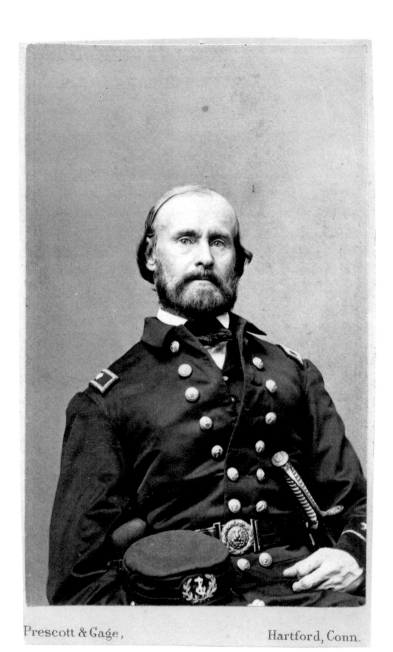

Ensign Henry Howard Brownell, U.S. Navy

Carte de visite by Daniel K. Prescott (1837–1895) & Edwin P. Gage (1830–unknown) of Hartford, Connecticut, about 1864. Collection of the author.

Battle Laureate

POETRY WAS A FIXTURE ON THE PAGES OF THE POPULAR newspaper *Hartford Evening Press*. Readers in Connecticut's capital enjoyed a regular dose of verse on a range of topics, from life and love to death and grief. During the tense months leading up to disunion and the outbreak of hostilities, political and military poems emerged as a dominant theme.

One of the contributors was an obscure writer with an insatiable appetite for literature that had revealed itself at an early age. Harry Brownell had been a precocious boy who read Homer and Milton at six and entertained family and friends with couplets and wild, imaginative stories. As a young man he set aside artistic pursuits in favor of a college education and business.[588] But stints as a clerk in New York, a schoolteacher in Alabama, and lawyer in Hartford proved mere distractions. Then, in 1846, the death of his father, a physician, left Brownell a small inheritance that provided a modest income.[589]

Brownell, now in his mid-twenties, turned his full attention to writing. A volume of collected poems received scant though positive notice, and a history book aimed at children fared about the same.[590] The political poems and articles in the newspapers roused his abolitionist leanings and inspired him to strike with the pen while others chose the sword or musket. Before long, his fiery rhyme roared across the pages of the *Press* printed under his name or initials and sometimes anonymously.

As the war unfolded, Brownell responded with stirring military verse. One of his poems set him on a path that transported him from the fringes of literary society into the exclusive circle of America's great poets.

The poem was based on published orders issued by Rear Adm.

David Farragut to his fleet before the victorious Battle of New Orleans in April 1862. "Mr. Brownell amused himself by turning into verse the terse 'general order' of the Admiral," recalled *Press* editor Charles Dudley Warner. "Being printed anonymously in the *Hartford Evening Press*, it met the Admiral's eye, and Mrs. Farragut wrote the editor, saying that it touched her husband even to tears, and asking the favor of the author's name. It was given, and a correspondence ensued, which soon led to a solicitation that Mr. Brownell should go to sea with the admiral on his personal staff."[591]

Brownell accepted the invitation and in December 1863 became a navy officer at age forty-two. He reported to the Gulf of Mexico and joined Farragut on his flagship, the *Hartford*. The two men became fast friends.

Ensign Brownell was present when Farragut and the *Hartford* steamed into Mobile Bay in the vanguard of a federal fleet on August 5, 1864. Brownell witnessed the engagement from the flagship's poop deck, which provided a commanding view of the action. According to a fellow officer, Surg. James C. Palmer, Brownell calmly and coolly jotted down notes and times with watch in hand while the battle raged around him.[592]

Brownell recalled the chaos of battle in a private letter to a friend, "The noise being indescribable, and the ship, for all the forward half of her, being an absolute 'slaughter-house.' Though we had only twenty-five killed and twenty-eight wounded (some of whom afterwards died) on that day, yet numbers were torn into fragments (men with their muscles tense, subjected to violent concussion, seem as *brittle as glass*), causing the deck and its surroundings to present a most strange spectacle."[593]

These and other impressions were woven into "Bay Fight." Brownell's poem included a description of the carnage on the *Hartford*:

And now, as we looked ahead,
　All for'ard, the long white deck

Was growing a strange dull red—
 But soon, as once and agen
Fore and aft we sped
 (The firing to guide or check),
You could hardly choose but tread
 On the ghastly human wreck
(Dreadful gobbet and shred
 That a minute ago were men!)

Brownell captured the moment when one of Farragut's iron-clads, the *Tecumseh*, struck an underwater mine, or torpedo, and sunk early in the action. The sudden and unexpected loss stunned the fleet and threatened to stall the attack. Farragut, lashed to the rigging above the deck of his flagship to get a better access the situation, sensed the loss of momentum and spurred his blue-jackets onward:

From the main-top, bold and brief,
Came the word of our grand old Chief—
 "Go on!"—'twas all he said—
Our helm was out to starboard,
 And the *Hartford* passed ahead.

Others aboard the *Hartford* recollected that Farragut said much more than "Go on!" from his perch. "Damn the torpedoes, full speed ahead!" was eventually accepted as the popular para-phrase. Brownell's omission of the full phrase was the subject of some conjecture. Surg. Palmer suggested that "Go on!" was all Brownell had heard above the din of battle, or perhaps the prim and proper Farragut ordered his ensign-poet to suppress the profane language.[594]

"Bay Fight" was well received when it appeared in the Decem-ber 1864 issue of *Harper's New Monthly Magazine*.[595] Meanwhile, a recently published collection of Brownell's writings, *Lyrics of a Day; or, Newspaper Poetry by a Volunteer in the U.S. Service*,

received praise from critics. The *North American Review* proclaimed, "In him the nation has found a new poet, vigorous, original, and thoroughly native."[596]

Dr. Oliver Wendell Holmes, America's distinguished man of letters, read the *North American* review. He followed up with a glowing essay, "Our Battle-Laureate," in the May 1865 issue of the *Atlantic Monthly*. "It happens rarely that poets put their delicate-fibred brains in the paths of bullets, but it does happen," Holmes observed. "Mr. Brownell has weathered the great battle-storms on the same deck with Farragut, and has told their story as nobly as his leader made the story for him to tell."[597]

Holmes singled out "Bay Fight" and "River Fight," which set Farragut's victory at New Orleans to verse, as the best. "They hush any circle of listeners, and many cannot hear those exquisitely tender passages which are found toward the close of each without yielding them the tribute of their tears. They are to all the drawing-room battle-poems as the torn flags of our victorious armadas to the stately ensigns that dressed their ships in the harbor."[598]

The review by Holmes brought Brownell wide acclaim. Prominent intellectuals mentioned Brownell in the same breadth as Whittier, Hawthorne, and Bryant. The Battle Laureate rode a wave of popularity after the war. In 1866, his *War-Lyrics and Other Poems* was published. He received top billing at events, including a July 1871 reunion of war veterans who had served along the Gulf of Mexico. Brownell read his poem "Gulf Weed," a tribute to Adm. Farragut, who had died the previous year.

The reading was Brownell's last public literary appearance before doctors diagnosed him with oral cancer. Two operations that included the removal of the tumor and a significant section of bone failed to halt the spread of the cancerous cells. Brownell succumbed on October 31, 1872. He was fifty-two years old.[599]

A large crowd attended his funeral and burial in East Hartford. The mourners included the late Adm. Farragut's wife, Susan, who had been instrumental in bringing together her husband and Brownell, and her son, Capt. Loyal Farragut.[600]

The *Hartford Daily Courant* opined, "His rank as a poet must depend upon this little volume of 'War Lyrics,' and we think it is enough long to keep his memory green." It was not. Brownell's poems quickly faded from the American memory.

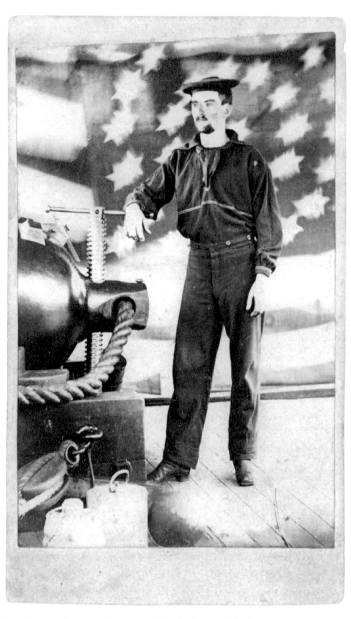

Landsman Freeman Thomas MacArthur, U.S. Navy

Carte de visite by an unknown photographer, about 1864. Collection of Michael J. McAfee.

Among the Last to Arrive and First to Leave

On Saturday, August 13, 1864, Freeman MacArthur stepped into a navy recruiter's office in New York City and enlisted. Although the motivations for leaving his job as a boatman and donning a landsman's uniform are not known, his timing is noteworthy. A week earlier in Alabama, Mobile Bay had fallen to the Union fleet commanded by Rear Adm. David Farragut. It was the first positive bit of war news in months, as the Union armies were at a stalemate in Virginia and Georgia.

MacArthur may have been motivated by personal loss. One of his three older brothers, an infantryman, had suffered a mortal wound in the fighting in Mississippi.[601] His biggest motivator may have been patriotism, however. He posed for his *carte de visite* portrait soon after his enlistment, surrounded by the symbols of country and defense of the homeland, and they suggest his devotion to the Union. He stands confidently with an arm at rest upon the elevation screw of a ship's gun.

MacArthur went on to serve nine months in the navy, which included assignments on two ships. The side-wheel steamer *Florida* had a long record of service as a blockader in the Atlantic Ocean. The *Queen* was the British blockade-runner *Victory* until her capture in 1863, when she was refitted and commissioned by the U.S. Navy. By the time MacArthur joined the crews, the war was winding down, and these vessels were used for shuttling supplies to and from bases along the Atlantic coast and the Gulf of Mexico.

The end of hostilities in April and May 1865 prompted a rapid reduction of forces to cut costs and to return the military closer to peacetime levels. Ships were rapidly decommissioned and sailors

discharged. MacArthur numbered among the first men to be mustered out at the Brooklyn Navy Yard on May 24, 1865.[602]

MacArthur remained in New York City, married in 1873, and started a family. He worked as an engineer to make ends meet. A stroke paralyzed his left side in the 1880s and he died in 1890 at age fifty-one. His wife, Kate, and son, Henry, survived him.[603]

Target Practice at Battery Semmes

Life on the front lines of Richmond had degenerated into one seemingly endless round of heavy artillery shelling by the autumn of 1864. Day after day of firing sharpened the marksmanship of gunners on both sides to a point of almost perfect precision.

Such was the case at Battery Semmes, a Confederate emplacement dug into the banks of the James River just a few miles south of the capital. The navy lieutenant in command of the battery, Hilary Cenas of Louisiana, admired the abilities of an enemy artillerist opposite his position. Sometimes when the firing had died down, Cenas would emerge from the works with a barrel or tobacco box and set it down atop an old stump.

Cenas, according to a comrade, "would wave his arms as a signal to his favorite gun-pointer on the other side, and immediately we would see a puff of smoke and the projectile would always tear up the ground very close to the stump and frequently both stump and barrel would be knocked into smithereens."[604]

Confederate commanders would not have been surprised by Cenas's unmilitary conduct, for he had a history of running afoul of his superiors. Back in 1855, after he failed to gain admission to West Point, Cenas traveled from his home in New Orleans and entered his freshman year at South Carolina College. His father, who desired a military education for Cenas secured an appointment for him to attend the U.S. Naval Academy. The president of South Carolina College was pleased to be rid of Cenas: "His standing has been fair, & his deportment, as far as I have had the opportunity of knowing, unexceptionable—& I take great pleasure in commending him to the kind regards of the Naval School."[605] Cenas passed the academy with less than

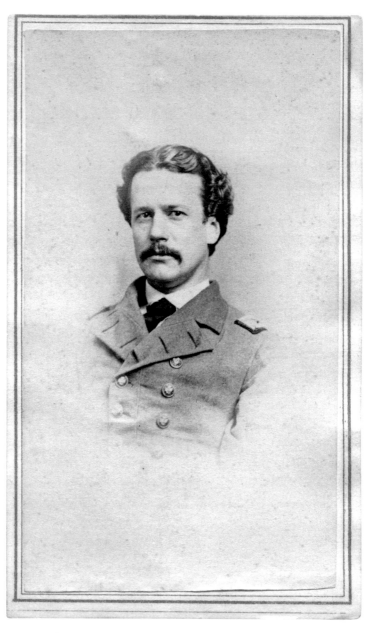

1st Lt. Hilary Cenas, C.S. Navy

Carte de visite by Samuel Anderson (1825–unknown) of New Orleans, Louisiana, about May 1864. Collection of Gerald Roxbury.

flying colors, having graduated fourteenth of twenty in the Class of 1859.

In the summer of 1861, he resigned his commission while serving aboard the frigate *Congress*. U.S. navy secretary Gideon Welles had him arrested under suspicion of planning to join the Confederates.[606]

Cenas spent the rest of the year at Fort Lafayette in New York and later at Fort Warren in Boston. On December 21, 1861, he was paroled and exchanged for a Union navy officer in Confederate hands. Three days later, on Christmas Eve, Cenas entered the Confederate navy as a second lieutenant.[607]

In early 1863, while serving on the side-wheel gunboat *Gaines* in Mobile Bay, he evoked the ire of his commander, Capt. Thomas T. Hunter.[608] Cenas, while on watch, turned over command to an inexperienced junior officer and left the deck without permission—the second time he had done so. Hunter reprimanded Cenas, who responded by excusing his actions as a mere "inadvertency."[609]

Infuriated by Cenas's lack of appreciation for the seriousness of the offense, Hunter fired off a missive to Adm. Franklin Buchanan, the region's senior naval commander. Hunter requested that Cenas be brought before a court martial. Buchanan agreed. "The example made by the trial of this Officer will have a salutary effect on others in this Squadron: Without discipline there cannot be efficiency and I think it necessary occasionally to impress this upon those under my command."[610]

Cenas was tried and found guilty but received no more than a slap on the wrist as punishment and was soon restored to duty. But before the end of 1863 he was unceremoniously transferred out of the Mobile Bay area.

Cenas landed at Battery Semmes. Its armament included two large Columbiad cannon and other big guns. The battery was located less than two miles from Dutch Gap, where Union troops engaged in a massive effort to dig a canal that would bypass a Confederate-occupied and well-defended section of the James River. In the fall of 1864, Cenas commanded the battery as first lieutenant. "The enemy is all around us," Cenas wrote to

his mother on October 20, 1864. "Their batteries here, there, & everywhere, and their pickets only a few hundred yards from our Fleet."[611]

Battery Semmes was Cenas's last recorded military command. On April 2, 1865, the battery was abandoned as part of the withdrawal of Confederate forces from Richmond. Cenas avoided capture by Union troops and made his way to the Army of Northern Virginia. A week later at Appomattox Court House, he surrendered with the rest of Gen. Robert E. Lee's army and received a parole. Cenas signed the oath of amnesty to the federal government on May 18, 1865.[612]

He returned to New Orleans and became active in the violence against the Republicans and Reconstruction. An admirer summed up his character and contributions: "Ardent, fearless, and chivalrous, he was a foremost leader of his race against attempted carpet-bag domination."[613]

As political and civic authority deteriorated in the wake of the elections of 1872, paramilitary groups battled federal forces for control of the state arsenal and other government buildings in and about New Orleans. On March 5, 1873, in a fight that became known as the Battle of Jackson Square, Cenas and other antifederal forces took control of the city for a brief period. Cenas suffered a gunshot wound in the foot. It never healed and was cited as the cause of his death in 1877 at age thirty-eight.[614]

Convoy Gone Wrong

THERE ARE TIMES WHEN A MUNDANE MISSION TURNS OUT to be anything but routine. The Union warship *Augusta* was at the center of one such event during the autumn of 1864.

The wooden side-wheel steamer and her 157-man crew had seen plenty of action along the Atlantic coast and elsewhere since the first year of the war. Her cadre of officers included newcomer George W. Marchant of Massachusetts. The twenty-year-old master's mate had recently completed officer's school.[615]

On the evening of November 6, Marchant and his shipmates left New York on the *Augusta* to rendezvous with the merchant steamer *North Star*. She was bound from California laden with mail and other cargo from the Pacific coast. The safety of the *North Star* and other California mail steamers had worried the federal government since the start of the Rebellion. Recent reports of activity by Confederate raiders and Southern patriots, disguised as passengers, who seized civilian vessels heightened fears in Washington.[616]

The unescorted *North Star* was a possible target, and the overburdened Navy Department scrambled to identify a warship for convoy duty. The *Augusta* was the only vessel available in New York, and she was promptly dispatched to intercept the *North Star* as she approached the Atlantic Coast—a likely place for would-be pirates to act.[617]

Marchant and his fellow crewmembers had an uneventful trip to Panama, where they arrived on November 16, 1864, and found the *North Star* unmolested. Her captain was informed of the navy's orders. Two days later, the vessels departed for New York.

The trip went as planned until the night of November 21. The

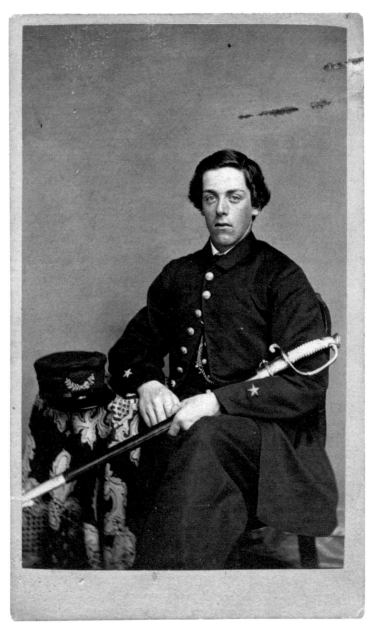

Master's Mate George W. Marchant, U.S. Navy

Carte de visite by E. M. Douglas (life dates unknown) of Brooklyn, New York, about 1864. Collection of the author.

Augusta steamed at top speeds to keep up with the *North Star* when a heavy thumping sound was heard. The source was a loose piston on the engine rod, according to the first engineer. The chief engineer of the *North Star* confirmed the diagnosis.[618]

The *Augusta* continued on at a moderate speed on a gamble that the damaged engine would hold out. Then, on November 25, a meltdown occurred about 425 miles due east of St. Augustine, Florida. "The piston, under 15 pounds of steam, dropped with a violent concussion from the rod when about midway of its downward stroke, irreparably cracking three-fourths of the circumference of the lower part of the cylinder, the lower steam and exhaust-valve chests, and the cylinder bottom, and tearing out the hub of the piston. The engine was utterly disabled," explained Cmdr. Thomas G. Corbin,[619] in his after-action report.[620] The *Augusta* was dead in the water. Marchant and his shipmates were helpless.

The *North Star* came to the rescue. Her crew took the *Augusta* in tow, and three days later arrived at the federal army base in Port Royal, South Carolina. Cmdr. Corbin asked his counterpart on the *North Star* if he might tow the *Augusta* all the way to New York. The captain declined on the grounds that this action would violate the insurance policy carried on the cargo in his hold. Corbin eventually managed to get the *Augusta* to Baltimore, where she was decommissioned on January 6, 1865. She was eventually repaired and recommissioned.[621]

Marchant would go on to serve on at least two more vessels until he received an honorable discharge in September 1866. He returned to his family in Plymouth, Massachusetts, and later moved to Minnesota. He married in 1876, started a family that grew to include two daughters, and earned a living as a post office clerk.

In 1877, the *Augusta*, which had been sold to a civilian firm and renamed the *Magnolia*, foundered off Cape Hatteras, North Carolina, and sank. No lives were lost.[622]

Marchant lived until 1912, dying at age sixty-seven. His wife and children survived him.

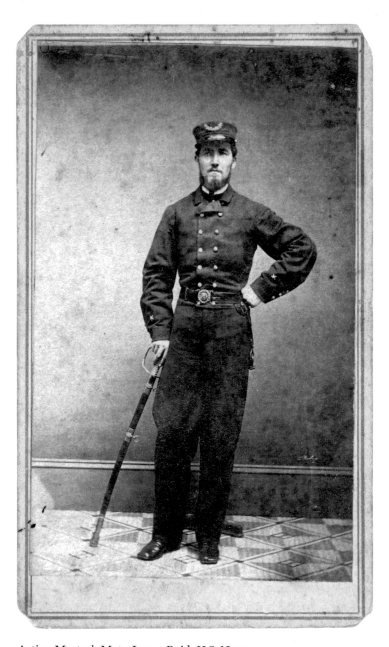

Acting Master's Mate James Reid, U.S. Navy

Carte de visite by David P. Barr (life dates unknown) of Paducah, Kentucky, about 1864–1865. Collection of Ron Field.

Ordered to the Relief of Fitch's Flotilla

Master's Mate James Reid was concerned about his parents. "I hope you will not alarm them by telling them that I am in danger," he wrote to an aunt from his quarters in Mound City, Illinois, on December 7, 1864. "Just tell them that our boat is ordered up the Cumberland River and may see some guerrillas."[623]

The "guerrillas" to whom Reid alluded were Confederate gunners. They manned artillery batteries along the banks of the Cumberland outside Union-occupied Nashville. The big guns protected the left wing of Gen. John B. Hood's twenty-thousand-man Army of Tennessee. Just a week earlier, Hood's boys had suffered a massive defeat in battle on the outskirts of nearby Franklin. Seriously weakened by heavy casualties, Gen. Hood dug in southeast of Union-occupied Nashville and pondered his next move.

A flotilla of federal warships launched a series of intense bombardments to dislodge the batteries during the first week of December. The Confederates responded in kind. In one engagement on December 6, the ironclads *Carondelet* and *Neosho* blasted the batteries at close range. The *Neosho* was struck by enemy fire more than a hundred times but was not seriously injured, reported LeRoy Fitch, the officer who led the attacks.[624]

The next day, Reid reported that he and his shipmates "received orders to proceed with all possible haste up the Cumberland River to assist Capt. Fitch and his fleet in driving the Rebels from the river bank."[625]

Reid also noted, "Our boat is hardly ready but I suppose we will try and start tomorrow." His vessel, the *St. Clair*, had arrived in Mound City four months earlier for much-needed repairs. A shallow-draught, side-wheel steamer sheathed in light armor, or "tinclad," she was perfect for river duties and mobile artillery

support for the army. She was commissioned in September 1862 and assigned to the Mississippi Squadron. Also known as *Gunboat No. 19*, the *St. Clair* and her crew participated in numerous operations, including the 1863 Siege of Vicksburg and the 1864 Red River Campaign.

Reid was not an original member of the crew. He joined the navy in May 1864, just as activities along the Red River concluded.

The son of a joiner and native of Glasgow, Scotland, Reid came to America with his parents in 1843 when he was about four years old. The immigrant family settled in Buffalo, New York, where young Reid grew up in close proximity to the commercial traffic along Lake Erie and the Niagara River.[626]

The military situation in the western waters was a far cry from what Reid had known in New York, although the hustle and bustle of Mound City must have reminded him of home. When he arrived in town and found the *St. Claire* in a state of repair, he took up residence on the steamer *Paw Paw*.

Then came the December 7 order to support the flotilla along the Cumberland. Reid confided to his aunt, "We do not expect to be gone long but cannot tell what may happen 'ere we return." He added, "I trust that I may be ready for whatever the future may bring forth and be able to say God's will be done."[627]

The orders came to naught. A week later, On December 15, Maj. Gen. George H. Thomas advanced his Union forces against Hood's army and won a decisive victory that forced the Confederates to withdraw from the area.

Reid and his shipmates on the *St. Clair* spent the rest of the war on escort and dispatch duty along the Tennessee and Mississippi rivers. In July 1865, the *St. Claire* was decommissioned. Reid received an honorable discharge soon after and returned to his home in Buffalo.

Reid married twice. His first wife, Mary, bore him two children before she died in 1870. He moved to Detroit after her death and married Harriet Hartley. She became mother to his children and provided him with two more.[628] Reid lived until age seventy-seven, dying in 1917.

A Strict Accounting of Stripped Ships

THE UNION NAVY'S APPETITE FOR SHIPS WAS INSATIABLE. Paymasters and other purchasing officers searched high and low for qualified vessels up until the very end of the war. One of the largest hubs of activity was Cincinnati, Ohio, where civilian steamers of all classes were routinely brought in and refitted for navy service.

One such ship, the veteran stern-wheeler *Abeona*, was obtained for the fleet on December 21, 1864. The crew of the receiving ship *Grampus*[629] was notified of the transaction, and stripped her down—the first step in the conversion process.

The crew of the *Grampus* included Landsman George Early. A Kentucky native, he had married an Indiana girl in 1855, settled in her hometown of Terre Haute, and started a family that grew to include three children. He worked as a bookkeeper to support them.[630] Early had enlisted in the navy only three weeks before the purchase of the *Abeona* and was placed on detached duty as a clerk.[631]

Meanwhile, the commander of the *Grampus* had received detailed orders about stripping incoming vessels. "When a boat comes alongside," stated a purchasing officer, "you will have every article of furniture, crockery, tableware, tablecloths, napkins, towels, bedding of all kinds, sheets and pillowcases, carpets, engineers' tools, stores, and fittings removed to the *Grampus*, taking a careful inventory of each and every article, furnishing me with duplicate copies of the same."[632]

Early and other designated clerks were tasked with the inventories. They worked tirelessly behind the scenes to account for the never-ending flow of ships and materials needed to support the navy. Early served in this capacity on the *Grampus* and another

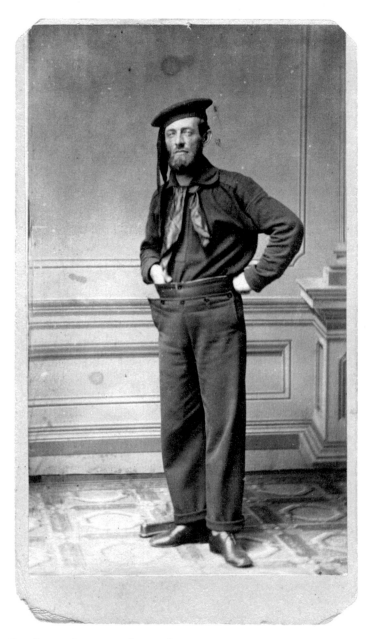

Landsman George Marlyn Early, U.S. Navy

Carte de visite by Cowan's (life dates unknown) New Photograph Gallery of Cincinnati, Ohio, about 1864. Collection of Steven M. Karnes.

receiving ship, the *Great Western*, during the waning days of the Confederacy.[633]

On April 10, 1865, the day after Gen. Robert E. Lee surrendered at Appomattox Court House, the *Abeona* was formally commissioned. Her conversion to a thin iron-plated gunboat, or "tinclad," complete, she went on to patrol the Mississippi River during the first months of a reunited homeland. Her life in as a navy vessel was brief—she was decommissioned in August 1865 and returned to her previous function as a merchant vessel.

By this time, Early had been discharged after eleven months of service. He returned to his family in Terre Haute and worked a variety of jobs, including as a clerk at a penitentiary and a superintendent at a gas company.[634]

Early died in 1886 at age fifty-six. His wife and children survived him.

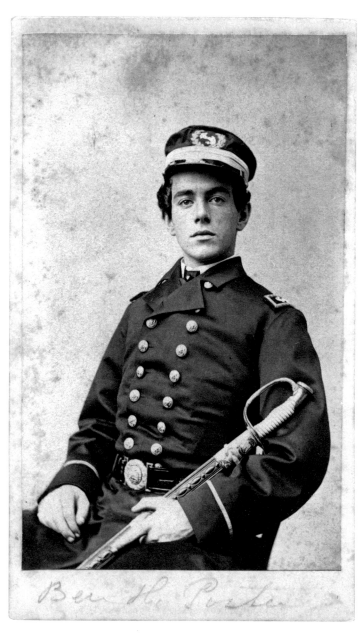

Lt. Benjamin Horton Porter, U.S. Navy

Carte de visite by George Gardner Rockwood (1832–1911) of New York City, about 1864. Collection of Orton Begner.

Leading the Assault against Fort Fisher

A COMPACT COLUMN OF BLUEJACKETS AND MARINES charged across a narrow strip of sand towards Fort Fisher on the afternoon of January 15, 1865. Conspicuous in the tight-knit vanguard of the 1,400-man strike force was the commander of the flagship *Malvern*, Ben Porter, his gloved hands holding the admiral's banner aloft.

Porter, it was said, was that rare leader whom men would follow to their death. Fierce and fearless, his ability to inspire and rally his command in the heat of battle verged on the supernatural. He was, at age twenty, the *beau ideal* of a naval officer.[635]

He had skyrocketed to recognition barely two years earlier with a tour de force along the North Carolina coast. In early 1862, then-seventeen-year-old Porter volunteered for amphibious operations against Confederates holed up on Roanoke Island. Placed in command of a battery of six howitzers, he and his crew joined ten thousand infantry and established a beachhead on the island during the evening of February 7. Porter's guns were the only fieldpieces deployed for the assault.

At daylight the next morning Porter and his howitzer battery moved forward in double-quick time with the main skirmish line towards enemy artillery and infantry. To keep pace with the skirmishers, his crew dragged the guns with ropes, paused to fire a single round, then grabbed the ropes and repeated the exercise. "I advanced the pieces after each fire until they were in the open space directly in front of the rebel battery, where we made a stand under a most destructive fire from the rebel infantry," Porter stated in his after-action report.[636]

The Confederate fire struck with deadly accuracy. One of the howitzers was left with a single man standing. Porter jumped

in and together they worked the gun until a bullet struck his crewmate. "A slug passed into his throat, from which the blood streamed out; he looked in my face, choked, fell down, and died. This made me *madder* than ever, and I went in on my muscle," Porter wrote to his mother. He continued the fight with utter disregard for his own life as he furiously loaded, fired, and swabbed out the howitzer while the fighting raged.[637]

The Union ultimately won the day. Maj. Gen. Ambrose E. Burnside, the commander of the expedition that would become known by his name, and a subordinate, Brig. Gen. John G. Foster, informed Rear Adm. Louis M. Goldsborough of Porter's gallantry. The admiral, who led the supporting naval fleet, later sent a commendation letter to navy secretary Gideon Welles. "The battery under his command," Goldsborough stated, was "handled with a degree of skill and daring which not only contributed largely to the success of the day, but won the admiration of all who witnessed the display." He added, "Mr. Porter was but 17 years of age, and in my belief no father in the land can, with truth, boast of a nobler youth as a son."[638]

Porter's father, James G. Porter, a prosperous merchant and carriage builder in New York, could be justifiably proud. Ben was the youngest of his six sons, and the family favorite. The Porters had always lived close to water, first in the village of Skaneateles on the Finger Lakes and later in Lockport, near Lake Ontario and the Niagara Falls.[639]

It is perhaps no surprise that Porter was drawn to the sea from an early age. When a vacancy at the U.S. Naval Academy in Annapolis became available in his congressional district, he was selected after a competitive examination. Porter, then fifteen, arrived at the academy in late 1859 and took his place as a cadet in the class of 1863.

The war interrupted his formal education. Porter and many fellow cadets were ordered to active duty on warships in the rapidly expanding fleet. Porter was assigned to the Atlantic blockade on the frigate *Roanoke*. Technically a midshipman, he performed the tasks of a lieutenant with the ease of a veteran officer.

The *Roanoke* was stranded in Hampton Roads, Virginia, with a broken shaft when Burnside's expedition was fitted out. Porter itched for an opportunity to join and managed to talk his way in charge of six launches that transported the howitzers and their crews.

Porter's performance at Roanoke Island was consistent with his credo. "I came into the country's service; to fight, and, if necessary, to lay down my life. And I assure you that I am not only glad of the opportunity, but if any thing is to be gained for my country, I will gladly welcome any fate that awaits me."[640]

News of his deeds at Roanoke Island spread to the far corners of the navy and to his hometown. During a brief visit to Lockport after the battle, his friends presented him with an elaborate sword as a testament of their pride in his achievement. At some point afterwards he posed for a *carte de visite* portrait holding the saber.

Porter returned to the front lines with a promotion to acting master and an assignment aboard the *Ellis*, a gunboat commanded by another bright star in the navy, Lt. William B. Cushing.[641] The two young officers had known each other at the academy and now became good friends as they wreaked havoc along the North Carolina coast.

In November 1862, Porter received his ensign's stripe and an assignment to the steam sloop *Canandaigua*, stationed off the coast of Charleston. Here he added to his laurels after being selected to reconnoiter the Confederate defenses of Charleston harbor. Beginning one day in July 1863, he set out after dark with one or two small boats and a bare-bones crew to explore the various batteries, forts, and vessels. He returned to the harbor for twenty-four successive nights, during which time he came into close contact with underwater mines and enemy patrols. After each clandestine visit he returned with valuable details of enemy positions and strength. Then he snatched an hour or two of sleep and reported to the gun deck to command a section of cannon that bombarded Fort Sumter daily. Stripped down to his shirt and trousers, his skin black with smoke and gunpowder, Porter

sighted guns and directed his crew. He and his men helped reduce Sumter to a heap of ruins.[642]

His conduct verged on superhuman. But the stresses of command and constant activity took a toll. "So deeply did he feel his responsibility," noted one historian of his nights in the harbor, "that while the labor lasted he lost a pound of flesh each day."[643]

On September 7, 1863, Fort Wagner and Battery Gregg fell to the federals. Rear Adm. John A. Dahlgren sought to take advantage of the weakened defenses and called for a storming party to capture Fort Sumter. Porter was one of four hundred men who volunteered. They landed on the debris-strewn grounds of Sumter during the early hours of September 8 and were immediately pinned down and trapped. About 125 were captured, including Porter, and held as prisoners of war in Charleston until October 1864, when they were paroled and sent to the North.

Porter returned to his family and anxiously awaited a formal exchange and return to active duty as a lieutenant, a promotion he had received during his captivity. The negotiations were soon completed, and before Thanksgiving 1864 he reported to Rear Adm. David D. Porter at Hampton Roads. The two men were distantly related.[644]

Lt. Porter's reputation preceded him. He was assigned to the command of the *Malvern*, the admiral's flagship. Here Porter also reunited with his best friend, Lt. Samuel W. Preston.[645] The pair had attended the academy together, and both had been captured during the assault on Sumter. Preston served as the admiral's flag lieutenant. Cushing, Porter's friend and former commander on the *Ellis*, was also on the scene.

Less than a month later, the trio was part of a Union expeditionary force that commenced operations against Wilmington, North Carolina. The Confederacy's last major port and a critical supply line for the Southern armies, the city was defended by Fort Fisher. The incursion occurred during the last week of December 1864 but failed.

Overall Union commander Lt. Gen. Ulysses S. Grant was disappointed with the results. He ordered another expedition to try

again. On January 13–14, 1865, a Union force of eight thousand infantry and artillery landed and established a beachhead while an armada of sixty warships with a total firepower of 627 guns readied for action.

The commander of the expedition, Maj. Gen. Alfred H. Terry, planned a massive bombardment by the navy to soften the enemy's defenses followed by a two-pronged ground assault. One column of infantry would attack the west side of the fort while a column of navy men hit the northeast salient. Terry scheduled the attack for January 15.

"It is 4 o'clock in the morning, and we are moving in for the attack," Porter stated in a hastily written letter to his mother. "We will strike a telling blow for Columbia to-day. America expects every man to do his duty, and our gallant tars never flinch."[646]

The landing and initial deployment in preparation for the attack was made during the massive naval bombardment, which lasted from about 10:00 a.m. until 3:00 p.m. that afternoon. About that time a signal was given for the columns to begin the assault. Though the naval column was under the tactical command of Fleet Captain Kidder R. Breese, Lt. Porter was the catalyst to spur the men forward.[647]

"The terrible hour for the assault came," recounted historian John S. C. Abbott. "Young Porter, bearing the Admiral's flag, claimed the post of honor in leading the headmost column with the *Malvern* men. As he left the ship, with the flag in his hand, he said, 'Admiral, this shall be the first flag on the fort.'"[648]

Lieutenants Preston and Cushing stood alongside Porter. All were dressed in their best uniforms complete with gold lace. Cushing recalled the charge: "Ben looked grave and determined, and I remember being much impressed by his supremely noble bearing. In a moment we were under a terrific fire, and the men commenced to get confused. It needed all the pluck and daring that man can have to lead and give confidence to the sailors in charging up that bare and level beach. Ben threw himself to the front, flag in hand, and the charge went on."

Cushing continued, "At the palisade, by the ditch that sur-

rounds the fort, Ben fell, shot through the breast. His last words were, 'Carry me down to the beach.'" Four sailors tried to move him, but two were killed in the attempt as shot and shelled rained down upon them. Cushing, still on his feet, noted that Porter then "waved the others aside with a last motion, and died, with as sweet a smile as I could paint with words."[649]

Porter was twenty years old. His body was left behind in the sand. A few yards away lay his best friend, Samuel Preston, who had fallen at almost the same moment.

The assault lost power and the column crumbled. The defenders of Fisher sensed the shift in momentum, mounted the parapet, and fired down into the disorganized mass. The sailors and Marines broke and ran while the enemy firing raged unabated. A small group of stalwarts dug in to the sand and remained until nightfall when they made their escape. One of these men, Lt. John Bartlett, had befriended Porter at the academy. Bartlett had seen Porter fall. "I wished to see if my friend Porter was still alive," he explained to his sisters in a letter a few days after the fight. "He was lying on the beach about a hundred yards from the palisades. I ran to him and dropped beside him. I found him dead, a shot having passed through his body. I took his sword, belt, and glove, and then, oh! how I did run for a little way. The rebels fired about twenty shots at me."[650]

The assault was a complete failure with a long casualty list—307 men and officers. Seeking perhaps to put a brave face on the disaster, navy commanders asserted that the action succeeded in creating a diversion that drew attention away from the west end of the fort. There the army column scored a major breakthrough that led to the capture of the fort and subsequent fall of Wilmington.

The navy mourned their fallen, especially Porter and Preston. "Two more noble spirits the world never saw, nor had the Navy ever two more intrepid men," stated Fleet Captain Breese in his after-action report. He added, "Young, talented, and handsome, the bravest of the brave, pure in their lives, surely their names deserve something more than a passing mention and are worthy

to be handed down to posterity with the greatest and best of naval heroes."[651]

Perhaps no officer mourned Porter's loss more than Rear Adm. Porter. "I have seen my official family cut down one after another, and my heart is so sad that I feel as if I could never smile again," he confessed in a letter to Porter's parents. "Among all the young men who have been on my staff no one had my entire confidence more than your lost son—lost only for a time. You will find him again where all is peace and joy. I would like to drink of the waters of Lethe and forget the last four years."[652]

The remains of Porter and Preston were recovered and carried to the *Malvern* to be prepared for transport, then sent to the North with naval wounded on the side-wheel brig *Santiago de Cuba*. Preston was interred at the Naval Academy Cemetery in Annapolis. Porter's body was sent to his family in New York. On top of his casket was placed the sword given to him by his friends.

Porter was buried in a local cemetery at his birthplace, Skaneateles. Here he joined one of his older brothers, Stanley, a corporal in the Twenty-first New York Infantry who was killed in action on August 30, 1862, at the Second Battle of Bull Run.[653]

In Skaneateles on May 28, 1882, the Benjamin H. Porter Post of the Grand Army of the Republic was chartered in his memory.

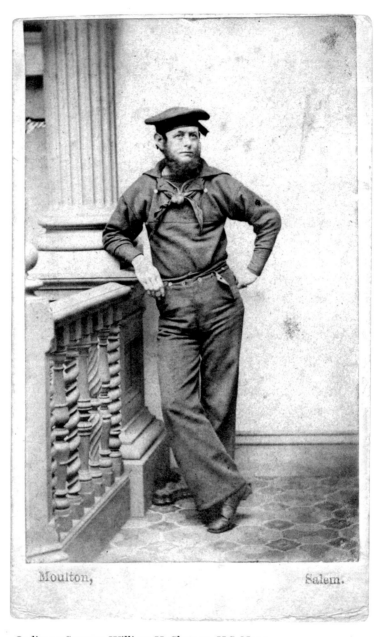

Moulton, Salem.

Ordinary Seaman William H. Sluman, U.S. Navy

Carte de visite by Joshua W. Moulton (1817–1895) of Salem, Massachusetts, about 1861–1863. Collection of Ron Field.

Yellow Fever Tornado

The naval war was all but over when William Sluman joined the Union navy in the middle of February in 1865. In the east, the fall of Fort Fisher and capture of Wilmington, North Carolina, closed the last major Confederate port. In the west, the Mississippi River and Gulf of Mexico were firmly in federal hands.

Sluman, a forty-two-year-old born in Salem, Massachusetts, descended from Anglo-Saxon ancestors who had come to America in colonial times. In 1841, when Sluman was in his teens, his father purchased a tract of land in Illinois and moved the family from Salem to Little Fort, an old Indian settlement and later a French trading post situated along the banks of Lake Michigan. The pioneer community grew rapidly and was renamed Waukegan before the decade ended. Sluman worked on the lake, married, and, in 1858, became the father of a baby girl.

At some point soon after the birth of his daughter, Sluman returned to Salem. He joined the navy in October 1860 as an ordinary seaman for a three-year enlistment. Little is known about this first tour of duty—his motivations and ship assignments were not recorded. Evidence suggests he mustered out after his term expired and took a year off before signing up for another tour of duty.

Records for Sluman's second tour are more complete. After he reenlisted on February 11, 1865, authorities assigned him to the *Kearsarge*. The sloop-of-war had made international newspaper headlines the previous summer when she and her commander, John A. Winslow, defeated rebel Capt. Raphael Semmes and his raider *Alabama* at the Battle of Cherbourg, France.

On April 14, 1865, the day President Abraham Lincoln was assassinated in Washington, D.C., the *Kearsarge* set out from

Boston for the Mediterranean under the guidance of a new commander, Abram D. Harrell.[654] Less than a year later, off the coast of West Africa, yellow fever struck the ship and crew with a fury. "The whole affair," wrote Cmdr. Harrell, "can be told in a few words, but the scenes on board the vessel, for the period of ten or twelve days, baffle description. The fever made its appearance on board on the 15th of March, immediately after leaving Sierra Leone. Unhappily for us, our doctor was the first person attacked, and was never after able to prescribe. He lived five days."[655]

"The epidemic passed over us like a tornado," Harrell noted. "The insane ravings of the dying, vainly calling for that assistance which it was not in our power to render, formed a spectacle not easily forgotten." Temperatures hovering near the 100-degree mark added to the men's sufferings.[656]

When the scourge finally ended, fourteen men were dead—seven officers and seven enlisted men. Among the bluejackets who lost the battle with the dreaded fever was Sluman. He died on March 20, the same day as the surgeon, giving him the grim distinction of being one of the first to be infected and succumb to its effects.

Sluman and the other dead were buried at sea and their personal effects tossed overboard. Sluman's wife and seven-year-old daughter survived him.[657]

Affair at Bayou Teche

Bands of rebels roamed the rich sugar lands of Louisiana in search of Yankees during the waning days of the war. One group was active in the vicinity of Bayou Teche, and on March 21, 1865, it happened upon the federal gunboat *Carrabasset*, laden with supplies.

The rebels charged the vessel with muskets blazing. The sailors on board the side-wheel steamer snapped into action and returned fire. "A few shells and shrapnel soon dispersed them," reported Lt. Ezra M. Leonard, the senior officer of the *Carrabasset*.[658]

Leonard's crew included a citizen sailor from his home state of Massachusetts, twenty-one-year-old Ansel Delano. The lone survivor of twins born to a Barnstable County farmer and is wife, he worked in a factory during the early part of the war.[659] Delano left his job in early 1864 and joined the navy as an acting master's mate. His primary duty was to assist the master of a vessel in navigation and steering.

While Delano received basic training, a navy agent purchased the merchant vessel *Carrabasset* in Cincinnati, Ohio. The ship was named for a river in Maine, and a Native American warrior who was the subject of an 1830 play.[660] The *Carrabasset* steamed to New Orleans, where she was commissioned in May 1864 and attached to the West Gulf Blockade Squadron. A versatile and dependable vessel, she participated in small-scale operations along Louisiana's interior waterways as a tug, a transport, and a gunboat.

In March 1865, Delano and the crew of the *Carrabasset* were ordered to Bayou Teche to fetch the family of a civilian named Williams. He was employed at a military post in Union-occupied

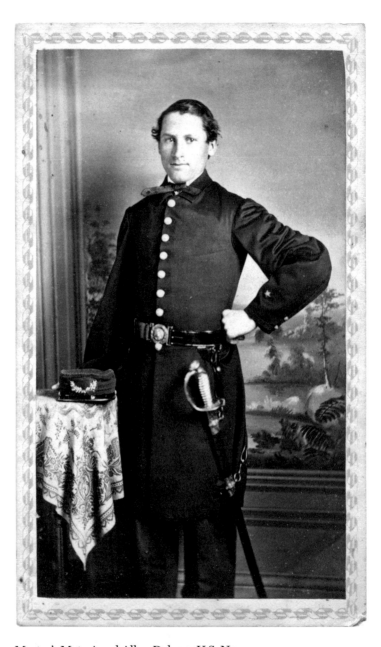

Master's Mate Ansel Allen Delano, U.S. Navy

Carte de visite by an unidentified photographer, about 1864. Collection of the author.

Brashear City. The *Carrabasset* set out on the evening of March 20 with Williams and a detachment of about forty men from the Ninety-third U.S. Colored Infantry to bring the family into federal lines.[661]

The *Carrabasset* arrived within a mile of Bayou Teche later that night. The infantrymen disembarked and marched through the darkness with Williams as a guide. They soon arrived at the Williams homestead. According to an official report filed by Simon Jones, the colonel and commander of the Ninety-third, "The family of Mr. Williams, for peculiar and domestic reasons, could not be induced to come with him."[662]

Colonel Jones noted, "While at Bayou Teche, a party of from twenty-five to thirty of the enemy rode down to the bayou on its southern bank, and dismounting, fired a number of shots at my detachment."[663] Jones's men fired back and drove the enemy away. Then they reconnoitered the area in search of more enemy forces.

It may have been these same rebels that attacked the ship and crew back on the *Carrabasset*. Lt. Leonard acted quickly after fire from his guns scattered the enemy. Then he ordered a detachment of sailors in pursuit. Delano may have been placed in charge of the landing party, as it was common practice for the master's mate to perform this duty. Lt. Leonard reported, "I landed with a small force and captured one musket and equipments of a rebel picket and several pirogues," or small flat-bottomed boats.[664]

A few months later, in July 1865, the *Carrabasset* was decommissioned and returned to civilian service. Delano received a promotion from acting to full master's mate, served on several more vessels, and left the navy in the summer of 1866.

Delano returned to Massachusetts and resumed life as a factory worker in Brockton. He married in 1871 and started a family that grew to include three children who lived to maturity. Active in the Grand Army of the Republic and the Masons, he died in 1914.[665]

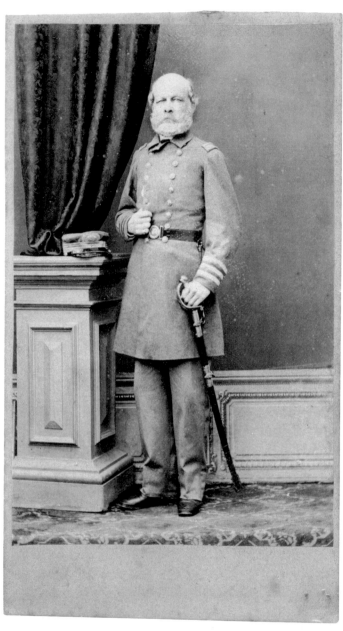

Capt. Thomas Jefferson Page, C.S. Navy

Carte de visite by Ulysse Ferrant (life dates unknown) of Ferrol, Spain, about 1865. Collection of Gerald Roxbury.

Showdown at Ferrol Harbor

The Confederate ironclad ram *Stonewall* steamed out of the Spanish port of Ferrol in broad daylight on March 24, 1865. The distinctive metal stem protruding from her bow cut through the glassy waters like a plowshare through fertile Southern farmland. She moved deliberately into the Atlantic, where two Union warships waited to destroy her.

The commander of the *Stonewall*, Jeff Page, had resolved himself and his crew to their fate. "Coolly and calmly we look things in the face, trusting to the guidance of an all-wise and merciful God and to our own hard exertions."[666]

Only a seasoned veteran of Page's stature could make such statements with confidence. He had started his career in the U.S. Navy back in 1827—years before many of his crew had been born—and had risen to prominence as a respected commander and representative of American interests across the globe. His four-year expedition to South America in the 1850s resulted in widespread acclaim and a wealth of data and specimens for the Smithsonian Institution.[667]

When the Civil War broke out in 1861, Page was offered a commission as admiral in the Italian navy, one of the many governments he had befriended in his travels. According to a biographer, "He declined, because as he said, his native state, Virginia, had a prior claim upon him."[668]

Born Thomas Jefferson Page in Gloucester County, he descended from Virginia's first families. His grandfather, John Page,[669] was a close friend and college classmate of future president Thomas Jefferson. His maternal grandfather, Thomas Nelson Jr., was a signer of the Declaration of Independence.[670]

In April 1861, Page resigned his commission and joined the

Virginia Navy, which formed to counter a concentration of Union warships along the commonwealth's vast waterways. Page agreed with fellow Virginian and navy officer Matthew F. Maury, who promoted a doctrine of "big guns and little ships" to destroy over-sized federal frigates. Page noted in a letter of support, "The caliber and range of our guns being quite equal to those of the enemy, and our boats presenting such comparatively diminutive objects, would give us an incalculable advantage, and when attacked on all sides a frigate would find such a 'hornet's nest.'" He added, "It will, I confidently believe, drive the vandals out of the waters of Virginia."[671]

Page had a firsthand opportunity to put Maury's ideas into practice as the Union Army of the Potomac made its way up the peninsula towards Richmond in the summer of 1862. Page, in charge of a battery at Gloucester Point along the York River in his home county, awed the invaders with his marksmanship. One Union officer, in a report to overall army commander Maj. Gen. George B. McClellan, remarked that Page's guns were so precise that he "can kill a dog at a mile."[672]

About this time the Virginia Navy integrated with the Confederate navy, and Page was appointed to the rank of commander. One senior officer suggested that Page replace Capt. Raphael Semmes of the raider *Alabama* after rumors of his declining health surfaced.[673]

In 1863, Page was sent to England and joined other officers awaiting assignment as Confederate officials and European powers negotiated purchase agreements for warships. More than a year passed before he received a command. In December 1864 he was placed in charge of a new vessel constructed in secret by the French—the *Stonewall*.[674]

In late January 1865, Page and his crew took possession of the *Stonewall* off the west coast of France and steamed south. Battered by unexpectedly stormy seas along the way, the ship suffered numerous leaks and other damage. Page had no choice but to stop for repairs and refueling. The *Stonewall* limped into

the nearest port for assistance, which happened to be Ferrol, a major Spanish shipbuilding center and naval station.

The Union navy got wind of the *Stonewall*'s whereabouts. On February 16, the frigate *Niagara* arrived outside Ferrol. The sloop-of-war *Sacramento* joined her five days later.

The *Niagara*'s commander, Thomas T. Craven,[675] was a career navy man who had suffered a personal loss six months earlier when his younger brother, Tunis, died heroically while in command of the monitor *Tecumseh* during the Battle of Mobile Bay.

The rebel ship unnerved Cmdr. Craven. "The *Stonewall* is a much more formidable vessel than any of our monitors," he wrote on February 28 to secretary of the navy Gideon Welles with reference to her thick iron plating, heavy armament, and engines. "In smooth water and open sea she would be more than a match for three such vessels as the *Niagara*. In rough weather, however, we might be able to annoy if not to destroy her." Craven continued, "I feel, sir, as if placed in a most unenviable position. All that I can now do is to watch closely her movements, and hope that at any rate she may be detained where she is definitely, or until such necessary reinforcements are sent out as to enable us to cope with her."[676]

Welles meanwhile worked diplomatic channels to remind the Spanish that harboring a ship hostile to U.S. interests was intolerable. The Spanish, determined to avoid entanglement in America's troubles, were anxious to get rid of the *Stonewall*. Page, aware of Spain's unease, worked as quickly as possible to make the *Stonewall* seaworthy. But the damage was greater than initial estimates, and time was required for repairs.[677]

Weeks passed. In late March, Page decided that the *Stonewall* was ready. Despite lingering concerns that her power was greatly exaggerated and wishing he had a few more ships to go up against the Union vessels, he got under way on March 24.

"We got out at 10:30 a.m., accompanied by a Spanish frigate, to see that there was no violation of Spanish territory," Page later recalled. "I remained off the harbors of Ferrol and Coruña (where lay the Yankee men-of-war, the *Niagara* and *Sacramento*, with

steam up, in full view) until 8:30 p.m., but neither of them made a move from their anchors. This will doubtless seem as inexplicable to you as it is to myself and all of us. To suppose that these two heavily armed men-of-war were afraid of the *Stonewall* is to me incredible; and yet the fact of their conduct was such as I state to you."[678]

"How Captain Craven can excuse himself for not meeting her yesterday is a thing I can not conceive," Page ridiculed. "Unless he has a reason beyond his control his commission would not be worth much in most navies."[679]

Craven's after-action report contains his view of events. "At this time the odds in her favor were too great and too certain, in my humble judgment, to admit of the slightest hope of being able to inflict upon her even the most trifling injury, whereas, if we had gone out, the *Niagara* would most undoubtedly been easily and promptly destroyed. So thoroughly a one-sided combat I did not consider myself called upon to engage in."[680]

Craven wrote more candidly to the American chargé d'affaires in Madrid, "With feelings that no one can appreciate, I was obliged to undergo the deep humiliation of knowing that she (the *Stonewall*) was there, steaming back and forth, flaunting her flags, and waiting for me to go out to the attack. *I dared not do it!* The condition of the sea was such that it would have been perfect madness for me to go out. We could not have inflicted the slightest injury upon her, and should have exposed ourselves to almost instant destruction."[681]

The *Stonewall* steamed off unmolested. A few days later in the Portuguese harbor of Lisbon the Union warships and the *Stonewall* crossed paths a second time. Craven again declined to attack, and the *Stonewall* slipped away. "I have been compelled to lose sight of one of the most formidable ironclad vessels now afloat," Craven admitted. "It may appear to some that I ought to have run the hazard of a battle, but according to my judgment I shall ever feel that I have done all that could properly be attempted toward retarding the operations and progress of that vessel."[682]

Craven was promptly court-martialed and after a grueling sixteen-day trial found guilty of failure to overtake and destroy the *Stonewall*. He was sentenced to a suspension from duty with leave pay for two years. But conflicts in the ruling by the court prompted Secretary Welles to declare a mistrial, and Craven was restored to full command.

Page and his crew crossed the Atlantic and were bound for South Carolina, where they planned to raise the blockade at Port Royal and disrupt the flow of supplies to Union Maj. Gen. William T. Sherman's army. The *Stonewall* arrived at Nassau, Bahamas, on May 6, 1865. Here Page learned that Richmond had fallen and Gen. Robert E. Lee had surrendered the Army of Northern Virginia.[683]

Page set a course for Havana. The situation at the Cuban port was not good. Four Union warships were gathered off the coast, and, on May 16, a fifth arrived. She was the side-wheel steamer *Connecticut*, and her captain, Charles S. Boggs, had known Page in the navy before the war. Boggs sent Page a letter that detailed the many setbacks suffered by the South in recent weeks and ended with an offer: "I beg of you to reflect whether it will not be better for you to surrender the Confederate steamer *Stonewall* to me, with the officers and all the crew that may be with her at the time of surrender, upon the same terms granted to Generals Lee, Johnston, and others who have heretofore surrendered."[684]

Page declined. Instead he negotiated with Spain for favorable surrender terms and funds to pay the men. On May 19, Spanish authorities took possession of the *Stonewall* and released Page and his crew. Spain eventually turned the *Stonewall* over to the U.S., who in turn sold her to the Empire of Japan. Renamed the *Kōtetsu*, she remained on active duty until 1888.

Page fled to Argentina with his wife, Benjamina, and children. He became a sheep and cattle farmer and participated in the development of the country's coastal defenses and the modernization of its navy. They eventually moved to Italy, where Page became affectionately known as the "Commodore." He passed

away in 1899 at age ninety-one and was buried in Rome alongside his son, Thomas Jefferson Page Jr., a promising young Confederate officer who had died in 1864 while in Italy to recover his health.[685]

Long Journey Home

Edward Archer could not sleep. Mentally and physically exhausted, he rested on a damp blanket thrown over a pile of freshly cut rushes from the Florida marsh in which he and others were stranded. His tattered gray uniform was little protection against sand flies and mosquitoes that swarmed about him. Yet somehow the rest of his party slept soundly, and their deep snores only added to his frustration.[686]

"I was never as much annoyed in my life as I was *that* night," he later noted of his experience in the wilderness near St. Marks, Florida, on March 26, 1865. How he came to be there is the story of a failed enterprise and a deep desire to return to the Confederacy.[687]

Four years earlier, Virginia-born Archer had worked as a superintendent in the machinery department of the Tredegar Iron Works in Richmond. He had amassed engineering expertise that belied his twenty-seven years, first as an apprentice at Tredegar during his late teens and early twenties, and then as an engineer in the U.S. Navy.[688] He had resigned his commission in November 1860 and was welcomed back to Tredegar. According to a company representative, Archer possessed "a thorough practical knowledge of his profession, for which he had naturally a genius."[689]

Archer also possessed familial ties to Tredegar. Brother-in-law Joseph R. Anderson was the company's president. Father Robert Archer was an iron maker and owner of a mill that merged with Tredegar in 1859. Both men were former U.S. Army officers.[690]

After the start of the Civil War, young Archer continued his employment at Tredegar. He contributed to the production of high-quality munitions for the Confederate army and navy, which

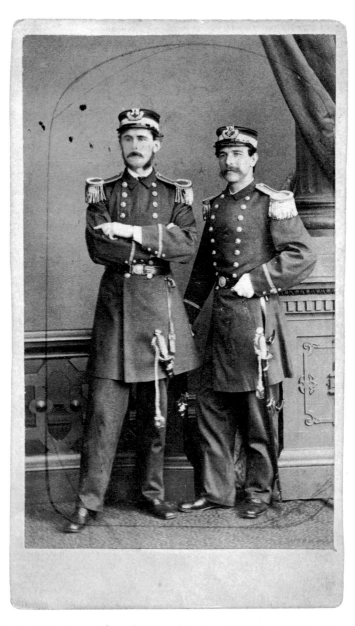

1st Asst. Engineer Edward Richard Archer, C.S. Navy (*right*), with Asst. Paymaster Daniel D. Talley, C.S. Navy.

Carte de visite by John Jabez Edwin Mayall (1813–1901) of London and Brighton, England. Collection of Gerald Roxbury.

included the iron plating for the *Virginia*, the South's first iron-clad warship.

As the war progressed, the Union blockade slowed the flow of supplies to the South. In response, the Confederacy ramped up its acquisition of vessels to wage war on Northern navy and merchant ships. In one of many moves to procure funds to buy or build vessels, the Virginia State Assembly passed a novel act. On October 13, 1863, it chartered the Virginia Volunteer Navy Company, a privately funded and operated quasi-military firm. The charter was a win for the government, the military, and the private sector: company ships would fight in the war with the promise that after the successful conclusion of hostilities they would be converted to commercial use.[691]

About this time Archer applied to the company for the position of chief engineer on a future steamer. He was offered and accepted a spot as first assistant engineer, and the Navy Department followed up with a formal commission. He also received a government pass that authorized him to sail from any Southern port to Europe.

Archer traveled to Britain and was introduced to the *Hawk*, a Scottish-built iron steamer under contract by the company. He utilized his engineering experience to adapt the vessel for use as a privateer. The alterations included reinforced decks and passageways, reconfigured coalbunkers and boilers for added protection from shot and shell, and quarters for more than a hundred crewmen. The work attracted the attention of U.S. diplomats, who alerted their British counterparts. They were however unable to find evidence to link the *Hawk* to the Confederates.[692]

On June 13, 1864, the *Hawk* departed British waters for Bermuda, where she would be armed with guns and turned loose on the Yankee fleet. Archer was aboard. "I can not speak to highly in praise of the ship as she is acknowledged by all to be the finest specimen of naval architecture of her class afloat," he wrote with pride to the president of the company.[693]

This was the high point of Archer's military experience. Two weeks later, he and his shipmates arrived in Bermuda and learned

that funds promised to complete the purchase of the *Hawk* were not available. Accusations of financial irregularities and recriminations by company members continued for months. Meanwhile yellow fever swept Bermuda. The contagion resulted in the deaths of eight officers and men, though Archer was spared.

In the end, the company could not pay the bill. Archer and the rest of the dejected crew returned to Britain aboard the *Hawk* in late 1864. Strapped for cash and left with two coins "to jingle in my pockets to keep up appearances when in company with gentlemen," Archer scrimped by until funds were advanced from home.[694]

On January 21, 1865, Archer left Liverpool on the steamer *Africa* bound for Halifax, Nova Scotia. Thus began a harrowing four-month odyssey to rejoin his family. The deteriorating military and political situation in the Confederacy slowed Archer's progress as he journeyed from Halifax and Bermuda to Nassau and Havana. In Cuba he ran into a bit of luck. The blockade-runner *Owl* was in port, and her commander, the celebrated privateer John N. Maffitt, agreed to carry about a dozen men to the Confederate mainland. Archer was among them.

On March 21, the *Owl* left Havana. Three days later, she arrived in the Gulf of Mexico along the Florida coast near St. Marks. Maffitt observed to his dismay that the Union blockade was in full force and turned to head back out to sea. Archer and the rest of his party begged Maffitt to give them a rowboat, which he did, and they struck out on their own. The men landed in a marshy area and battled the elements as they picked their way through desolate swamplands. Days later they arrived at a Confederate camp too exhausted and hungry to remove their muddy and torn uniforms.

Archer eventually made his way with the others to nearby Tallahassee to rest and recuperate. The party separated here. Archer set out with a few others on March 29 and spent the next month traveling northward by rail and on foot through war-torn Georgia and South Carolina and into North Carolina. On April 15, 1865, they arrived in Charlotte and learned that Gen. Robert

E. Lee had surrendered the Army of Northern Virginia. Archer recollected, "We could not believe this report, but the next day it was confirmed, and of course we *had* to believe it. We were a *blue* party that day, but, still hoping for the best, we determined to push on."[695]

Archer continued on, alone now, to Greensboro. He stopped at the headquarters of Gen. Joseph Johnston in the midst of negotiations for the surrender of the Army of Tennessee. Here he attached himself to the Naval Brigade, an infantry organization composed of sailors who escaped after Richmond fell to Union forces on April 3. Commanded by Adm. Raphael Semmes, the Naval Brigade surrendered along with the rest of Johnston's army on April 26, 1865. Archer received his parole five days later and immediately left for Richmond. He arrived in the conquered capital on May 4 and "finding all of the family well, who were astonished to see me."[696]

A few weeks later, Archer revealed his feelings to a friend. "After four years of deadly strife to have failed almost breaks the hearts and spirit of the noble soldiers of the South but still there exists a smouldering flame which I have no doubt will one day burst forth and fire again the whole Southern mind; our soldiers were overpowered and tired, down but not whipped and if the people had have stood by them and given them all their aid instead of speculating and quarrelling amongst themselves everything would have gone as we could have desired, but as it now is we will have to submit to Power since the hands of justice are tied, and her scales fraudulently balanced by the enemy against us."[697]

He added, "We have much to be proud of when we look around us and consider who we have been fighting; not only the Yankee & Slavery but the whole world, and her Northern friends now are magnanimous enough to give us a great deal of credit and take but little themselves at what they have gained."[698]

Archer returned to Tredegar and became chief engineer. He held this position until his death at age eighty-four in 1918. He never married.

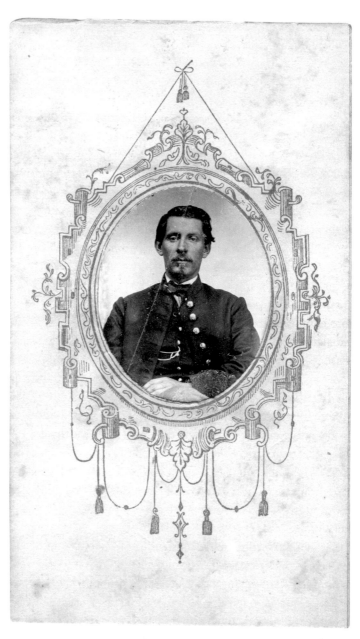

Acting Lt. Amos P. Foster, U.S. Navy

Sixteenth-plate tintype by an unidentified photographer, about 1861. Collection of Ron Field.

The Lieutenant Who Nearly
Drowned Lincoln

On April 3, 1865, Union ground forces made a mad dash into Richmond after Confederates abandoned their capital. Close on their heels were Acting Lt. Amos Foster and his crew aboard the warship *Commodore Perry*.

A Naval Academy dropout who had proven himself to be an aggressive commander in wartime, Foster characteristically pushed towards the city as quickly as possible—and in the heat of the moment almost drowned President Abraham Lincoln.[699]

The near-tragic event unfolded after a series of terrific explosions coming from the direction of Richmond lit up the night sky and alerted the federals. It was the scuttling of the rebel fleet in the James River as the Confederate navy abandoned the capital.

Downriver on the Union side, Foster called for his gig and went ashore. He made his way to the nearby artillery battery known as Crow's Nest and climbed a signal tower. He saw the spires of Richmond and fires that raged from the burning warships and elsewhere in the city. Satisfied that the rebel evacuation was under way, he returned to the *Perry*. Soon afterwards the flagship *Malvern* signaled him to go on to Richmond. "My God! What a feeling went through the officers and crew of the old *Perry* when the fact was made known to them!" recalled O. E. Pierce, a signal officer who later wrote his reminiscences about the journey to Richmond.[700]

The *Perry* got under way on April 4. "The good old boat began to move up the river over waters that no Union vessel had touched since the war began," noted the signalman.[701]

Getting to Richmond by water was easier signaled than done. The rebels had laced the James with torpedoes, or underwater mines. Foster sent three of his rowboats ahead of the *Perry* to

find them. "They had not long to search—a little chip was seen floating in the water. It was examined—a line was found attached, and on the end of that a tin can containing seventy-five pounds of pounds of powder," explained Pierce. The crew cut the lines and other wires, carefully cut open the can and spilled the powder into the river. Foster's bluejackets removed fifty-one torpedoes in this manner.[702]

The *Perry* continued on, but her progress ended abruptly after she grounded hard on underwater obstructions below Drewry's Bluff and Fort Darling, only seven miles from Richmond. Foster ordered part of the coal supply dumped overboard to lighten the load and all the guns moved to one side to lift the vessel. Then he directed his chief engineer to turn its massive side-wheel paddle back and forth.[703] Until the *Perry* could break free, no ships could pass.

Soon afterwards the *Malvern* arrived on the scene with Adm. David Dixon Porter and President Lincoln. They were in as much of a rush to get to Richmond as Foster. Porter decided to set out in the *Malvern*'s small flat-bottomed barge and row the rest of the way. The barge was lowered into the water, and Porter and Lincoln took seats in the stern. A second boat filled with a bodyguard of Marines followed.

The signal officer recounted what happened next: "Between the *Perry* and the shore was a very narrow passage of deep water, and it was through this that the admiral intended the boats should pull. But on reaching this, he found it was not wide enough for him to pass through pulling the oars on both sides. Just as they had given the barge good headway—thinking she would shoot far enough ahead to clear the steamer and allow them to use the oars again—the current struck her on the bow and set her directly under the steamer's immense wheel. At this very moment the engineer, not aware that anyone was near the wheel, began to turn her over." He added, "The President halloed; the admiral halloed; and the crew halloed."[704]

Foster ran to his engineer. "I rushed to the engine room hatch,

roared out to stop her. He stopped her, but one half turn more would have killed the President, Admiral and all."[705]

Porter was livid. "Where is the captain of this vessel?"

Foster leaned over the *Perry*'s rail, "Here I am, sir."

"Well, sir," replied Porter, "When you back off from here, don't you attempt to go to Richmond. Come to anchor and allow the other boats to go up."

"Aye, aye, sir," acknowledged Foster.[706]

Foster had no intention of remaining behind. He ordered up three small tugs that squeezed through the narrow passage and fixed hawsers to the *Perry*. Foster waved a handkerchief and the tugs pulled. "Crash!—went the obstructions, and away went the good old *Perry* over the obstructions, bow first! What a cheer rent the air! Away we went under a full head of steam," recounted the signal officer.[707]

Meanwhile the presidential party in its two small vessels arrived in Richmond and the president made his historic appearance on the streets of the conquered capital. Then the *Perry* arrived, and she became the first warship to weigh anchor at Richmond. The *Malvern* followed in her wake.

Foster, aware that he had disobeyed a direct order from Porter to steer clear of Richmond, went aboard the *Malvern* later that day to announce his presence. According to the signalman, an orderly showed him into a cabin where Porter and Lincoln sat at a table. Foster reportedly saluted the men and said to Porter, "Admiral, I have the honor to report the arrival of the U.S. steamer *Commodore Perry* at Richmond."

"I thought I told you not to attempt to come to Richmond, sir," Porter exclaimed.

Foster replied, "I did not so understand you, sir. I understood you to say when I *backed off* not to attempt to come up."

Porter interrupted, but before he could complete his thought, Foster continued. "I did not back off," he said with a smile. "I came off bow first."

The signalman noted, "The admiral was mad, but Old Abe

saw the joke and enjoyed it, as he always enjoyed a good joke, and laughed loudly." The president rose from his chair and taking Foster's hand congratulated him on commanding the first warship to arrive in Richmond.

Porter did not appreciate the humor. "Go aboard your vessel, sir, and I will see you in the morning concerning the matter."[708]

The admiral let the matter drop. Years later, in his *Naval History of the Civil War*, Porter did not mention the incident.

Foster acknowledged the episode in a paper he presented to a veteran's group in 1914. "Suffice it to say that at the last I led the fleet up the James River, took out 51 torpedoes so that the fleet could pass in safety, nearly drowned President Lincoln and Admiral Porter, and was the first boat to arrive at Richmond, on the surrender of that city."[709]

Two years after he read his paper, Foster died in Milwaukee, Wisconsin, after a long civilian career as a ship's captain on the Great Lakes. A native of Brooklyn, New York, he was survived by three children from his first wife, Jacqueline, who died in 1876, and his second wife, Eliza.[710]

The Great New Orleans Chase

A SIDE-WHEEL STEAMER LADEN WITH COTTON CHUGGED along the Mississippi River above New Orleans early on April 24, 1865. Her crew lounged about the deck, dressed in army overcoats to counter the morning chill, and casually smoked cigars or picked their teeth. The Stars and Stripes hung above them at half-mast, in mourning for the slain president.[711]

This section of the river was crowded with vessels of all classes, including federal gunboats and military support ships. All the navy vessels were on high alert after a reliable report stated that a Confederate ram was moving in their direction. Word also reached the citizens of the city, who had gathered in the streets and along the levees to await the arrival of the rebels. According to an account published in the *New York Herald*, the fleet "looked for something of the *Merrimac* style of iron-clads."[712]

One of the sailors in New Orleans was Thomas Armstrong. An English immigrant who had joined the navy in 1861, he had been stationed in the Pelican City since it fell to Union forces in 1862. He had recently been appointed third assistant engineer and assigned to the supply ship *Hollyhock*, a paddle-wheel steamer armed with three guns.[713] Armstrong could not have known that the *Hollyhock* was about to participate in one of the war's great chases.

The drama began on the sloop-of war *Lackawanna*, which lay just above the section of New Orleans known as Algiers. Her pilot, described by the *Herald* as "an old steamboat man in these waters," recognized the side-wheel steamer packed with cotton as the Confederate warship *Webb*. She looked nothing like the metal monster that sailors and citizens expected.[714]

The pilot of the *Lackawanna* informed his captain, who or-

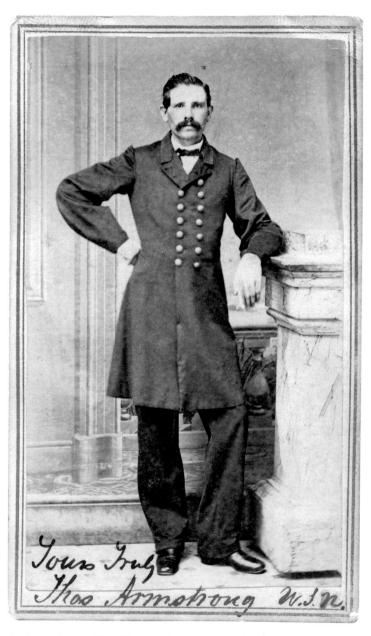

Acting 3rd Asst. Eng. Thomas Armstrong, U.S. Navy

Carte de visite by Theodore Lilienthal (1829–1894) of New Orleans, Louisiana, about 1864–1866. Collection of the author.

dered his gunners to open fire. The Union sloop *Ossipee* joined in the action. The sound of the big guns alerted nearby ships in the Union fleet.

The crew of the *Webb* sprang into action the moment they were discovered. They hauled down the American flag and sent up the Confederate ensign. "The *Webb* was hit several times, and she at once dashed forward, and ran by the *Portsmouth*, *Quaker City*, *Florida* and other vessels, whose batteries were manned, but which could not be fired in consequence of the danger of killing innocent people, who thronged the streets and levee of Algiers, watching for the ram," reported the *Herald*.[715] The *Webb* steamed rapidly downriver and ran the gauntlet at New Orleans, unaffected by the federal fire.

Only one ship was prepared to pursue the rebels—the *Hollyhock*. She fired up her engines and sped off. "The boat dashed after the flying foe," reported the *New York Times*. "The race was tie and tie. The *Webb*, as is well known, was always a fast boat, and gallantly maintained its reputation upon this tremendous occasion, but the noble *Hollyhock* clung to her like an avenging Fate. In vain were the efforts of the rebel ram to elude the fast-coming ruin. Mile after mile was passed; the boats throbbed their fierce and fiery way and apparently no advantage was gained on either side."[716]

About twenty-five miles south of New Orleans, the *Webb* slowed to allow the *Hollyhock* to catch up. The commander of the *Webb*, Lt. Charles W. Read, hoped to capture the *Hollyhock* before moving into the Gulf of Mexico and freedom. A graduate of the U.S. Naval Academy who had cast his lot with the South, the daring and cunning Reed had captured numerous Yankee ships during the war.[717]

But this prize eluded him. As the *Webb* maneuvered into a position, the masts of the twenty-two-gun Union warship *Richmond* appeared on the near horizon. Read knew in an instant that the *Webb* would prove no match against the *Richmond*. He ordered the *Webb* grounded and burned, and for the crew to escape.

By the time the *Hollyhock* arrived on the scene, the *Webb* was

in flames. Most of her crew was captured, including Lt. Read. He and other officers were sent to the North and imprisoned for a few months. Armstrong earned a share of the credit for the reliability of the *Hollyhock*'s engines, which can fairly be attributed to him and the other engineers and support crew.

Armstrong barely survived the war. In 1867, he fell victim to an epidemic of Yellow Fever. His wife, Josephine, whom he had married a few months before the great chase, and an infant daughter, survived him.[718]

Investigating the Loss of the Harvest Moon

THE COURT OF INQUIRY ASSEMBLED ON THE UNION GUN-
boat *Mingoe* off the South Carolina coast on April 27, 1865, exam-
ined its eighth and final witness. Judge Advocate Charles Cable
turned to the individual, a landsman, and said, "State what you
know about the sinking of the *Harvest Moon*."[719]

The landsman told Cable and the other members of the court
how he had been thrown overboard after the steamer struck an
underwater mine. The device exploded with a terrific force that
blew a large hole in the bottom of the *Harvest Moon* and sent
her to the bottom of Winyah Bay, north of Charleston. One sailor
died.[720]

The tragedy that befell the *Harvest Moon* could easily have
struck Cable and his shipmates aboard the *Mingoe*. They had
plied the waters along this part of the coast on blockade duty for
the better part of a year without a major incident.

Cable, a twenty-four-year-old clerk from New York City and
the eldest son of a ship's pilot, had entered the navy with an act-
ing assistant paymaster's appointment in the autumn of 1863. He
joined the crew of a newly commissioned tugboat, the *Marigold*,
and steamed to the Gulf of Mexico for duty with the blockading
squadron that patrolled the eastern expanse of the coast.[721]

In January 1865, Cable was transferred to the *Mingoe*, which
belonged to Rear Adm. John A. Dahlgren's[722] South Atlantic
Blockading Squadron. The steamer had patrolled the South Caro-
lina coast for months with little activity. The situation changed
soon after Cable's arrival. In February 1865, the *Mingoe* and other
ships received orders to support Maj. Gen. William T. Sherman's
army as it marched northward from Savannah, Georgia. Dahl-
gren's flagship, the *Harvest Moon*, became one of the few navy

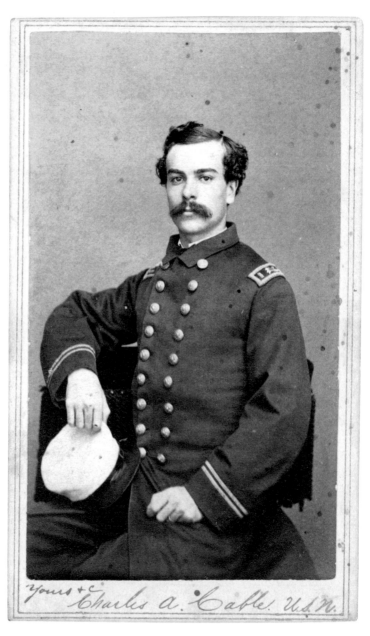

Yours &c Charles A. Cable. U.S.N.

Paymaster Charles A. Cable, U.S. Navy

Carte de visite by Charles DeForest Fredricks (1823–1894) & Co. of New York City, Havana, and Paris, about 1866. Collection of Earl Sheck.

casualties after it struck the mine on March 1, 1865. Dahlgren escaped unharmed.

The rear admiral ordered a court of inquiry to investigate. Cable, as judge advocate, completed the examination and conferred with his three fellow court members. His final report found the destruction of the flagship an accident and exonerated the crew.

The inquiry was Cable's highest profile activity during the war. He continued in the navy after the end of hostilities. Promoted to full assistant paymaster in June 1866, he resigned before the end of the year and returned to New York, where he reunited with his wife, Bella. The couple had married in October 1865 while Cable was on leave.[723]

In 1867, Bella gave birth to their only child, Amy. Cable would not live to see his daughter grow to adulthood. In the spring of 1879 he succumbed to pneumonia. The examining doctor listed malaria, which Cable had likely contracted during the war, as a secondary cause of death.[724]

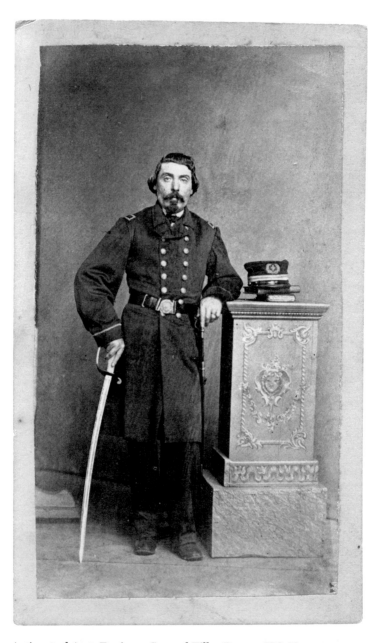

Acting 2nd Asst. Engineer Samuel Tiller Reeves, U.S. Navy

Carte de visite by unidentified photographer, about 1863–1864. Collection of the author.

Fast Vessel to New Orleans

The crews of Union warships in the waters off Galveston, Texas, awoke on May 25, 1865, to an unusual site. A white flag had been hoisted above the Customs House. Curious onlookers soon spotted a boat that made its way out of Galveston to the federal flagship *Fort Jackson*. The occupants of the boat, which included a Confederate officer and a civilian, were prepared to discuss surrender terms. They met the ranking federal officer, Benjamin F. Sands.[725] After a brief conference, Sands ordered a fast vessel to convey the Confederates to New Orleans for negotiations.[726]

The ship selected for the assignment was the *Antona*, a former rebel blockade-runner that had been captured in 1863 and commissioned in the Union navy. The sleek, screw-propelled steamer was armed with five guns and manned by a crew of fifty-six. Her cadre of officers included Samuel Reeves, an engineer and machinist.

Born in Maryland and raised in Pennsylvania, Reeves grew up in Phoenixville, an industrial center northwest of Philadelphia. He was likely employed in the local ironworks, with which his family had been associated for years. In 1855, the works became known as the Phoenix Iron Company.[727] The firm produced nails and rails and about 1,200 cannon for the Union army and navy during the war.[728]

Reeves left his home in Philadelphia in the summer of 1863 and joined the navy as an acting second assistant engineer. He was then about forty years old. Authorities assigned him to the newly commissioned *Arkansas*, a wood-hulled, barkentine-rigged steamer. The ship was attached to the West Gulf Squadron, where it served as a dispatch and supply vessel for warships on blockade duty.

Reeves transferred to the *Antona* about January 1, 1865. Six months later, the *Antona* shuttled Confederate Col. Ashbel Smith[729] and Texas attorney William P. Ballinger[730] to New Orleans. Smith, who commanded the defenses of Galveston, explained the purpose of the mission in a letter written May 29, 1865, while aboard the *Antona* at New Orleans. He and Ballinger were to negotiate "the cessation of hostilities between the United States and Texas." Smith added, "We also beg leave to say that we are in possession of the views of the civil authorities of the State of Texas, as well as many citizens, and that our object is the prompt and satisfactory restoration of the relations of Texas to the United States government."[731]

A report in the *New York Times* shed light on why Smith and Ballinger desired a quick settlement of affairs. "These gentlemen state that prior to their leaving Texas, the military forces had disbanded, refusing any longer to obey orders. The forces stationed in an around Houston were converted into a mob."[732]

Perhaps no one knew the situation better than Maj. Gen. John B. Magruder,[733] who commanded Confederates in the Lone Star State. Magruder had sent the peace commissioners and declared an armistice until they concluded their business.

There was however no business to conclude. Smith and Ballinger learned upon their arrival in New Orleans that Maj. Gen. E. Kirby Smith had just surrendered Confederate forces in the sprawling Trans-Mississippi Department, which included Magruder's district. The commissioners took the opportunity to stress the importance of a rapid reunification before they left on the *Antona* to return to Galveston.

Reeves and his shipmates on the *Antona* executed their orders without a hitch. They went on to participate in mop-up operations along the Gulf coast.[734]

The *Antona* was decommissioned in August 1865. Authorities discharged Reeves soon after. He returned to Pennsylvania and reunited with his wife, Rebecca, and their five children. Rebecca died in 1878, and Reeves followed her five years later. He was about sixty years old.

In Pursuit of Pirates

In July 1865, two months after the Confederacy's collapse, a final act of rebel defiance occurred in waters just below the Arctic Circle. The commerce raider *Shenandoah* captured and burned several New England whaling ships.[735]

The *Shenandoah*'s sailors had yet to receive the news that the struggle for Southern independence was over, and they continued to represent themselves as Confederate nationals. But the rest of the world branded them pirates as word of their exploits spread.

Meanwhile, thousands of miles away in Mexico, the crew of a U.S. warship went about their daily duties unaware of the *Shenandoah*'s Arctic adventure. The officers and men of the side-wheel sloop *Saranac* were stationed in Acapulco Bay on a delicate mission to protect American interests in the region.[736]

The assignment required tact and diplomacy. Neither of these attributes were historically strong suits for one of the members of the *Saranac*'s crew. William Mott, an acting master's mate, seemed to stir up trouble wherever he went. The son of a New York sea captain, he was born and grew up on Long Island. He was fifteen when the Civil War began in 1861. Later that year, Mott received an appointment as an acting midshipman at the U.S. Naval Academy. He entered his freshman year at the academy's temporary campus at Newport, Rhode Island. Officials had recently moved it there from Annapolis, Maryland, where it was vulnerable to occupation by Confederates.[737]

Mott immediately ran afoul of everyone. Disorderly conduct. Fighting with classmates. Willfully destroying public property. Neglecting his studies. He racked up demerits by the score. In June 1862, he failed his final examination and resigned before authorities dismissed him.[738]

Acting Master's Mate William Harvey Mott, U.S. Navy

Carte de visite by Henry William Bradley (1813–1891) & William Herman Rulofson (1826–1878) of San Francisco, California, about 1865–1866. Collection of the author.

If all this had happened in peacetime, Mott's navy career would likely have been forever ended. However, the navy badly needed men, for the war raged on and no end to it was in sight. A week after he resigned, Mott joined the navy as a volunteer and received an appointment as an acting master's mate. Naval authorities shipped him off to the California coast for duty to the *Saranac*.[739]

Mott spent his time in relative isolation, far from the main theaters of the war. Particulars of his service on the *Saranac* were not recorded in any official reports. But a note penciled on the back of his *carte de visite* portrait taken in San Francisco is perhaps indicative of his performance: "A know nothing & good for nothing."

In early 1865, during the waning days of the war, concerns about French forces in Mexico were on the rise in the Union capital. The White House and War Department moved to dispatch army and navy forces to the Mexican-American border to counter threats to American sovereignty posed by France's incursion. The *Saranac* steamed from its station in San Francisco to Acapulco as part of a show of force.

On July 29, 1865, a general courts-martial was under way aboard the *Saranac* when word was received about the *Shenandoah*. The crew received orders to hunt down the pirates, and the military tribunal was immediately dissolved.[740]

The *Saranac* set out the next day in search of the *Shenandoah*. Mott and his crewmates circumnavigated the Pacific, with stops in San Francisco, Hawaii, Tahiti, and elsewhere. They finally gave up the hunt without ever setting sight on their prey, and arrived empty-handed in San Francisco on November 19, 1865. During its four-month cruise, the *Saranac* logged in 13,165 miles.[741] Mott's conduct during the mission was not mentioned in official reports. But a note in his service record mentions that he was treated for syphilis the day after the *Saranac* arrived in San Francisco.[742]

By this time the *Shenandoah* had turned up along the coast of Britain. Her commander, James Waddell, formally surrendered the vessel to his counterpart on the British warship *Donegal* on November 6, 1865.[743] The Confederate flag lowered on that day

was reportedly the last rebel banner to be flown by combatants during the war.

Mott turned in his resignation from the navy a year later and received an honorable discharge. He returned to New York, and eventually went to work as a clerk in the Brooklyn Water Department. Active in his local Grand Army of the Republic post, he died after a sudden illness in 1904 at age fifty-eight. He was unmarried.[744]

No Country, No Flag, No Home

THE TRIUMPHANT ACT OF BOARDING A CAPTURED VESSEL had become almost a matter of routine for the crew of the rebel raider *Shenandoah*. On the afternoon of August 2, 1865, the sleek cruiser captured her thirty-eighth prize, the British bark *Barracouta*, in the North Pacific. A group from the *Shenandoah* made its way aboard the ship to claim her and returned with devastating news. Several Confederate generals had surrendered their armies and President Jefferson Davis had been captured.[745]

The Southerners were stunned. Executive officer William C. Whittle Jr. echoed the reaction of many in his diary, "The darkest day of my life. The past is gone for naught—the future as dark as the blackest night. Oh! God protect and comfort us I pray." He added, "Oh! God aid us to stand up under this, thy visitation. There is no doubting the truth of this news. We now have no country, no flag, no home. We have lost all but our honor & self respect, and I hope our trust in God Almighty. Were men ever so situated."[746]

Whittle, known as "Willie" to his friends, had poured his heart and soul into the Confederate cause. A Virginian who graduated from the U.S. Naval Academy in 1858, he resigned his commission in May 1861. In doing so he followed in the footsteps of his father, William Whittle Sr., a veteran commander who had cast his lot with the fledgling Confederate navy a month earlier.

Whittle was first assigned as a junior officer aboard the *Nashville*. On November 21, 1861, she became the first warship flying the rebel ensign to float in British waters. On the return voyage, the *Nashville* passed through the Union blockade at Beaufort, North Carolina, and arrived at Morehead City. There the crew learned that the vessel had been sold and received new orders to

1st Lt. William Conway Whittle Jr., C.S. Navy

Carte de visite by Penabert (life dates unknown) & Co. of Paris, France, about 1863. Collection of Gerald Roxbury.

deliver the ship to South Carolina. On March 17, 1862, a skeleton crew with Whittle in command successfully broke out of the blockade under the light of a full moon and with a full head of steam. The *Nashville* shot past two federal vessels at close range and endured a barrage of gunfire before making it out to open sea. Whittle delivered the ship safely to the Palmetto State.[747] "The experience passed through taught me that even the youngest veteran should know when to run," Whittle recalled years later.[748]

Whittle's brazen move was an embarrassment to the Union navy. "It is a terrible blow to our prestige," bemoaned assistant secretary of the navy Gustavus V. Fox from Washington, D.C., to fleet commander Lewis M. Goldsborough.[749] "You can have no idea of the feeling here. It is a Bull Run to the Navy," Fox added.[750]

Whittle's next assignment took him to New Orleans, where his father commanded the naval station. He raised recruits for the new armor-plated warships *Mississippi* and *Louisiana*. Assigned to the latter vessel, he fell into enemy hands during the Battle of New Orleans on April 25, 1862. He spent the next four months locked away in Fort Warren at Boston harbor.

Exchanged in August 1862, Whittle served a brief stint in Georgia on the gunboat *Chattahoochee* and then was detailed for special duty in Europe. He arrived in the spring of 1863 and reported to James D. Bulloch, who operated the Confederacy's secret service from headquarters in Liverpool.[751] The two had met in 1861, and Bulloch had come away impressed with the young lieutenant. Now he employed Whittle as a courier to shuttle sensitive dispatches and private memoranda related to the procurement and construction of vessels back and forth to Richmond. Whittle sat for his portrait in Paris about this time.

Meanwhile, the Confederate offensive against merchant marine vessels suffered a heavy blow after the raider *Alabama* was sent to the bottom of the English Channel by the Union cruiser *Kearsarge* on June 19, 1864. Bulloch immediately searched for a replacement and in August 1864 found a worthy successor, the *Sea King*, in London. He outfitted her for Confederate service as

the *Shenandoah* and appointed officers. He tapped James I. Wad-dell[752] to serve as commander and Whittle as executive officer.

Bulloch laid out a bold plan for Waddell and Whittle: "You are about to proceed upon a cruise in the far-distant Pacific, into the seas and among the islands frequented by the great American whaling fleet, a source of abundant wealth to our enemies and a nursery for their seamen. It is hoped that you may be able to greatly damage and disperse that fleet, even if you do not succeed in utterly destroying it."[753]

The *Shenandoah* began its mission well supplied with provisions but severely understrength in men, the result of failures to recruit able-bodied sailors. Waddell and others had believed she should not have left port with a crew of forty-six instead of the recommended 150. But Whittle championed the argument that they should make do with the resources available, and his view won the day. Whittle stated in his diary on October 21, 1864, the second day of the voyage, "I trust we may soon get a prize from which we may get some men."[754]

Manpower was always short and prizes aplenty. The first ship taken was the *Alina*, off the African coast on October 29. "Very soon we had the extreme satisfaction of seeing the flag which is now the emblem of tyranny hauled down," Whittle observed.[755]

By April 1, 1865, the *Shenandoah* had captured eight merchant ships. Four more prizes, all whalers, were added that day off Ascension Island in the South Atlantic Ocean. "Oh what an April fool to the poor Yanks," Whittle declared in his diary. He also noted, "We have bad news from home. They say Hood has met with a terrible defeat at Nashville; Sherman has taken Savannah, and Porter Fort Fisher at Wilmington. All this if true is very bad. But 'They will be done, O Lord.' All will yet be well."[756]

The news was accurate. There was more to come. On June 22 in the Bering Sea, the capture of another whaler, the *William Thompson* out of New Bedford, Massachusetts, brought word of the assassination of President Abraham Lincoln and failed plot to murder Secretary of State William H. Seward. "I only fear that these attempts will be put to the credit of some Confeder-

ates, but I am certain it was not done by anyone from our side," Whittle stated. He also learned about the evacuation of Richmond by Confederate forces and the surrender of Gen. Robert E. Lee. Whittle accepted the former as fact but not the latter. "Lee may have left a portion of his force to protect the retreat of his army, and even he might have been taken with this portion, but as to his surrender of his whole army, and of his treating with Gen. Grant for peace I do not believe one single word," he declared.[757]

The next day, Whittle reported that the *Shenandoah* chased the New Bedford whaler *Sophia Thornton* and finally brought her to bay after firing two shots at her. They would later be accepted as the final hostile naval shots of the Civil War.

Six weeks later, the crew learned of the war's conclusion from newspapers after they captured their thirty-eighth prize, the *Barracouta*. Waddell realized that further resistance was futile. "The Captain," Whittle recounted, "gave me an order to dismount & strike our battery, turn in all arms except the private arms, and disarm the vessel, as no more depredations, of course, upon the United States shipping would be done."[758]

Waddell ordered the *Shenandoah* to England with the hope that the crew would receive better treatment by surrendering to a foreign power. On November 6, 1865, with the ensign of the defunct Confederacy flying from her peak, Waddell surrendered the *Shenandoah* to the British. The flag was lowered for the final time at 10:00 a.m.

The *Shenandoah* was handed over to American authorities soon after and the crew released. Whittle fled to Argentina and eventually received a pardon from Lincoln's successor, President Andrew Johnson. Whittle returned to the United States in 1868 and settled in his hometown of Norfolk, Virginia. He married in 1872 and started a family that grew to include eight children. He worked as a steamboat captain and became a founder of the Bank of Virginia.

In 1910, Whittle recounted his war experiences in *Cruises of the Confederate States Steamers* Shenandoah *and* Nashville. Ten years later he died in Norfolk at age seventy-nine.

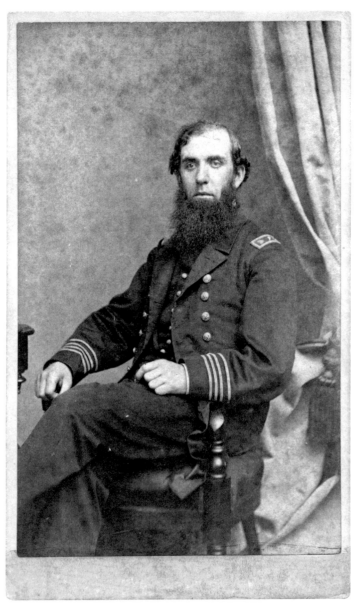

Chaplain Charles Reuben Hale, U.S. Navy

Carte de visite by James Wallace Black (1825–1896) of Boston, Massachusetts, and Newport, Rhode Island, about 1863. Collection of Martin Schoenfeld.

The Lord in His Temple

On a bright Sunday morning shortly after the war, far from the American homeland in the waters of the Mediterranean, Union sailors assembled for church service. Six hundred men gathered on the quarterdeck of the *Colorado*, flagship of the European fleet, and filed into tidy rows by division. The cadre of officers sat directly in front of the pulpit. One seat was left vacant—a large armchair reserved for Louis M. Goldsborough,[759] the rear admiral who commanded the fleet.

Chaplain Charles Hale took his place and waited patiently while an orderly informed Goldsborough that service was about to begin. An organist played a hymn and the minutes passed. No Goldsborough. The orderly was sent again, and the organist struck up another hymn. Goldsborough failed to appear. The senior officer present assumed that the rear admiral planned not to attend and ordered Chaplain Hale to begin.

According to a navy historian, "With reverential voice and ministerial solemnity, the Chaplain bowed his head and intoned: 'The Lord is his Holy Temple…' and came to a full stop, for at that precise moment the Admiral suddenly appeared and shouted: 'Hold on. Chaplain, hold on. I'll have you to understand that the Lord is not in his Holy Temple until I get there!'"[760]

The historian did not record the crew's reaction, but it is a safe bet that the timely quip by the admiral prompted laughter all around, even from the chaplain.

An Episcopal minister in his late twenties, Hale was the scion of a prominent Philadelphia family. His father, attorney Reuben C. Hale, was appointed quartermaster general of Pennsylvania and played an important role in the development of the state's re-

serve corps. He died in Philadelphia on July 2, 1863, while battle raged 125 miles away in the crossroads village of Gettysburg.

Young Hale followed in the footsteps of his father and heeded the call of Union arms. Where his father used his considerable influence and political connections to serve the army, Hale offered his spiritual services to the navy. In March 1863, he traded his clerical robes for Union blue and the shoulder straps of a chaplain.

On paper, the navy needed chaplains. The authorized number was set at twenty-four, but the average number on active duty was only nineteen. As more men were appointed to fill vacant positions, assistant secretary of the navy Gustavus V. Fox worried what to do with them. On September 30, 1862, he observed in a letter to Naval Academy superintendent George S. Blake,[761] "We have more chaplains in the navy than can be used, and are about to appoint a few more. Should you like to have any of them as Asst. Prof's, temporarily attached to the Academy?" Blake responded, "If chaplains of a suitable character and qualifications can be ordered as Asst. Professors, I think they should come, though I should deeply regret to see an unsuitable man here."[762]

Hale was one of the chaplains ordered to the academy to teach math, and Blake could not have been more impressed with his new instructor's scholarly background. Prior to his ordination as a priest in 1861, Hale had earned undergraduate and master's degrees at the University of Pennsylvania, where he had displayed a remarkable talent as a linguist and translator. In 1859, while an undergraduate, he gained national attention after he and two fellow students translated a section of the Rosetta Stone from a plaster cast of the famed relic.[763]

Hale spent a year and a half at the academy. In February 1865 he received new orders to report to Rear Adm. Goldsborough in the European fleet. The tour of duty lasted six years. During this period he visited Russia and discovered a passion for the language and culture that would figure prominently in his future scholarly studies.[764]

In 1871, Hale resigned his commission and left the navy. Over the next three decades he rose to prominence as one of the most

scholarly clergymen in the country. His passion for languages followed him through the years—he would eventually read as many as a dozen and was fluent in several. Russia and the Eastern Orthodox Church emerged as an area of special focus, and he became well known as an author and speaker on the subject.

Hale also advanced to great heights in the church hierarchy. In 1892, after attending to flocks of the faithful in New York, Maryland, and Iowa, he was named Bishop of Cairo in Illinois. Among his high-profile activities was assisting in the 1872 funeral of statesman William Henry Seward. According to one admirer, "He was well known in Jerusalem, Alexandria, and Constantinople by many Russian prelates, with whom he was in almost constant touch by correspondence." He added, "Bishop Hale was a man of great erudition. Closely conversant with all topics, religious or secular, he was a ready talker and an entertaining host. His acquaintance with scholars was extended, and his company was frequently sought out by theologians and other learned men."[765]

On Christmas Day 1900, Hale died of heart disease at age sixty-three. He outlived his wife, Anna, whom he had married in 1872. The couple had no children. His remains were brought home to Philadelphia and buried with honors.

Religious scholars around the world mourned his passing. His will stipulated a large part of his sizable estate to establish a trust to fund a memorial series of lectures at the Western Theological Seminary of Chicago.[766]

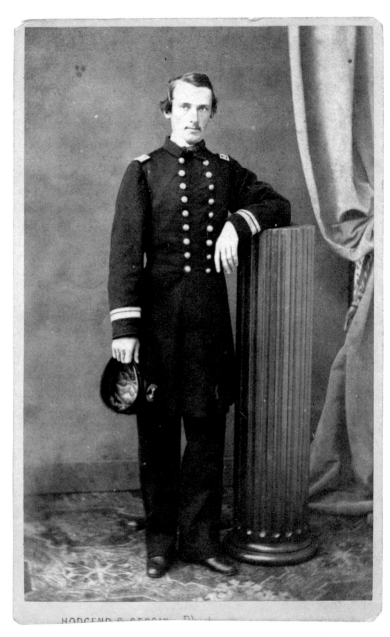

Lt. Sylvanus Backus, U.S. Navy

Carte de visite by Hodcend (life dates unknown) & Degoix (life dates unknown) of Genoa, Italy, about 1862–1864. Collection of the author.

Crazy Drunk

Lieutenant Sylvanus Backus was crazy drunk. Stumbling around the quarterdeck of the *Mohongo* after midnight with a drawn sword, his raucous behavior stirred the sleeping crew. The warship's executive officer soon arrived on the scene, relieved Backus from duty, and sent him belowdecks under guard.[767]

But Backus broke free. The *Mohongo*'s commander, Capt. James Nicholson,[768] wakened and was apprised of the situation. He ordered Backus to be confined to his room and a sentry posted at the door.

Nicholson went back to bed. "Immediately after I heard a great noise in the wardroom and got up and went into the wardroom where Mr. Backus was endeavoring to break open the door of his room. As I entered the wardroom he said 'that damned old cuss wishes to frighten me with a court martial.'"

Nicholson said, "'Mr. Backus, unless you keep quiet, it will be necessary to put you in irons. Mind, this is no ill threat, so you had better keep suit'—or words to that effect."

Backus replied, "I should like to know what I am confined here for." Nicholson responded with an order to shackle the young lieutenant.[769]

Backus had a long history of disciplinary problems. In 1857, he had been appointed as an acting midshipman to the U.S. Naval Academy from his home state of Michigan but was dismissed for chronic misconduct in October 1861. Academy officials allowed him to resign rather than have the stain of an expulsion on his record.[770]

Less than a year later, with no end to the war in sight and a desperate need for sailors, the navy reinstated Backus with the rank of midshipman. Ordered to active duty, Backus joined the

crew of the *Constellation*. A sloop-of-war bristling with twenty-five guns and a compliment of 240 men and 45 Marines, she spent the war years guarding Union merchant vessels against enemy raiders in the Mediterranean Sea.

In early 1865, Backus was detached from the *Constellation* with no blemishes on his record and a promotion to lieutenant. With the war winding down he was ordered to the steamer *Mohongo*. By all appearances he was on track to continue his career in the navy and perhaps retire in a few decades with higher rank and a comfortable pension.

Then came the events that brought his military service to a screeching halt. On November 19, 1866, the *Mohongo* was lying at anchor in the Bay of Valparaiso along the Chilean coast. Backus had the nighttime watch on the quarterdeck until he was relieved for intoxication. He was held in irons until he calmed down, and subsequently arrested and confined. Charges were preferred against him on three counts—drunkenness, disrespecting his superior officer, and insubordination.[771]

His trial, held on May 7, 1867, resulted in a guilty verdict on all counts. Backus received a one-year suspension and a public reprimand. Nicholson, perhaps still smarting from being called an "Old Cuss" by Backus, appealed the sentence as too lenient. The court reconvened and passed a much harsher sentence: a one-year suspension and loss of pay, and dismissal from the Pacific Squadron.[772]

About a month later, Backus appeared before an examination board back in the United States. It found that he was incapacitated from further service and ordered him retired—effectively an honorable discharge.

Backus returned to Michigan and became an attorney in Detroit. According to the 1870 federal census, he resided in the home of a saloonkeeper. Backus eventually applied for and received a pension that he drew until his death in 1915 at age sixty-six. He was unmarried and without children.[773]

Unhealthy Season

No matter where he was in the world, Lt. George Flagg found a way to visit his family after he received orders that called him away on a new assignment. It was something of a custom that verged on superstition with the young navy officer.[774]

Home was the bustling Vermont town of Middlebury. His mother, Lucina, and six brothers and sisters had fallen on hard times since the 1854 death of their husband and father, carpenter William Flagg. Lucina could not feed her brood, so she packed some of the children off to live with relatives or friends. George, then twelve and the eldest son, left school and found work in a local store to pay for his room and board.[775]

Flagg determined to get an education despite his circumstances and studied whenever he could find time. His steadiness of purpose attracted the attention of a family friend who secured him admission to the U.S. Naval Academy in 1861.[776]

By this time war had broken out between the states. Fears for the safety of the academy prompted its removal from Annapolis, Maryland, to Newport, Rhode Island. The pressing demand for officers accelerated the pace of learning, and the normal four years of education and training was compressed into three. Flagg made it through the rigorous course of study with little room to spare—twenty-five of thirty-one graduates in the class of November 1864.

A few months later, in February 1865, he received orders for active duty. Flagg bid his family farewell and reported to New York Navy Yard, where he was assigned to the *Colorado*. The frigate had just returned from North Carolina, where she and her crew and participated in the capture of Fort Fisher and the port city of Wilmington.

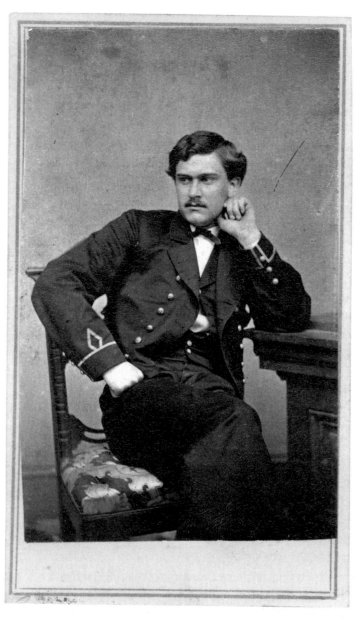

Lt. George Newell Flagg, U.S. Navy

Carte de visite by John D. Fowler (about 1823–1865) & Co., Newport, Rhode Island, about 1861. Collections of the Mariners' Museum, Newport News, Virginia.

The war ended while Flagg and his crewmates waited for the *Colorado* to be repaired. In June 1865, the vessel steamed for Europe and spent the next two years as the fleet's flagship. Flagg's record suggests that the service agreed with him. By the time the *Colorado* returned to New York in 1867, he had advance two ranks.

He was promoted again the following year. By this time he had been reassigned to the *Saratoga*, a practice ship for academy midshipmen. Flagg had the right stuff for a trainer. Disciplined, fearless, and patriotic, he was also generous and warm-hearted.

Flagg was tapped for a training cruise to Havana in early 1869. On April 21, he shipped out on the *Saratoga* with the 146 officers and crew plus 78 students. They arrived in the Cuban port on May 10 and began a program of training exercises.

Late May marked the beginning of the unhealthy season in Havana, when, according to one navy surgeon, "The general climactic influences, at all times unfavorable to the acclimated, tended most to the production of the special diseases incident to them."[777]

The most dreaded of the diseases was yellow fever, and it visited the *Saratoga* and five other warships of the West India Squadron.[778] On June 2, the first two cases were reported. The first to fall was the *Saratoga*'s surgeon, who succumbed to its effects on June 6. His death was a serious loss, though the physician had told Flagg before the voyage started that if yellow fever struck, "he should not have the faintest idea as to what would be the best course to pursue."[779]

On June 7, the *Saratoga* steamed for the North with the idea that the cooler climate and healthier air would stop the spread of the disease. On the night of June 15, near Cape Hatteras, North Carolina, the *Saratoga* reported its fourteenth case: Flagg. He had struggled to overcome head-splitting aches, pains, and black vomit to no avail. He breathed his last five days later, just as the vessel rounded Sandy Hook, New Jersey, on the approach to New York harbor. He was twenty-five years old.

In total, thirty-seven of the crew were stricken with yellow

fever and seventeen died. The victims, including Flagg, were hastily buried in a quarantined area attached to the New York Naval Hospital. The graves were marked with simple stakes, and no visitors were allowed until the winter.

It was the one time that Flagg did not visit his mother and family before going to sea.[780]

He Helped Preserve the Memory
of the Naval War

U.S. SECRETARY OF THE NAVY GIDEON WELLES HAD EVERY
reason to suspend activities at the U.S. Naval Academy after civil
war divided the country in April 1861. Many midshipmen had
cast their lot with the fledgling Confederacy. The school grounds
in Annapolis, Maryland, were under threat of occupation by the
rebels.

Welles chose instead to focus on not what he had lost but what
remained. "Although numbers at the school are greatly reduced by
the resignation of nearly every student from the insurrectionary
region and a call of the elder classes to active professional duty,
the younger classes that remain form a nucleus to re-establish
and give vitality to the institution," Welles stated in the summer
of 1861. He also called for double the number of midshipman to
meet the rapidly expanding needs of the navy.[781]

The secretary relocated the academy to Newport, Rhode Is-
land, for the duration of the war, and classes were soon under
way at Fort Adams. Among those who entered the academy in
Newport was a Pennsylvania boy who would play a noteworthy
role in preserving the memory of these tumultuous times. Rich-
ard "Dick" Rush, fifteen, started in September 1863, only a few
months after the Battle of Gettysburg ended the Confederate
invasion that threatened his home city of Philadelphia.[782]

Few Pennsylvanians or any other American could match
Rush's pedigree. His great-grandfather, Dr. Benjamin Rush, had
signed the Declaration of Independence. His grandfather and
namesake, Richard Rush, had served in the administrations of
presidents James Madison and John Quincy Adams. He was also
candidate for vice president in President Adams's failed reelec-
tion bid in 1828.

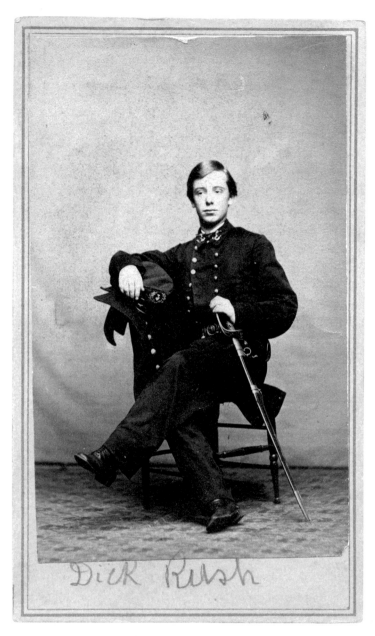

Lt. Cmdr. Richard Rush, U.S. Navy

Carte de visite by F. Kindler (life dates unknown) of Newport, Rhode Island, about 1863–1864. Collection of the author.

While his illustrious forefathers occupied highly visible positions in the public eye, young Rush toiled quietly behind the scenes. He tended to his studies at the academy as federal blockaders hunted down rebel privateers and disrupted the Confederate supply chain. He trained for combat as Union warships and their crews achieved great victories at Mobile Bay and Fort Fisher. The war ended halfway through his schooling. Rush moved with his fellow midshipmen to Annapolis, and graduated in 1867.

The call to action for which he would be best known came long after the Rebellion had been put down. In May 1893, Lt. Cmdr. Rush succeeded a fellow officer as superintendent of naval war records. He inherited a mammoth task—the organization and publication of the *Official Records of the Union and Confederate Navies*. Authorized by Congress in 1884, a small force of clerks and copyists set about the work. They were overwhelmed by the amount of material. Reinforcements were ordered in to help collect, classify, and arrange documents and data from public and private sources.

Rush took charge and found plenty of room for improvement. He instituted significant changes to the organizational structure and rededicated the men under his command to a mission of publishing naval history.

Rush noted the biggest change in his 1895 annual report: "An examination of the present plan of publication which has been adopted by the Department will show that the selection of original manuscript to be introduced into the record rests entirely in the hands of the superintendent. I am of the opinion, in the interests of the true historical value of the work, that this duty could be performed to better advantage by a board of publication, to be composed of one naval officer and two civilian expert members." He noted its chief advantage. "The question of the selection or rejection of original manuscript for introduction into the compilation could be more fairly decided upon to the impartial interest of each side of the conflict in the civil war, an important consideration to the historical value of the work."[783]

The idea of a board of publication was not original. The War

Department had adopted the same approach for its monumental *Official Records of the War of the Rebellion.* Still, Rush recognized the need and made it happen.

The result was success, and the first volume received favorable reviews. "The work so far accomplished gives promise of a valuable addition to the sources of war history," observed one newspaper. "It is all the more valuable in that it deals with naval operations, for that branch of the service has never had its full share of credit for its work in the suppression of the rebellion, owing, perhaps, to the more popular interest in the army, which came so much more closely home to the people."[784]

Rush went on to supervise the publication of the next four volumes. Then, in 1897, he received orders to field duty. After a stint in command of the *Michigan,* an antebellum vessel and the navy's first iron-hulled warship, he took charge of the *Armeria.* A lighthouse tender converted to navy service, she served as a supply ship during the Spanish-American War in 1898.

Rush fell sick during his time on the *Armeria,* possibly with dysentery, malaria, or yellow fever. The illness ultimately forced his retirement from the navy in 1899. He settled in Washington, D.C., his health broken. He died in 1912 at age sixty-three. His wife, Ella, whom he had married in 1873, and a daughter survived him.[785]

Rush did not live to see the completion of the *Official Records.* The Navy Department published the twenty-fifth volume the year he died and released the thirtieth and final volume in 1922.

Notes

Biographical information on enlisted men and officers referenced in the profiles was obtained primarily from the National Archives and Record Service, Washington, D.C.; from Boatner's *Civil War Dictionary*; and from a variety of genealogical and historical sources on the Web sites Ancestry. com, GenealogyBank, and Newspapers.com. Information about the vessels was obtained from the U.S. Navy's digital edition of the *Dictionary of American Naval Fighting Ships*.

Abbreviations

NARS: National Archives and Record Service, National Archives and Records Administration, Washington, D.C.

OR: The War of the Rebellion: A Compilation of the Official Records of the Union and Confederate Armies, 128 vols. (Washington, D.C.: Government Printing Office, 1880–1901). The *Official Records*, established by federal law in 1864, contain reports written and filed by commanders within days, weeks, or sometimes months of the events. The volumes are arranged in four series: Volumes 1–111 make up Series I and consist of official battle reports for the Union and Confederate armies. The remaining three series contain correspondence relating to prisoners of war, conscription, blockade-running, and other communications. Each citation of this source includes four numbers—series, volume, part, and page—and names the author of the cited report.

ORN: U.S. Naval War Records Office, *Official Records of the Union and Confederate Navies in the War of the Rebellion*, 30 vols. (Washington, D.C., 1894–1922). Following the general organization of the *Official Records*, the navy's war records include after-action reports, ship logs, letters, and other communications from military commanders and government officials. The volumes are arranged in two series: Volumes 1–27 make up Series I (*ORN* I) and consist of reports for the Union and Confederate navies, organized largely by theaters of the war. Series II (*ORN* II) is composed of three volumes that include ship statistics and correspondence with diplomats and various agents operating abroad.

The Profiles

1. Winslow, *Francis Winslow*, 308–310.
2. Ibid.
3. Ibid.
4. Ibid.
5. Ibid., 311.
6. LaRue Perrine Adams (1843–1868) graduated from the U.S. Naval Academy in 1859 and served as an ensign on the *R. R. Cuyler*. LaRue P. Adams to Mary S. Winslow, November 9, 1862, Winslow Papers.
7. President Abraham Lincoln's Minister to Britain, Charles Francis Adams Sr., sent a letter of thanks on behalf of the U.S. Navy Department to his counterpart, the Earl Russell. Dated September 30, 1862, it commended Capt. Ewart, Surgeon Ratliffe, and their shipmates on the *Melpomene* for their assistance to the crew of the *Cuyler*. *Medical Times and Gazette* 2 (1862): 619–620.
8. Report of acting master Simeon N. Freeman, U.S. Navy, of the arrival of the *R. R. Cuyler* at New York, *ORN* I, 17:304–305.
9. North Carolina–born John Ancrum Winslow (1811–1873) graduated from the U.S. Naval Academy in 1833 and remained loyal to the Union during the Civil War. He held the rank of commander at the commencement of hostilities and advanced to captain in July 1862. Less than a year later he assumed command of the *Kearsarge* and was promoted commodore to date from June 19, 1864—the day he and his crew emerged victorious over the *Alabama*. Winslow and his men also received the Thanks of Congress for their actions. Commodore Winslow's uncle Joshua was the father of Francis Winslow.
10. Assistant secretary of the navy Gustavus Vasa Fox (1821–1883) to Winslow's cousin Arthur Pickering, September 15, 1862, Winslow Papers.
11. Francis Winslow II (1851–1908) graduated from the U.S. Naval Academy in 1870 and retired as a lieutenant in 1889. Cameron McRae Winslow (1854–1932) graduated from the academy in 1875. During the Spanish-American War, as a lieutenant on the warship *Nashville*, he suffered a gunshot wound in the hand while in command of an expedition to cut communication cables that linked Cuba with Europe. He transferred to the retired list as an admiral in 1916 but was called to active duty during World War I. During this time he served stateside as inspector of naval districts on the Atlantic Coast.
12. *Evening Star* (Washington, D.C.), March 25, 1903.
13. *Charleston Courier*, December 29, 1860.
14. Navy comrades often addressed letters to "Jack" Grimball. One family member referred to him as Johnnie Grimball. Grimball Family Papers.
15. Grimball's father, John Berkley Grimball (1800–1892), was a graduate of Princeton College, a slaveholder, owner of Grove Plantation, and a state politician. Mother Margaret "Meta" Ann Morris Grimball hailed from

a wealthy plantation family. Grimball had four military-aged brothers who all served. Lewis Morris Grimball (1835–1901) served as assistant surgeon of the First South Carolina Infantry, also known as Butler's regiment after its colonel, William Butler. William Heyward Grimball (1837–1864) served as a lieutenant in Battery E of the First South Carolina Light Artillery and died of typhoid during his service. Brothers Berkley (1833–1899) and Arthur (1842–1894) served as privates in the Marion Artillery, also known as Capt. Parker's Light Artillery Battery or Parker's Company, for its commander, Charles W. Parker.

16. *Charleston Courier*, January 10, 1861.

17. *New York Times*, January 14, 1861.

18. *Charleston News and Courier*, February 3, 1895.

19. *The State* (Columbia, S.C.), December 27, 1922.

20. *Charleston News and Courier*, December 28, 1922.

21. Reports related to measures taken for the relief of workers of the Pensacola Navy Yard. *ORN* I, 4:7–12.

22. Kentucky-born Cmdr. James Armstrong (1794–1868) had taken charge as commandant of the Pensacola Navy Yard in October 1860. A respected officer who entered the navy in 1809, he had been captured by the British during the War of 1812. His spotless career ended at Pensacola. Appearing before a court-martial on charges of neglect of duty, disobedience of orders, and conduct unbecoming of an officer, he was found guilty and suspended from duty for five years. Armstrong was restored to duty in 1866.

23. William T. Morrill pension record, Confederate Veterans and Widows Pension Applications.

24. Ibid.

25. Ibid.

26. Dr. Horace Clark to William B. Mann, February 7, 1861, Mann Papers.

27. William B. Mann to his father, Joseph Mann, October 14, 1860, ibid.

28. New York surgeon general S. Oakley Vanderpoel to William B. Mann, June 6, 1861, ibid.

29. Maryland-born Charles Williamson Flusser (1832–1864) graduated from the U.S. Naval Academy in 1853 and was serving as an instructor at his alma mater when the Civil War began. He requested active duty and was assigned to the *Jamestown*. In January 1862 he was named commander of the *Commodore Perry* and participated in the Burnside Expedition, which secured part of the North Carolina coast for the Union. In July 1862 he was promoted to lieutenant commander, and in May 1863 he assumed command of the side-wheel steamer *Miami*, a double-ender gunboat. A year later, during the April 19, 1864, Battle of Plymouth, Flusser personally fired three shots at the Confederate ironclad ram *Albemarle*. The third shot struck the side of the ram and exploded, sending fragments back towards the *Miami*. One or more fragments struck and killed Flusser instantly. Two of Flusser's brothers fought and died for the Confederacy. Ottokar Flusser of the Fourth

Texas Infantry was killed at the Battle of Antietam on September 17, 1862. Guy Flusser of the Fourth Kentucky Cavalry died during Brig. Gen. John Hunt Morgan's successful raid and capture of the Union camp at Mount Sterling, Kentucky, on June 8, 1864.

30. Report of Acting Master William N. Welles, U.S. Navy, executive officer of the *Miami*, *ORN* I, 9:639–640.

31. Report of Asst. Surg. William B. Mann, U.S. Navy, *ORN* I, 9:642–643.

32. *Rochester (N.Y.) Democrat and Chronicle*, October 25, 1920.

33. *Charleston Mercury*, April 15, 1861.

34. Harriet Rebecca Lane Johnston (1830–1903) made a lasting impression during her time as First Lady to James Buchanan. She was antislavery and believed in gradual emancipation. She and her uncle left the White House in 1861 with resentment towards Abraham Lincoln but passively supported him as president and commander-in-chief of the Union. In the general election of 1864, Lane and Buchanan lined up behind the candidacy of Maj. Gen. George B. McClellan. Lane married banker Henry Elliott Johnston in 1866. They had two sons who died young. She is credited with founding the first pediatric medical center in the country, the Harriett Lane Home, which was connected with the Johns Hopkins Hospital in Baltimore, Maryland.

35. Pulsifer, "Reminiscences of the *Harriet Lane*"; *Boston Evening Transcript*, October 20, 1860.

36. The quote was taken from a news report that detailed the near loss of the *Lane* after she became stuck on a shoal during operations against Confederate batteries guarding Hatteras Inlet, North Carolina, in August 1861. "We can well imagine the anxiety, and the energy that Capt. Faunce exhibited, at the critical position of his beautiful steamer,—which he loves as his life." *Columbian Register* (New Haven, Conn.), September 7, 1861.

37. *New York Commercial Advertiser*, January 2, 1861.

38. McCabe, *The Grayjackets*, 163–167.

39. Gustavus Vasa Fox (1821–1883) of Massachusetts graduated from the U.S. Naval Academy in 1841 and served in the Mexican War and other stations until he resigned his commission in 1856 to enter the woolens business. In February 1861 he was tapped by Gen. Winfield Scott to consult on a plan for the relief of Fort Sumter. President Buchanan vetoed it. But President Lincoln accepted it and placed Fox in command. Lincoln later elevated Fox to the position of first assistant secretary of the navy. Fox, who worked closely with secretary of the navy Gideon Welles, is credited with many important decisions that led to naval success. After the war he informally negotiated the purchase of Alaska with Russian representatives and then left government to return to the woolens business.

40. Irish-born Stephen Clegg Rowan (1808–1890) began his naval career as a midshipman in 1826. He served during the Mexican War and along the Pacific coast prior to the Civil War. In 1861, as commander of the *Pawnee*, he

joined Capt. Faunce and others in successful amphibious operations against the batteries at Hatteras Inlet. On February 7, 1863, he received the Thanks of Congress for his role in the Battle of New Bern, North Carolina. Five months later he was promoted simultaneously to captain and commodore in recognition of his record. He went on to command the warships *Powhatan* and *New Ironsides* during the remainder of the war. He remained in the navy after the war and retired as vice admiral in 1889.

41. Cmdr. Stephen C. Rowan's abstract log of the *Pawnee*, *ORN* I, 4:254; extracts from report of assistant secretary of the navy Gustavus V. Fox regarding the expedition of April 1861, under his command, for the relief of Fort Sumter, *ORN* I, 4:245–251.

42. Gustavus V. Fox regarding the expedition of April 1861, under his command, for the relief of Fort Sumter, *ORN* I, 4:245–251.

43. Ibid.

44. Smith, "The Flag of Our Country."

45. The *Nashville* served in the Confederate navy until mid-1862, when she was sold and converted into a private blockade-runner. Sold again in November 1862, she became the privateer *Rattlesnake*. On February 28, 1863, the Union monitor *Montauk* destroyed her in the area of Savannah, Georgia.

46. Jonathan Mayhew Wainwright II (1821–1863) graduated from the Naval Academy in 1843. His grandson, Jonathan Mayhew Wainwright IV (1883–1953), became a noted general in World War II. He received the Medal of Honor for his actions in the Philippines.

47. *Charleston Mercury*, April 30, 1864.

48. *New York Times*, January 26, 1865, March 30, 1867.

49. *Evening Star* (Washington, D.C.), May 20, 1884.

50. *New York Times*, June 7, 1891; *New York Herald*, June 7, 1891.

51. *Boston Herald*, September 13, 1861.

52. Field, "Four Decades on the High Seas."

53. *Boston Herald*, September 13, 1861.

54. A postwar report submitted to the U.S. House of Representatives Committee on War Claims included testimony from Capt. Gardner C. Whiting and his wife, Mary Eleanor Whiting, and reprinted after-action reports submitted by Cmdr. Charles Green of the *Jamestown*. The report is dated March 3, 1875. *Index to Reports . . . Second Session of the Forty-Third Congress*, vol. 7, no. 332.

55. Ibid.

56. Ibid.

57. *Boston Herald*, September 13, 1861.

58. *Index to Reports . . . Second Session of the Forty-Third Congress*, vol. 7, no. 332.

59. Charles Green (1814–1887) of Connecticut began his navy career in 1826 and became a midshipman in 1832. He steadily advanced in rank to commander and served at this rank on the *Jamestown* from 1861 to 1862. He was promoted to captain in 1862, and between 1863 and 1865 he commanded

the receiving ship *Ohio* at the Boston Navy Yard. He remained in the navy after the war ended and was promoted commodore in 1867.

60. Report of Cmdr. Charles Green, commanding the *Jamestown*, of the burning of the bark *Alvarado*, *ORN* I, 6:56–58.

61. Ibid.

62. *Boston Herald*, September 13, 1861.

63. Sarah E. Long pension record, NARS.

64. John Berrien Montgomery (1794–1873) of New Jersey started his navy career as a midshipman during the War of 1812 and distinguished himself during the Mexican War as commander of the *Portsmouth*. He advanced to command of the Pacific Squadron in 1859 and guided the fleet as flag officer until he was relieved in January 1862. He spent the rest of the Civil War in an administrative capacity, remained in the navy after hostilities ended, and had advanced to the rank of rear admiral by the time he died. Montgomery Street in San Francisco is named for him.

65. Report of Flag Officer John B. Montgomery, U.S. Navy, commanding Pacific Squadron, of the inadequacy of the force for the protection of American commerce on the Pacific coast, *ORN* I, 1:71.

66. Ibid.

67. John F. Sullivan pension record, NARS.

68. New York–born Charles H. Bell (1798–1875) began his navy service in the War of 1812. During the Mexican War period, he commanded the sloop-of-war *Yorktown* along the coast of Africa on a mission to disrupt the slave trade and afterwards served at the New York Navy Yard. He commanded the Mediterranean Squadron at the start of the Civil War and replaced John B. Montgomery in command of the Pacific Squadron in July 1862. Bell served in this capacity until 1864, when he was placed in command of warships in the James River in Virginia. He retired in 1868 as a rear admiral.

69. Order of Flag Officer Charles H. Bell, commander of the Pacific Squadron, to Commander Fabius Maximus Stanly of the *Narragansett*, *ORN* I, 1:471–472.

70. Ibid.

71. Photographer Villroy L. Richardson (born about 1827) of Ohio worked as a daguerreotypist in Zanesville in 1850 and married Rebecca Rees in 1851. At some point, perhaps as early as 1852, he was hired to work in the studio of photographer Benjamin F. Pease in Peru. Richardson opened his gallery in 1862 and remained active until the 1890s.

72. *Oregonian* (Portland), December 29, 1863.

73. In 1861, Emma Adelma Keyes married Washington Kimball. He died of fever on the schooner *Dearborn* during a journey from the West Indian island of Sombrero to Philadelphia and was buried at sea. Her father, Ira W. Keyes, served in the Union army as a second lieutenant in Company H of the Fortieth New York Infantry from June to November 1861. In January 1862

he enlisted as a private in Company H of the Twenty-ninth Massachusetts Infantry, mustering out as a corporal at the end of the regiment's three-year term of enlistment.

74. *Sunday Herald* (Boston), September 12, 1897.

75. John F. Sullivan pension record, NARS.

76. Report by Flag Officer William Mervin, U.S. Navy, of the destruction of the Confederate privateer *Judah*, *ORN* I 16:670–672.

77. Virginia-born Henry Steece (1792–1868) served as a private in Key's Regiment of the Ohio Militia.

78. Report by Flag Officer William Mervin, U.S. Navy, of the destruction of the Confederate privateer *Judah*, *ORN* I, 16:670–672; report of the involvement of U.S. Marines in the destruction of the *Judah* by Lt. John H. Russell, U.S. Navy, Cowan's American History Auction, June 21, 2012, Cowan's Auctions.

79. Report of the involvement of U.S. Marines in the destruction of the *Judah* by Lt. John H. Russell, Cowan's American History Auction, June 21, 2012.

80. The October 12, 1861, edition of *Harper's Weekly* incorrectly identified the *Judah* as the *Judith*.

81. A career military officer with close ties to President Jefferson Davis, Braxton Bragg (1817–1876) was eventually promoted to full general and given charge of the Army of Tennessee. He was relieved from command after the disastrous loss at Chattanooga. He served the rest of the war as a military adviser to Davis. Report of Brig. Gen. Braxton Bragg of the loss of the *Judah*, *ORN* I, 16:675; *Harper's Weekly*, October 12, 1861.

82. Letter of commendation from U.S. Secretary of the Navy Gideon Welles to Flag Officer William W. McKean, commander of the Gulf Blockading Squadron, *ORN* I, 16:674.

83. D. Porter, *Naval History of the Civil War*, 51–52.

84. *Index to the Reports . . . First Session of the Forty-Seventh Congress*, vol. 1, no. 93.

85. Ibid.

86. Report of Lt. Edward P. McCrea, U.S. Navy, commanding the *Jacob Bell*, *ORN* I, 4:689–690.

87. U.S. Census, 1850, 1860; Hamersly, *Records of Living Officers*, 103.

88. Maj. Gen. Robert E. Lee, commanding Virginia forces, to Gov. John Letcher, June 15, 1861, *ORN* I, 5:806–808.

89. Report of Lt. Edward P. McCrea, U.S. Navy, commanding the *Jacob Bell*, *ORN* I, 4:689–690; *Philadelphia Inquirer*, September 26, 1861.

90. Edward P. McCrea (1832–1881) was appointed to the U.S. Naval Academy in 1849 and graduated in 1855. He received a promotion to lieutenant two years later. He spent the Civil War along the Potomac and James rivers, where he engaged numerous Confederate batteries as commander of the *Jacob Bell*. McCrea continued in the navy after the war, and advanced to

captain one year before he died unexpectedly on October 14, 1881, during a visit with Adm. David D. Porter.

91. Report of Lt. Edward P. McCrea, U.S. Navy, commanding the *Jacob Bell*, *ORN* I, 4:689–690.

92. *Daily Evening Traveller* (Boston), September 27, 1861.

93. Report of Lt. Edward P. McCrea, U.S. Navy, commanding the *Jacob Bell*, *ORN* I, 4:689–690.

94. *Army and Navy Journal*, May 9, 1896.

95. *New-York Tribune*, September 28, 1861.

96. Samuel J. Shipley pension record, NARS.

97. Barrows, *History of Fayette County, Indiana*, 656–659.

98. Ibid., 237.

99. The representative was Jonathan McCarty. Ibid., 656–659.

100. Ibid.; Earle, *Life at the U.S. Naval Academy*, 7–9.

101. Report of Flag Officer Samuel F. Du Pont of the Battle of Port Royal, South Carolina, *ORN* I, 12:261–266.

102. One of America's most distinguished naval officers at the start of the Civil War, New Jersey–born Samuel Francis Du Pont (1803–1865) was a logical choice to preside over a board organized in Washington, D.C., in June 1861 to plan military operations against the fledgling Confederacy. In subsequent and victorious operations against Port Royal, Du Pont received the Thanks of Congress. In April 1863 he suffered a defeat in an attempt to take Charleston and requested to be relieved of command. His health in decline, Du Pont died on active duty in June 1865 with the rank of rear admiral. Duyckinck, *National History of the War for the Union*, 106.

103. Ibid.

104. *New Bedford (Mass.) Evening Standard*, March 18, 1916.

105. Aaron C. Joseph (about 1800–about 1849) and Frances Ann Seymour (about 1802–1869) were married in Boston on February 11, 1836. Dorman, *Twenty Families of Color*, 193.

106. Thomas West Sherman (1813–1879) of Rhode Island graduated from West Point in 1836 had a reputation for iron discipline. During the Mexican War he received a brevet, or honorary rank, for gallantry during the Battle of Buena Vista. He went on to command a well-regarded light artillery battery, "Sherman's Battery," and at the start of the war was promoted lieutenant colonel of the Fifth U.S. Artillery. In May 1861, he received his brigadier's star and command of army forces in the Port Royal expedition. Sherman went on to command on the division level and spent the reminder of the war fighting in Mississippi and Louisiana. On May 27, 1863, he suffered a severe wound and the amputation of his right leg during the failed Union assault against Port Hudson.

107. Report of Flag Officer Samuel F. Du Pont of the Battle of Port Royal, South Carolina, *ORN* I, 12:261–266.

108. *New York Times*, November 8, 1861.

109. Massachusetts-born Jane Curtis Maddox (1848–1910) was a younger sister of Stephen H. Maddox. A corporal in Company A of the Fifty-fifth Massachusetts Infantry, he succumbed to pneumonia on January 31, 1864, while on active duty at Folly Island, South Carolina.

110. *New Bedford (Mass.) Evening Standard*, March 18, 1916.

111 William D. Gregory II pension record, NARS.

112. Ibid.

113. Ibid.

114. Ibid.

115. Ibid.

116. John Lorimer Worden (1818–1897) of New York began his navy career as a midshipman in 1835. By the start of the Civil War, Worden ranked as a lieutenant. His first assignment was as a special messenger bearing dispatches from Washington, D.C., to Fort Pickens and the federal fleet in Pensacola Bay, Florida. He successfully delivered the papers but was caught and arrested as he made his way back to the North. Held as a prisoner of war in Montgomery, Alabama, he was exchanged in October 1861 and assigned to supervise work on the *Monitor*. In January 1862 he was placed in command of the ironclad and was the only reported injury in the historic battle against the *Virginia* when an explosion temporarily blinded him. Worden received a formal Thanks of Congress for his leadership. He went on to command the Montauk and other ironclads and ended his war service as a captain. Worden continued in the navy and retired in 1886 as a rear admiral.

117. Sunstrom's younger brother, Robert C. Sunstrom (1847–1925) served s a private in Companies A and B of the Eleventh Maryland Infantry from June 1864 to June 1865.

118. Johnson and Buel, *Battles and Leaders of the Civil War*, 731.

119. Samuel Dana Greene (1839–1884), the lieutenant and executive officer, was born in Cumberland, Maryland. Robinson Woollen Hands (1828–1862), third assistant engineer, was appointed from Maryland. He perished when the *Monitor* was lost at sea. A memorial marker to Hands is located in Baltimore's Green Mount Cemetery.

120. *New York Journal of Commerce*, March 8, 1862.

121. Grenville Mellen Weeks (1837–1919) left his work as a physician in New York to join the navy as an acting assistant surgeon in July 1862. During his escape from the sinking Monitor his shoulder was dislocated and hand crushed, and injury that resulted in the amputation of three fingers. His account of the sinking of the *Monitor* was published in the March 1863 issue of *Atlantic Monthly*. He resigned his commission in November 1863.

122. Mark T. Sunstrom pension file, NARS.

123. Ibid.

124. *The Sun* (Baltimore, Md.), October 25, 1875.

125. Report of Flag Officer Franklin Buchanan, C.S. Navy, of the Battle at Hampton Roads, Virginia, March 8–9, 1862, *ORN* I, 7:43–49.

126. Franklin Buchanan (1800–1874) was one of the U.S. navy's most prominent officers. His achievements included service as the first superintendent of the Naval Academy in Annapolis (1845–1847) and as commander of Cmdr. Matthew C. Perry's flagship during the historic expedition to Japan (1852–1855). Buchanan was captain of the Washington Navy Yard at the start of the Civil War. He resigned his commission in April 1861 in anticipation that his home state would secede but had second thoughts about his decision to resign after Maryland remained loyal to the Union. Buchanan was wounded during the attack at Hampton Roads, Virginia, on March 8, 1862. His brother, Thomas McKean Buchanan, a paymaster on the *Congress*, lost his life when the frigate was sunk. Buchanan recovered and in August 1862 was promoted to full admiral—the only Confederate naval officer to serve at this rank. Two years later at the Battle of Mobile Bay, his fleet was defeated, and he suffered his second wound of the war fighting a Union armada commanded by Rear Adm. David Farragut.

127. Still, *Odyssey in Gray*, 2–5.

128. Wise, *History of the Seventeenth Virginia Infantry*, 20–22, 37.

129. *Daily Dispatch* (Richmond, Va.), July 27, 1861.

130. Virginia-born and Kentucky-raised Isaac Ridgeway Trimble (1802–1888) graduated from West Point in 1822 and resigned from the army a decade later. He rose to prominence as a chief engineer and superintendent of several railroads in the East. When the war started, in 1861, Trimble burned bridges north of Baltimore, slowing the movements of federal troops headed to Washington, D.C. In May 1861 he joined the Confederate army as a colonel of engineers. A few months later he advanced to brigadier and was charged with the construction of artillery batteries along the Potomac River. It was during this time that Forrest joined him. In late 1862 he became a combat commander and went on to lead forces on the brigade and division level. He participated in numerous engagements, including the Second Battle of Manassas, where he was severely wounded, and the Battle of Gettysburg, where he was wounded and captured during Pickett's Charge. His wound resulted in the amputation of a leg. He was exchanged in February 1865 and returned to the Confederacy. After the war he lived in Baltimore.

131. Hughes, *Yale's Confederates*, 77.

132. Still, *Odyssey in Gray*, 2–5.

133. Ibid.

134. Ibid.

135. John George Walker (1822–1893) of Missouri served in the Mexican War and afterwards joined the regular army. He resigned in 1861 to become a Confederate cavalry major. He rapidly advanced to brigadier general and brigade command and participated in engagements including the Second

Battle of Bull Run and Antietam. Promoted to major general in late 1862, he moved to the western theater of the war. In 1864 he was named commander of the District of Texas, New Mexico, and Arizona. He fled to Mexico at the end of hostilities. He later returned to the United States and served a stint as consul in Bogotá, Colombia. He died in Washington, D.C.

136. *Obituary Record of Graduates of Yale University*, 155–156.

137. McClellan, *McClellan's Own Story*, 309.

138. Telegram from Maj. Gen. George B. McClellan to Flag Officer Louis M. Goldsborough, *ORN* I, 7:232.

139. Abstract log of the *Sebago*, *ORN* I, 7:726–728.

140. Report of Cmdr. John S. Missroon, U.S. Navy, of the shelling of the York River batteries by the *Sebago*, *ORN* I, 7:243.

141. Ibid.

142. Hannibal Proctor (1830–1867) began his service in the Union army as a private in Company B of the 118th New York Infantry in September 1864 and mustered out in June 1865. Hannibal Proctor military service record, NARS.

143. Frank C. Morey pension record, NARS.

144. Morey's second son, Frederick F. Morey, succumbed to complications of typhoid fever in 1884. Ibid.

145. William W. Heavener pension file, NARS.

146. Maine-born George Henry Preble (1816–1885) was soon promoted to commander and given command of the steam sloop-of-war *Oneida* and her five sister ships with orders to blockade Mobile Bay. Under his watch the Confederate raider *Florida*, on her maiden voyage, broke through the blockaders. Preble was dismissed from the service, an unusually severe punishment. He was later restored to command and exonerated of wrongdoing and went on to become an admiral. He wrote several books, including *Origin and History of the American Flag*, and reportedly contributed to saving the original flag that flew over Fort McHenry in 1814—the flag that inspired Francis Scott Key to write "The Star-Spangled Banner." Morrison, "Disunion: Commander Preble's Very Bad Day."

147. *Portland (Me.) Advertiser*, April 5, 1862; Report of Lt. George H. Preble, commanding the *Katahdin*, *ORN* I, 18:91–92.

148. Report of Lt. George H. Preble, commanding the *Katahdin*, *ORN* I, 18:215–216.

149. Ibid.

150. William W. Heavener pension file, NARS.

151. Ibid.

152. Report of Lt. Charles Swasey, U.S. Navy, *ORN* I, 18:212–214.

153. Charles Stewart Boggs (1811–1877) of New Jersey began his navy career as a midshipman in 1826. By the start of the Civil War he had advanced to the rank of commander. In 1861 he was placed in charge of the *Varuna*. Later promoted to captain, he took charge of the *Connecticut* in January

1865. He remained in the navy after the end of the war and retired in 1872 as commodore.

154. *Evening Post* (New York City), May 9, 1862.

155. Report of Lt. Charles Swasey, U.S. Navy, *ORN* I, 18:212–214.

156. Ibid.

157. Ibid.

158. *Evening Post* (New York City), May 9, 1862.

159. Littell, *Littell's Living Age*, 486.

160. Four of the recipients served as gun captains: Seaman Thomas Bourne, Coxswain William McKnight, Seaman William Martin, and John Greene, a seaman rated captain of the forecastle. Two, according to Swasey, stood at the wheel of the *Varuna*: Landsman Amos Bradley and Quartermaster John McGowan. Two others were also mentioned: Third Class Boy George Hollat and Second Class Boy Oscar E. Peck.

161. Report of Lt. Charles Swasey, U.S. Navy, *ORN* I, 18:212–214.

162. Veit, *A Dog before a Soldier*, 71–91; Report of Lt. Cmdr. Reigart B. Lowry, U.S. Navy, *ORN* I, 19:250–251.

163. Veit, *A Dog before a Soldier*, 71–91.

164. The son of a U.S. consul, Reigart Bolivar Lowry (1826–1880) graduated from the Naval Academy in 1846. He served in the Mexican War and was wounded in action at the Third Battle of Tuxpan on June 30, 1847. He also participated in Cmdr. Matthew C. Perry's historic expedition to Japan (1852–1855). Lowry ranked as lieutenant at the start of the Civil War. He served on several vessels along the Atlantic Coast early in the war before being named executive officer of the *Brooklyn* and participating in the capture of New Orleans. It is likely here that he first became acquainted with Swasey. Promoted to lieutenant commander in July 1862, he was assigned to the *Sciota* and spent the rest of the war on this ship. Lowry remained in the navy after the end of hostilities and died on active duty with the rank of commodore.

165. Report of Lt. Cmdr. Reigart B. Lowry, U.S. Navy, *ORN* I, 19:250–251.

166. The DD-273, a Clemson-class destroyer, was transferred to the Royal Navy in 1940 and renamed the *Rockingham*. In 1944 during training exercises off the coast of Britain she struck a mine and sank. The DE-248, an Edsall-class destroyer escort, was decommissioned in 1946 and sold for scrap in 1974.

167. Clark, *Seven Years of a Sailor's Life*, 229.

168. Ibid., 230.

169. Ibid., 11.

170. Ibid., 169–170.

171. Ibid., 230.

172. Ibid., 231.

173. Ibid., 232.

174. Ibid., 232.

175. Ibid., 233.

176. Report of Acting Volunteer Lieutenant Edward Cavendy, U.S. Navy, commanding the *Gemsbok*, *ORN* 1, 7:280–281.

177. *Highland Weekly News* (Hillsboro, Ohio), November 26, 1868.

178. Clark, *Seven Years of a Sailor's Life*, 194.

179. Ibid., 358.

100. Report of Capt. Charles H. Davis, commanding Western Flotilla, Mississippi River, *ORN* I, 23:13–14; report of Lt. Seth L. Phelps, U.S. Navy, *ORN* I, 23:18–19; *Daily Missouri Democrat*, May 13, 1862.

181. U.S. Census, 1860; Charles A. Gardner Jr. military service record, NARS.

182. Charles A. Gardner Sr. (1813–1880) served as a private in the First Company of Massachusetts Sharpshooters. Charles A. Gardner military service record, NARS; Charles A. Gardner pension record, NARS.

183. The *Chicago Times* report was reprinted in the May 15, 1862, issue of the *New York Times*.

184. The captain of the *Cincinnati*, Roger Nelson Stembel (1810–1900), suffered a serious wound after a gunshot struck him in the neck. He later returned to duty in an administrative capacity and advanced to admiral in the postwar navy.

185. Charles A. Gardner Jr. military service record, NARS.

186. Ibid.

187. Charles A. Gardner pension record, NARS.

188. Solomon Rockwell Hinsdale (1835–1907) enlisted as a private in Company A of the Twelfth Connecticut Infantry on November 5, 1861, and resigned from the regiment as second lieutenant of Company G on August 9, 1862. He joined the navy on September 15, 1862, and served on the *Cincinnati*. His resignation was accepted on April 3, 1863. He was discharged on April 29, 1863.

189. Report of Acting Rear Adm. David D. Porter, U.S. Navy, Commanding Mississippi Squadron, *ORN* I, 25:38–41.

190. Ibid.

191. Ibid., 43–44.

192. Ibid., 38–41.

193. Ibid.

194. Ibid.

195. Ibid.

196. This quote appears in a commendatory letter sent by Secretary Welles to Lt. Bache on June 12, 1863. Ibid.

197. Ibid.

198. The Medal of Honor recipients were Quartermaster Frank Bois, who nailed the flag to the broken mast; Quartermaster Thomas W. Hamilton, who was severely wounded and would not abandon his post until he was ordered to do so; and four courageous sailors: Seaman Thomas Jenkins,

Seaman Martin McHugh, Landsman Thomas E. Corcoran, and Boatswain's Mate Henry Dow.

199. Report of Lt. Gen. John C. Pemberton, C.S.A., commanding the Department of Mississippi, Tennessee, and East Louisiana, *OR* I, vol. 24, pt. 1: 294.

200. William H. Hathorne pension record, NARS.

201. Ibid.

202. Buck's letter abbreviates captain as "capt," and it has been changed here for readability. Justus W. Buck to his father, William Buck, September 5, 1862, in Justus W. Buck pension record, NARS.

203. William Talbot Truxton (1824–1887) officially held the rank of lieutenant. Buck may have assumed Truxton was captain, or used the term generally to describe Truxton's role as commander of the *Dale*. Truxton, a native Pennsylvanian who graduated from the U.S. Naval Academy in 1847, spent his Civil War years in the blockade squadrons that patrolled the Atlantic coast. He also participated in the attacks against Fort Fisher in late 1864 and early 1865. He remained in the navy after the end of hostilities and retired with the rank of commodore.

204. Carnie Buck was twenty-one years old when he enlisted in August 1861 as a private in Company F of the Forty-third New York Infantry. He advanced to sergeant and was killed in action at the Battle of Cedar Creek, Virginia, on October 19, 1864. Halsey D. Buck was eighteen years old when he enlisted in September 1861 as a private in Company K of the Forty-fourth New York Infantry. Wounded at the Battle of Malvern Hill on July 1, 1862, he survived his injury and mustered out of the regiment in October 1864.

205. Justus W. Buck to his father, William Buck, September 5, 1862, in Justus W. Buck pension record, NARS.

206. Ibid.

207. Ibid.

208. Ibid.

209. *Springfield (Mass.) Daily Republican*, October 7, 1862.

210. George F. Ormsbee rendezvous report, NARS.

211. U.S. Census 1880, 1900, and 1910.

212. Johnson and Buel, *Battles and Leaders of the Civil War*, 745–748; report of 2nd Asst. Eng. Joseph Watters, U.S. Navy, *ORN* I, 8:349–350.

213. Report of 2nd Asst. Eng. Joseph Watters, U.S. Navy, *ORN* I, 8:349–350.

214. Joseph Watters pension file, NARS; *Record of the Officers and Men of New Jersey*, 2:1602.

215. Albert Bogart Campbell (about 1838–1867) started his navy career in 1859 as third assistant engineer. He advanced to second assistant engineer in October 1861 and resigned in May 1863. He worked as a manufacturer in Brooklyn, N.Y., at the time of his death.

216. George S. Geer to Martha Geer, December 28, 1862, Geer Papers.

217. *Brooklyn (N.Y.) Daily Eagle*, January 5, 1863.

218. Report of Cmdr. John P. Bankhead, U.S. Navy, commanding the *Monitor*, *ORN* I, 8:346–349.

219. South Carolina–born John Payne Bankhead (1821–1867) hailed from a family of divided loyalties. One brother, Henry Cary Bankhead (1828–1894), served as a Union lieutenant colonel and brevet brigadier general. Another brother, Smith Pyne Bankhead (1823–1867), was a Confederate artillery colonel. Bankhead began his navy career in 1838 and served in the Mexican War. By the start of the Civil War he had advanced to lieutenant. Prior to taking command of the *Monitor* he served in the Atlantic blockade on the warships *Susquehanna* and *Pembina*. He required a year to recover after the loss of the *Monitor* and evidence suggests his health remained poor until his death. The highest rank he obtained was captain.

220. Report of 2nd Asst. Eng. Joseph Watters, U.S. Navy. *ORN* I, 8:349–350.

221. Ibid.

222. Weeks, "Last Cruise of the Monitor."

223. Joseph Watters pension file, NARS.

224. *New York Herald*, February 26, 1863.

225. Vermont-born George Foster Emmons (1811–1884) captured or destroyed about forty-six enemy ships and blockade-runners during the Civil War, yet he is perhaps best remembered for his exploits as an explorer and author. As a young midshipman, he participated in the United States Exploring Expedition, also known as the Wilkes Expedition, for overall commander Lt. Charles Wilkes, from 1838 to 1842. Emmons received a promotion to lieutenant during the four-year survey of the Pacific region. A few years later, during the Mexican War, he distinguished himself as an officer on the *Ohio*, *Warren*, and other vessels. He provided a detailed listing of ships captured during the war with Mexico and previous wars in his 1853 book, *The Navy of the United States, from the Commencement, 1775 to 1853; with a Brief History of Each Vessel's Service and Fate as Appears upon Record*. Emmons continued in the navy after the end of the Civil War and retired as a rear admiral in 1873. A description of his character and mention of his nickname appears in the postwar reminiscence "Life on the Texan Blockade," by Surg. William F. Hutchinson.

226. Born in New York and raised in Ohio, Homer Crane Blake (1822–1880) graduated from the U.S. Naval Academy in 1846 and served as a midshipman during the Mexican War. During the Civil War, he served on the frigate *Sabine* and gunboat *R. R. Cuyler* prior to taking command of the *Hatteras* in November 1862. After his ship was sunk by the *Alabama*, Blake was reported killed. It was soon discovered that he had survived, and upon his return to the United States he was exonerated of any wrongdoing in connection with the loss of the *Hatteras*.

227. Columbian College was used as a hospital and barracks during the

Civil War, and its volunteer staff included poet Walt Whitman. Renamed Columbian University in 1873, it became George Washington University in 1904. "History," www.gwu.edu/history.

228. Hodgkins, *Historical Catalogue of the Officers and Graduates*, 111; Hamersly, *Records of Living Officers*, 207.

229. Report of Lt. Cmdr. Homer C. Blake of the engagement between the *Hatteras* and the *Alabama*, *ORN* I, 2:18–20.

230. Ibid.

231. Ibid.

232. Marylander Raphael Semmes (1809–1877) resigned his U.S. navy commission in 1861 after his adopted state of Alabama seceded from the Union. Commissioned commander, he began his service in charge of the lighthouse bureau. He rose to fame first on the *Sumter*, in which he captured eighteen ships in six months, and then on the *Alabama*. With this vessel he was credited for the capture of sixty-nine ships between September 1862 and June 1864. His tenure as commander ended on June 19, 1864, when the *Alabama* was defeated and sunk by the Union warship *Kearsarge* off Cherbourg, France. Semmes was rescued by a British ship and returned to the Confederacy. Promoted to rear admiral, he commanded the James River squadron until the fall of Richmond on April 3, 1865. He surrendered with Lt. Gen. Joseph E. Johnston's army later that month. After the war he practiced law, worked as a newspaper editor, and wrote two books about his navy experience.

233. Report of Lt. Cmdr. Homer C. Blake of the engagement between the *Hatteras* and the *Alabama*, *ORN* I, 2:18–20.

234. *Charleston Daily Courier*, January 26, 1863.

235. *New York Herald*, January 28, 1863.

236. *New York Herald*, February 26, 1863.

237. Ibid.

238. Edward S. Matthews pension file, NARS.

239. Ibid.

240. Ibid.

241. Ibid.

242. *New York Times*, March 15, 1863, and March 18, 1863; *Daily Constitutionalist* (Augusta, Ga.), March 19, 1863.

243. The scion of New Yorkers who had moved to the South, Savannah-born Francis Stebbins Bartow (1816–1861) was considered one of the foremost legal minds in the state. He was also one of its largest slaveholders. Active in the Georgia secession convention, Bartow championed immediate withdrawal from the Union. He was elected a member of the Provisional Confederate Congress in Montgomery, Alabama. After the outbreak of war he opted to join the military, having been active in the militia since the 1850s. His death was mourned throughout Georgia. The last words reportedly spo-

ken by Bartow—"They have killed me boys, but never give up the field"—are
inscribed on his gravestone.

244. Beville's father, Gideon Claiborne Beville, died in 1850 at age thirty.
Beville's grandfather, Claiborne Beville, died in 1852 at age seventy. Lichliter,
Pioneering with the Beville and Related Families, 151–152; U.S. Census, 1860.

245. Beville, listed on the Oglethorpe Light Infantry roll as F. B. Bevill, is
noted as one of five men who joined the company after it arrived in Virginia.
Rockwell, *Oglethorpe Light Infantry*, 8.

246. Francis B. Beville pension application, April 19, 1862, Georgia Con-
federate Pension Office.

247. *New York Times*, March 15, 1863.

248. Tucker's naval brigade is not to be confused with another naval
brigade hastily formed by Rear Adm. Raphael Semmes. It was composed
of sailors who had served with the James River squadron until the destruc-
tion of the warships during the night of April 2–3, 1865. Ordered to link
up to Gen. Lee's army, Semmes's naval brigade never made the connection
and ultimately surrendered with the remnants of Gen. Joseph E. Johnston's
forces on April 26, 1865.

249. John Randolph Tucker (1812–1883) of Alexandria, Virginia, began
as military career as a midshipman in the U.S. navy in 1826. He left in 1861
with the rank of commander to cast his lot with the Confederacy. He went
on to command the *Patrick Henry* during the historic contest between the
Monitor and *Virginia* at Hampton Roads, Virginia, on March 9, 1862. He
spent the rest of the war on active duty in Charleston, South Carolina, and
Richmond. After the war he served as a rear admiral in the Peruvian navy.

250. Rochelle, *Life of Rear Admiral John Randolph Tucker*, 52–54.

251. Ibid.

252. *Daily Constitution* (Atlanta, Ga.), September 9, 1879; Francis B.
Beville pension application, Georgia Confederate Pension Office.

253. U.S. Secretary of the Navy Gideon Welles to Rear Adm. David Far-
ragut regarding operations of March 14, 1853, *ORN* I, 19: 695–696.

254. Dewey, *Autobiography of George Dewey*, 89–90.

255. *Harvard Graduates Magazine* 17 (December 1908): 342.

256. John Dove (about 1805–1876) immigrated with his wife, Helen
McLaggan Dove (1810–1869), in 1833. Their only son, George, was born
two years later. The elder Dove was partner in the firm Smith, Dove & Co.

257. Roe, *History of the First Regiment of Heavy Artillery*, 57–59.

258. In 1862 the Fourteenth Massachusetts Infantry was reorganized as
the First Massachusetts Heavy Artillery. The regiment went on to distinguish
itself in numerous actions during Lt. Gen. Grant's 1864 Overland Campaign.

259. The *Hartford* and the *Albatross* led the way, followed by the *Rich-
mond* and the *Genessee*, the *Monongahela* and the *Kineo*, and the *Missis-
sippi*.

260. Excerpts of the journal of the *Richmond*, July 15, 1862, to March 15, 1863, *ORN* I, 19:769–770.

261. Ibid.

262. Raymond, *Record of Andover during the Rebellion*, 196.

263. *Boston Herald*, March 1, 1889.

264. Ibid.; *Boston Herald*, October 25, 1908.

265. Keegan's name was spelled in various ways, probably the result of his inability to write and having others spell his surname phonetically. Harry Keakans pension file, NARS.

266. Ibid.

267. Ibid.

268. Ibid.

269. Holland, *Letters and Diary of Laura M. Towne*, 108–109, 138.

270. John C. Dutch pension record, NARS.

271. *Boston Evening Journal*, February 15, 1895; Holland, *Letters and Diary of Laura M. Towne*, 109.

272. Spencer, *Edisto Island, 1861 to 2006*, 36–38; report of Acting Master John C. Dutch of the expedition to Edisto Island, *ORN* I, 14:121–122.

273. The Confederates were Sgt. Townsend Mikell, Corp. Fred M. Bailey, and privates William G. Baynard, Joseph Edings, Arthur C. Lee, Whitmarsh S. Murray, Robert E. Seabrook, Julius J. Westcoat, and William B. Whaley.

274. Reports of the loss of the *Kingfisher*, *ORN* I, 15:383–388.

275. John C. Dutch pension record, NARS.

276. Ibid.; *Boston Evening Journal*, February 15, 1895.

277. Report of Lt. Roswell H. Lamson, commanding the Upper Nansemond Flotilla, *ORN* I, 8:722–725.

278. Sands, "Lieutenant Roswell H. Lamson, U.S. Navy."

279. The men who remained with Lamson were sailors from the *Minnesota*. Sands noted that these men had accompanied Lamson in a boat from the frigate, where Lamson had a stateroom that served as his quarters. Ibid.

280. Ibid.

281. Francis Preston Blair Sands (1842–1928) hailed from a prominent military family that included his father, Rear Adm. Benjamin Franklin Sands. Born in Washington, D.C., he chose a career in law. He joined the navy in 1862 as an acting master and resigned as an acting master in 1867. During the Civil War, he served in the North Atlantic Blockading Squadron on the warships *Dacotah*, *Minnesota* (where he first became acquainted with Lamson), *Fort Jackson*, and *Gettysburg*, where he served under the command of Lamson. Ibid.

282. McPherson and McPherson, *Lamson of the Gettysburg*, 103.

283. Sands, "Lieutenant Roswell H. Lamson."

284. Ibid.

285. Lt. Col. Theophilus L. England of the Eighty-ninth New York Infantry commanded a detachment of 140 men and Col. John Ward of the Eighth

Connecticut Infantry led a 130-man detachment. Career soldier George Washington Getty (1819–1901) graduated from West Point in 1840 and earned a brevet during the Mexican War. At the start of the Civil War he ranked as an artillery captain. Promoted to brigadier general in 1862, he served as commander of a division in the Union army's Ninth Corps during the engagement at Hill's Point. He went on to serve in several other commands on the division and corps level, and suffered a severe wound during the Battle of The Wilderness in May 1864. He continued in the regular army after the end of hostilities and retired in 1882 as a colonel.

286. Sands, "Lieutenant Roswell H. Lamson."

287. Report of Brig. Gen. George W. Getty, *OR* I, 18:304.

288. Getty reported 137 prisoners (7 officers and 130 men) and a loss of four killed and ten wounded. Ibid.

289. Ibid.

290. McPherson and McPherson, *Lamson of the Gettysburg*, 231–232.

291. Catherine "Kate" Buckingham (1843–1892) was the daughter of Union Brig. Gen. Catharinus Putnam Buckingham (1808–1888) of Ohio.

292. McPherson and McPherson, *Lamson of the Gettysburg*, 233.

293. *Oregonian*, August 23, 1908.

294. *New York Times*, May 17, 1863.

295. The officer, Acting Ensign Elias Smith (1814–1887), was a *New York Times* reporter prior to his appointment as a navy officer on December 22, 1862. His eyewitness account of the running of the Vicksburg batteries was published in the *New York Times*. In it, he profiles the officers of the *Lafayette*. He describes himself as "a native of Rhode Island, but of late years has been a resident of New York, and was for several years an attaché of the *New York Times*." Ibid.

296. Born in Princess Anne County, Virginia, Henry Augustus Walke (1809–1896) started his navy career in 1827 as a midshipman aboard the *Alert*, which was commanded by then Lt. David G. Farragut. Walke participated in the Mexican War and during the Civil War played an important role in early operations along the Mississippi River. As commander of the gunboat *Tyler*, he supported then Brig. Gen. Ulysses S. Grant's forces during the Battle of Belmont, Missouri, on November 7, 1861. He commanded the gunboat *Carondelet* during the capture of Forts Henry and Donelson, as well as in other actions in that region in early 1862. He received a promotion to captain in August 1862 and an assignment to the *Lafayette*. After the fall of Vicksburg in July 1863, Walke was ordered east and spent the remainder of the war in much less active service. He was promoted to rear admiral in 1870.

297. Josiah James Higbee (1838–1890) served as a private in the Twelfth Ohio Infantry for a three-year term of enlistment. He then joined the Twenty-third Ohio Infantry for the duration of the war. Josiah J. Higbee military service record, NARS.

298. Walke, *Naval Scenes and Reminiscences*, 348–349.

299. The fleet included the ironclads *Benton, Carondelet, Lafayette, Louisville, Mound City, Pittsburg*, and *Tuscumbia*; the wood gunboat *General Price*; transports *Forest Queen, Henry Clay*, and *Silver Wave*; and the tug *Ivy*.

300. *New York Times*, May 17, 1863.

301. Ibid.

302. Report of Capt. Henry Walke, U.S. Navy, commanding the *Lafayette*, *ORN* I, 24:557.

303. Walke, *Naval Scenes and Reminiscences*, 353.

304. *Cincinnati Gazette*, January 27, 1866.

305. Massachusetts-born Lizzie Parker Howell hailed from a family of musical ability, and studied voice in Boston and New York prior to moving to California in 1861. She made San Francisco her home and established a reputation as a gifted singer. She began to teach voice in 1866 and eventually devoted herself to training up-and-coming talent full time.

306. David King Perkins 1863–1864 diary, Perkins Papers.

307. Ibid.

308. George Clement Perkins (1839–1923) served as the governor of California (1880–1883), and as a U.S. senator (1893–1915). Guinn, *History of the State of California*, 1:303–309.

309. Masonic Resolutions upon the Death of D. K. Perkins, Perkins Papers.

310. Ibid.

311. David King Perkins 1863–1864 diary, Perkins Papers.

312. Ibid.

313. Ibid.

314. Ibid.

315. Undated newspaper clippings, Perkins Papers.

316. *Denver Post*, January 28, 1910; *Biographical Sketches of Representative Citizens of the Commonwealth of Massachusetts*, 79–81.

317. The Boston City Guards were one of four militia companies that composed the Fourth Battalion of Rifles. The official uniform was gray with red trim and shoulder knots and included a cap trimmed in scarlet and topped by a pompom. Davis, *Three Years in the Army*, xiv–xvi.

318. Nehemiah M. Dyer military service record, NARS.

319. Report by Lt. Cmdr. James E. Jouett, U.S. Navy, of the destruction of the Confederate schooner *Isabel*, *ORN* I, 20:198–199.

320. Ibid.

321. On November 7, 1861, then Lt. James Edward Jouett (1826–1902) commanded two launches on a raid of Confederate vessels in Galveston harbor, which ended with the destruction of the schooner *Royal Yacht*. His actions prompted his elevation to independent command. A veteran officer who started his career as a midshipman in 1841, he is perhaps best known for being mentioned in the paraphrase of Rear Adm. David Farragut's orders

during the Battle of Mobile Bay on August 5, 1864: "Damn the torpedoes! Four bells! Captain Drayton go ahead! Jouett full speed!" During the engagement, Jouett commanded the *Metacomet*, which was lashed to Farragut's flagship *Hartford*. Jouett remained in the navy after the war and retired as a rear admiral in 1890. Three navy ships have been named in his honor. Ibid.

322. Farragut made these comments to Capt. John R. Goldsborough, who commanded the Mobile section of the West Gulf Blockade Squadron. Order of Rear Adm. David Farragut to Capt. John R. Goldsborough, regarding additional vessels for his command, *ORN* I, 20:205.

323. The *Glasgow* was formerly known as the *Eugenie*, a Confederate blockade-runner captured by the *Cuyler* on May 6, 1863, less than two weeks before Dyer burned the *Isabel*. The *Eugenie* was converted for use by the Union navy and in January 1864 was renamed the *Glasgow*.

324. Report of Lt. Cmdr. James E. Jouett, U.S. Navy, regarding the Battle of Mobile Bay. *ORN* I, 21:442–443.

325. Ibid.

326. E. Beach, *From Annapolis to Scapa Flow*, 80.

327. Ibid., 84–86.

328. Ibid.

329. Ibid.

330. Ibid.

331. *San Francisco Call*, September 13, 1899.

332. *Sun* (Baltimore, Md.), September 13, 1899.

333. John Elliott Copp was third lieutenant of the privateer *James Monroe* and a member of the crew that sailed from Savannah, Georgia, on December 8, 1814, bound for France with a cargo of cotton. During the voyage the War of 1812 officially ended with the signing of the Treaty of Ghent on February 7, 1815. Meanwhile, the crew of the *James Monroe* captured several vessels, unaware that the war was over. On March 2, 1815, the British brig *Harmony* fell victim to the *James Monroe* off the coast of Spain. Seven members of the *James Monroe*, two Americans and five Frenchmen, were placed aboard the *Harmony* to man the prize. Copp acted as prize master. The English mate aboard the *Harmony* persuaded the Frenchmen to take back the ship. They did so on March 24, and Copp lost his life when he was thrown overboard. Malcom, "A Brief History of the Sailing Brig Last Known as the Piratical Slaver *Guerrero*."

334. John E. Hart to his wife, Harriet E. Hart, July 20, 1861, Hart Letters.

335. Report by Rear Adm. David G. Farragut, commanding the West Gulf Squadron, of the passage of Port Hudson, *ORN* I, 19:665–668.

336. John E. Hart to his wife, Harriet E. Hart, June 7, 1863, Hart Letters.

337. John E. Hart death certificate, Certificates of Death, Disability, Pension.

338. Ibid.

339. Theodore Bailey DuBois (1822–1874) was orphaned as a boy and

went to sea at age sixteen. By the start of the Civil War he had established himself as a merchant ship captain and entered the navy as an acting master in 1861. Assigned to the *Albatross*, he was transferred at some point after Hart's suicide to the monitor *Osage*. In November 1864 he received a promotion to acting lieutenant commander and served in this capacity until he mustered out in 1866. About 1873 he began exhibiting signs of a mental disorder diagnosed as softening of the brain. He was committed to an asylum and died there the following year at age fifty-two. Theodore B. DuBois pension record, NARS; Du Bois, *Bi-centenary Reunion of the Descendants of Louis and Jacques Du Bois*, 136–137.

340. William Stanton Burdick Harcourt (1823–1888) of New York was also a Mason. He began his navy career as a sailor in 1836 and was twice wounded during the Mexican War. He joined the officer's ranks in 1853 as a gunner. Assigned to the *Albatross* early in the war, he went on to serve aboard the *Arizona*. An anecdote in Harcourt's February 8, 1888, obituary in the *Baltimore American* is relevant to his Masonic connection: "The *Arizona* took part in the Sabine Pass expedition and did blockade on the coast of Texas. While in this command Captain Harcourt received the thanks of the Grand Lodge of Mason of Louisiana, and a letter from Grand Master J. Q. A. Fellows, for restoring valuable Masonic jewels and other property that had been despoiled from a lodge at Point Coupee, La.; and for restoring the plate and altar vestments pillaged from a Catholic Church at the same place, he also received a letter of thanks from the priest in charge." Harcourt served on two more vessels, the *Richmond* and *Narcissus*. He was the commander the latter ship. Harcourt received an honorable discharge in November 1865 and settled in Baltimore. He suffered at least two bouts with mental illness, the second of which landed him in an asylum in 1886. He died two years later. William Harcourt pension file, NARS; *Baltimore American*, February 18, 1888.

341. DuBois, "Masonry and the War."

342. Ibid.

343. Ibid.

344. According to the terms of his parole, as reported in *Confederate Veteran* magazine, William Walter Leake (1833–1912) would be free to return to the army after the surrender of Port Hudson, which occurred in July 9, 1863. Upon his release Leake helped organize a cavalry company and served through the end of the war. He went on to command a local home guard company in his home parish and practice law until his death.

345. Franklin Kitchell Gardner (1823–1873) of New York was appointed to West Point from Iowa and graduated in 1843. He received two honorary brevets for his service in the Mexican War and continued as an army officer until 1861, when he joined the Confederate army as a lieutenant colonel. In 1862 he commanded a brigade at the Battle of Shiloh and in the Kentucky Campaign and was promoted to brigadier general and major general. In

early 1863 he became the commander of the defenses of Port Hudson and held the fortress city until the surrender of Vicksburg, Mississippi, on July 4, 1863 made his position untenable. He surrendered his forces five days later. Gardner was exchanged and served through the rest of the war. After the end of hostilities he became a planter in Louisiana. At his death, Gardner was remembered for his stubborn defense of Port Hudson.

346. Cunningham, "Tribute to Capt. William W. Leake."

347. DuBois, "Masonry and the War."

348. Ibid.

349. James Morris Morgan (1845–1928) resigned from the U.S. Naval Academy in 1860. He joined the Confederate navy in 1861 as an acting midshipman and served through the war in a variety of duties. He was promoted to passed midshipman shortly before being ordered to the Battery Semmes. After the war he served as an officer in the Egyptian army. He also served as U.S. consul general to Australasia from 1885 to 1888. His memoirs were published in 1917. Morgan, *Recollections of a Rebel Reefer*, 136–139.

350. Ibid.

351. Ibid.

352. Ibid.

353. Ibid.

354. Matthew Fontaine Maury (1806–1873) was one of the great thinkers in both navies. He began his career in 1825 and distinguished himself as a scientist, historian, and educator. His publications included *The Physical Geography of the Sea* (1855). The volume is considered a classic work in oceanography. The December 29, 1873, edition of the New York *Daily Graphic* summarized his contributions: "The simplicity and great clearness of Maury's mind fitted him in an eminent degree for the splendid physical researches which have made his name familiar to all nations as 'the pathfinder of the seas.'" He attempted to resign his commission, but his request was refused and he was instead dismissed from the navy on April 26, 1861.

355. A study of genealogical records on Ancestry.com indicates that their common ancestor is Rev. James Fontaine Maury, born in Dublin, Ireland, about 1717. He came to America in 1742, settled in Albemarle County, Virginia, and married Mary Elizabeth Walker the following year. Maury died in 1769. His wife and twelve children survived him.

356. Morgan, *Recollections of a Rebel Reefer*, 115–117.

357. Ibid.; abstract log of the *Georgia*, April 9, 1863, to January 18, 1864. *ORN* I, 2: 811–818.

358. Anne Fontaine Maury (1832–1890) was Maury's second wife. They married in 1856 and became parents to five children who lived to maturity, though only three of them had been born by 1864. Maury had two other children from his first marriage to Mary Hill Beckham, whom he had wed in 1842. Their union ended when she died, in 1850.

359. Flag Officer Samuel Barron to Secretary of the Navy Stephen R. Mallory, February 15, 1864, *ORN* II, 2:581 583.

360. *Pigeon (Mich.) Progress*, January 23, 1920.

361. Ibid.

362. John Rodgers (1812–1882), was described by a subordinate officer who met him after the war as "one of the grandest men I have ever known. His character was open, frank, and noble. He went straight forward in the path of duty perfectly fearless." His navy service began as a midshipman in 1828, and he spent his early career on survey and other duties at various ports around the globe. In 1861, after the outbreak of the Civil War, Rodgers assisted in the organization of a gunboat fleet to operate along the Mississippi and other western rivers, and later that year participated in the capture of Port Royal, South Carolina, as commander of the steamer *Flag*. He went on to command the ironclad *Galena* and, in November 1862, the *Weehawken*. He left the *Weehawken* in late 1863 to take charge of the *Dictator*, serving on this vessel for the duration of hostilities. He continued in the navy after the war and advanced to rear admiral. Hall, *Biographical Memoir of John Rodgers*.

363. *Semi-Weekly Wisconsin* (Milwaukee), June 30, 1863.

364. "Extract of a letter from an officer of Admiral Dupont's Squadron, to the *National Intelligencer*, dated Port Royal, June 19th," *Wilmington (N.C.) Journal*, July 2, 1863.

365. William Augustine Webb (1824–1881) of Virginia was the son of U.S. Navy captain Thomas Tarleton Webb. He followed his father into the navy at age thirteen and might have remained in the service for his entire career. But the outbreak of Civil War prompted Webb to resign his commission and join the fledgling Confederate navy. On March 8, 1862, he participated in the Battle of Hampton Roads and was slightly wounded. By the end of 1862 he commanded a squadron at Charleston, South Carolina. At some point in early 1863 he was assigned to the *Atlanta*. His surrender of the ironclad resulted in heavy criticism by many who blamed him for a failure of command. In December 1864 he left the Confederate navy citing poor health. He swore the oath of allegiance to the federal government to the U.S consul in London and returned to Virginia after the end of the war. He requested and received a pardon from President Andrew Johnson. Report of Cmdr. William A. Webb, C.S. Navy, *ORN*, I, 14:290–292; Sturner, "Webbs in History: William Augustine Webb."

366. Irish-born journalist-turned-soldier Charles Graham Halpine (1829–1868) is perhaps best known for a series of wartime writings published under the pseudonym Miles O'Reilly, a fictitious infantry private. In early 1863, Halpine served as assistant adjutant general and chief of staff to Maj. Gen. David Hunter, who commanded the Tenth Corps and the Department of the South. After Halpine learned from the Confederate deserters of the movements of the *Atlanta*, he immediately communicated the information to senior navy commanders who took prompt and decisive action. *ORN* I, 14:281–282.

367. Report of Capt. John Rodgers, commanding the *Weehawken*. *ORN* I, 14:265–266.

368. Ibid.

369. *Pigeon (Mich.) Progress*, January 23, 1920.

370. Ibid.

371. Mississippian Charles William Read (1840–1890) graduated from the U.S. Naval Academy in 1860 and resigned his commission after the start of the war. Prior to joining the *Arkansas*, he served on the warship *McRae* during the fight for New Orleans in 1862. On April 24, during the naval action against Union Rear Adm. David Farragut's fleet, the *McCrae* suffered severely. After her commander, Thomas B. Huger, suffered a mortal wound, Read assumed command and delivered the vessel and its wounded to New Orleans, where she sank at her moorings from damage received during the fight. Thus began the high-profile Confederate navy career of Read. His exploits were celebrated during the war itself. In a letter to the editor published in the July 17, 1863, edition of the *Macon (Ga.) Telegraph*, a writer known only as "J.H.D." stated of Read: "His feats have been most daring and gallant in destroying the enemy's shipping at the mouth of their own harbors. Had Lieut. Read been in command of a small fast steamer, properly equipped, his deeds would have ranked him with [John] Paul Jones, [Stephen] Decatur and [Raphael] Semmes, and his name a terror to the enemy."

372. Additional report of Lt. Charles H. Read. *ORN* I, 2:655–657.

373. Hodsdon, *Annual Report*, 23.

374. J. Porter, *A Record of Events in Norfolk County*, 126.

375. Although Mississippi-born Earl Van Dorn (1820–1863) graduated close to the bottom of his West Point class in 1842, he proved an aggressive fighter. He was wounded four times in one skirmish against Indians on the frontier, and in the Mexican War he suffered a wound and received two brevet, or honorary, ranks for his battlefield courage. He resigned his commission as major in 1861 and became brigadier general of Mississippi troops. He was soon named major general of state forces in place of Jefferson Davis. By June 1861 he had risen to major general in the Confederate army and briefly led a division in the Confederate Army of the Potomac before advancing to command on the district level. He was in charge of the Department of Mississippi with headquarters in Vicksburg at the time of the loss of the *Arkansas*. Van Dorn went on to lead Confederate forces against the Union army commanded by Maj. Gen. William S. Rosecrans at Corinth, Mississippi, on October 3–4, 1862. Van Dorn requested a court of inquiry and was cleared of wrongdoing. But he was transferred to a lesser cavalry command. On May 8, 1863, a Tennessee physician murdered Van Dorn in retaliation for an alleged affair between the general and his wife.

376. Read, "Reminiscences of the Confederate States Navy."

377. The son and namesake of a clergyman, John Newland Maffitt (1819–1886) was born during the passage of his parents from their native Ireland to

America. He was adopted by an uncle and moved from his home in Connecticut to North Carolina. Maffitt began his U.S. Navy career as a midshipman in 1832 and by the start of the Civil War ranked as a lieutenant. He resigned his commission in 1861. In the summer of 1862 he took command of the British-built cruiser *Oreto*, which was rechristened the *Florida*. He and his crew captured numerous ships until February 1864, when Maffitt resigned due to poor health. He eventually recovered and settled on a small farm in Wilmington, North Carolina.

378. Lt. Charles W. Read, C.S. Navy, to Lt. John N. Maffit, commanding the *Florida*, proposing plans for a raid upon U.S. shipping in Chesapeake Bay, *ORN* I, 2:644.

379. Ibid.

380. Report of Lt. John N. Maffit, C.S. Navy, commanding the *Florida*, of the cruise and captures by that vessel from March to May 1863, *ORN* I, 2:649.

381. Shaw, *Sea Wolf of the Confederacy*, 114–124.

382. Read had just taken possession of the *Tacony* but had yet to transfer his crew when the schooner *M. A. Shindler* was intercepted and captured. The transfer from the *Clarence* to the *Tacony* was in progress when another vessel, the *Kate Stewart*, was taken. Read completed his transfer to the *Tacony* and fired the *Clarence* and *M. A. Shindler*. Then he sent his prisoners, which according to his count numbered over fifty, to the *Kate Stewart* and "bonded her for the sum of $7,000, payable to the President of the Confederate States thirty days after the ratification of peace between the Confederate States and the United States." From this time through June 25, the *Tacony* captured fifteen vessels, including the *Arabella*, *Umpire*, *Isaac Webb*, *Micawber*, *Byzantium*, *Goodspeed*, *Marengo*, *Florence*, *E. Ann*, *R. Choate*, *Ripple*, *Ada*, *Wanderer*, *Shatemuc*, and *Archer*. Additional report of Lt. Charles H. Read of his cruise on the *Clarence*, *Tacony*, and *Archer*, and the capture of the *Caleb Cushing*. *ORN* I, 2:655–657.

383. Hodsdon, *Annual Report*, 23.

384. Additional report of Lt. Charles H. Read, *ORN* I, 2:655–657.

385. Ibid.

386. *Sun* (Baltimore, Md.), December 21, 1892; *Evening Star* (Washington, D.C.), May 23, 1916.

387. Report and diary extracts of Rear Adm. John A. Dahlgren of the attack on Fort Wagner, *ORN* I, 14:359–368.

388. *New-York Daily Reformer* (Watertown), July 30, 1863.

389. U.S. Census, 1860.

390. Morrison, *History of New York Ship Yards*, 157.

391. *Boston Evening Transcript*, July 25, 1863.

392. Report and diary extracts of Rear Adm. John A. Dahlgren of the attack on Fort Wagner, *ORN* I, 14:359–368.

393. *New-York Tribune*, July 27, 1863.

394. Albert J. Kenyon pension file, NARS.

395. Ibid.

396. David Dixon Porter (1813–1891), one of the most decorated officers in the Union navy, made this statement in *Naval History of the Civil War*, 447.

397. John Adolph Dahlgren (1809–1870) is perhaps best known for his invention of the rifled cannon that bears his name. A longtime ordnance officer who has graduated from the U.S. Naval Academy in 1826, he served during the early part of the Civil War as commander of the Washington Navy Yard and as Chief of the Ordnance Bureau. He received a promotion to rear admiral in February 1863 and was placed in command of the South Atlantic Blockading Squadron in July 1863, only two months before he ordered the assault on Fort Sumter. His son, Col. Ulric Dahlgren, was killed in January 1864 during an ill-fated raid on Richmond, Virginia.

398. Peacetime plantation owner Stephen Elliott Jr. (1832–1866) of South Carolina commanded the defenses of Fort Sumter from 1863 until May 1864, when he reported to Petersburg, Virginia, as colonel in command of Hol-combe's Legion. Promoted to brigadier general, he was severely wounded in the Battle of the Crater. He died from the effects of his wound two years later.

399. Johnson, *Defense of Charleston Harbor*, 156.

400. Charles H. Bradford military service records, NARS; *Portland (Me.) Advertiser*, September 3, 1861.

401. Charles H. Bradford pension files, NARS.

402. Report of Ensign James Wallace, U.S. Navy, commanding Naval Battery, *ORN* I, 14:612–613; *New York Times*, September 17, 1863.

403. Gillmore, *Supplementary Report to Engineer and Artillery Operations*, 109.

404. Iowa-born George Collier Remey (1841–1928), an 1859 graduate of the U.S. Naval Academy, led one of the divisions during the September 8 assault on Fort Sumter. After his capture, Remey was confined at Columbia, South Carolina. He was exchanged and released after thirteen months in prison and returned to duty. Remey remained in the navy after the war and served in posts that included service in the Spanish-American War. He retired in 1903 with the rank of rear admiral. Remey, *Life and Letters*, 2:200.

405. *Daily Eastern Argus* (Portland, Me.), October 14, 1863.

406. *Providence (R.I.) Evening Press*, March 28, 1865.

407. Ibid.

408. *Daily Eastern Argus* (Portland, Me.), April 7, 1865.

409. *Providence (R.I.) Evening Press*, March 28, 1865.

410. Beverly M. Donald, superintendent of Magnolia Cemetery, to the author, September 2, 2014.

411. Holden, "A Cruise on the 'Sassacus.'"

412. Career naval officer Francis Asbury Roe (1823–1901) of New York is perhaps best known for being in command of the *Sassacus* when the ship rammed the Confederate ironclad *Albemarle* during an engagement on May

5, 1864. Both vessels were damaged during the attack. Roe served through the rest of the war and continued in the navy until he retired as rear admiral in 1884.

413. G.W.B., "Ben Wood."

414. Ibid.

415. Holden, "A Cruise on the 'Sassacus.'"

416. Stump Inlet is known today as Rich Inlet.

417. Holden, "A Cruise on the 'Sassacus.'"

418. Ibid.

419. Ibid.

420. Report of Lt. Cmdr. Francis A. Roe, U.S. Navy, *ORN* I, 9:438–439.

421. Ibid.

422. G.W.B., "Ben Wood."

423. *Watertown (N.Y.) Daily Times*, July 5, 1910.

424. G.W.B., "Ben Wood."

425. On May 30, 1861, Bradbury married Caroline G. Hanscom in Machias. Isaac S. Bradbury pension file, NARS.

426. The friend and recipient of the letter was William Bartlett Smith (1806–1869). Born and raised in Machias, Smith was a prominent attorney, state politician, and three-time collector of customs for the District of Machias. He was in charge of planning the town's centennial celebration in 1863, and his book, *Memorial of the Centennial Anniversary of the Settlement of Machias*, was published the same year. The printer of the book, Charles Osborne Furbush (1835–1916), was also the publisher of the *Machias Republican*. Bradbury intended this letter for publication in the *Republican*. Bradbury's commander, William F. Spicer (1820–1878) of New York City, graduated from the U.S. Naval Academy in 1839 and became a career navy man who served on assignments around the world. He commanded the *Cambridge* and *Quaker City* from 1863 to 1865 as part of the North Atlantic Blockading Squadron, including operations against Fort Fisher, North Carolina, in January 1865. He remained in the navy after the war. At his death, in 1878, he held the rank of commodore and commandant of the Charlestown Navy Yard in Boston. Isaac S. Bradbury to William B. Smith, September 14, 1863, Bradbury Letters.

427. Ibid.

428. Ibid.

429. Isaac S. Bradbury to William B. Smith, February 11, 1864, Bradbury Letters.

430. Ibid.

431. Isaac S. Bradbury pension file, NARS.

432. Report of Acting Rear-Adm. Henry Knox Thatcher, December 31, 1865, *ORN* I, 22:261–263.

433. Bendus, "A Proposal to Establish the Shipwreck USS *Narcissus* as a State Underwater Archaeological Preserve."

434. Ibid.

435. Isaac S. Bradbury pension file, NARS.

436. Report of Capt. Joseph M. Anderson, Eightieth Ohio Infantry, of the expedition from Vicksburg, Mississippi, to Waterproof, Louisiana, *OR* I, vol. 32, pt. 1: 157–159.

437. John D. Moore pension record, NARS.

438. *Providence (R.I.) Evening Press*, August 13, 1863.

439. Born in Cincinnati, Ohio, John Vincent Johnston (1826–1912) started his navy service as master of the *St. Louis* and participated in the successful operations against Fort Henry in February 1862. On April 1, 1862, he commanded an amphibious mission to silence Battery No. 1, which protected Confederate-occupied Island No. 10 along the Mississippi River between New Madrid, Missouri, and Lake County, Tennessee. Johnston and his command carried the battery and spiked its six guns before returning safely to their home base. Island No. 10 fell to Union forces a week later. Johnston was promoted to lieutenant for gallantry. He added to his laurels as commander of the *Forest Rose*. Johnston resigned in June 1864. He resided in St. Louis, Missouri, until his death. Two vessels have been named in his honor: the World War II–era destroyer DD-557, which was sunk by the Japanese during the Battle off Samar on October 25, 1944, and the destroyer DD-821, which operated from its launch in 1945 until 1981, when she was transferred to the Republic of China (Taiwan) navy. She was decommissioned in 2003.

440. Joseph M. Anderson served as captain and commander of Company I of the Eightieth Ohio Infantry from November 1861 until he mustered out of the regiment in March 1865.

441. The Eleventh Louisiana Infantry, African Descent, was organized in May 1863 and fought in the Battle of Milliken's Bend on June 7, 1863. On March 11, 1864, its designation was changed to the Forty-ninth U.S. Colored Infantry. The regiment mustered out of federal service in March 1866.

442. Capt. Joseph M. Anderson, commanding post at Waterproof, Louisiana, to Lt. John V. Johnston, commanding Gunboat *No. 9*, February 19, 1864, *ORN* I, 25:751.

443. Report of Lt. Cmdr. James A. Greer, *ORN* I, 25:749–751.

444. John D. Moore pension record, NARS.

445. *Omaha (Neb.) World Herald*, July 27, 1930; John D. Moore pension record, NARS.

446. Naval Enlistment Weekly Returns, Baltimore, Md., for the week ending February 20, 1864, NARS.

447. William H. Tucker rendezvous report, NARS.

448. The *Southfield* sunk after the prow of the *Albemarle* pierced her, and the *Miami* suffered the loss of its commander, Charles W. Flusser, and other crewmen during the fight.

449. Report of Lt. Cmdr. Walter W. Queen, U.S. Navy, commanding the *Wyalusing*, *ORN* I, 9:750–752.

450. Ibid.

451. *Hartford (Conn.) Daily Courant*, May 12, 1864.

452. The destruction of the *Albemarle* was the work of U.S. Naval Academy graduate William Barker Cushing (1842–1872). The lieutenant led a successful raid that made him a hero across the North and resulted in he and his men being recognized with the formal Thanks of Congress. Cushing was not the first to try to destroy the ram by torpedo. Five sailors who served on the *Wyalusing* made the first attempt on May 26, 1864. It failed after Confederates spotted them. All five survived and received the Medal of Honor: Coal Heaver Charles H. Baldwin, Fireman Alexander Crawford, Fireman John Lafferty, Coal Heaver Benjamin Lloyd, and Coxswain John W. Lloyd. Cushing's crew also received the Medal of Honor. They included a coal heaver, Richard Hamilton; landsmen Lorenzo Denning, Robert H. King, and Henry Wilkes; and ordinary seamen Daniel G. George, Bernard Harley, and Edward J. Houghton.

453. William H. Tucker rendezvous report, NARS.

454. Communications and reports related to the capture and abandonment of the blockade-runner *Little Ada*, ORN I, 15:374–380.

455. Edward H. Sheffield pension file, NARS.

456. The *Winona* was the first ship commanded by Washington, D.C., native Aaron Ward Weaver (1832–1919). An 1854 graduate of the U.S. Naval Academy, he started his Civil War service on the side-wheel steamer *Susquehanna* and participated in operations along the North and South Carolina coast in 1861 and 1862. He left the *Winona* in 1864 to command the *Chippewa*. He remained in the navy after the war and retired as a rear admiral in 1893.

457. Communications and reports related to the capture and abandonment of the blockade-runner *Little Ada*, ORN I, 15:374–380.

458. Ibid.

459. The deserter, Charles M. Muldoon, is not listed in navy records. Ibid.

460. Ibid.

461. The *Gettysburg* and *Little Ada* were originally Scottish-built blockade-runners. The *Gettysburg* was originally known as the *Douglass* and later as the *Margaret and Jessie*. Captured in November 1863, she was converted, renamed, and dispatched for blockade duties along the Atlantic coastline. She participated with the *Little Ada* in operations against Fort Fisher.

462. Report of Capt. Alexander M. Pennock, commander of the Western Gunboat Flotilla at the U.S. Depot in Cairo, Illinois, ORN I, 26:215–216.

463. William H. Gray military service record, NARS.

464. Report of Lt. Cmdr. Le Roy Fitch, U.S. Navy, commanding 8th District Mississippi Squadron, ORN I, 26:218–219.

465. The federal gunboats that shelled Forrest's command included the *Hastings, Moose, New Era*, and the *Volunteer*. Report of Capt. Alexander M.

Pennock, commander of the Western Gunboat Flotilla at the U.S. Depot in Cairo, Illinois, *ORN* I, 26:216–217.

466. Nathaniel Downing Wetmore Jr. (1838–1881) wrote a letter to the editors of the *Argus* off Fort Pillow on April 13, 1864. According to the 1860 census, he was born in New Hampshire and was a merchant in Memphis, Tennessee. Wetmore does not state exactly how he came to be at Fort Pillow. He may have been a passenger on the mail steamer *Platte Valley*, which happened to be in the area at the time of Forrest's attack. Report of Capt. Alexander M. Pennock, 224–226.

467. William H. Gray pension record, NARS.

468. S. Thompson, *Thirteenth Regiment of New Hampshire Volunteer Infantry*, 252.

469. Austin Bearse (1808–1881) worked alongside key figures in the abolitionist movement, including Frederick Douglass, during the years leading up to the Civil War. He documented his activities in *Reminiscences of Fugitive-Slave Law Days in Boston*, published in 1880. In one case that involved the removal of a slave from a ship that had docked in Boston, Bearse references his brother but does not mention his name. Bearse had three brothers, Lothrop Lewis Bearse (1810–1885), Alexander Bearse (1815–1864), and the subject of this profile, Frederic, also spelled Frederick (1820–1871).

470. Eleazer Hatch Bearse served as a private in the First Regiment Massachusetts Militia commanded by Lt. Col. David Nye.

471. *Lowell (Mass.) Daily Citizen & News*, February 9, 1871.

472. Report of Capt. Melancton Smith, U.S. Navy, commanding the *Mattabesett*, of arrival in Pamlico Sound, *ORN* I, 9:699–700.

473. Report from the Committee on Naval Affairs for the relief of Henry M. Meade, in *Reports of Committees…for the Third Session of the Forty-Fifth Congress*, no. 799, pp. 1–2.

474. Henry Meigs Meade's father, Richard Worsam Meade Sr. (1807–1870), was the younger brother of Maj. Gen. George Gordon Meade (1815–1872). His mother, Clara Forsyth Meigs Meade (1811–1879), was the daughter of Henry Meigs (1782–1861) and niece of Charles Delucena Meigs (1792–1869), the father of Quartermaster General Montgomery Cunningham Meigs (1816–1892).

475. Report from the Committee on Naval Affairs for the relief of Henry M. Meade, in *Reports of Committees…for the Third Session of the Forty-Fifth Congress*, no. 799, pp. 1–2.

476. Henry M. Meade pension record, NARS.

477. Report from the Committee on Naval Affairs for the relief of Henry M. Meade, in *Index to the Reports…for the First and Second Session of the Forty-Fifth Congress*, vol. 1, no. 94, pp. 1–2; report from the Committee on Naval Affairs for the relief of Henry M. Meade, in *Reports of Committees…for the Third Session of the Forty-Fifth Congress*, no. 799, pp. 1–2.

478. An Act for the Relief of Henry M. Meade, late paymaster in the United States Navy, in *Statutes at Large of the United States of America, Vol. XX*, 606.

479. Reports of Joseph P. Sanford, commander of the *Neptune*, and James L. Lardner, Acting Rear Admiral in command of the West India Squadron, *ORN* I, 3:55–56.

480. Little, *Genealogical and Family History of the State of Maine*, 1:132–133.

481. Callahan, *List of Officers of the Navy*, 107.

482. Reports of Joseph P. Sanford, commander of the *Neptune*, and James L. Lardner, Acting Rear Admiral in command of the West India Squadron, *ORN* I, 3:55–56.

483. Campbell, *Confederate Naval Cadet*, 93–97.

484. Minor enlisted in Company E of the Forty-second Tennessee Infantry and was later promoted to ordnance sergeant in the Third Missouri Battalion. *Richmond (Va.) Dispatch*, May 30, 1894.

485. Ibid.

486. Campbell, *Confederate Naval Cadet*, 53.

487. Born in Pennsylvania and raised in Louisiana, William W. Hunter (1803–1884) ran away from home to follow the sea. In 1822 he was appointed as a midshipman in the U.S. Navy. He invented a propulsion system based on bladed horizontal wheels. The system was installed in the iron-hulled warship *Allegheny* (1847). The design proved impractical and she was refit with convention screw propellers. By the start of the Civil War, Hunter had advanced in rank to commander. He resigned his commission in 1861 and accepted the same rank in the Confederate navy. He served at New Orleans and along the Texas coast before taking charge of the Savannah Squadron in 1863. He ended his Confederate service as commodore and spent the rest of his life in Louisiana.

488. Thomas Postell Pelot (1835–1864) graduated from the U.S. Naval Academy in 1855 and upon his resignation from the navy in January 1861 had attained the rank of lieutenant. At the time of his assignment to the expedition to capture the *Water Witch*, Pelot commanded the floating battery *Georgia*, part of the defenses of Savannah.

489. Campbell, *Confederate Naval Cadet*, 90.

490. Wilmington, North Carolina, native Joseph Price (1835–1895) served in the U.S. Revenue Marine Service prior to the Civil War. He served as a lieutenant in the Confederate army after the outbreak of hostilities and in May 1863 received a lieutenant's commission in the navy and assignment to the *Georgia*. He was promoted to commander for gallant and meritorious conduct for the capture of the *Water Witch*.

491. Campbell, *Confederate Naval Cadet*, 93–97.

492. Ibid.

493. Ibid.

494. Report of Lt. Joseph Price, C.S. Navy, of the capture of the *Water Witch*, *ORN* I, 15:501–502.

495. Campbell, *Confederate Naval Cadet*, 93–97.

496. Ibid.

497. Ibid.; report of Flag Officer William W. Hunter, commanding Savannah Squadron, *ORN* I, 15:500.

498. Campbell, *Confederate Naval Cadet*, 137.

499. Report of Rear Adm. David D. Porter, *ORN* I, 26:395–396.

500. Lewis J. Laybourn military service record, NARS; Lewis J. Laybourn pension record, NARS.

501. Report of Acting Master Henry T. Keene, commanding the *Naiad*, *ORN* I, 26:396–397.

502. Report of Rear Adm. David D. Porter, *ORN* I, 26:395–396.

503. Rockel, *20th Century History of Springfield*, 794–795.

504. Lewis J. Laybourn pension record, NARS.

505. Prince, *A Standard History of Springfield*, 2:379.

506. William H. Cushman to Frances H. Cushman, June 15, 1864, Cushman Papers.

507. Ibid.

508. *Daily Picayune* (New Orleans, La.), September 21, 1859; *The Times* (London), June 5, 1860.

509. Virginia-born Otway Henry Berryman (1812–1861) began his navy career in 1829 as a midshipman and received a promotion to lieutenant in 1841. He commanded seven different vessels during his service, including the brig *Dolphin*, which participated in operations that led to the installation of the first transatlantic cable, completed in 1858. He died on April 2, 1861, from "brain fever," or meningitis, after three months in command of the *Wyandotte*. The April 9, 1861, edition of the *New York Herald* noted of Berryman's passing, "His joyous, merry laugh, and happy disposition; his fine, officer-like bearing and self-possession under all circumstances, will be pleasantly remembered by those who were ever associated with him."

510. Pennsylvanian Henry Allen Adams (1800–1869) began his navy career at age thirteen and was best known before the war as chief of staff and second-in-command to Capt. Matthew C. Perry during the historic 1852–1854 expedition to Japan. Named commander of the *Sabine* in 1858, Adams and his crew arrived off Pensacola in early February 1861. In July 1862, Adams received a promotion to commodore and was placed on the retired list.

511. Capt. Henry A. Adams to the U.S. Naval Engineers Board of Examination, May 10, 1861, Cushman Papers.

512. Ibid.

513. Report of Chief Engineer William H. Cushman, U.S. Navy, *ORN I*, 3:63.

514. William H. Cushman to Frances H. Cushman, June 19, 1864, Cushman Papers.

515. James Shepard Thornton (1827–1875) received high praise from Capt. Winslow for his leadership during the fight against the *Alabama*, particularly his command of the guns of the *Kearsarge*. The great-grandson of Declaration of Independence signer Matthew Thornton, he was the son of James B. Thornton, ambassador to Peru. After his father died, young Thornton's upbringing was partly taken over by future president Franklin Pierce. Thornton started his navy career in 1841. During the Civil War he served in the successful campaigns against New Orleans, Louisiana, and Vicksburg, Mississippi. At one time he served as executive officer to Read Adm. David G. Farragut. His actions on the *Kearsarge* earned him the Thanks of Congress. He eventually became commander of the *Kearsarge* and at his death ranked as a captain.

516. John Ancrum Winslow (1811–1873) served as the second commander of the *Kearsarge*. Its original captain, Charles Whipple Pickering (1815–1888), was relieved from duty in 1863 for a less-than-vigorous pursuit of Confederate cruisers that wreaked havoc against Union merchant ships. Winslow received the Thanks of Congress and a promotion to commodore for his defeat of the *Alabama*. After the war he advance to rear admiral and head of the Pacific Squadron.

517. Reports of Capt. John A. Winslow and Lt. Cmdr. James S. Thornton, U.S. Navy, of the engagement between the *Kearsarge* and the *Alabama*, ORN I, 3:59–62.

518. Certificates from the New York Chamber of Commerce and the New England Board of Trade. Cushman Papers.

519. Frances Hertzog Bower (1814–1877) had married William J. Cushman (1809–1877) in 1837. William H. Cushman pension record, NARS.

520. *New-York Tribune*, June 24, 1864.

521. Charles M. Rowe pension record, NARS.

522. The navy officer held responsible for the problems with the twenty monitors that composed the *Casco* class was Chief Engineer Albert Crocker Stimers (1827–1876). A career navy man, Stimers supervised construction of the original *Monitor*, accompanied her to Virginia, and was in the turret during the historic duel with the Confederate ironclad *Virginia* at the Battle of Hampton Roads on March 8–9, 1862. The *Casco* controversy tarnished his otherwise brilliant military career.

523. *New-York Tribune*, June 26, 1865.

524. Charles M. Rowe pension record, NARS.

525. Ibid.

526. Ibid.

527. Statement of Nathan E. Hopkins, n.d., Hopkins Papers.

528. Ibid.

529. Bartlett, *History of the Twelfth Regiment*, 152–153.

530. Statement of Nathan E. Hopkins, n.d. Hopkins Papers.

531. Ibid.

532. Ibid.

533. *Press* (Philadelphia), October 24, 1864.

534. Statement of Nathan E. Hopkins, n.d. Hopkins Papers.

535. Ibid.

536. Ibid.

537. Dana, "William Dana Has a Firsthand View."

538. Dana's father, Richard Perkins Dana (1810–1894), was born in Marblehead, Massachusetts. In 1835, he married Juliette Starr, a New York City native. Dana, *A Fashionable Tour*, 2–3.

539. *Reports of Committees…for the Second Session of the Fifty-First Congress*, no. 3275; M. Thompson, *General Orders and Circulars*, 15.

540. Ibid.

541. Ibid.

542. Farragut was especially fond of John Crittenden Watson (1842–1923), who served him as flag lieutenant. Farragut wrote a letter to his son on July 6, 1864, in which he expressed his fears for Watson's safety during the Ivanhoe raid. "It was an anxious night for me; for I am almost as fond of Watson as yourself, and interested in the others." Watson, a native of Kentucky and grandson of noted political figure John J. Crittenden, graduated from the U.S. Naval Academy in 1860. He remained in the navy after the end of the Civil War, and retired as rear admiral in 1904. Farragut, *Life of David Glasgow Farragut*, 403.

543. Reports documenting the "chasing ashore of the steamer *Ivanhoe* at Fort Morgan, June 30, and her destruction by boat expedition, July 6, 1864," *ORN* I, 21:353–357.

544. Dana, "William Dana Has a Firsthand View."

545. Ibid.

546. *Reports of Committees…for the Second Session of the Fifty-First Congress*, no. 3275.

547. New York–born Frances Theodora Smith (1861–1952) remarried six years after Dana died. In 1896 she wed James Russell Parsons, a diplomat who died in a carriage accident in Mexico City in 1905. She wrote several more books during her long life but none as popular as her first. Active in Republican politics and women's suffrage, "Fanny" exchanged many letters with Theodore Roosevelt.

548. *Daily National Intelligencer* (Washington, D.C.), August 30, 1864.

549. New Hampshire–born Tunis Augustus McDonough Craven (1813–1864) began his naval career as a midshipman in 1829 and saw action in the Mexican War. Promoted to the rank of commander in April 1861, he tracked Confederate vessels in European waters and the Mediterranean Sea until he was assigned to the *Tecumseh*. Three military vessels have been named in his honor: a torpedo boat (commissioned in 1900 and decommissioned in 1913) and two destroyers (1918–1945 and 1937–1945).

550. U.S. Census, 1850, 1860.

551. Callahan, *List of Officers of the Navy*, 603.

552. *Boston Evening Transcript*, August 16, 1864.

553. David Glasgow Farragut (1801–1870) achieved hero status for his role in operations that led to the federal occupation of New Orleans and opening up the Mississippi River to Vicksburg in 1862. At Mobile Bay he uttered words that later became paraphrased as "Damn the torpedoes, full speed ahead." Farragut received a promotion to the newly created rank of vice admiral in December 1864. Two years later he advanced to full admiral, the first officer in the U.S. navy to hold this rank.

554. Report of Brig. Gen. Gabriel J. Rains, C.S. Army, and Superintendent of the Torpedo Bureau, *ORN* I, 21:567.

555. *Boston Evening Transcript*, August 15, 1864.

556. *Daily National Intelligencer* (Washington, D.C.), August 30, 1864.

557. Report of acting masters Charles F. Langley and Gardner Cottrell, August 6, 1864, *ORN* I, 21:490–491.

558. Ibid.

559. Ibid.

560. The pilot was John Collins. Craven's last words were popularized after the war. Dwight, "After You!"

561. Report of Adm. David Farragut, U.S. Navy, of the Battle of Mobile Bay, *ORN* I, 21:415–491.

562. James Alden Jr. (1810–1877) of Maine started his navy career as a midshipman in 1828. Promoted to lieutenant in 1841, he served in this capacity during the Mexican War and participated in the capture of Vera Cruz, Tuxpan, and Tabasco. Few navy officers saw as much action as Alden during the Civil War. He participated in operations in the Gulf of Mexico and the Mississippi River. He took charge of the *Brooklyn* in 1863 and went on to perform admirably at Mobile Bay, Alabama, in 1864 and Fort Fisher, North Carolina, in 1865. He remained in the navy after the end of the war and received a promotion to rear admiral in 1871.

563. Report of Capt. James Alden Jr., U.S. Navy, commanding the *Brooklyn*, *ORN* I, 21:445.

564. General Order of Rear Adm. Farragut, U.S. Navy, *ORN* I, 21:438.

565. Report of Lt. and Executive Officer Oliver A. Batcheller of the *Monongahela*, August 6, 1864, *ORN* I, 21:473; abstract log of the *Monongahela*, *ORN* I, 21:829.

566. *Frank Leslie's Illustrated Newspaper*, September 3, 1864.

567. "Obituary: Philip Joseph Langer."

568. U.S. Census, 1860, 1880.

569. Philip J. Langer pension record, NARS.

570. Ibid.

571. Ibid.

572. Farragut acknowledged Buchanan as a worthy foe in his response to a congratulatory letter from the Navy Department: "He, though a rebel and

a traitor to the Government that had raised and educated him, had always been considered one of its ablest officers, and no one knew him better or appreciated his capacity more highly than myself, and, I may add, felt more proud of overcoming him in such a contest." Rear Adm. David Farragut, U.S. Navy, to Secretary of the Navy Gideon Welles acknowledging congratulatory letter from the Navy Department, *ORN* I, 21:544–545.

573. Report of Adm. Franklin Buchanan, commander of the Confederate naval forces at Mobile Bay, August 25, 1864, *ORN* I, 21:577.

574. Philip J. Langer pension record, NARS.

575. "Obituary: Philip Joseph Langer."

576. Philip J. Langer pension record, NARS.

577. Report of Rear Adm. David G. Farragut regarding the Battle of Mobile Bay, *ORN* I, 21:405–406.

578. William Wingood Jr. pension record, NARS.

579. Ibid.

580. Forbes, "From Mobile Bay to Santiago."

581. Abstract log of the *Monongahela*, July 1–August 5, 1864. *ORN* I, 21:831; abstract log of the *Lackawanna*, August 5–23, 1864, *ORN* I, 21:808–809.

582. William Edgar LeRoy (1818–1888) of New York graduated from the U.S. Naval Academy in 1832 and made the navy a career. He served in the Mexican War and by the start of the Civil War had advanced to commander. In this capacity he commanded the *Keystone State* and *Oneida* before taking charge of the *Ossipee*. According to Forbes's biography of Charles Edgar Clark, who served with LeRoy on the *Ossipee*, "Captain Wm. E. LeRoy, because of his bearing and manner, was sometimes spoken of as the Chesterfield of the Navy. When the *Ossipee* was heading for the *Tennessee*, an officer said, 'There goes Lord Chesterfield at him—he is getting ready to apologize now for hitting him so hard.'" Forbes, "From Mobile Bay to Santiago," 81. LeRoy remained in the navy after the war, advanced in rank to rear admiral, and retired in 1880.

583. Abstract log of the *Ossipee*, August 5–23, 1864, *ORN* I, 21:841.

584. William Wingood Jr. pension record, NARS.

585. Ibid.

586. Gott, *History of the Town of Rockport*, 273.

587. William Wingood Jr. pension record, NARS.

588. Brownell graduated from Trinity College in 1841. His uncle, Thomas Church Brownell (1779–1865), founded the institution.

589. *Hartford (Conn.) Daily Courant*, November 8, 1872.

590. *Poems* was published in 1847, and the *People's Book of Ancient and Modern History* in 1851.

591. Charles Dudley Warner (1829–1900) is perhaps best known for *The Gilded Age: A Tale of Today*, which he co-authored with humorist Mark Twain. *Evening Post* (New York City), November 26, 1872.

592. This quote and other notes were written along the margins of a copy of "Bay Fight" published in pamphlet form and presented by Brownell to James C. Palmer (1811–1883). The pamphlet was sold at Cowan's American History Auction on June 13, 2014, Cowan's Auctions. Maryland-born Palmer had started his navy career in 1834, and at the time of the Battle of Mobile Bay served as fleet surgeon to Farragut's Gulf Squadron. Palmer remained in the navy after the war ended, and served as surgeon general of the navy from 1872–1873.

593. Holmes, "Our Battle-Laureate."

594. Palmer's inscribed copy of "Bay Fight," Cowan's Auctions.

595. The year 1864 was a defining one for Brownell. In March, his *Lyrics of a Day: Or Newspaper Poetry* was published in New York. In July, the volume received favorable mention in the *North American Review*, and Brownell was praised as an American original. "In him the nation has found a new poet, vigorous, original, and thoroughly native." Crosby and Ainsworth, "Review: Lyrics of a Day."

596. Ibid.

597. Holmes, "Our Battle-Laureate."

598. Ibid.

599. *Hartford (Conn.) Daily Courant*, November 8, 1872.

600. Ibid.

601. Corp. Rensalaer A. MacArthur served in Company E of the Twenty-eighth Connecticut Infantry. He suffered a wound during the June 14, 1863, assault on Port Hudson and died on July 12, 1863. He was three years older than Freeman.

602. Freeman T. MacArthur pension record, NARS.

603. Ibid.

604. The subordinate officer was James Morris Morgan (1845–1928). Morgan, *Recollections of a Rebel Reefer*, 216.

605. Certificate of honorable dismissal from South Carolina College (to-day the University of South Carolina) issued by President James Henley Thornwell on March 22, 1855, Cenas Family Papers.

606. *ORN* II, 2:47–48.

607. The officer was Acting Master's Mate William A. Abbott. *ORN* II, 3:165.

608. Virginia-born Thomas Triplett Hunter (1813–1872) was a career U.S. navy officer who resigned his commission to serve his home state after the start of the war. He was assigned to several vessels, including the gunboat *Gaines* and the ironclad sloop *Chicora*. He ended the war with the rank of commander and returned to Virginia.

609. Documents related to the court-martial of Hilary Cenas. Subject files of the Confederate States Navy, 1861–1865, NARS.

610. Ibid.

611. Hilary Cenas to his mother, Margaret Octavia Cenas, October 20, 1864, Cenas Family Papers.

612. Brock, "Paroles of the Army of Northern Virginia."

613. *Daily Picayune* (New Orleans, La.), June 29, 1868; Arthur and de Kernion, *Old Families of Louisiana*, 41–42; De Leon, *Belles, Beaux, and Brains*, 298–299.

614. Ibid.

615. Callahan, *List of Officers of the Navy*, 350.

616. Report of Cmdr. Thomas G. Corbin, commanding the *Augusta*, of the cruise of that vessel as convoy to California steamer *North Star*, ORN I, 3:382–383.

617. Ibid.

618. Ibid.

619. Thomas G. Corbin of Virginia (1820–1886) was appointed to the U.S. Naval Academy from Alabama and graduated in 1844. He numbered among the few Southern officers to remain loyal to the Union during the Civil War. He remained in the navy after the end of hostilities and retired with the rank of captain in 1874.

620. Report of Cmdr. Thomas G. Corbin, *ORN* I, 3:382–383.

621. Ibid.

622. *Boston Evening Journal*, October 3, 1877.

623. "1864: James Reid to Susan Jane (Young) Reid."

624. LeRoy Fitch (1835–1875) of Indiana graduated from the U.S. Naval Academy in 1856. Promoted to lieutenant commander in 1862, he ably commanded the U.S. navy district that included the Cumberland River and a section of the Ohio River. Report of Lt. Cmdr. LeRoy Fitch, U.S. Navy, *ORN* I, 26:649–652.

625. "1864: James Reid to Susan Jane (Young) Reid."

626. The family name is also spelled "Reed." U.S. Census, 1860.

627. "1864: James Reid to Susan Jane (Young) Reid."

628. U.S. Census, 1880.

629. A grampus, or Risso's dolphin, typically measures ten feet long. Named for French naturalist Giuseppe Antonio Risso (1777–1845), it is distinguished by a rounded head.

630. A fourth child, daughter Mary Rae, was born June 4, 1864, and died on July 6, 1864.

631. George M. Early pension file, NARS.

632. Instructions from Lt. Cmdr. James A. Greer to Acting Ensign C. W. Litherbury regarding the stripping of vessels purchased for conversion into gunboats, *ORN* I, 26:756.

633. George M. Early pension file, NARS.

634. *Saturday Spectator* (Terre Haute, Ind.), November 18, 1911.

635. Abbott, "Heroic Deeds of Heroic Men."

636. Report of Midshipman Benjamin H. Porter, U.S. Navy, commanding howitzer battery in conjunction with the army, *OR* I, 4:578–579.

637. According to Porter's after-action report, three of his men were killed on Roanoke Island. They were privates John McCoy and John Doyle, both members of Company B, Ninety-ninth New York Infantry, and Pvt. James Herbert, Company C, Ninth New Jersey Infantry, *Daily Evansville (Ind.) Journal*, September 4, 1863.

638. Letter from Rear Adm. Louis M. Goldsborough, U.S. Navy, to Secretary of the Navy Gideon Welles in commendation of Midshipman Benjamin H. Porter's action in command of the howitzer battery in the Battle of Roanoke Island, *OR* I, 4:580.

639. By the end of the Civil War, four of the six sons of James Gurdon Porter (1808–1885) and Sarah Smith Grosvenor Porter (1811–1882) were dead. In addition to the two killed during the war, Benjamin (1844–1865) and Stanley (1842–1862), another two died from other causes: Henry (1839–1861) and Frederick B. (1840–1864). A fifth son, Samuel (1837–1868), died soon after the war. Only one son, steamship captain Seth Grosvenor Porter (1835–1910), survived his parents. The Porters also had three daughters, Lucia Mary (1831–1834), Laura H. (1833–1900), and Maria Grosvenor (1848–after 1893). Andrews, *Descendants of John Porter*, 725.

640. Abbott, "Heroic Deeds of Heroic Men."

641. William Barker Cushing (1842–1874) is best known for leading an October 1864 mission to destroy the Confederate ironclad ram *Albemarle* with a torpedo-tipped spar. Its success made him a national hero and earned him a formal Thanks of Congress. He was two years ahead of Porter at the academy but did not graduate—in 1861 he was expelled during his senior year for poor conduct. He begged his way back into the navy, which desperately needed men and received an appointment as master's mate. During the first attack on Fort Fisher he marked the channel in preparation for navy warships under heavy enemy fire. During the second attack he led a contingent of sailors and Marines from the *Monticello*. He remained in navy after the war and died of illness on active duty. He was one of four brothers who served in the Union military. Alonzo Hersford Cushing (1841–1863) suffered a mortal wound while in command of a battery during Pickett's Charge at the Battle of Gettysburg. He received the Medal of Honor in 2014. Howard Bass Cushing (1838–1871) followed in his brother Alonzo's footsteps as an artilleryman and after the war served in the U.S. cavalry. He was killed during a campaign against the Apache Indians in Arizona Territory. Milton Buckingham Cushing Jr. (1837–1887) served as an assistant paymaster during the war. He retired as a full paymaster in 1882.

642. Abbott, "Heroic Deeds of Heroic Men."

643. Ibid.

644. A study of genealogical records on Ancestry.com finds that the common ancestor shared by Rear Adm. David D. Porter and Lt. Benjamin H.

Porter is John Porter (1594–1648) of the English village of Felsted, northeast of London. One of his sons, also named John Porter (1622–1688), is directly connected to David D. Porter. Another son, Samuel Porter (1635–1689), is directly connected to Benjamin H. Porter.

645. Samuel William Preston (1840–1865) was born in Canada to parents who had lived there temporarily. They eventually returned to their permanent home in Illinois, from which state Preston was appointed in 1858 to the Naval Academy. He stood first in his class at the start of the war and with Porter and other acting midshipmen were activated to regular duty. He went on the serve as staff officers to rear admirals Samuel F. Du Pont and John A. Dahlgren. Preston's death was reported extensively in newspapers immediately following the capture of Fort Fisher. The January 19, 1865, issue of the *Philadelphia Inquirer* mentioned his relationship with Porter: "Their friendship, a very warm one, was begotten in danger. Together they braved the iron storm of the batteries in Charleston harbor. Together they went on the storming party against Sumter. Together they were taken prisoners. Together they were released. Together they were assigned to Admiral Porter's fleet. Together they charged in the gallant and dashing assault of yesterday, and in death they were not divided."

646. Abbott, "Heroic Deeds of Heroic Men."

647. Kidder Randolph Breese (1831–1881) of Pennsylvania began his navy career as a midshipman in 1846. He graduated from the Naval Academy in 1852 and participated in Cmdr. Matthew C. Perry's expedition to Japan in 1852–1855. During the Civil War, he participated in many of the navy's most significant events, including the *Trent* Affair in 1861, the 1862 capture of New Orleans, and the 1863 Siege of Vicksburg. He remained in the navy after the war ended and died on active duty with the rank of captain.

648. Abbott, "Heroic Deeds of Heroic Men."

649. Ibid.

650. John Russell Bartlett (1843–1904) of New York entered the academy at the same time as Porter. Activated to regular duty along with Porter and other acting midshipmen, Bartlett was sent to the Gulf of Mexico, where he participated in the capture of New Orleans, and then on to the Mississippi River and operations against Vicksburg. He remained in the navy after the war ended and was later celebrated as an oceanographer. He was one of the cofounders of the National Geographic Society in 1888. He ended his navy service as a captain. Lt. John Bartlett, U.S. Navy, to his sisters, January 18, 1865, *ORN* I, 11:526–529.

651. Report of Capt. Kidder R. Breese. ORN I, 11:449.

652. Abbott, "Heroic Deeds of Heroic Men."

653. Stanley Porter (1842–1862), enlisted as a private in Company D of the Twenty-first New York Infantry in May 1861 at Buffalo for a two-year term. He was later transferred to Company I and promoted to corporal. He served at this rank during the Second Battle of Bull Run.

654. Abram Davis Harrell (died 1871) started his career as a midshipman in 1834. He left the navy as a lieutenant in 1855 and rejoined with a commission as commander in 1862. The *Kearsarge* was his last command before he retired in 1867.

655. Surg. Benjamin Vreeland of New York joined the navy as an assistant surgeon in 1850, the same year he joined the Grinnell Expedition, which attempted without success to find a missing group of 128 British explorers led by Sir John Franklin. Vreeland advanced to surgeon in April 1861. In 1863 he was named to a board of naval surgeons to examine candidates for admission into the medical corps of the navy. Finnell and Eliot, "Benjamin Vreeland"; *New York Herald*, May 11, 1866.

656. *New York Herald*, May 11, 1866.

657. William H. Sluman pension record, NARS.

658. According to his pension file, Ezra Mace Leonard (1823–1870) joined the navy as an acting master in 1861. He served as an acting lieutenant when in command of the *Carrabasset*. Leonard remained in the volunteer navy until 1868, when he became a regular. He died two years later after a bout with malaria while serving on the *Nyack*, one of the vessels that participated in the Darien Expedition. The purpose of the expedition was to survey the Isthmus of Darien, also known as the Isthmus of Panama, which today includes the Panama Canal. Leonard ranked as a lieutenant at the time of his death. Report of Acting Lt. Ezra M. Leonard, U.S. Navy. *ORN* I, 22:116.

659. U.S. Census, 1860; *Middleboro (Mass.) Gazette*, May 15, 1914.

660. Hanson, *History of the Old Towns Norridgewock and Canaan*, 74.

661. Report of Simon Jones, colonel of the Ninety-third U.S. Colored Infantry and post commander at Brashear City, Louisiana, *OR* I, vol. 48, pt. 1: 146–147.

662. Ibid.

663. Ibid.

664. Ibid.

665. Delano, *The Genealogy History and Alliances of the American House of Delano*, 459; *Middleboro (Mass.) Gazette*, May 15, 1914.

666. Report of Capt. Thomas J. Page of the readiness of the *Stonewall* for departure from Ferrol, Spain, *ORN* I, 3:741.

667. Page expanded on his notes of the expedition, which lasted from 1853 to 1856, in *La Plata, the Argentine Confederation, and Paraguay*, published in 1859.

668. Quote from an obituary first published in the London *Times*, reprinted in the Portland *Oregonian*, December 1, 1899.

669. John Page (1743–1808) graduated with Jefferson from the College of William and Mary. He served as a colonel of Gloucester County militia during the Revolutionary War and after the establishment of the United States became a member of the First U.S. Congress. He ultimately served

four terms in Congress, and went on the serve as the thirteenth governor of Virginia. Gov. Page's son, Mann Page (1766–1813), was Page's father.

670. Thomas Nelson Jr. (1738–1789) represented Virginia in the Continental Congress and followed Thomas Jefferson as governor of Virginia. He also served as a militia general during the American Revolution. During the Siege of Yorktown, British Gen. Cornwallis occupied Nelson's home. Legend has it that Nelson ordered the artillery he commanded to fire on his own house and reportedly offered five guineas to the first gunner who hit it. Nelson's daughter, Elizabeth (1770–1853), was Page's mother. She married Mann Page in 1788.

671. Extracts from the Journal of the Virginia State Convention of 1861. *OR* I, vol. 51, pt. 2: 423.

672. Letter from Cmdr. John S. Missroon, U.S. Navy, to Maj. Gen. George B. McClellan, U.S. Army, regarding the battery on Gloucester Point, *ORN* I, 7:234–235.

673. Flag Officer Samuel Barron, C.S. Navy, to Stephen R. Mallory, Secretary of the Confederate Navy, May 12, 1864, *ORN* II, 2:652–653.

674. The *Stonewall* was constructed in secret for the Confederate government by shipbuilder Lucien Arman in Bordeaux, France, during 1863–1864. Rumors spread that she was destined for the Egyptian navy as the *Sphinx*. But U.S. diplomats discovered the truth and protested to French authorities, who then refused to allow the Confederates to take possession. Denmark, engaged in the Schleswig-Holstein War at the time, negotiated via a Swedish intermediary to purchase the ship. The deal fell apart after the abrupt end of their war. The Danes refused to accept the vessel, now officially known as the *Stærkodder*, returning the title to Arman. By this time the warship had arrived in Copenhagen. Arman then sold her to the Confederates.

675. Born in Washington, D.C., Thomas Tingey Craven (1808–1887) served with distinction in several stations before the war, including two stints as commandant of midshipmen at the U.S. Naval Academy. In 1861 he received a promotion to captain and the following year commanded the *Brooklyn* during the capture of New Orleans. He advanced to the rank of commodore in 1862 and command of the *Niagara* in 1863. His court-martial, convened in November 1865, was on a single charge: "Failing to do his utmost to overtake and capture or destroy a vessel which it was his duty to encounter." The court found him guilty but disputed the wording of the original charge and sentenced him to a lesser punishment of suspension, which was generally considered no more than a slap on the wrist by Secretary Welles, who believed the charge was a death penalty offense. "The Department is therefore forced to conclude that in awarding this pretended punishment the court-martial which tried Commodore Craven has disregarded the law," Welles noted in a statement dated December 6, 1865. Citing confusion in the decision by the court that made it impossible to judge guilt from innocence, Welles declared

a mistrial and released Craven from his punishment. Craven was promoted to rear admiral in 1866 and retired three years later.

676. Report of Cmdr. Thomas T. Craven, U.S. Navy, commanding the Niagara, regarding the movements of the *Stonewall*, *ORN* I, 3:434–436.

677. Letter from Capt. Thomas J. Page, C.S. Navy, to Cmdr. James D. Bulloch, regarding repairs to the *Stonewall*, *ORN* I, 3:737.

678. The Spanish ship was reportedly the steam frigate *Conception*. Letter from Capt. Thomas J. Page, C.S. Navy, to Cmdr. James D. Bulloch, regarding the condition of affairs of the *Stonewall*, *ORN* I, 3:741–743.

679. Ibid.

680. Report of Cmdr. Thomas T. Craven, U.S. Navy, commanding the *Niagara*, regarding the movements of the *Stonewall*, *ORN* I, 3:461–462.

681. Cmdr. Thomas T. Craven, U.S. Navy, to Horatio J. Perry, American chargé d'affaires in Madrid, March 25, 1865, *ORN* I, 3:467.

682. Ibid.

683. Page had been initially ordered to disrupt Union operations at Wilmington, North Carolina, then to menace New England fishing boats or mail steamers en route from California. The plan was later revised to go to Port Royal via Bermuda, where funds were waiting for him. But weather and the seaworthiness of the *Stonewall* prompted Page to alter his plan and go to Nassau instead of Bermuda.

684. Report of Capt. Charles S. Boggs, U.S. Navy, commanding the *Connecticut*, regarding the surrender of the *Stonewall*, *ORN* I, 3:520–521.

685. Page, *Genealogy of the Page Family*, 92–94; *Oregonian* (Portland), December 1, 1899.

686. Edward R. Archer to his sister, July 30, 1865, Archer Papers; Rahm, *Reminiscences of His Capture*, 33–34.

687. Rahm, *Reminiscences of His Capture*, 33–34.

688. According to military records, Archer (incorrectly listed as Edward K. Archer) served as third assistant engineer on the frigates *Roanoke* and *Powhatan* from June 26, 1856, to November 3, 1860.

689. Letter of endorsement from J. R. Anderson & Co., Tredegar Iron Works, August 25, 1863, Archer Papers.

690. Born in Norfolk, Virginia, Robert Archer (1794–1877) started his career as an army physician at Fortress Monroe, Virginia. In 1839 he left the army and after a stint as a farmer moved to Richmond and became an iron manufacturer in partnership with his son Robert. Their company merged with Tredegar in 1859. Joseph Reid Anderson (1813–1892) wed Robert Archer's daughter Sarah Eliza "Sally" Archer. An 1836 graduate of West Point, Anderson resigned his commission after he married in 1837. Four years later he joined Tredegar and rose to become its president and one of Virginia's most prominent industrialists. He was absent from Tredegar from September 1861 to July 1862 while he served as brigadier general in the Confederate army. He commanded the District of Cape Fear in North

Carolina through the spring of 1862, during which time he briefly presided over the Department of North Carolina. He went on to command a brigade during the Peninsula Campaign and suffered a slight wound in the face during the Seven Days' Battles. He returned to his position at Tredegar after he resigned his commission and remained with the firm until his death.

691. State of Virginia, *Acts of the General Assembly*, 38–39.

692. Case notes of the *Hawk*, in *Index to the Executive Documents*, 155–166.

693. Edward R. Archer to Samuel J. Harrison, June 30, 1864, Archer Papers.

694. Rahm, *Reminiscences of His Capture*, 25.

695. Ibid., 42.

696. Ibid., 43.

697. Edward R. Archer to Mr. Newcomb, May 25, 1865, Archer Papers.

698. Ibid.

699. Mansfield, *History of the Great Lakes*, 2:306–309.

700. I have been unable to find any record of O. E. Pierce in navy or army records. W. Beach, *First New York (Lincoln) Cavalry*, 491–493.

701. Ibid.

702. Ibid.

703. Accounts differ as to which side the guns were moved. Pierce notes that they were moved to starboard. Foster recalled that they were moved to port. But both men agree that they were moved to provide lift for the *Perry*.

704. W. Beach, *First New York (Lincoln) Cavalry*, 491–493.

705. Commandery of the State of Wisconsin, *War Papers, Vol. IV*, p. 478.

706. W. Beach, *First New York (Lincoln) Cavalry*, 491–493.

707. Ibid.

708. Ibid.

709. Commandery of the State of Wisconsin, Military Order of the Loyal Legion of the United States, *War Papers*, 478.

710. "Captain Amos P. Foster," 1–2.

711. *New York Herald*, May 7, 1865.

712. Ibid.

713. Thomas Armstrong pension record, NARS.

714. *New York Herald*, May 7, 1865.

715. Report of Allan Pinkerton, *OR* I, vol. 48, pt. 1: 203–205; *New York Herald*, May 7, 1865.

716. *New York Times*, May 3, 1865.

717. Charles William Read (1840–1890) of Mississippi graduated in 1860 from the U.S. Naval Academy. In 1862, he accepted a commission in the Confederate navy. Nicknamed "Savvy" of "Savez," Read is perhaps best known for a daring 1863 raid along the East Coast that resulted in the capture of twenty-two Union vessels. The raid ended on June 27, 1863, when he and his crew were captured off the coast of Portland, Maine. Read was imprisoned,

and gained his release in October 1864. He returned to active duty, and took command of the *Webb* on April 22, 1865. He left on the evening of the 23rd to run the defenses of New Orleans and grounded the ship the next day.

718. Thomas Armstrong pension record, NARS.

719. The landsman was Patrick McGrath. Court of Inquiry report of the sinking of the *Harvest Moon*, April 27, 1865, Records of General Courts-Martial.

720. The dead sailor was Ward Room Steward John Hazzard, an African American. He was thrown overboard by the force of the explosion and drowned.

721. U.S. Census, 1860; Charles A. Cable pension record, NARS.

722. John Adolph Dahlgren (1809–1870) of Pennsylvania, who started his navy service as a midshipman in 1826, is perhaps best known for the rifled cannon that bears his name. The Dahlgren gun, with its distinctive curved shape, was popular during the Civil War. An ordnance officer for a significant part of his career, he was named commander of the South Atlantic Blockade Squadron in July 1863 and served in this capacity until the end of the war. His son, Col. Ulric Dahlgren, was killed in January 1864 during the ill-fated Kilpatrick-Dahlgren raid on Richmond. Papers reportedly found on his body contained instructions to kill Jefferson Davis and his cabinet, and they stirred an enormous controversy in the North and South.

723. Charles A. Cable pension record, NARS.

724. Ibid.

725. Benjamin Franklin Sands (1811–1883) of Baltimore, Maryland, began his naval career as a midshipman in 1828. He was extremely familiar with the Gulf of Mexico, having surveyed the coast in the 1850s. Prior to his service in the West Gulf Squadron during the Civil War, he had served in the North Atlantic Blockading Squadron as captain of the *Dacotah* and *Fort Jackson*. As commander of the latter vessel, he participated in the attacks on Fort Fisher, North Carolina, in December 1864 and January 1865. He moved to the Gulf in February 1865. He continued in the navy after the war, served a stint as superintendent of the Naval Observatory in Washington, D.C., and retired in 1874 as a rear admiral.

726. The order to dispatch a "fast vessel" to carry the Confederates was issued by Acting Rear Adm. Henry Knox Thatcher who commanded the West Gulf Squadron. Note from Henry K. Thatcher to Maj. Gen. Edward R. S. Canby, commander of the Union army and Division of West Mississippi, May 26, 1865, *OR* I, vol. 48, pt. 2: 603.

727. Samuel Tiller Reeves is not to be confused with Samuel J. Reeves, who became president of the company from 1871 to 1878. Pennypacker, *Annals of Phoenixville and Its Vicinity*, 169–172.

728. The Phoenix Iron Works manufactured a popular rifled cannon that came to be known as the "Griffen gun" after inventor John Griffen. The cannon are branded "P. I. Co." Ibid.

729. Connecticut-born and Yale-educated physician Ashbel Smith (1805–1886) established a successful medical practice in North Carolina before he relocated to the Republic of Texas in 1836. Smith befriended Sam Houston, who took note of the doctor's abilities as a diplomat. Smith went on to serve on various missions, as well as in military roles, during the early years of the Republic and state.

730. William Pitt Ballinger (1025–1888) of Kentucky moved to Texas in 1843 and settled in Galveston. He became a prominent lawyer and served as U.S. district attorney for Texas from 1850 to 1854.

731. Col. Ashbel Smith, C.S.A., to Maj. Gen. Edward R. S. Canby, May 29, 1865, *OR* I, vol. 58, pt. 2: 648–649.

732. *New York Times*, June 11, 1865.

733. John Bankhead Magruder (1810–1871) of Virginia graduated from West Point in 1830. Nicknamed "Prince John" for his courtly manners, he resigned from the U.S. Army in 1861 and immediately enlisted in the Confederate cause. He is perhaps best known for leading his forces to victory at the Battle of Big Bethel on June 10, 1861, and for resisting Union Maj. Gen. George B. McClellan's failed Peninsular Campaign in 1862. Later that year he was dispatched to Texas, where he remained until the cessation of hostilities.

734. The crew of the *Antona* escorted several Confederate officers, including members of Maj. Gen. Magruder's staff, out of Texas in early June. The *New-Orleans Times* published this news on June 15, 1865. The report also listed the officers of the *Antona* but did not include Reeves. The cause of his absence is not known.

735. Abstract of the log of the *Shenandoah*, Lt. James I. Waddell commanding, *ORN* I, 3:792.

736. Letter from U.S. Secretary of the Navy Gideon Welles to Allan McLane, president of the Pacific Mail Steamship Company, March 20, 1865, *ORN* I, 3:459.

737. U.S. Naval Academy Registers of Delinquencies, Vol. 356 (1861–1862): 154–155.

738. Ibid.

739. William H. Mott pension record, NARS.

740. On the following day, July 30, 1865, another U.S. warship, the *Suwanee*, was dispatched to assist in the hunt for the *Shenandoah*. Report of Acting Rear-Adm. George F. Pearson, U.S. navy, commanding the Pacific Squadron, *ORN* I, 3:577.

741. *New York Herald*, December 20, 1865.

742. William H. Mott pension record, NARS.

743. Abstract of the log of the *Shenandoah*, Lt. James I. Waddell commanding, *ORN* I, 3:792.

744. *Brooklyn Daily Eagle*, January 23, 1904.

745. Extracts of notes from Cmdr. James Iredell Waddell, commander of the *Shenandoah*, *ORN* I, 3:832.

746. Harris and Harris, *The Voyage of the CSS* Shenandoah, 182–183.

747. Whittle, "Cruise of the Confederate States' Steamer *Nashville*."

748. Whittle, *Cruises of the Confederate States Steamers* Shenandoah *and* Nashville, 32.

749. Louis Malesherbes Goldsborough (1805–1877) served as captain and flag officer of the North Atlantic Blockade Squadron at the time of Whittle's daring escape. Goldsborough had received commanded of the Atlantic Blockading Squadron in September 1861. One month later the sector was subdivided: Goldsborough commanded the northern half and Samuel F. Du Pont the southern half. Goldsborough, who had started his navy career in 1812, served prior to the war in various stations, including a stint as superintendent of the Naval Academy. His claim to fame during the Civil War was participating with Maj. Gen. Ambrose Burnside in amphibious operations against Confederate forces along the North Carolina coast in 1862. In subsequent campaigns Goldsborough adopted a cautious approach that ultimately led to criticisms prompting his request to be relieved of duty. He was promoted to rear admiral in July 1862 and relinquished command of the North Atlantic Squadron soon afterwards. He served the reminder of the war in an administrative capacity in Washington, D.C. Goldsborough continued in the navy after the end of hostilities and retired in 1873.

750. Letter from assistant secretary of the navy Gustavus Vasa Fox to Flag Officer Louis M. Goldsborough, regarding the feeling excited by the escape of the steamer *Nashville*, *ORN* I, 7:139.

751. James Dunwoody Bulloch (1823–1901) details his activities and those of the Confederate and U.S. governments in his two-volume memoirs, *Secret Service of the Confederate States in Europe* (1883). Born in Georgia, this former lieutenant in the U.S. Navy became the Confederacy's naval agent in Europe. His half-sister, Martha Bulloch, was the mother of future president Theodore Roosevelt.

752. North Carolina–born James Iredell Waddell (1824–1886) graduated from the U.S. Naval Academy in 1847 and resigned his commission in late 1861. His stint as commander of the *Shenandoah* marked the apex of his Confederate naval career. After the war he worked for Pacific mail service and the Maryland fishery fleet.

753. Instructions from Cmdr. James D. Bulloch to Lt. James I. Waddell, *ORN* I, 3:749–755.

754. Harris and Harris, *The Voyage of the CSS* Shenandoah, 53–54.

755. Ibid., 55–57.

756. Ibid., 136–137.

757. Whittle has two separate entries for June 22, 1865. A note in the *Official Records* provides a succinct explanation: "Navigators in crossing the Pacific Ocean on an easterly course repeat the day on which they cross the one hundred eightieth degree of longitude," also known as the Interna-

tional Date Line. *ORN* I, 3:790; Harris and Harris, *The Voyage of the CSS Shenandoah*, 165–166.

758. Harris and Harris, *The Voyage of the CSS Shenandoah*, 182–183.

759. Louis Malesherbes Goldsborough (1805–1877) of Washington, D.C., the son of the chief clerk of the Navy Department, "early manifested a predilection for the sea, for in 1812, at the breaking out of the war with Great Britain— being then seven years of age—he waited upon the Hon. Paul Hamilton, the Secretary of the Navy, and solicited from him an appointment as midshipman. Without the aid of even the knowledge of his father he received it, his warrant bearing the date June 18, 1812—the very day on which war was declared. The exultation and triumph with which he bore home the evidence of his appointment is well remembered," reported the *New York Herald* in his obituary on February 21, 1877. Goldsborough did not officially begin his navy career until 1817, and from that time on steadily rose through the ranks to captain by the start of the Civil War. He was named commander of the Atlantic Blockading Squadron in 1861. After the squadron was subdivided into two sections he took charge of the northern half. In this capacity Goldsborough participated in successful operations along the North Carolina coast in coordination with ground forces commanded by Brig. Gen. Ambrose Burnside in early 1862. Later that year, during the Peninsula Campaign, Goldsborough exhibited excessive caution. He was promoted to rear admiral and sent to Washington, where he served in an administrative capacity for the reminder of the war. Afterwards he resumed active duty as commander of the European fleet. Goldsborough retired in 1873.

760. Drury, *History of the Chaplain Corps*, 101.

761. George Smith Blake (1802–1871) served as superintendent of the Naval Academy from 1857 to 1865, and under his direction the institution was relocated from Annapolis, Maryland, to Newport, Rhode Island, for the war's duration. Blake is credited with saving the venerable frigate *Constitution*, which at the start of the war was used as a training ship by midshipman, from falling into Confederate hands. Blake began his navy career in 1818 and served in various capacities during his four decades in the service.

762. Thompson and Wainwright, *Confidential Correspondence of Gustavus Vasa Fox*, 389, 392.

763. According to the April 1859 issue of *Godey's Lady's Book*, "About four years ago, Mr. Thomas K. Conrad presented to the University of Pennsylvania a facsimile of the Rosetta Stone. This was the talisman that called Young America—literally the young—into the hieroglyphic battle. One of the College societies chose three of its members—Charles R. Hale, S. Huntington Jones, and Henry Morton—to prepare the report."

764. Wright and Kasinec, "Charles Hale and the Russian Church."

765. *Illinois State Journal* (Springfield), December 26, 1900.

766. *Illinois State Journal* (Springfield), April 5, 1901.

767. Proceedings of the General Court Martial of Sylvanus Backus, May 7, 1866, Records of General Courts-Martial.

768. James William Augustus Nicholson (1821–1887) of Massachusetts, the son and grandson of navy officers, began his navy career as a midshipman in 1838. During the Civil War, he was commended for his actions as commander of the monitor *Manhattan* during the 1864 Battle of Mobile Bay. Nicholson remained in the navy after the end of the war and retired as a rear admiral in 1883.

769. Proceedings of the General Court Martial of Sylvanus Backus, May 7, 1866, Records of General Courts-Martial.

770. Sylvanus Backus pension record, NARS.

771. Proceedings of the General Court Martial of Sylvanus Backus, May 7, 1866, Records of General Courts-Martial.

772. Ibid.

773. Sylvanus Backus pension record, NARS.

774. *Middlebury (Vt.) Register*, June 29, 1869.

775. Lucina Miller (1810–1883) of Sudbury, Vermont, married William Flagg (1804–1854) of South Brimfield, Massachusetts, on September 26, 1836, in Rutland, Vermont. U.S. Census 1850, 1860; George N. Flagg pension file, NARS.

776. *Middlebury (Vt.) Register*, June 29, 1869.

777. The unhealthy season extended from late May until the last of November. U.S. Navy Department, *Medical Essays*, 213–227.

778. The West India Squadron included six vessels: the *Albany, Gettysburg, Narragansett, Penobscot, Saratoga,* and *Yantic*.

779. *Middlebury (Vt.) Register*, June 29, 1869.

780. Ibid.

781. Report of the Secretary of the Navy, July 4, 1861, *Executive and Miscellaneous Documents*, 93–94.

782. Hamersly, *Records of Living Officers*, 162.

783. Report of the Secretary of the Navy, July 4, 1861, *Executive and Miscellaneous Documents*, 41–43.

784. *New York Herald*, March 2, 1895.

785. *Evening Star* (Washington, D.C.), February 3, 1912.

References

Books and Unpublished Manuscripts

Andrews, Henry P. *Descendants of John Porter of Windsor, Conn., Vol. I.* Saratoga Springs, N.Y.: G. W. Ball, Book and Job Printer, 1893.

Arthur, Stanley C., and de Kernion, George C. H., eds. *Old Families of Louisiana*. Baltimore, Md.: Genealogical Publishing Co., 1999.

Barrows, Frederic I., ed. *History of Fayette County, Indiana: Her People, Industries and Institutions*. Indianapolis, Ind.: B. F. Bowen & Co., 1917.

Bartlett, Asa W. *History of the Twelfth Regiment New Hampshire Volunteers in the War of the Rebellion*. Concord, N.H.: Ira C. Evans, Printer, 1897.

Beach, Edward L. *From Annapolis to Scapa Flow: The Autobiography of Edward L. Beach Sr.* Annapolis, Md.: U.S. Naval Institute Press, 2003.

Beach, William H. *First New York (Lincoln) Cavalry*. New York: Lincoln Cavalry Association, 1902.

Biographical Sketches of Representative Citizens of the Commonwealth of Massachusetts. Boston: Graves & Steinbarger, 1901.

Boatner, Mark M., III. *The Civil War Dictionary*. New York: David McKay Co., 1962.

Callahan, Edward E., ed. *List of Officers of the Navy of the United States and of the Marine Corps from 1775 to 1900*. New York: L. R. Hamersly & Co., 1901.

Campbell, R. Thomas, ed. *Confederate Naval Cadet: The Diary and Letters of Midshipman Hubbard T. Minor, with a History of the Confederate Naval Academy*. Jefferson, N.C.: McFarland & Co., 2007.

Clark, George E. *Seven Years of a Sailor's Life*. Boston: Adams & Co., 1867.

Commandery of the State of Wisconsin, Military Order of the Loyal Legion of the United States. *War Papers, Vol. IV*. Milwaukee, Wis.: Burdick & Allen, 1914.

Dana, David T. III. *A Fashionable Tour through the Great Lakes and Upper Mississippi: The 1852 Journal of Juliette Starr Dana*. Detroit, Mich.: Wayne State University Press, 2004.

Davis, Charles E. *Three Years in the Army: The Story of the Thirteenth Massachusetts Volunteers.* Boston: Estes & Lauriat, 1894.

DeBruyne, Nese F., and Anne Leland. "American War and Military Operations Casualties: Lists and Statistics." Congressional Research Service report. January 2, 2015.

Delano, Joel A. *The Genealogy History and Alliances of the American House of Delano, 1621 to 1899, Part IV–VI.* New York: n.p., 1899.

De Leon, Thomas C. *Belles, Beaux, and Brains of the 60's.* New York: G. W. Dillingham Co., 1909.

Dewey, George. *Autobiography of George Dewey: Admiral of the Navy.* New York: Charles Scribner's Sons, 1913.

Dorman, Franklin A. *Twenty Families of Color in Massachusetts 1742–1998.* Boston: New England Historic Genealogical Society, 2010.

Drury, Clifford M. *History of the Chaplain Corps, United States Navy, Vol. 1.* Washington, D.C.: U.S. Bureau of Navy Personnel, 1948.

Du Bois, William E. *Bi-centenary Reunion of the Descendants of Louis and Jacques Du Bois.* Philadelphia: Press of Rue & Jones, 1876.

Duyckinck, Evert A. *National History of the War for the Union: Civil, Military and Naval, Vol. II.* New York: Johnson, Fry & Co., 1861.

Earle, Ralph. *Life at the U.S. Naval Academy: The Making of the American Naval Officer.* New York: G. P. Putnam's Sons, 1917.

Executive and Miscellaneous Documents and Reports of Committees, First Session of the Thirty-Seventh Congress, 1861. Washington, D.C.: Government Printing Office, 1861.

Farragut, Loyall. *Life of David Glasgow Farragut, First Admiral of the United States Navy.* New York: D. Appleton & Co., 1879.

Gillmore, Quincy A. *Supplementary Report to Engineer and Artillery Operations against the Defences of Charleston Harbor in 1863.* New York: D. Van Nostrand, 1868.

Gott, Lemuel. *History of the Town of Rockport.* Rockport, Mass.: Rockport Review Office, 1888.

Guinn, James M. *History of the State of California and Biographical Record of Oakland and Environs.* Los Angeles: Historic Record Co., 1907.

Hall, Asaph. *Biographical Memoir of John Rodgers, 1812–1882.* Washington, D.C.: Press of Judd & Detweiler, 1906.

Hamersly, Lewis R. *Records of Living Officers of the U.S. Navy and Marine Corps.* Philadelphia: J. B. Lippincott & Co., 1870.

———. *Records of Living Officers of the U.S. Navy and Marine Corps.* 5th ed. Philadelphia: L. R. Hamersly & Co., 1894.

Hannavy, John, ed. *Encyclopedia of Nineteenth-Century Photography, Vol. 1.* New York: Routledge, 2008.

Hanson, John W. *History of the Old Towns Norridgewock and Canaan, Comprising Norridgewock, Canaan, Starks, Skowhegan, and Bloom-field, from Their Early Settlement to the Year 1849*. Boston: Coolidge & Wiley, 1849.

Harris, Alan, and Anne B. Harris, eds. *The Voyage of the CSS* Shenandoah: *A Memorable Cruise*. Tuscaloosa: University of Alabama Press, 2005.

Hodgkins, Howard L. *Historical Catalogue of the Officers and Graduates of The Columbian University, Washington, D.C., 1821–1891*. Washington, D.C.: Byron S. Adams, Printer, 1891.

Hodsdon, John L. *Annual Report of the Adjutant General of the State of Maine for the Year Ending December 31, 1863*. Augusta, Me.: Stevens & Sayward, Printers to the State, 1863.

Holland, Rupert S., ed. *Letters and Diary of Laura M. Towne, Written from the Sea Islands of South Carolina, 1862–1884*. Cambridge, Mass.: Riverside Press, 1912.

Hughes, Nathaniel C., Jr. *Yale's Confederates: A Biographical Dictionary*. Knoxville: University of Tennessee Press, 2008.

Index to Reports of Committees of the House of Representatives for the Second Session of the Forty-Third Congress 1874–'75. Washington, D.C.: Government Printing Office, 1875.

Index to the Executive Documents, Printed by Order of the Senate, for the First Session of the Forty-First Congress of the United States of America, 1869. Washington, D.C.: Government Printing Office, 1869.

Index to the Reports of Committees of the House of Representatives for the First and Second Session of the Forty-Fifth Congress, 1877–'78. Washington, D.C.: Government Printing Office, 1878.

Index to the Reports of Committees of the House of Representatives for the First Session of the Forty-Seventh Congress 1881–'82. Washington, D.C.: Government Printing Office, 1882.

Johnson, John. *Defense of Charleston Harbor, Including Fort Sumter and the Adjacent Islands, 1863–1865*. Charleston, S.C.: Walker, Evans & Cogswell Co., 1890.

Johnson, Robert U., and Clarence C. Buel, eds. *Battles and Leaders of the Civil War, Vol. I*. New York: Century Co., 1887.

Lichliter, Assélia S. *Pioneering with the Beville and Related Families in South Carolina, Georgia, and Florida: Their Lives, Times, and Descendants*. Washington, D.C.: n.p., 1982.

Littell, Eliakim. *Littell's Living Age*. Boston: Littell, Son, & Co., 1862.

Little, George T., ed., *Genealogical and Family History of the State of Maine*. New York: Lewis Historical Publishing Company, 1909.

Mansfield, John B. ed. *History of the Great Lakes*. Chicago: J. H. Beers & Co., 1899.

McCabe, James D., Jr. *The Grayjackets: And How They Lived, Fought, and Died, for Dixie*. Richmond, Va.: Jones Brothers & Co., 1867.

McClellan, George B. *McClellan's Own Story*. New York: Charles L. Webster & Co., 1887.

McPherson, James M., and Patricia R. McPherson. *Lamson of the Gettysburg: The Civil War Letters of Roswell H. Lamson, U.S. Navy*. New York: Oxford University Press, 1997.

Morgan, James M. *Recollections of a Rebel Reefer*. Boston: Houghton Mifflin Co., 1917.

Morrison, John H. *History of New York Ship Yards*. New York: Press of Wm. F. Sametz & Son, 1909.

Obituary Record of Graduates of Yale University Deceased during the Academic Year Ending in June 1902. New Haven, CT: Yale University, 1902.

Office of the Adjutant General. *Record of Officers and Men of New Jersey in the Civil War, 1861–1865, Vol. I*. Trenton, N.J.: John L. Murphy, Steam Book & Job Printer, 1876.

Page, Richard C. M *Genealogy of the Page Family in America*. New York: Press of the Publishers' Printing Co., 1893.

Pennypacker, Samuel W. *Annals of Phoenixville and Its Vicinity: From the Settlement to the Year 1871*. Philadelphia: Bavis & Pennypacker, Printers, 1872.

Porter, David D. *Naval History of the Civil War*. New York: Sherman Publishing Co., 1886.

Porter, John W. H. *A Record of Events in Norfolk County, Virginia, from April 19th, 1861, to May 10th, 1862, with a History of the Soldiers and Sailors of Norfolk County, Norfolk City and Portsmouth Who Served in the Confederate States Army or Navy*. Portsmouth, Va.: W. A. Fiske, Printer and Bookbinder, 1892.

Prince, Benjamin F. *A Standard History of Springfield and Clark County, Ohio, Vol. II*. Chicago: American Historical Society, 1922.

Rahm, Frank H. *Reminiscences of His Capture and Escape from Prison and Adventures within the Federal Lines by a Member of Mosby's Command, with a Narrative by a C.S. Naval Officer*. Richmond, Va.: Daniel Murphy, Printer, 1895.

Raymond, Samuel. *Record of Andover during the Rebellion*. Andover, Mass.: Warren F. Draper, Printer, 1875.

Remey, Charles M. *Life and Letters of Rear Admiral George Collier Remey United States Navy*. N.p.: n.p., 1939.

Report of the Secretary of the Navy; Being Part of the Message and Documents Communicated to the Two Houses of Congress at the Beginning

of the First Session of the Fifty-Fourth Congress. Washington, D.C.: Government Printing Office, 1895.

Reports of Committees of the Senate of the United States for the Second Session of the Fifty-First Congress, 1890–'91. Washington, D.C.: Government Printing Office, 1891.

Reports of Committees of the Senate of the United States for the Third Session of the Forty-Fifth Congress, 1878–'79. Washington, D.C.: Government Printing Office, 1879.

Rochelle, James H. *Life of Rear Admiral John Randolph Tucker.* Washington, D.C.: Neale Publishing Co., 1903.

Rockel, William M, ed. *20th-Century History of Springfield, and Clark County, Ohio and Representative Citizens.* Chicago: Biographical Publishing Co., 1908.

Rockwell, William S. *Oglethorpe Light Infantry of Savannah, in Peace and in War.* Savannah, Ga.: J. H. Estill, 1894.

Roe, Alfred S. *History of the First Regiment of Heavy Artillery, Massachusetts Volunteers.* Worcester, Mass.: Commonwealth Press Printers, 1917.

Shaw, David W. *Sea Wolf of the Confederacy: The Daring Civil War Raids of Naval Lt. Charles W. Read.* Dobbs Ferry, N.Y.: Sheridan House, 2004.

Spencer, Charles. *Edisto Island, 1861 to 2006: Ruin, Recovery, and Rebirth.* Mount Pleasant, S.C.: History Press, 2008.

State of Virginia. *Acts of the General Assembly of the State of Virginia, Passed at Called Session, 1863, in the Eighty-Eighth Year of the Commonwealth.* Richmond, Va.: William F. Ritchie, Public Printer, 1863.

Statutes at Large of the United States of America, from October 1877 to March 1879, Vol. XX. Washington, D.C.: Government Printing Office, 1879.

Still, William N. Jr., ed. *Odyssey in Gray: A Diary of Confederate Service, 1863–1865.* Richmond, Va.: Virginia State Library, 1979.

Thompson, Magnus S., comp. *General Orders and Circulars Issued by the Navy Department from 1863 to 1887.* Washington, D.C.: Government Printing Office, 1887.

Thompson, Robert M., and Richard Wainwright. *Confidential Correspondence of Gustavus Vasa Fox, Vol. II.* New York: De Vinne Press, 1919.

Thompson, S. Millett. *Thirteenth Regiment of New Hampshire Volunteer Infantry in the War of the Rebellion 1861–1865.* Boston: Houghton, Mifflin & Co., 1888.

U.S. Naval War Records Office. *Official Records of the Union and Con-*

federate Navies in the War of the Rebellion. 30 vols. Washington, D.C.: Government Printing Office, 1880–1901.

U.S. Navy Department. *Medical Essays: Compiled from Reports to the Bureau of Medicine and Surgery, by Medical Officers of the U.S. Navy*. Washington, D.C.: Government Printing Office, 1872.

Veit, Chuck L. *A Dog before a Soldier: Almost Lost Episodes in the U.S. Navy's Civil War*. Raleigh, N.C.: Lulu Press, 2010.

Walke, Henry. *Naval Scenes and Reminiscences of the Civil War in the United States*. New York: F. R. Reed & Co., 1877.

The War of the Rebellion: A Compilation of the Official Records of the Union and Confederate Armies. 128 vols. Washington, D.C.: Government Printing Office, 1894–1922.

Whittle, William C. *Cruises of the Confederate States Steamers* Shenandoah *and* Nashville. Norfolk, Va.: n.p., 1910.

Winslow, Arthur. *Francis Winslow: His Forbears and Life*. Norwood, Mass.: Plimpton Press, 1935.

Wise, George. *History of the Seventeenth Virginia Infantry, C.S.A.* Baltimore, Md.: Kelly, Piet & Co., 1870.

Articles

"1864: James Reid to Susan Jane (Young) Reid." *Spared & Shared 5*, February 26, 2014. https://sparedshared5.wordpress.com/2014/02/26/1864-james-reid-to-susan-jane-young-reid/.

Abbott, John S. C. "Heroic Deeds of Heroic Men: True Chivalry. Benjamin H. Porter." *Harper's New Monthly Magazine* 34 (April 1867): 559–571.

Bendus, Robert F. "A Proposal to Establish the Shipwreck USS *Narcissus* as a State Underwater Archaeological Preserve." December 2011. Division of Historical Resources, Florida Department of State, Tallahassee, Fla.

Brock, Robert A. "Paroles of the Army of Northern Virginia." *Southern Historical Society Papers* 15 (1887): 449–450.

"Captain Amos P. Foster." *St. Francis Historical Society Newsletter* (October 2011): 1–2.

Crosby, William, and Joseph F. Ainsworth, eds. "Review: Lyrics of a Day." *North American Review* 99, no. 204 (July 1864): 320.

Cunningham, Sumner A. "Tribute to Capt. William W. Leake." *Confederate Veteran Magazine* 22, no. 5 (May 1914): 221.

Dana, David T. III "William Dana Has a Firsthand View of the Battle of Mobile Bay from Rear Adm. David Farragut's Flagship Hartford." *America's Civil War* 12, no. 2 (May 1999): 14–17.

DuBois, Theodore W. "Masonry and the War." *Freemasons' Monthly Magazine* 24, no. 9 (July 1, 1865): 283–284.

Dwight, Charles A.S, "After You!" *The Sailors' Magazine and Seamen's Friend* 66, no. 7 (July 1894): 193–194.

Field, Ron. "Four Decades on the High Seas: Boatswain William Long, an Englishman in the U.S. Navy." *Military Images* 32 (Winter 2014): 30–31.

Finnell, Thomas C., and Ellsworth Eliot. "Benjamin Vreeland," *New York Medical Journal* 3 (June 1866): 239–240.

Forbes, Charles E. "From Mobile Bay to Santiago: An Authorized Biography of Rear Admiral Charles E. Clark." *Vermonter* 11, no. 1 (July 1904): 79–81.

G.W.B. "Ben Wood." *Journal of the American Society of Naval Engineers* 22, no. 4 (November 1910): 1318–1319.

Holden, Edgar. "A Cruise on the 'Sassacus.'" *Harper's New Monthly Magazine* 29 (November 1864): 712–724.

Holmes, Oliver W. "Doings of the Sunbeam." *Atlantic Monthly Magazine* 12 (July 1863): 8.

———. "Our Battle-Laureate." *Atlantic Monthly Magazine* 15 (May 1865): 589–591.

Malcom, Corey. "A Brief History of the Sailing Brig Last Known as the Piratical Slaver *Guerrero*." *Mel Fisher Maritime Museum* (June 2008): 7–8.

Morrison, Jed. "Disunion: Commander Preble's Very Bad Day." *New York Times*, September 4, 2012. http://opinionator.blogs.nytimes.com/2012/09/04/commander-prebles-very-bad-day.

"Obituary: Philip Joseph Langer, M.D." *Hahnemannian Monthly* 22, no. 6 (June 1887): 384.

Pulsifer, Frank H. "Reminiscences of the *Harriet Lane*." *Journal of the United States Coast Guard Association* 1, no. 1 (January–March 1917): 29–35.

Read, Charles W. "Reminiscences of the Confederate States Navy." *Southern Historical Society Papers* 1, no. 5 (May 1876): 331–362.

Ruffini, Giovanni D. "A Contemporary Hobby." *MacMillan's Magazine* 3, no. 6 (April 1861): 467–473.

Sands, Francis P. B. "Lieutenant Roswell H. Lamson, U.S. Navy." *United States Naval Institute Proceedings* 35, no. 1 (March 1909): 137–152.

Smith, Horatio D. "The Flag of Our Country." *The United Service: A Monthly Review of Military and Naval Affairs* 6, no. 1 (July 1904): 116–117.

Sturner, Eileen. "Webbs in History: William Augustine Webb." *Webb Bulletin* 3, no. 1 (January 2012): 1–2.

Weeks, Grenville M. "Last Cruise of the Monitor." *Atlantic Monthly* 9, no. 65 (March 1863): 366–372.

Whittle, William C. "Cruise of the Confederate States' Steamer *Nashville*." *Southern Historical Society Papers* 38 (1910): 334–340.

Wright, J. Robert, and Edward Kasinec. "Charles Hale and the Russian Church: The Biography of Innokentii." *Anglican and Episcopal History* 71, no. 1 (March 2002): 26–41.

Manuscript Collections

Archer, Edward R. Papers. Collection of the Gilder Lehrman Institute of American History, New York.

Bradbury, Isaac S. Letters, 1863–1864. New-York Historical Society.

Case Files of Approved Pension Applications of Civil War and Later Navy Veterans. U.S. National Archives and Records Administration, Washington, D.C.

Cenas Family Papers. Louisiana State Museum Collections, New Orleans.

Certificates of Death, Disability, Pension, and Medical Survey. Bureau of Medicine and Surgery. U.S. National Archives and Records Administration, Washington, D.C.

Compiled Military Service Records. U.S. National Archives and Records Administration, Washington, D.C.

Confederate Veterans and Widows Pension Applications. State Archives of Florida, Tallahassee.

Court-Martial Case Files. U.S. National Archives and Records Administration, Washington, D.C.

Cowan's Auctions. Cincinnati, Ohio.

Cushman, William H. Papers. Library of Congress, Washington, D.C.

Geer, George S. Papers. The Mariners' Museum Library and Archives, Newport News, Va.

Georgia Confederate Pension Office. Georgia Archives, Atlanta.

Grimball, John. Family Papers. South Carolina Historical Society, Charleston.

Hart, John E. Letters. Nimitz Library, U.S. Naval Academy, Annapolis, Md.

Hopkins, Nathan E. Papers. Collection of Jerry and Teresa Rinker, Springfield, Ohio.

Mann, William Barrow. Papers. University Archives, State University of New York at Buffalo.

Perkins, David King. Papers. David Critchfield Collection, Saratoga, Calif.

Records of General Courts-Martial and Courts of Inquiry of the Navy Department, 1799–1867. U.S. National Archives and Records Administration, Washington, D.C.

Register of Enlistments in the U.S. Army, 1798–1914. U.S. National Archives and Records Administration, Washington, D.C.

U.S. Census Population Schedules. U.S. National Archives and Records Administration, Washington, D.C.

U.S. Naval Academy Registers of Delinquencies, 1846–1850 and 1853–1882. U.S. National Archives and Records Administration, Washington, D.C.

U.S. Naval Enlistment Weekly Returns. U.S. National Archives and Records Administration, Washington, D.C.

Winslow, Francis. Papers. Library of Congress, Washington, D.C.

Newspapers and Periodicals

Army and Navy Journal
Baltimore American
Boston Evening Journal
Boston Evening Transcript
Boston Herald
British Journal of Photography
Brooklyn (N.Y.) Daily Eagle
Charleston Courier
Charleston Daily Courier
Charleston Mercury
Charleston News and Courier
Chicago Times
Christian Recorder (Boston)
Christian Watchman (Boston)
Cincinnati Gazette
Columbian Register (New Haven, Conn.)
Daily Constitution (Atlanta)
Daily Constitutionalist (Augusta, Ga.)
Daily Dispatch (Richmond, Va.)
Daily Eastern Argus (Portland, Me.)
Daily Evansville (Ind.) Journal
Daily Evening Traveller (Boston)
Daily Missouri Democrat
Daily National Intelligencer (Washington, D.C.)
Daily Picayune (New Orleans, La.)
Denver Post
Evening Post (New York City)
Evening Star (Washington, D.C.)
Frank Leslie's Illustrated Newspaper

Godey's Lady's Book
Harper's Weekly
Hartford (Conn.) Daily Courant
Harvard Graduates Magazine
Highland Weekly News (Hillsboro, Ohio)
Illinois State Journal (Springfield)
London Review
Lowell (Mass.) Daily Citizen & News
Massachusetts Spy (Worcester)
Medical Times and Gazette: A Journal of Medical Science, Literature, Criticism, and News (London)
Middleboro (Mass.) Gazette
Middlebury (Vt.) Register
New Bedford (Mass.) Evening Standard
New York Commercial Advertiser
New-York Daily Reformer (Watertown)
New York Herald
New York Journal of Commerce
New York Times
New-York Tribune
Omaha (Neb.) World Herald
Oregonian (Portland)
Philadelphia Inquirer
Pigeon (Mich.) Progress
Plain Dealer (Cleveland, Ohio)
Portland (Me.) Advertiser
Press (Philadelphia)
Providence (R.I.) Evening Press
Richmond (Va.) Dispatch
Rochester (N.Y.) Democrat and Chronicle
San Francisco Call
Saturday Spectator (Terre Haute, Ind.)
Semi-Weekly Wisconsin (Milwaukee)
Springfield (Mass.) Daily Republican
The State (Columbia, S.C.)
The Sun (Baltimore, Md.)
Sunday Herald (Boston)
The Times (London)
Watertown (N.Y.) Daily Times
Wilmington (N.C.) Journal

Online Sources

Accessible Archives. www.accessible-archives.com/collections/.

American Civil War Research Database. Historical Data Systems. www.civilwardata.com.

Ancestry. www.ancestry.com.

Dictionary of American Naval Fighting Ships. U.S. Navy Naval History and Heritage Command. http://history.navy.mil/research/histories/ship-histories/danfs.html.

FamilySearch. Church of Jesus Christ of Latter-Day Saints. www.familysearch.org.

Fold3 by Ancestry. www.fold3.com.

GenealogyBank. NewsBank, Inc. http://genealogybank.com.

Making of America. Cornell University Library. http://ebooks.library.cornell.edu/m/moawar/index.html.

Newspapers.com. http://newspapers.com.

Rank Charts for Civil War Navies. U.S. Naval Landing Party. http://usnlp.org/civilwarnavalranks.

Acknowledgments

The creation of this manuscript was a memorable twenty-six-month journey. The similarity of the number of months to the miles in a marathon occurred to me about the midpoint of its development. The realization helped me stay on track as I sprinted towards the finish line. Along the way, serendipity seemed ever present.

One of the many happy events occurred in the summer of 2013 when I became editor and publisher of *Military Images* magazine. With the position came a wonderful network of contributors. One of them, Ron Field, is a senior editor at *MI*. Indefatigable and ready to pitch in at a moment's notice, Ron generously shared of his knowledge, research, and contacts with navy image collectors who contributed to his beautifully illustrated book, *Bluejackets: Uniforms of the United States Navy in the Civil War Period, 1852–1865*. A total of fourteen portraits in this volume are from Ron's personal collection.

Another fourteen images reproduced here come from collectors known to Ron. Mike McAfee, who has been associated with *Military Images* for many years, shared his portrait of Landsman Freeman MacArthur. Eight images come from the holdings of Earl Sheck. Five portraits are part of the collection of the late Jerry Rinker and his wife, Teresa. Their collection remains intact today thanks to the continuing efforts of Jerry's daughter, Lynda Setty, and her husband, Randy. I have great admiration for Lynda, who understands the historical value of the images and other relics her father collected. I appreciate her commitment to carrying on her father's legacy and making the Rinker Collection available to me.

Altogether, more than a third of the images included in this volume connect to Ron Field. I owe him a sincere debt of gratitude for his patience, generosity, kindness, and support for this project.

Military Images also connected me to other collectors. Orton Begner, Dan Binder, Steve Karnes, and Marty Schoenfeld all contributed, and I am thankful for their eagerness to participate.

Other photos appeared simply by being in the right place at the right time. At the Gettysburg Civil War Collector's Show in the summer of 2014 I met Gerry Roxbury and viewed his display of rare Confederate

navy portraits. I quickly discovered Gerry's affable and generous spirit, as well as his passion for the navy. He opened his display case on the spot with the show in progress and allowed me to make digital copies of his images with my portable scanner and laptop. I captured seven Confederates that day.

A few images come from institutions. Thanks to Tom Liljenquist, who pointed me to the identified Union and Confederate sailors in his extensive collection at the Library of Congress, and Claudia Jew of the Mariners' Museum in Newport News, Virginia.

Images from the holdings of three prominent collectors who contributed to my other volumes are also included here. I am grateful to Greg French, Ronn Palm, and David Wynn Vaughan for the continued support.

Special thanks are due to Rick Brown. His enthusiasm and energy as a collector are infectious. Rick's stunning *carte de visite* of a Union bluejacket and powder boy grace the cover of this volume.

Though the digitization of primary resources and searchable databases greatly reduced the need for research trips, I still found material in the collections of private and public institutions unavailable online. In these cases I often turned to Lynn Kristianson of the interlibrary loan program at my public library in Arlington, Virginia. She fielded my requests in her usual efficient and friendly manner. I join with her friends, family, and colleagues in mourning her recent passing.

Two individuals who opened doors for me early on deserve recognition here. Editor Kay Jorgensen accepted my proposal to write a regular column in the *Civil War News*. Kay suggested the name, *Faces of War*. I retired the column in January 2016 after fifteen years and more than 150 columns. Robert J. Brugger, Editor Emeritus of Johns Hopkins University Press, recognized the historical importance of profiles and portraits of citizen soldiers of the Civil War. Bob responded positively to my first book proposal and worked patiently with me to develop it into *Faces of the Civil War*. I live by his often-repeated words of encouragement, "Onward!" and "Press the Attack!" I owe Bob and Kay so much and thank them for believing.

Special thanks to copyeditor Glenn Perkins and everyone on the staff of Johns Hopkins University Press for editing, designing, promoting, and distributing this book.

The debt of gratitude I owe to Chuck Myers, steadfast friend and veteran battlefield traveler, for his numerous contributions can never be repaid.

My family has always been supportive. This book and my other Civil War pursuits have their origins in day trips to Gettysburg and other

historic sites. Carol, my mother, was a driving force behind those early visits, and she continues to take an active interest in my work today. Thanks are also due to my brothers and their wives, Gary and Wendi, and Michael and Michelle. Special thanks to my nephew, Michael, who, with my mother walked the national cemetery in Florence, South Carolina, on a steaming summer day in 2015 on a search for the gravesite of Marine Charles II. Bradford.

Bella the intrepid battlefield and trail-hiking pug is my alarm clock. She wakes me every morning before dawn, follows me as I make my way bleary-eyed to the kitchen for coffee, and then on to the study. Then she promptly goes to sleep at my feet as I tap away on the laptop. Though age has slowed her down, her tightly curled tail and intense gaze are still strong. Our beloved Missy, ever so sweet, left us midway through this project.

The biggest thank you of all is reserved for my wife, Anne. Her implicit faith and trust in me, and the support and love that flows as a result, enables me to go forward confident in the belief that bringing these old warriors from another time back to life through pictures and stories is a worthy pursuit. I could not ask for more.

Index

Page numbers in italic refer to photographs.